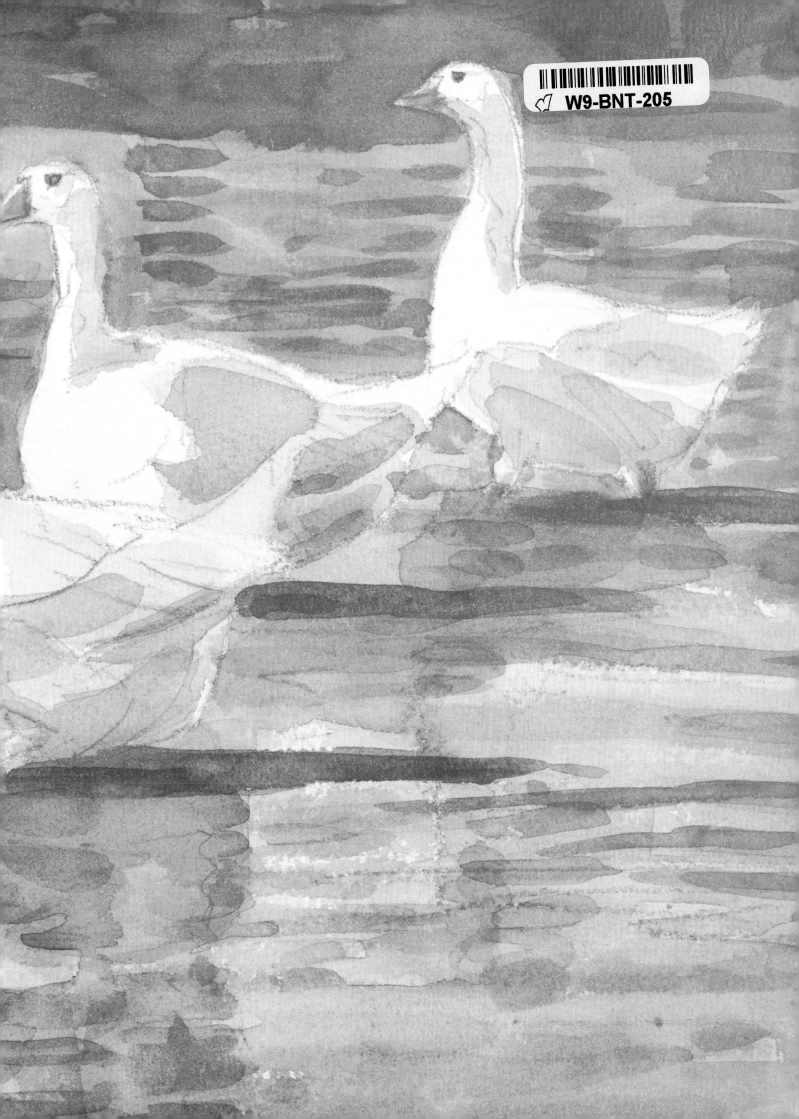

MASTERING THE ART OF DRAWING & PAINTING

ANIMALS

WILDLIFE, PETS, REPTILES, BIRDS, FISH & INSECTS

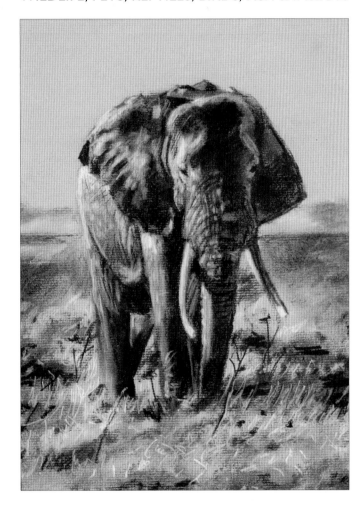

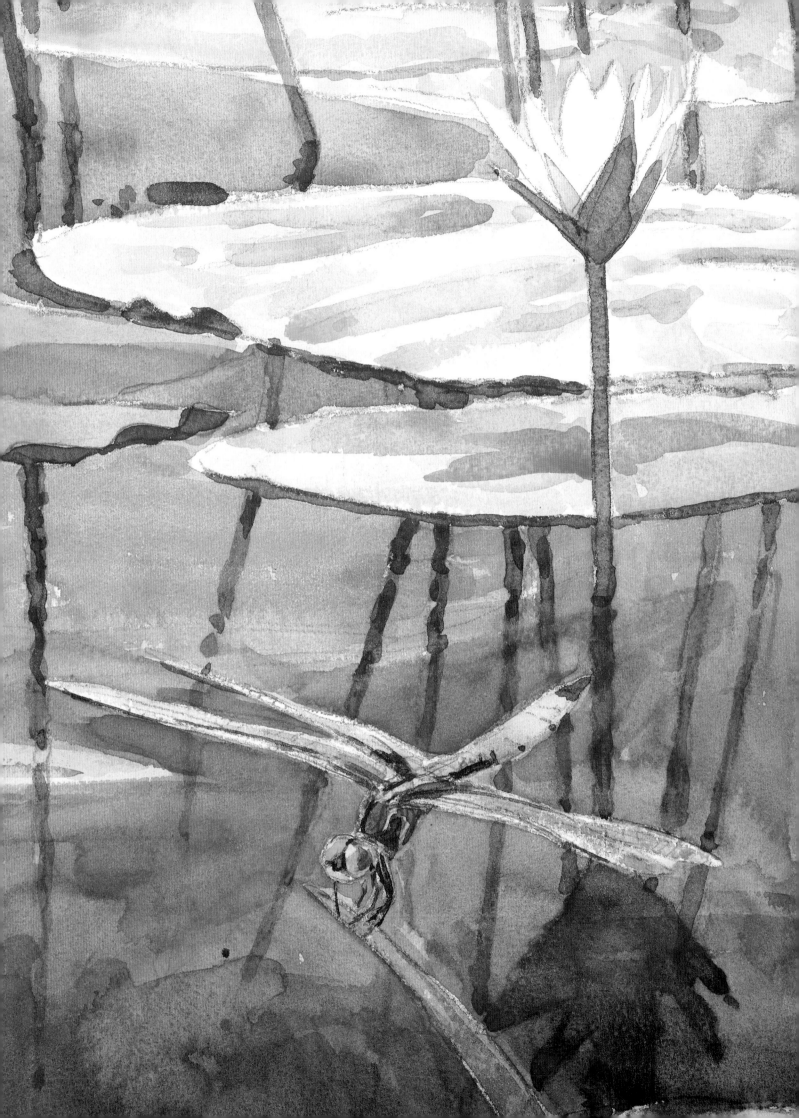

MASTERING THE ART OF DRAWING & PAINTING
ANIMALS

WILDLIFE, PETS, REPTILES, BIRDS, FISH & INSECTS

Learn to produce lively studies in oils, acrylics, pastels, ink, pencils and charcoal

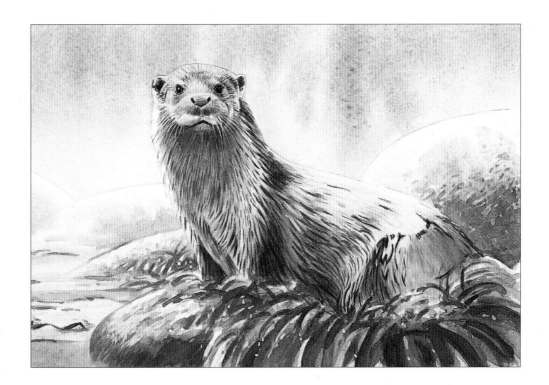

With expert step-by-step tutorials and 30 projects shown in more than 800 photographs

JONATHAN TRUSS & SARAH HOGGETT

METRO BOOKS
New York

METRO BOOKS
New York

An Imprint of Sterling Publishing
387 Park Avenue South
New York, NY 10016

METRO BOOKS and the distinctive Metro Books logo are trademarks of Sterling Publishing Co., Inc.

© 2011 by Anness Publishing Ltd.
Illustrations © 2011 by Anness Publishing

This 2011 edition published by Metro Books by arrangement with Anness Publishing

Publisher: Joanna Lorenz
Editorial Director: Helen Sudell
Project Editors: Rosie Gordon and Elizabeth Young
Photographers: Martin Norris and Jessica Madge
Designer: Ian Sandom
Cover Designer: Nigel Partridge
Proofreading Manager: Lindsay Zamponi
Production Controller: Mai-Ling Collyer

ISBN 978-1-4351-3876-6

For information about special sales, and premium and corporate purchases, please contact Sterling Special Sales at 800-805-5489 or specialsales@sterlingpublishing.com

Manufactured in the United Arab Emirates

www.sterlingpublishing.com

10 9 8 7 6 5 4 3 2 1

Parts of this book were previously published in *Mastering the Art of Drawing, Mastering the Art of Watercolour, Mastering the Art of Acrylics, Oils and Gouache*, and *How to Master the Art of Drawing and Painting Landscapes*.

Special thanks to the following artists for producing the sketches and step-by-step demonstrations used in this book:
Lucie Cookson 47; 128–133; 146–151; 152–155; 194–199; 238–243. Martin Decent page 163 (bottom right). Paul Dyson page 42 (top); 88–93; 110–115; 162 (bottom); 182–187. Timothy Easton pages 75; 165 (bottom).
Abigail Edgar pages 46 (top); 55; 78–79; 98–103; 134–139; 156–159; 206–209. Trudy Friend pages 39 (both); 40; 44 (bottom); 48 (left); 50 (right); 52 (top right); 54 (top); 56; 66; 69 (bottom). Robert Greenhalf pages 200–205; 228–233. Suzy Herbert pages 178–181. Wendy Jelbert pages 116–121; 172–177; 210–213; 214–217; 218–223. Beverley Johnston pages 104–109; 244–249. Jonathan Latimer pages 36–37; 67 (top); 166 (bottom right); 188–193; 234–237. Melvyn Petterson pages 82–7; 94–7. John Raynes pages 224–227. Ian Sidaway page 53. Jonathan Truss pages 32–5; 38; 41 (both); 43; 44 (top); 45; 48 (right); 49; 50 (left); 51; 52 (left); 57 (both); 58 (both); 59; 60–61; 64, 65; 66; 68; 69 (bottom); 76 (bottom); 80–81; 122–127; 140–145; 163 (bottom left); 168–169 (all); 170–171 (all). Thanks also to the following for permission to reproduce copyright photographs: Pat Ellacott (www.patellacott.co.uk) page 74 (bottom right); 167 (top). Tracy Hall (www.watercolour-artist.co.uk) pages 72 (top); 77 (top); 166 (top and bottom left). Jonathan Hibberd pages 42 (bottom); 78 (top); 94 (top); 98 (top); 178 (left); 210 (top). Istockphoto pages 46 (bottom); 54 (bottom); 104 (top); 128 (top); 134 (top); 152 (top); 156 (left); 170, 194; 200 (left); 206 (left); 214 (left); 218; 228 (both); 238; 244 (left). Jonathan Latimer (www.jonathanlatimer.com) pages 67 (top); 73 (bottom); 74 (top left, top right); 162 (top); 167 (bottom). David Miller (www.davidmillerart.co.uk) pages 67 (bottom); 164 (both); 165 (top). Martin Ridley (www.martinridley.com) pages 73 (top); 76 (top); 163 (top). David Stribbling (www.davidstribbling.com) pages 72 (bottom); 77 (bottom). Jonathan Truss (www.jonathantruss.com) pages 7; 45; 49; 50; 58; 62–63 (all); 80; 146 (left); 76 (bottom); 168 (top); 169 (left). Tina Warren (www.artist-tinawarren.com) page 6 (bottom right).

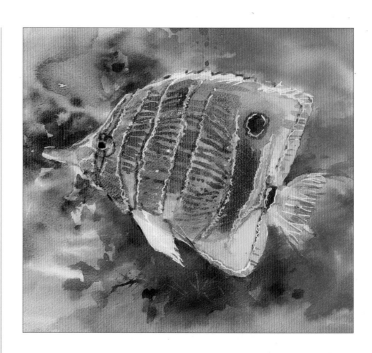

Contents

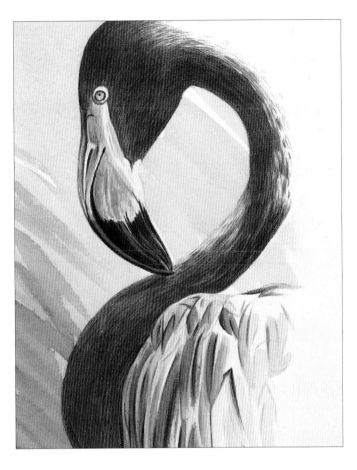

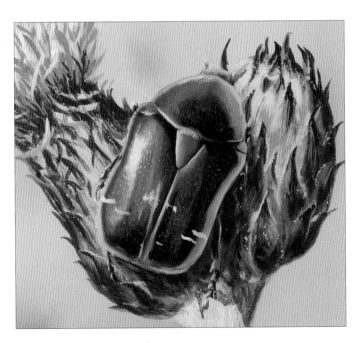

Introduction

Paintings of wildlife are among the oldest surviving forms of pictorial representation on earth, created thousands of years ago by cave dwellers who had only the most rudimentary of tools. Wildlife was, however, for many centuries, largely ignored by Western artists as potential subject matter. There are notable exceptions, of course. To name but two, the works of the German artist Albrecht Dürer (1471–1528) include wonderfully detailed watercolours of animals and birds that remain unsurpassed to this day, while the English artist George Stubbs (1724–1806) is still renowned as one of the greatest equestrian artists ever. There is also a long history of painting flora and fauna in the interests of scientific research. Illustrators accompanied many of the great explorers on their voyages in order to make visual records of the new flora and fauna they discovered. And there are many wonderful illustrations by naturalists such as the American John James Audubon, whose *Birds of America* was published in the 1840s.

But in terms of art history, animals and birds have featured in paintings more often for their symbolic meaning (particularly in the religious art of the Middle Ages and Renaissance) than for any other reason. Even paintings in which they are the main subject, such as the works of Sir Edwin Landseer (1803–73), often tend to portray animals in an idealized, romanticized landscape that says more about the individual artist's view of the world than about the animals themselves.

It is only relatively recently – perhaps in the last 100–150 years or so – that wildlife art has become widely accepted as a subject in its own right. The German painter Friedrich Wilhelm Kühnert (1865–1926) was perhaps one of the first European artists to specialize in painting wildlife and travelled widely in east Africa in order to paint animals in their natural habitat. Maybe this growing interest in wildlife is a result of people seeing more of the wonders of the natural world – through their own

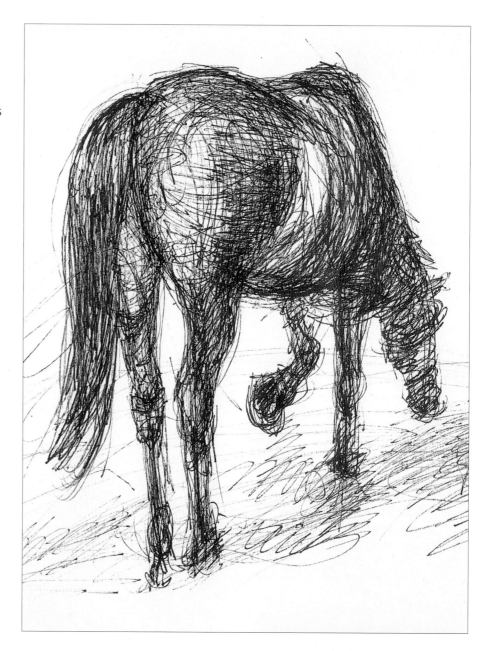

▲ **Careful control**
This pen-and-ink sketch has a spontaneous feel but it has been carefully thought out. The lines and scribbles may appear random, but they follow either the form of the animal or the direction in which the hair grows: note the curved lines on the barrel of the body, the long flowing lines of the tail, and how some areas on the flank and belly are left virtually untouched to convey the play of bright light on the form.

▶ **Tonal awareness**
With an almost monochromatic subject such as this gorilla, careful observation of the tones is the key. Note how the soft fur, created by blending the oil paint wet into wet, frames the animal's expressive face.

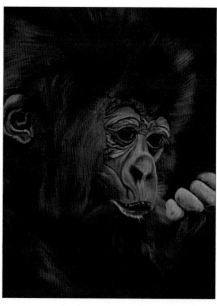

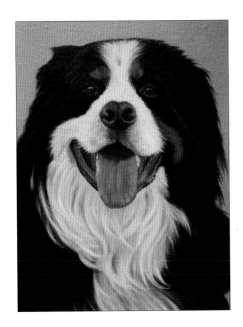

▲ The familiar
If you're new to drawing and painting, a family pet is a good subject to start with, as you will know instantly if you've managed to capture its character and personality.

travels or through natural history documentaries; at the same time, they have also become more aware of the importance of biodiversity and conservation. Either way, more and more people are entranced by the beauty of the natural world and the creatures that we share it with.

Anyone who has painted a landscape scene full of wildlife knows about the detail involved in producing 'animal art'. The animal artist has to think about exactly the same things as any other artist – composition, light, tones, colour, shadows, and so on. But he or she also has to contend with topics that are peculiar to wildlife subjects, such as how to paint fur or feathers, and how to make sure that the animals are appropriate to the landscape in which they're placed – and so the whole subject area provides many challenges that are quite unique to animal art.

This book is designed to provide a thorough introduction to drawing and painting animals, birds, insects and other living creatures. After a quick look at the tools and materials available, we move on to a tutorials section that sets out some of the technicalities, from capturing the texture of fur and

feathers to creating your own wildlife compositions and the pros and cons of working from photographs. Here you will find short practice exercises that you can use as a starting point alongside sketches and studies by professional artists. If you're a complete beginner, it's a good idea to work through this chapter page by page to give yourself a thorough grounding. If you've already done some wildlife painting, turn to it for a refresher course whenever you need extra guidance on specific topics.

The rest of the book is broken down into two sections – animals, and birds, fish and insects. Each section begins with a gallery of works by professional artists that you can use as a source of inspiration and ends with a series of step-by-step demonstrations covering a range of subjects in different media, from domestic pets to animals and birds in the wild, in their natural habitat. All the demonstrations are by professional artists with many years' experience.

Even if the subject does not appeal to you, or the artist works in a medium with which you are not familiar, take the time to study them. You'll glean all kinds of useful tips and insights that you can include in your own work. You will also quickly realize that you do not have to fly to an exotic location to find animals or birds; even in your own garden or local park there will be an abundance of creatures to draw and paint, from tiny bugs and butterflies to common birds that many artists might overlook in favour of more unusual and eye-catching species. Capturing the beauty of the natural world is an engrossing challenge, and this book will help you to produce studies and artworks of all kinds of animals.

▼ Unobtrusive background
The browns, ochres and creamy yellows of the giraffe's coat are echoed in the background, the colours blended on the canvas to create a soft, impressionistic blur against which the animal stands out sharply.

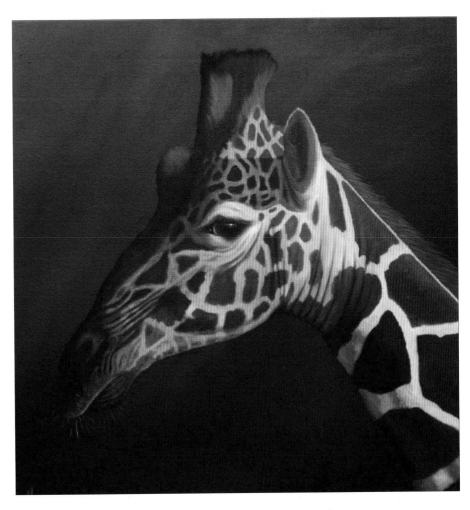

Materials

Most artists have one medium in which they prefer to work. For some, it's the translucency of watercolour that captures their imagination, while others love the linear detailing that can be achieved with pen and ink. Or perhaps it's the versatility of soft pastels – which can be blended to create an almost infinite range of subtle colour mixes – that appeals, or the soft, buttery consistency of oil paints. You might use easily portable pencils, charcoal or coloured pastels for quick sketches of animals, birds, fish or insects in their natural habitat, and another quick-drying medium, such as acrylics, for more detailed studies back at home, in your own studio.

The important thing is to become familiar with what your chosen materials can do, so this chapter sets out the characteristics of all the main drawing and painting media. And if you're already experienced in one medium, then why not use the information given here to try out something different? Experimenting with a range of new materials is a great way to reinvent yourself as an artist, as it encourages you to try out a variety of techniques and visual approaches and create exciting new visual effects.

Monochrome media

For sketching and underdrawing, as well as for striking studies in contrast and line, there are many different monochrome media, all of which offer different qualities to your artwork. A good selection is the foundation of your personal art store, and it is worth exploring many media, including different brands, to find the ones you like working with.

Pencils

The grading letters and numbers on a pencil relate to its hardness. 9H is the hardest, down to HB and F (for fine) and then up to 9B, which is the softest. The higher the proportion of clay to graphite, the harder the pencil. A choice of five grades – say, a 2H, HB, 2B, 4B and 6B – is fine for most purposes.

Soft pencils give a very dense, black mark, while hard pencils give a grey one. The differences can be seen below – these marks were made by appying the same pressure to different grades of pencil. If you require a darker mark, do not try to apply more pressure, but switch to a softer pencil.

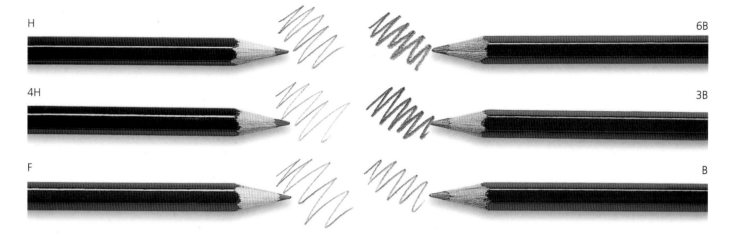

Water-soluble graphite pencils

There are also water-soluble graphite pencils, which are made with a binder that dissolves in water. Available in a range of grades, they can be used dry, dipped in water or worked into with a brush and water to create a range of

watercolour-like effects. Water-soluble graphite pencils are an ideal tool for sketching on location, as they allow you to combine linear marks with tonal washes. Use the tip for fine details and the side of the pencil for area coverage.

Water-soluble graphite pencils

Graphite sticks

Solid sticks of graphite come in various sizes and grades. Some resemble conventional pencils, while others are shorter and thicker. You can also buy irregular-shaped chunks and fine graphite powder, as well as thinner

strips of graphite in varying degrees of hardness that fit into a barrel with a clutch mechanism to feed them through.
 Graphite sticks are capable of making a wider range of marks than conventional graphite pencils.

For example, you can use the point or edge of a stick to make a thin mark, or stroke the whole side of the stick over the paper to make a broader mark.

Charcoal

The other monochromatic drawing material popular with artists is charcoal. It comes in different lengths and in thin, medium, thick and extra-thick sticks. You can also buy chunks that are ideal for expressive drawings. Stick charcoal is very brittle and powdery, but is great for broad areas of tone.

Compressed charcoal is made from charcoal dust mixed with a binder and fine clay and pressed into shape. Sticks and pencils are available. Unlike stick charcoal, charcoal pencils are ideal for detailed, linear work. As with other powdery media, drawings made in charcoal should be sprayed with fixative

to hold the pigment in place and prevent smudging during and after working on the piece.

Thick and thin charcoal sticks

Pen and ink

With so many types of pens and colours of ink available, not to mention the possibility of combining linear work with broad washes of colour, this is an extremely versatile medium and one that is well worth exploring. Begin by making a light pencil underdrawing of your subject, then draw over with pen – but beware of simply inking over your pencil lines, as this can look rather flat and dead. When you have gained enough confidence, your aim should be to put in the minimum of lines in pencil, enough to simply ensure you have the proportions and angles right, and then do the majority of the work in pen.

Rollerball, fibre-tip and sketching pens

Rollerball and fibre-tip pens are ideal for sketching out ideas, although finished drawings made using these pens can have a rather mechanical feel to them, as the line does not vary in width. This can sometimes work well as an effect. By working quickly with a rollerball you can make a very light line by delivering less ink to the nib. Fibre-tip and marker pens come in a range of tip widths, from super-fine to calligraphic-style tips, and also in a wide range of colours. Sketching pens and fountain pens enable you to use ink on location without having to carry bottles of ink.

Dip pens and nibs

A dip pen does not have a reservoir of ink; as the name suggests, it is simply dipped into the ink to make marks. Drawings made with a dip pen have a

Nibs and dip pens

unique quality, as the nib can make a line of varying width depending on how much pressure you apply. You can also turn the pen over and use the back of the nib to make broader marks. As you have to keep reloading with ink, it is difficult to make a long, continuous line – but for many subjects the rather scratchy, broken lines are very attractive.

When you first use a new nib it can be reluctant to accept ink. To solve this, rub it with a little saliva.

Sketching pen

Bamboo, reed and quill pens

The nib of a bamboo pen delivers a 'dry', rather coarse line. Reed and quill pens are flexible and give a subtle line that varies in thickness. The nibs break easily, but can be recut with a knife.

Fibre-tip pen

Quill and bamboo pens

Rollerball pen

Inks

The two types of ink used by artists are waterproof and water-soluble. The former can be diluted with water, but are permanent once dry, so line work can be worked over with washes without any fear of it being removed.

They often contain shellac, and thick applications dry with a sheen. The best-known is Indian ink, actually from China. It makes great line drawings, and is deep black but can be diluted to give a beautiful range of warm greys.

Water-soluble inks can be reworked once dry, and work can be lightened and corrections made. Do not overlook watercolours and soluble liquid acrylics – both can be used like ink but come in a wider range of colours.

Waterproof ink

Water-soluble ink

Liquid acrylic

Coloured drawing media

Containing a coloured pigment and clay held together with a binder, coloured pencils are impregnated with wax so that the colour holds to the support with no need for a fixative. They are especially useful for making coloured drawings on location, as they are a very stable medium and are not prone to smudging. Mixing takes place optically on the surface of the support rather than by physical blending, and all brands are inter-mixable, although certain brands can be more easily erased than others; so always try out one or two individual pencils from a range before you buy a large set. Choose hard pencils for linear work and soft ones for large, loosely applied areas of colour.

Box of pencils ▲
Artists who work in coloured pencil tend to accumulate a vast range in different shades – the variance between one tone and its neighbour often being very slight. This is chiefly because you cannot physically mix coloured pencil marks to create a new shade (unlike watercolour or acrylic paints). So, if you want lots of different greens in a landscape, you will need a different pencil for each one.

Water-soluble pencils

Most coloured-pencil manufacturers also produce a range of water-soluble pencils, which can be used to make conventional pencil drawings and blended with water to create watercolour-like effects. In recent years, solid pigment sticks that resemble pastels have been introduced that are also water-soluble and can be used in conjunction with conventional coloured pencils or on their own.

Wet and dry ▼
Water-soluble pencils can be used dry, the same way as conventional pencils.

Conté crayons and pencils

The best way to use Conté crayons is to snap off a section and use the side of the crayon to block in large areas, and a tip or edge for linear marks.

The pigment in Conté crayons is relatively powdery, so, like soft pastels and charcoal, it can be blended by rubbing with a finger, rag or torchon. Conté crayon drawings benefit from being given a coat of fixative to prevent smudging. However, Conté crayons are harder and more oily than soft pastels, so you can lay one colour over another, letting the under-colour show through.

Conté is also available in pencils, which contain wax and need no fixing (setting); the other benefit is that the tip can be sharpened to a point.

Conté crayons ▼
These small, square-profile sticks are available in boxed sets of traditional colours. Drawings made using these traditional colours are reminiscent of the wonderful chalk drawings of old masters such as Michelangelo or Leonardo da Vinci.

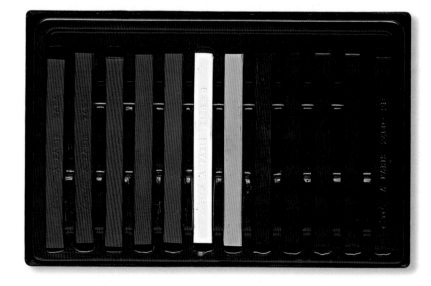

Conté pencils ▼
As they can be sharpened to a point, Conté pencils are ideal for drawings that require precision and detail.

Pastels

Working in pastels is often described as painting rather than drawing, as the techniques used are often similar to those used in painting. Pastels are made by mixing pigment with a weak binder, and the more binder used the harder the pastel will be. Pastels are fun to work with and ideal for making colour sketches as well as producing vivid, dynamic artwork.

Soft pastels

As soft pastels contain relatively little binder, they are prone to crumbling. For this reason they sometimes have a paper wrapper to help keep them in one piece. Even so, dust still comes off, and can easily contaminate other colours nearby. The best option is to arrange your pastels by colour type and store them in boxes.

Pastels are mixed on the support either by physically blending them or by allowing colours to mix optically. The less you blend, the fresher the image looks. For this reason, pastels are manufactured in a range of hundreds of tints and shades.

As pastels are powdery, use textured paper to hold the pigment in place. You can make use of the texture of the paper in your work. Spray soft pastel drawings with fixative to prevent smudging. You can fix (set) work in progress, too – but colours may darken.

Pastel pencils

A delight to use, the colours of pastel pencils are strong, yet the pencil shape makes them ideal for drawing lines. If treated carefully, they do not break – although they are more fragile than graphite or coloured pencils. The pastel strip can be sharpened to a point, making pastel pencils ideal for

describing detail in drawings that have been made using conventional hard or soft pastels.

Available in a comprehensive range of colours, pastel pencils are clean to use and are ideal for linear work. Ideally, store them in a jar with the tips upward to prevent breakage.

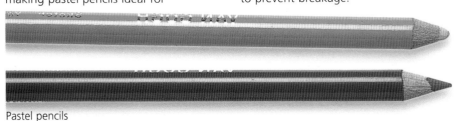

Pastel pencils

Hard pastels

One advantage of hard pastels is that, in use, they do not shed as much pigment as soft pastels, therefore they will not clog the texture of the paper as quickly. For this reason, they are often used in the initial stages of a work that is completed using soft pastels. Hard pastels can be blended together by rubbing, but not as easily or as seamlessly as soft pastels.

Hard pastels

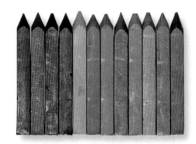

Box of soft pastels ▼
When you buy a set of pastels, they come packaged in a compartmentalized box so that they do not rub against each other and become dirtied.

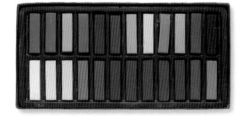

Oil pastels

Made by combining fats and waxes with pigment, oil pastels are totally different to pigmented soft and hard pastels and should not be mixed with them. Oil pastels can be used on unprimed drawing paper and they never completely dry.

Oil-pastel sticks are quite fat and therefore not really suitable for detailed work or fine, subtle blending. For bold, confident strokes, however, they are absolutely perfect.

Oil-pastel marks have something of the thick, buttery quality of oil paints. The pastels are highly pigmented and available in a good range of colours. If they are used on oil-painting paper, they can be worked in using a solvent such as white spirit (paint thinner), applied with a brush or rag. You can also smooth out oil-pastel marks with wet fingers. Oil and water are not compatible, and a damp finger will not pick up colour.

Oil pastels can be blended optically on the support by scribbling one colour over another. You can also create textural effects by scratching into the pastel marks with a sharp implement – a technique known as sgraffito.

Less crumbly than soft pastels, and harder in texture, oil pastels are round sticks and come in various sizes.

A box of oil pastels

Watercolour paint

One of the most popular media, watercolour paint comes in pans, which are the familiar compressed blocks of colour that need to be brushed with water to release the colour; or tubes of moist paint. The same finely powdered pigments bound with gum arabic solution are used to make both types. The pigments provide the colour, while the gum arabic allows the paint to adhere to the paper, even when diluted.

It is a matter of personal preference whether you use pans or tubes. The advantage of pans is that they can be slotted into a paintbox, making them easily portable, and this is something to consider if you often paint on location. Tubes, on the other hand, are often better if you are working in your studio and need to make a large amount of colour for a wash. With tubes, you need to remember to replace the caps immediately, otherwise the paint will harden and become unusable. Pans of dry paint can be rehydrated.

Tubes (above) and pans (right) of watercolour

Judging colours

It is not always possible to judge the colour of paints by looking at the pans in your palette, as they often look dark. In fact, it is very easy to dip your brush into the wrong pan, so always check before you put brush to paper.

Even when you have mixed a wash in your palette, do not rely on the colour, as watercolour paint always looks lighter when it is dry. The only way to be sure what colour or tone you have mixed is to apply it to paper and let it dry. It is always best to build up tones gradually until you get the effect you want. The more you practise, the better you will get at anticipating results.

Grades of paint

There are two grades of watercolour paint: artists' and students' quality. Artists' quality paints are the more expensive, because they contain a high proportion of good-quality pigments. Students' quality paints contain less pure pigment and more fillers.

If you come across the word 'hue' in a paint name, it indicates that the paint contains cheaper alternatives instead of the real pigment. Generally speaking, you get what you pay for: artists' quality paints tend to produce more subtle mixtures of colours. The other thing that you need to think about when buying paints is their

permanence. The label or the manufacturer's catalogue should give you the permanency rating. In the United Kingdom, the permanency ratings are class AA (extremely permanent), class A (durable), class B (moderate) and class C (fugitive). The ASTM (American Society for Testing and Materials) codes for light-fastness are ASTM I (excellent), ASTM II (very good) and ASTM III (not sufficiently light-fast). Some pigments, such as alizarin crimson and viridian, stain more than others: they penetrate the fibres of the paper and cannot be removed.

Working with watercolour paint

Different pigments have different characteristics. Although we always think of watercolour as being transparent, you should be aware that some pigments are actually slightly opaque and will impart a degree of opacity to any colours with which they are mixed. These so-called opaque pigments include all the cadmium colours and cerulean blue. The only way to learn about the paints' characteristics is to use them, singly and in combination with other colours.

Appearances can be deceptive ▼
These two pans look very dark, almost black. In fact, one is Payne's grey and the other a bright ultramarine blue.

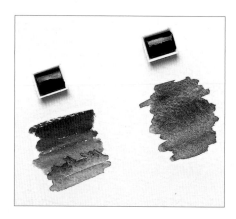

Test your colours ▼
Keep a piece of scrap paper next to you as you work so that you can test your colour mixes before you apply them.

Gouache paint

Made using the same pigments and binders found in watercolour, gouache is a water-soluble paint. The addition of *blanc fixe* – a precipitated chalk – gives the paint its opacity. Because gouache is opaque you can paint light colours over darker ones – unlike traditional watercolour, where the paint's inherent transparency means that light colours will not cover any darker shades that lie underneath.

Recently some manufacturers have begun to introduce paint made from acrylic emulsions and starch. The best-quality gouache contains a high proportion of coloured pigment. Artists' gouache tends to be made using permanent pigments that are light-fast. The 'designers' range uses less permanent pigments, as designers' work is intended to last for a short time.

Working with gouache paint

All of the equipment and techniques used with watercolour can be used with gouache. Like watercolour, gouache can be painted on white paper or board; due to its opacity and covering power it can also be used on a coloured or toned ground and over gesso-primed board or canvas. Gouache is typically used on smoother surfaces than might be advised for traditional watercolour, as the texture of the support is less of a creative consideration.

If they are not used regularly, certain gouache colours are prone to drying up over time. Gouache is water-soluble so can be rehydrated when dry, but dried-up tubes can be difficult to use. On the support, you can remedy any cracking of the dried paint by re-wetting it. During your work on the painting, you need assured brushwork when applying new paint over previous layers to avoid muddying the colours. Certain dye-based colours are particularly strong and, if used beneath other layers of paint, can have a tendency to bleed. With practice, this is easy to cope with.

Tubes of gouache paint

Bold brushwork ▲
Gouache remains soluble when it is dry, so if you are applying one colour over another, your brushwork needs to be confident: a clean stroke, as here, will not pick up paint from the first layer.

Muddied colours ▲
If you scrub paint over an underlying colour, you will pick up paint from the first layer and muddy the colour of the second layer, as here. To avoid this effect, see bold brushwork, left.

Change in colour when dry ▼
Gouache paint looks slightly darker when dry than it does when wet, so it is good practice to test your mixes on a piece of scrap paper – although, with practice, you will quickly learn to make allowances for this.

Wet gouache paint Dry gouache paint

Wet into wet ▲
Like transparent watercolour paint, gouache paint can be worked wet into wet (as here) or wet on dry.

Removing dry paint ▲
Dry paint can be re-wetted and removed by blotting with an absorbent paper towel.

Oil paint

There are two types of traditional oil paint – professional, or artists', grade and the less expensive students' quality. The difference is that artists' paint uses finely ground, high-quality pigments, which are bound in the best oils and contain very little filler, while students' paints use less expensive pigments and contain greater quantities of filler to bulk out the paint. The filler is usually *blanc fixe* or aluminium hydrate, both with a very low tinting strength.

Students' quality paint is often very good and is, in fact, used by students, amateur painters and professionals.

Tubes or cans? ▼
Oil paint is sold in tubes containing anything from 15ml to 275ml (1 tbsp to 9fl oz). If you tend to use a large quantity of a particular colour – for toning grounds, for example – you can buy paint in cans containing up to 5 litres (8¾ pints).

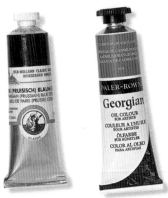

Drawing with oils ▶
Oil bars consist of paint with added wax and drying agents. The wax stiffens the paint, enabling it to be rolled into what resembles a giant pastel.

Water-mixable oil paint

Linseed and safflower oils that have been modified to be soluble in water are included in water-mixable oil paint. Once the paint has dried and the oils have oxidized, it is as permanent and stable as conventional oil paint. Some water-mixable paint can also be used with conventional oil paint, although its mixability is gradually compromised with the more traditional paint that is added.

Working with oil paint

However you use oil paint, it is most important to work on correctly prepared supports and always to work 'fat over lean'. 'Fat' paint, which contains oils, is flexible and slow to dry, while 'lean' paint, with little or no oil, is inflexible and dries quickly. Oil paintings can be unstable and prone to cracking if lean paint is placed over fat. For this reason, any underpainting and initial blocking in of colour should always be done using paint that has been thinned with a solvent and to which no extra oil has been added. Oil can be added to the

Glazing with oils ▲
Oils are perfect for glazes (transparent applications of paint over another colour). The process is slow, but quick-drying glazing mediums can speed things up.

Alkyd oil paints

Although they contain synthetic resin, alkyd oils are used in the same way as traditional oil paints and can be mixed with the usual mediums and thinners.

Alkyd-based paint dries much faster than oil-based paint, so it is useful for underpainting prior to using traditional oils and for work with glazes or layers. However, you should not use alkyd paint over traditional oil paint, as its fast drying time can cause problems.

paint in increasing amounts in subsequent layers. You must allow plenty of drying time between layers.

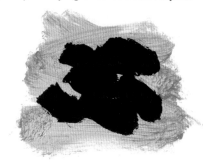

Working 'fat over lean' ▲
The golden rule when using oil paint is to work 'fat' (or oily, flexible paint) over 'lean', inflexible paint that has little oil.

Judging colour ▼
Colour mixing with oils is relatively straightforward: the colour that you apply wet to the canvas will look the same when it has dried, so (unlike acrylics, gouache or watercolour) you do not need to make allowances for changes as you paint. However, colour that looks bright when applied can begin to look dull as it dries. You can revive the colour in sunken patches by 'oiling out' – that is, by brushing an oil-and-spirit mixture or applying a little retouching varnish over the area.

Wet oil paint Dry oil paint

Acrylic paint

Unlike oil paint, acrylic paint dries quickly and the paint film remains extremely flexible and will not crack. Acrylic paint can be mixed with a wide range of acrylic mediums and additives and is thinned with water. The paint can be used with a range of techniques, from thick impasto, as with oil paint, to the semi-transparent washes of watercolour. Indeed, most techniques used in both oil and watercolour painting can be used with acrylic paint. Acrylic paints come in three different consistencies. Tube paint tends to be of a buttery consistency and holds its shape when squeezed from the tube. Tub paint is thinner and more creamy in consistency, which makes it easier to brush out and cover large areas. There are also liquid acrylic colours with the consistency of ink, sold as acrylic inks.

You may experience no problems in mixing different brands or consistencies, but it is always good practice to follow the manufacturer's instructions.

◀ **Liquid acrylics**
The consistency of liquid acrylic is like writing ink.

Tubs ▲
Acrylic paint in tubs stores easily.

Tubes ▶
Acrylic paints in tubes are convenient to carry and use with a palette.

Working with acrylic paint

Being water soluble, acrylic paint is very easy to use, requiring only the addition of clean water. Water also cleans up wet paint after a work session. Once it has dried, however, acrylic paint creates a hard but flexible film that will not fade or crack and is impervious to more applications of acrylic or oil paint or their associated mediums or solvents.

Acrylic paint dries relatively quickly: a thin film will be touch dry in a few minutes and even thick applications dry in a matter of hours. Unlike oil paints, all acrylic colours, depending on the thickness of paint, dry at the same rate and darken slightly. A wide range of mediums and additives can be mixed into acrylic paint to alter and enhance its handling characteristics.

Another useful quality in acrylic mediums is their good adhesive qualities, making them ideal for collage work – sticking paper or other materials on to the support.

Extending drying time ▲
The drying time of acrylic paint can be extended by using a retarding medium, which gives you longer to work into the paint and blend colours.

Covering power ▲
Acrylic paint that is applied straight from the tube has good covering power, even when you apply a light colour over a dark one, so adding highlights to dark areas is easy.

Texture gels ▲
Various gels can be mixed into acrylic paint to give a range of textural effects. These can be worked in while the paint is still wet.

Glazing with acrylics ▲
Acrylic colours can be glazed by thinning the paint with water, although a better result is achieved by adding an acrylic medium.

Shape-holding ability ▲
Like oil paint, acrylic paint that is applied thickly, straight from the tube, holds its shape and the mark of the brush as it dries, which can allow you to use interesting textures.

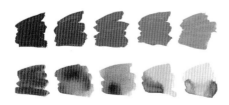

Lightening acrylic colours ▲
Acrylic colours can be made lighter by adding white paint, which maintains opacity (above top), or by adding water, which increases transparency (bottom).

Palettes

The surface on which an artist arranges colours prior to mixing and applying them to the support is known as a palette. (Somewhat confusingly, it is the same word that is used to describe a range of colours used by an artist, or the range of colours found in a painting.) The type of palette that you use depends on the medium in which you are working, but you will probably find that you need more space for mixing colours than you might imagine.

A small palette gets filled with colour mixes quickly and it is a false economy to clean the mixing area too often: you may waste usable paint or mixed colours that you could use again. Always buy the largest palette practical.

Wooden palettes

Flat wooden palettes in the traditional kidney or rectangular shapes with a thumb hole are intended for use with oil paints. They are made from hardwood, or from the more economical plywood.

Before you use a wooden palette with oil paint for the first time, rub linseed oil into the surface of both sides. Allow it to permeate the surface. This will prevent oil from the paint from being absorbed into the surface of the palette and will make it easier to clean. Re-apply linseed oil periodically and a good wooden palette will last for ever.

Wooden palettes are not recommended for acrylic paint, however, as hardened acrylic paint can be difficult to remove from the surface.

Holding and using the palette ▼
Place your thumb through the thumb hole and balance the palette on your arm. Arrange pure colour around the edge. Position the dipper(s) at a convenient point, leaving the centre of the palette free for mixing colours.

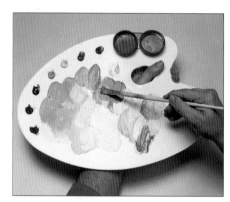

White palettes

Plastic palettes are uniformly white. They are made in both the traditional flat kidney and rectangular shapes. The surface is impervious, which makes them ideal for use with either oil or acrylic paint. They are easy to clean, but the surface can become stained after using very strong colours such as viridian or phthalocyanine blue.

There are also plastic palettes with wells and recesses, intended for use with watercolour and gouache. The choice of shape is entirely subjective, but it should be of a reasonable size.

White porcelain palettes offer limited space for mixing. Intended for use with watercolour and gouache, they are aesthetically pleasing but can easily be chipped and broken.

Wooden palette ▲
Artists working with oil paints generally prefer a wooden palette. Always buy one that is large enough to hold all the paint and mixes that you intend to use.

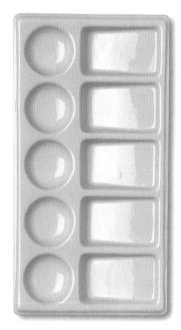

Slanted-well palette ▲
This type of porcelain palette is used for mixing gouache or watercolour. The individual colours are placed in the round wells and mixed in the rectangular sections.

Disposable palettes

A relatively recent innovation is the disposable paper palette, which can be used with both oils and acrylics. These come in a block and are made from an impervious parchment-like paper. A thumb hole punched through the block enables it to be held in the same way as a traditional palette; alternatively, it can be placed flat on a surface. Once the work is finished, the used sheet is torn off and thrown away.

Paper palette ▲
Disposable palettes are convenient and make cleaning up after a painting session an easy task.

Containers

A regular supply of containers, such as empty jam jars for cleaning and storing brushes, can be recycled from household waste and are just as good as a container bought for the purpose.

Among the most useful specially designed containers are dippers – small, open containers for oil and solvent that clip on to the edge of the traditional palette. Some have screw or clip-on lids to prevent the solvent from evaporating when it is not in use. You can buy both single and double dippers, like the one shown on the right. Dippers are useful when you want to work at speed, for example when painting on location.

Stay-wet palette

Intended for use with acrylic paints, the stay-wet palette will stop paints becoming dry and unworkable if left exposed to the air for any length of time. The palette consists of a shallow, recessed tray into which a water-impregnated membrane is placed. The paint is mixed on the moist membrane. If you like, you can simply spray acrylic paint with water to keep it moist while you work. If you want to leave a painting halfway through and come back to it later, you can place a plastic cover over the tray (many come with their own lids), sealing the moist paint in the palette. The entire palette can be stored in a cool place or even in the refrigerator, and will keep for up to three weeks. If the membrane does dry out, simply re-wet it using a spray bottle of water.

Stay-wet palette

Dipper ▼
Used in oil painting, dippers are clipped on to the side of the palette and contain small amounts of oil or medium and thinner.

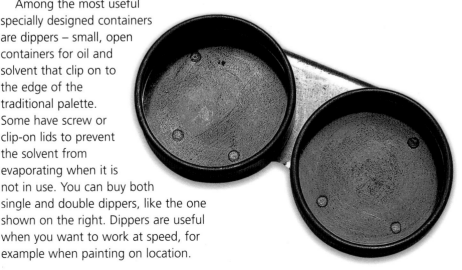

Storing brushes ▲
After cleaning your brushes, squeeze the hairs to remove any excess water and then gently reshape the brush with your fingertips. Leave to dry. Store brushes upright in a jar to prevent the hairs from becoming bent as they dry.

Acrylic and oil additives

Artists working with oils and acrylics will need to explore paint additives, which bring various textures and effects to their work. Although oil paint can be used straight from the tube, it is usual to alter the paint's consistency by adding a mixture of oil or thinner (solvent). Simply transfer the additive to the palette a little at a time and mix it with the paint. Manufacturers of acrylic paints have also introduced a range of mediums and additives that allow artists to use the paint to its full effect. Oils and mediums are used to alter the consistency of the paint, allowing it to be brushed out smoothly or to make it dry more quickly. Once exposed to air, the oils dry and leave behind a tough, leathery film that contains the pigment. Different oils have different properties – for example, linseed dries relatively quickly but yellows with age so is only used for darker colours.

A painting medium is a ready-mixed painting solution that may contain various oils, waxes and drying agents. The oils available are simply used as a self-mixed medium. Your choice of oil or medium will depend on several factors, including cost, the type of finish required, the thickness of the paint being used, as well as the range of colours employed.

There are several alkyd-based mediums on the market. They all speed the drying time of the paint, which can reduce waiting between applications. Some alkyd mediums are thixotropic; these are initially stiff and gel-like but, once worked, become clear and loose. Other alkyd mediums contain inert silica and add body to the paint; useful for impasto techniques where thick paint is required. Talking to an art stockist will help you decide which you need.

Types of finish

When acrylic paints dry they leave a matt or gloss surface. Gloss or matt mediums can be added, singly or mixed, to give the desired finish.

Gloss and matt mediums ▲
Both gloss (left) and matt (right) mediums are white. Gloss will brighten and enhance the depth of colour. Matt increases transparency and can be used to make matt glazes.

Retarding mediums

Acrylic paints dry quickly. Although this is generally considered to be an advantage, there are occasions when you might want to take your time over a particular technique or a specific area of a painting – when you are blending colours together or working wet paint into wet, for example. Adding a little retarding medium slows down the drying time of the paint considerably, keeping it workable for longer. Retarding medium is available in both gel and liquid form – experiment to find out which suits you best.

Retarding gel

Flow-improving mediums

Adding flow-improving mediums reduces the water tension, increasing the flow of the paint and its absorption into the surface of the support.

One of the most useful applications for flow-improving medium is to add a few drops to very thin paint, which can tend to puddle rather than brush out evenly across the surface of the support. This is ideal when you want to tone the ground with a thin layer of acrylic before you begin your painting.

When a flow-improving medium is used with slightly thicker paint, a level surface will result, with little or no evidence of brushstrokes.

The medium can also be mixed with paint that is going to be sprayed, as it greatly assists the flow of paint and also helps to prevent blockages within the spraying mechanism.

Gel mediums

With the same consistency as tube colour, gel mediums are available in matt or gloss finishes. They are added to the paint in the same way as fluid mediums. They increase the brilliance and transparency of the paint, while maintaining its thicker consistency. Gel medium is an excellent adhesive and extends drying time. It can be mixed with various substances such as sand or sawdust to create textural effects.

Modelling paste ▲
These pastes dry to give a hard finish, which can be sanded or carved into using a sharp knife.

Heavy gel medium ▲
Mixed with acrylic paint, heavy gel medium forms a thick paint that is useful for impasto work.

Without flow-improving medium

With flow-improving medium

Oils and thinners

If you dilute oil paints using only oil, the paint may wrinkle or take too long to dry. A thinner makes the paint easier to brush out, and then evaporates. The amount of thinner that you use depends on how loose or fluid you want the paint to be. If you use too much, however, the paint film may become weak and prone to cracking. Ideally, any thinner that you use should be clear and should evaporate easily from the surface of the painting without leaving any residue. There are a great many oils and thinners available. The common ones are listed below.

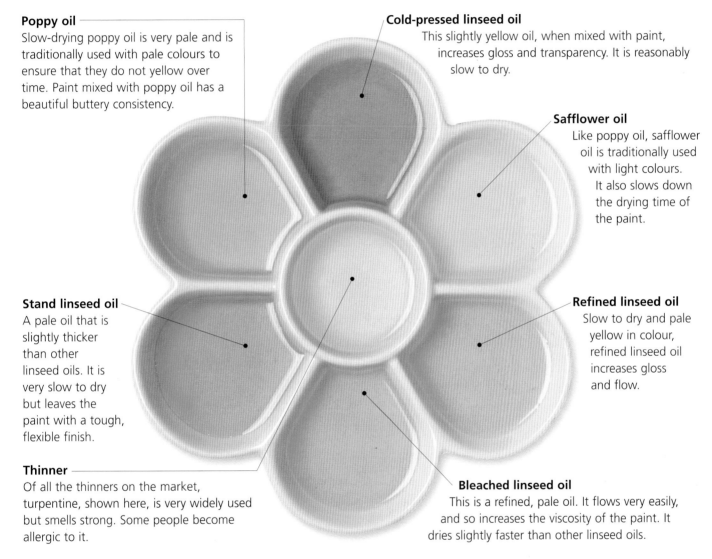

Poppy oil
Slow-drying poppy oil is very pale and is traditionally used with pale colours to ensure that they do not yellow over time. Paint mixed with poppy oil has a beautiful buttery consistency.

Cold-pressed linseed oil
This slightly yellow oil, when mixed with paint, increases gloss and transparency. It is reasonably slow to dry.

Safflower oil
Like poppy oil, safflower oil is traditionally used with light colours. It also slows down the drying time of the paint.

Stand linseed oil
A pale oil that is slightly thicker than other linseed oils. It is very slow to dry but leaves the paint with a tough, flexible finish.

Refined linseed oil
Slow to dry and pale yellow in colour, refined linseed oil increases gloss and flow.

Thinner
Of all the thinners on the market, turpentine, shown here, is very widely used but smells strong. Some people become allergic to it.

Bleached linseed oil
This is a refined, pale oil. It flows very easily, and so increases the viscosity of the paint. It dries slightly faster than other linseed oils.

Turpentine
This is the strongest and best of all the thinners used in oil painting, turpentine has an extremely strong smell. Old turpentine can discolour and become gummy if exposed to air and light. To help prevent this, store it in cans or dark glass jars.

White spirit
Paint thinner or white spirit is clear and has a milder smell than turpentine. It does not deteriorate and dries faster than turpentine. However, it can leave the paint surface matt.

Oil of spike lavender
Unlike other solvents, which speed up the drying time of oil paint, oil of spike lavender slows the drying time. It is very expensive. Like turpentine and white spirit, it is colourless.

Low-odour thinners
Various low-odour thinners have come on to the market in recent years. The drawback of low-odour thinners is that they are relatively expensive and dry slowly. However, for working in a confined space or for those who dislike turpentine's smell, they are ideal.

Citrus solvents
You may be able to find citrus thinners. They are thicker than turpentine or white spirit but smell wonderful. They are more expensive than traditional thinners and slow to evaporate.

Liquin
Just one of a number of oil and alkyd painting mediums that speed up drying time considerably – often to just a few hours – liquin also improves flow and increases the flexibility of the paint film. It is excellent for use in glazes, and resists age-induced yellowing well.

Paintbrushes

Oil-painting brushes are traditionally made from hog bristles, which hold their shape well and can also hold a substantial amount of paint. Natural hair brushes are generally used for watercolour and gouache, and can be used for acrylics and fine detail work in oils, if cleaned thoroughly afterward. Synthetic brushes are good quality and hard-wearing, and less expensive.

Brush shapes

Rigger brush

Liner brush

Rounded or 'mop' brush

Flat wash brush

Flat brushes ▼
These brushes have square ends and hold a lot of paint. Large flat brushes are useful for blocking in and covering large areas quickly and smoothly, whatever type of paint you are using – ask your stockist to advise which type of bristle or hair is best for your preferred medium. Short flats, known as 'brights', hold less paint and are stiffer. They make precise, short strokes, ideal for impasto work and detail.

Short flat brush

Large flat brush

Brushes for fine detail ◄
A rigger brush is very long and thin. It was originally invented for painting the rigging on ships in marine painting – hence the name. A liner is a flat brush which has the end cut away at an angle. Both of these brushes may be made from natural or synthetic fibres.

Wash brushes ◄
The wash brush has a wide body, which holds a large quantity of paint. It is used for covering large areas with a uniform wash of paint. There are two types: rounded or 'mop' brushes are commonly used with watercolour and gouache, and flat wash brushes are more suited to oils and acrylics.

Round brushes ▼
These round-headed brushes are used for detail and for single strokes. Larger round brushes hold a lot of paint and are useful for the initial blocking in. The point can quickly disappear, as it becomes worn down by the rubbing on the rough support. The brushes shown here are made of natural hair.

Small round brush

Large round brush

Unusually shaped brushes ▼
Fan blenders are used for mixing colours on the support and drybrushing. A filbert brush combines some qualities of a flat and round brush.

Fan blender Filbert

Cleaning brushes

1 Cleaning your brushes thoroughly will make them last longer. Wipe off any excess wet paint on a rag or a piece of newspaper. Take a palette knife and place it as close to the metal ferrule as possible. Working away from the ferrule toward the bristles, scrape off as much paint as you can.

2 Pour a small amount of household white spirit (paint thinner) – or water, if you are using a water-based paint such as acrylic or gouache – into a jar; you will need enough to cover the bristles of the brush. Agitate the brush in the jar, pressing it against the sides to dislodge any dried-on paint.

3 Rub household detergent into the bristles with your fingers. Rinse in clean water until the water runs clear. Reshape the bristles and store the brush in a jar with the bristles pointing upward, so that they hold their shape.

Other paint applicators

Brushes are only part of the artist's toolbox. You can achieve great textual effects by using many other types of applicator, from knives to rags.

Artists' palette and painting knives

Palette knives are intended for mixing paint with additives on the palette, scraping up unwanted paint from the palette or support, and general cleaning. Good knives can also be found in DIY or decorating stores.

You can create a wide range of marks using painting knives. In general, the body of the blade is used to spread paint, the point for detail and the edge for making crisp linear marks.

Regardless of the type of knife you use, it is very important to clean it thoroughly after use. Paint that has dried on the blade will prevent fresh paint from flowing evenly off the blade. Do not use caustic paint strippers on plastic blades, as they will dissolve; instead, peel the paint away.

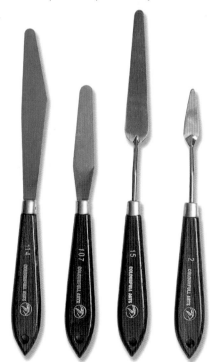

Steel knives ▲
A wide range of steel painting and palette knives is available. In order to work successfully with this method of paint application, you will need a variety.

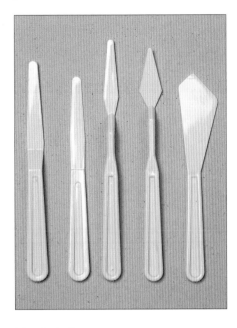

Plastic knives ▲
Less expensive and less durable than steel knives, plastic knives manipulate watercolour and gouache paints better than their steel counterparts.

Alternative applicators

Paint can be applied and manipulated using almost anything. The cutlery drawer and toolbox are perhaps a good starting point, but you will no doubt discover plenty of other items around the home that you can use. Card, rags, wire (steel) wool and many other objects around the house can all be pressed into service.

Rag (left) and wire wool

Natural sponge (left) and man-made sponge

Paint shapers, foam and sponge applicators

A relatively new addition to the artist's range of tools are paint shapers. They closely resemble brushes, but are used to move paint around in a way similar to that used when painting with a knife. Shapers can be used to apply paint and create textures, and to remove wet paint. Instead of bristles, fibre or hair, the shaper is made of a non-absorbent silicone rubber.

Nylon foam is used to make both foam brushes and foam rollers. Foam rollers can cover large areas quickly. Sponge applicators are useful for initial blocking in. Both are available in a range of sizes and, while they are not intended as substitutes for the brush, they are used to bring a different quality to the marks they make.

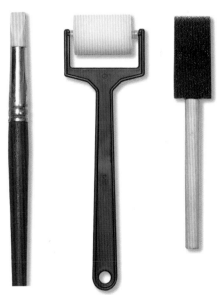

Paint shaper Foam roller Sponge applicator

Natural and man-made sponges ◄
With their pleasing texture, man-made and natural sponges are used to apply washes and textures, and are invaluable for spreading thin paint over large areas and for making textural marks. They are also useful for mopping up spilt paint, and for wiping paint from the support in order to make corrections. Man-made sponges can be cut to shape.

Supports

A 'support' is the name for the surface on which a drawing or painting is made. It needs to be physically stable and resistant to deterioration from the corrosive materials used, as well as the atmosphere. It should also be light enough to be transported easily. Importantly, choose a support with the right texture for the media, marks and techniques you intend to use.

There are many papers available and they vary enormously in quality and cost, depending on whether the paper is handmade, machine-made or mould-made. The thickness of a paper is described in one of two ways. The first is in pounds (lbs) and describes the weight of a ream (500 sheets). The second is in grams (gsm), and describes the weight of one square metre of a single sheet. Sheets vary in size.

Many papers can also be bought in roll form and cut to the size required. You can also buy pads, which are lightly glued at one end, from which you tear off individual sheets as required. One of the benefits of buying a pad of paper is that it usually has a stiff cardboard back, which you can lean on when working on location and means that you do not have to carry a heavy drawing board around with you. Sketchbooks have the same advantage.

Preparing your own drawing surfaces

It is both satisfying and surprisingly easy to prepare your own drawing surfaces. Acrylic gesso, a kind of primer that is used to prepare a surface such as canvas or board when painting in oils or acrylics, can also be painted on to paper to give a brilliant white, hard surface that receives graphite and coloured pencil beautifully.

To make a surface that is suitable for pastels, you can mix the gesso with pumice powder. You can also buy ready-made pastel primer.

To create a toned or coloured ground, simply tint the gesso by adding a small amount of acrylic paint to it in the appropriate colour.

Drawing papers

The most common drawing paper has a smooth surface that is suitable for graphite, coloured pencil and ink work. Papers for use with watercolour also make ideal drawing supports. These papers come in three distinctly different surfaces – HP (hot-pressed) papers, which are smooth; CP (cold-pressed) papers, also known as NOT, or 'Not hot-pressed' papers, which have some surface texture; and rough papers which have a rougher texture.

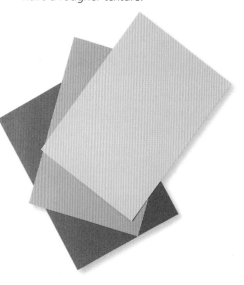

Coloured paper ▲
The main advantage of making a drawing on coloured paper is that you can choose a colour that complements the subject and enhances the mood of your drawing. Coloured papers can be used with all drawing media.

Art and illustration boards are made from cardboard with paper laminated to the surface. They offer a stable, hard surface on which to work and are especially useful for pen line and wash, but can also be used with graphite and coloured pencil. They do not buckle when wet, as lightweight papers are prone to do, and are available in a range of sizes and surface textures, from very smooth to rough.

Pastel papers ▲
Papers for use with pastels are coated with pumice powder or tiny cork particles that hold the pigment and allow for a build-up of colour. They are available in a range of natural colours that complement the pastel shades.

Drawing paper ◄
A medium-weight paper is suitable for most purposes, but if you are planning to use water-soluble pencils with water, a heavier paper is best. For fine, detailed work, choose a smooth paper. For charcoal and pastel work, a rougher paper with some 'tooth' to pick up the pigment is generally best.

Sketchbooks ◄
Available in a wide range of formats and containing all the above-mentioned papers, sketchbooks are great for sketching down rough ideas and drawing on location.

Painting papers

Papers for use with paints need to be carefully chosen. Some hold paint well, other papers are textured or smooth, and of course there are many different shades – all these factors will affect your work. Both oil and acrylic papers have a texture similar to canvas and sheets can be bought loose or bound together in blocks. Although they are not suitable for work that is meant to last, they are perfect for sketching and colour notes.

Types of paper ▼
From left to right: hot-pressed (HP), NOT and rough watercolour papers. Hot-pressed paper has a very smooth surface, while the other two are progressively more textured.

Smooth watercolour papers provide ideal surfaces for gouache and line work. The papers are found in various thicknesses and with three distinct surfaces – rough, hot-pressed (which is smooth) and NOT or cold-pressed, which has a slight texture. Rough paper has a prominent 'tooth' that will leave some deeper cavities unfilled when a wash is laid over.

Watercolour boards tend to have either a rough or a hot-pressed surface. Illustration board tends to be very smooth and is intended for use with gouache and linework.

Provided it is primed with acrylic primer, paper and illustration board can be used for painting in oils.

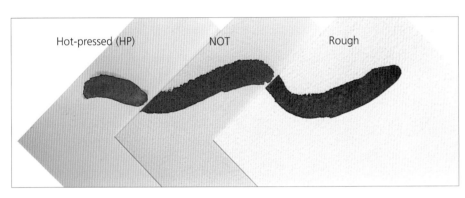

Hot-pressed (HP) NOT Rough

Canvas paper and board ▼
Artists' canvas boards are made by laminating canvas – or paper textured to look like canvas – on to cardboard. They are made in several sizes and textures and are ideal for use when painting on location. However, take care not to get them wet, as the cardboard backing will disintegrate. They can also be easily damaged if you drop them on their corners. They are ready-sized and can be used for painting in both oils and acrylics.

Canvas paper

Canvas board

Tinted papers ▼
Although they are sometimes frowned upon by watercolour purists, tinted papers can be useful when you want to establish an overall colour key. Ready-made tinted papers are a good alternative to laying an initial flat wash.

Duck-egg blue

Eggshell

Cream

Stretching paper for watercolours

Papers come in different weights, which refer to the weight of a ream (500 sheets) and can vary from 90lb (185 grams per square metre or gsm) to 300lb (640gsm) or more. The heavier the paper, the more absorbent. Papers that are less than 140lb (300gsm) in weight need to be stretched before use so that they do not cockle when wet.

1 Dip a sponge in clean water and wipe it over the paper, making sure you leave no part untouched. Make sure a generous amount of water has been applied over the whole surface and that the paper is perfectly flat.

2 Moisten four lengths of gum strip and place one along each long side of the paper. (Only gummed brown paper tape is suitable; masking tape will not adhere.) Repeat for the short edge of the paper. Leave to dry. (In order to be certain that the paper will not lift, you could staple it to the board.)

Canvases

Without doubt, canvas is the most widely used support for both oil and acrylic work. Several types of canvas are available, made from different fibres. The most common are made from either cotton or linen, both of which can be purchased ready-stretched and primed to a range of standard sizes (although there are suppliers who will prepare supports to any size) or on the roll by the yard (metre) either primed or unprimed. Unprimed canvas is easier to stretch.

Cotton duck ▼
With a more regular (some people might say more mechanical) weave than linen, cotton duck is also less expensive than linen.

Linen canvas ▼
This tough material is made from the fibres of the flax plant, *Linum usitatissimum*. The seeds of the plant are also pressed to make linseed oil, used by artists. Linen canvas is available in a number different textures and weights, from very fine to coarse. The fibres are stronger than cotton fibres, which means that the fabric is less likely to sag and stretch over time.

Stretching canvas

Canvas must be stretched taut over a rectangular wooden frame before use. For this you will need stretcher bars and wooden wedges. Stretcher bars are usually made of pine and are sold in pairs of various standard lengths. They are pre-mitred and each end has a slot-in tenon joint. Longer bars are morticed to receive a cross-bar (recommended for supports over 75 x 100cm/30 x 40in).

1 Tap the bars together to make a frame. Arrange the canvas on a flat surface and put the frame on top. Staple the canvas to the back of the frame, ensuring it stays taut.

2 Tap wooden wedges lightly into the inside of each corner. These can be hammered in further to allow you to increase the tension and tautness of the canvas if necessary.

Priming canvas

Canvas is usually sized and primed (or, increasingly, just primed) prior to being worked on. This serves two purposes. The process not only tensions the fabric over the stretcher bars but also (and more importantly in the case of supports used for oil) seals and protects the fabric from the corrosive agents present in the paint and solvents. Priming also provides a smooth, clean surface on which to produce work.

In traditional preparation, the canvas is given a coat of glue size. The most widely used size is made from animal skin and bones and is known as rabbit-skin glue. It is available as dried granules or small slabs. When mixed with hot water the dried glue melts; the resulting liquid is brushed over the canvas to seal it.

Increasingly, acrylic emulsions are used to size canvas. Unlike rabbit-skin glue, the emulsions do not have to be heated but are used diluted with water.

The traditional partner to glue size is an oil-based primer. Lead white, which is toxic, together with titanium white and flake white, are all used in oil-based primers. To penetrate the canvas the primer should be the consistency of single (light) cream; dilute it with white spirit (paint thinner) if necessary.

Traditional primer can take several days to dry, however; a modern alternative is an alkyd primer, which dries in a couple of hours.

Primers based on acrylic emulsion are easier to use. These are often known as acrylic gesso, although they are unlike traditional gesso. Acrylic primer should not be used over glue size, but it can be brushed directly on to the canvas. Acrylic primers can be used with both oil and acrylic paint, but oil primers should not be used with acrylic paints.

Primer can be applied with a brush or a palette knife. With a brush the weave of the canvas tends to show.

If you want to work on a toned ground, add a small amount of colour to the primer before you apply it. Add oil colour to oil primer and acrylic colour to acrylic primer.

Boards

Several types of wooden board make good supports for oil and acrylic work. There are three types of board in common use: plywood, hardboard (masonite) and medium-density fibreboard (MDF). You can obtain boards from DIY stores, and have them cut to size. Plywood is made up of a wooden core sandwiched between a number of thin layers of wood glued together. Hardboard is a composite panel made by hot pressing steam-exploded wood fibres with resin, and is less prone to warping than solid wood or plywood. MDF is made in the same way, with the addition of a synthetic resin. It has a less hard and glossy face side than standard dense hardboard. All these boards come in a range of sizes. If used at a size where they begin to bend, mount rigid wooden battens on the reverse to reinforce them.

Wood gives off acidic vapours that are detrimental to paint (for an example of how wood products deteriorate with age, think how quickly newspaper yellows). The solution is to prime the board with acrylic gesso, or glue canvas to the surface; a technique known as marouflaging.

Priming board

Wood was traditionally sized with rabbit-skin glue and then primed with a thixotropic primer in the same way as canvas; nowadays, most artists use ready-made acrylic primer or acrylic gesso primer, which obviates the need for sizing. Acrylic primer also dries much more quickly.

Before you prime your boards, make sure they are smooth and free of dust. You should also wipe over them with a rag dampened with methylated spirits to remove all traces of grease.

1 Using a wide, flat brush, apply primer over the board with vertical strokes. For a large surface, apply the primer with a paint roller. Allow to dry thoroughly, for at least an hour.

2 Rub the surface of the board with fine-grade sandpaper (abrasive paper) to smooth. Blow or dust off any powder to make the surface debris-free for the next coat of primer.

3 Apply another coat of primer, making smooth horizontal strokes. Allow to dry. Repeat as many times as you wish, sanding between coats.

Covering board with canvas

Canvas-covered board is a light painting surface that is useful when you are painting on location. It combines the strength and low cost of board with the texture of canvas. You can use linen, cotton duck or calico, which is cheap.

When you have stuck the canvas let it dry for two hours in a warm room. Prime with acrylic primer before use.

1 Arrange the canvas on a flat surface. Place the board on the canvas. Allowing a 5cm (2in) overlap all around, cut out the canvas. Remove the canvas and using a wide, flat brush, liberally, but not thickly, brush matt acrylic medium all over the board.

2 Place the canvas on the sticky side of the board and smooth it out with your fingertips, working from the centre outward. Brush acrylic medium over the canvas to make sure that it is firmly stuck down.

3 Place the board canvas side down on a bowl so that it does not stick to your work surface. Brush acrylic medium around the edges of the board. Fold over the excess canvas, mitring the corners, and brush more medium over the corners to stick them firmly.

Art essentials

There are a few other pieces of equipment that you will probably find useful in your painting, ranging from things to secure your work to the drawing board and easels to support your painting, to aids for specific painting techniques.

Boards and easels

The most important thing is that the surface on which you are working is completely flat and cannot wobble as you work. If you use blocks of watercolour paper, then the block itself will provide support; you can simply rest it on a table or on your knee. If you use sheets of watercolour paper, then they need to be firmly secured to a board. Buy firm boards that will not warp and buckle (45 x 60cm/18 x 24in is a useful size), and attach the paper to the board by means of gum strip or staples.

It is entirely a matter of personal preference as to whether or not you use an easel. There are several types on the market, but remember that watercolour paint is a very fluid liquid and can easily flow down the paper into areas that you do not want it to touch. Choose an easel that can be used flat and propped at only a slight angle. The upright easels used by oil painters are not really suitable for watercolour painting.

Table easel ▶
This inexpensive table easel is adequate for most artists' needs. Like the box easel it can be adjusted to a number of different angles, allowing you to alter the angle to suit the technique you are using. It can also be stored neatly.

Other useful items

Various pieces of equipment come in handy, including a scalpel or craft (utility) knife: the fine tip allows you to prise up pieces of masking tape that have become stuck down too firmly without damaging the paper. You can also use a scalpel to scratch off fine lines of paint – a technique known as

Portable box easel ▼
This easel includes a handy side drawer in which you can store all you need for a day's location work, as well as adjustable bars so that it can hold various sizes of drawing board firmly in place. Some easels can only be set at very steep angles, which is unsuitable for watercolour, so do check before you buy.

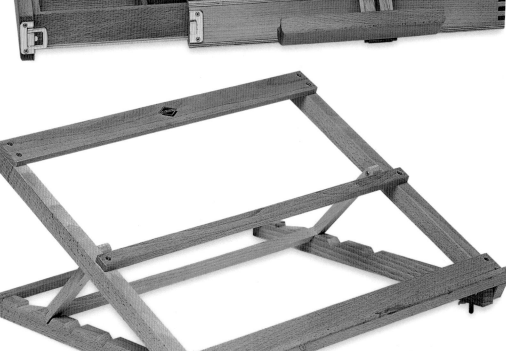

sgrafitto. Paper towel is invaluable for cleaning out paint palettes and lifting off or softening colour before it dries.

As you develop your painting style and techniques, you may want to add other equipment to the basic items shown here. You will probably assemble

a selection of props, from bowls, vases and other objects for still lifes, to pieces of fabric and papers to use as backgrounds. Similarly, you may want to set aside pictures or photographs that appeal to you for use as reference material. The only real limit to what you can use is your imagination.

Masking tape and masking fluid ▲
One of the basic techniques in watercolour is masking. It is used to protect areas of the paper you want to keep unpainted. Depending on the size and shape of the area you want to protect, masking tape and masking fluid are most commonly used. Masking tape can also be used to secure heavy watercolour paper to a drawing board.

Gum arabic ▲
Adding gum arabic, a natural substance also called gum acacia, to watercolour paint increases the viscosity of the paint and slows down the drying time. This gives you longer to work. Add a few drops of the gum arabic to your paint and stir to blend. Gum arabic imparts a slight sheen on the paper, and increases the intensity of the paint colour.

Gum strip ◄
Gummed brown paper strip is essential for taping stretched lightweight watercolour paper to a board to ensure that it does not buckle. Leave the paper stretched on the drawing board until you have finished and the paint has dried, then simply cut it off, using a scalpel or craft (utility) knife and a metal ruler. Masking tape is not suitable for this purpose.

Eraser ◄
A kneaded eraser is useful for correcting the pencil lines of your underdrawing, and for removing the lines so that they do not show through the paint on the finished painting.

Sponge ▲
Natural or synthetic sponges are useful for mopping up excess water. Small pieces of sponge can be used to lift off colour from wet paint. Sponges are also used to apply paint.

Mahl stick ▲
This rod of wood (bamboo) with a soft leather ball at one end can be positioned over the work and leant on to steady the painting hand and protect your work from being smudged.

Varnishes

Used on finished oil and acrylic paintings, varnishes unify and protect the surface under a gloss or semi-matt sheen. Here are some of the most widely used.

Acrylic matt varnish
Synthetic varnishes can be used on oil and acrylic paintings. The one shown here dries to a matt finish.

Wax varnish
Beeswax mixed with a solvent makes the wax varnish that is often used on oil paintings. The wax is brushed over the work and allowed to stand for a short time. The excess is then removed with a rag and the surface buffed. The more the surface is buffed, the higher the resulting sheen.

Acrylic gloss varnish
This synthetic varnish dries on acrylic paintings to a gloss finish.

Retouching varnish
If there are parts of your oil painting that look sunken, with dull looking paint, retouching varnish can be used at any time while the work is in progress to revive problem areas. Both damar and mastic thinned with solvent can be used as retouching varnish.

Damar varnish
For use on oil paintings, damar varnish is made from the resin of the damar tree, which is found throughout Indonesia and Malaysia. The resin is mixed with turpentine to create a slightly cloudy liquid. The cloudiness is caused by natural waxes in the resin, and clears as the varnish dries. Damar does yellow with age, but it is easy to remove it and replace it with a fresh coat. The varnish dries very quickly.

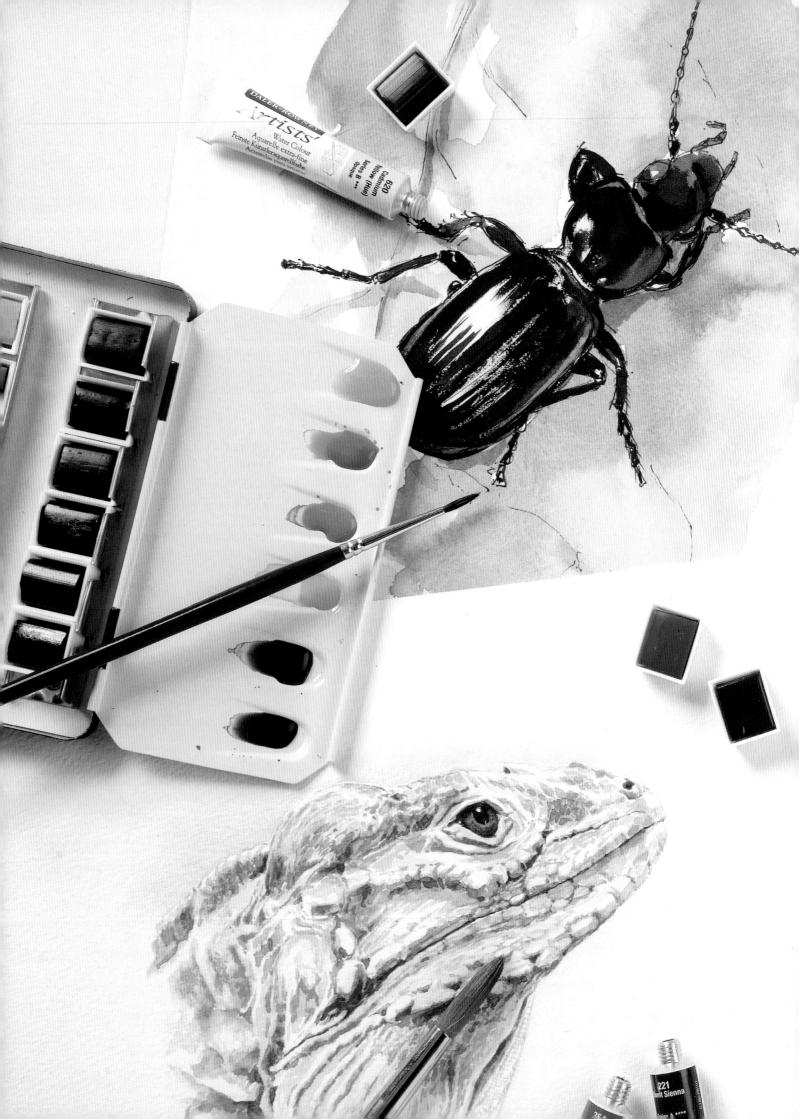

Tutorials

The natural world provides an infinite supply of subjects to draw and paint and it's impossible to cover every species in detail – in reality, you do not need a detailed knowledge of animal anatomy in order to be a good artist. The purpose of this chapter is to encourage careful observation and to provide some practical guidance that will help you tackle unfamiliar wildlife subjects. From getting the basic shape right to capturing anatomical details, textures and markings, this chapter provides a solid yet easy-to-follow grounding in the technicalities of wildlife art. There are also a number of short exercises that give you a chance to put your new-found skills into practice. Of course, good paintings are about much more than simply getting an accurate likeness: finding suitable reference material and composing your picture are just as important. The last part of this chapter is packed with useful tips that you can incorporate into your own work. Whether you're a complete beginner or a more experienced artist looking for a refresher course on particular aspects of drawing and painting animals and birds, these tutorials are an invaluable resource that you can turn to time and time again.

Mammals

If you want to specialize in animal art, then a good book on animal anatomy will be a useful addition to your reference library. However, unless you're a qualified veterinarian, you can't possibly know the names of all the bones and muscles in all the animals that you're likely to want to paint – and you don't need to. Regardless of whether you are working from life or from a photographic reference, it's the surface of the animal that you see, not the skeleton beneath – and it is the surface of the animal that you should concentrate on.

Your first step – as with drawing any subject – is to take measurements and to really look at the shapes involved.

Of course, the proportions of an animal vary from species to species: for example, a giraffe has a very long neck and legs in relation to its body size, whereas a mouse has a very short neck and legs. Even within species, different breeds have very different proportions: a greyhound, which is built for running, has relatively long legs and a slim body, while a bulldog does not.

Start by looking for a basic unit of measurement against which you can compare the size of other features. You might decide to use the head of the animal you're drawing as your standard unit of measurement. By working how many times this head measurement fits into the neck, or the

back of the body, or the leg, you can check that each part of the animal is correctly proportioned in relation to the rest. Alternatively, particularly if you're viewing an animal face-on to paint a 'portrait', you might choose a smaller unit of measurement, such as the distance between the outer corners of the eyes – but the principle remains the same. Get the basic measurements right and everything else will fall into place.

The next thing to consider is how to make the animal look rounded. Instead of starting with an outline of its shape, try to convey the feeling that it's a three-dimensional form right from the start.

Try making a series of very quick sketches of your chosen subject,

Positive shape ◀
Whatever you're drawing, try to see it as a geometric shape to get a feel for it as a three-dimensional object. This hedgehog can be viewed as a rounded 'box' shape; note how the top of the head is lighter than the side facing us.

Negative shapes ▼
In addition to measuring, look at the negative shapes – the spaces in between things – as it's often easier to assess these than the positive shapes of your subject. Here, for example, the curved space between the branch and the spider monkey's arm and tail forms a distinctive shape that you can use as a guide, as does the space between the monkey's left arm and its legs.

reducing it to simple geometric shapes rather than attempting to draw it in any detail. Then look at the same animal from a different viewpoint and see how perspective affects the shapes. If you're looking at, say, an elephant from the side, you might see the body as an almost square but shallow box and the legs as cylinders. If the animal turns slightly, so that you get a three-quarter view, the box shape of the body will appear to taper a little towards the rear and the 'cylinders' of the back legs will be shorter than those of the front legs. When the elephant turns to face you, the effects of perspective on those geometric shapes will become even more apparent: the 'box' of the body will appear deeper and shorter.

If you can train yourself to think in this way, you'll find it easier to add important details and textures.

Measure carefully ◀
Although hyenas bear some physical resemblance to dogs and many people think of them as a kind of canine, their front legs are longer than their back legs. The neck is also more elongated than one might expect. If you attempt to draw such an animal without carefully comparing the size of one feature against others, you may find that you get the proportions completely wrong.

▶

Next, look at how the animal stands and moves. Some animals place the full length of their feet on the ground when they walk, in the same way as humans. Many others walk on only parts of the foot. Cats and dogs, for example, place their toes on the ground, but not the heel, and there are noticeable anatomical differences between the limbs of these two groups of animals. Animals that walk on their toes have long carpals and tarsals, which means that the bones that correspond to the human ankle are much higher in the limb than in a human. There is also a third group of animals, which walk on the very tips of their digits, typically on hooves; this group includes horses and cattle.

The type of locomotion affects both the way the animal stands and its gait, so it is worth observing – even if you do not need to draw or paint the feet in any detail because they are obscured by long grass or sink into sand or mud.

Look at the ears, too. One mistake that beginners make is to place the ears on the top of the animal's head. In fact, the ears lie above and behind the eyes, and slightly below the top of the head. The ears are very expressive: you can tell by looking at them whether the animal is relaxed or listening for predators.

Think about what the animal eats, as this determines the shape of the jaw and mouth. For example, a predator such as a lion has strong, powerful jaws

that can open wide to hold its prey, while a ruminant such as a cow has a mouth that's designed for chewing and does not open as wide.

All these things will help you capture the essence and character of the animal.

Of course, you cannot completely ignore the bones and muscles as they have a visible effect on the surface of the body. When bones and muscles lie close to the surface, you will see shadows on the animal's fur or hide – you must render these shadows accurately to make the animal look three-dimensional. Similarly, when an animal is in motion or a particular set of muscles is under tension (perhaps strong neck muscles when a lion is

Orangutan walking ◀
When orangutans are on the ground, as here, they walk on all four limbs, using the knuckle pads on the back of the digits on the hands, and appear very ungainly and awkward. They move through the trees by 'brachiating', or hooking their long fingers over branches and swinging by their arms. Brachiation is the more usual mode of locomotion, hence their powerful forelimbs are longer than their hindlimbs. Although the animal's long, shaggy fur obscures the shapes of the limbs and underlying muscles, it is important to convey the form of the animal; to do this, look for shadows within the fur that give a sense of its volume.

TRUDY FRIEND

How do limbs move? ◄

If you want to paint a moving animal, do your research and find out how the limbs move. It was not until 1877 that ground-breaking photographer Eadweard Muybridge first proved that the legs of a horse at full gallop are all tucked under the body; in paintings from before that date, galloping horses were usually depicted with their forelegs stretched out in front of them and their hind legs stretched out behind. Note how the flowing mane and tail in this watercolour sketch also contribute to the sense of movement.

Alert pose ▼

The pricked-up ears, sharply focussed gaze and tense muscles of this rabbit tell us that it is on the lookout for predators, poised for flight should danger present itself. Always looks for clues such as these, as they can tell you a lot about the character of the animal and whether it is predator or prey.

tearing meat from a dead gazelle), muscles will appear more pronounced.

However, you do need to ensure that any shadows that you paint really are part of the animal. If you put in a shadow that's cast by something else, you will create a muscle that isn't there.

Another thing to bear in mind is that a wild animal, especially a big cat, may look very different to a zoo or safari park animal. You cannot paint a lioness from a zoo or safari park and simply place it in an African setting. The most obvious difference is the colour. The light at the time of day your scene is painted at may be different from that of the subject animal. The colour of the ground plays a part as well – not only because the animal may have been rolling in the dust or soil, but also because some of the ground colour will be reflected up onto the animal's skin or hide. You will also notice that the muscles of a wild animal tend to be more pronounced than those of a captive animal. Wild animals have to catch their food, so they are stronger than captive animals; they also have to do battle with other animals in order to survive, and so may bear some scars.

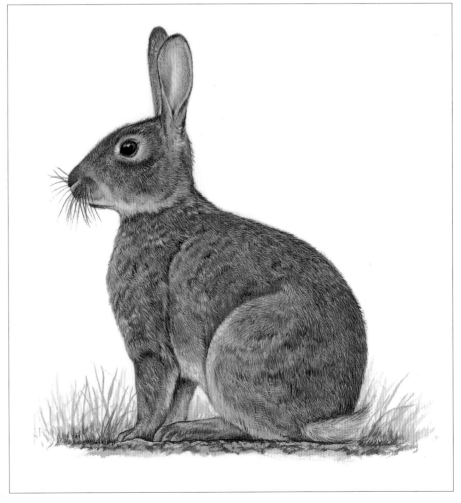

Birds

From eagles with a wingspan of several feet to tiny hummingbirds, the diversity of birds is enormous. Very often however, you can tell a lot about a bird simply by looking at it. The shape of the body and beak, the size of the wings, the length of the legs, the way the claws are arranged: all these things give you clues as to how the bird lives and what it eats. Conversely, if you already know a little about the bird you're drawing or painting – whether it's an insect eater or a seed eater, for example, or a waterbird or a bird of prey – you will know what characteristics make it special and be able to emphasise these features when you are sketching.

Field guides, used by all keen birdwatchers, are an invaluable source of reference, particularly when you're drawing a species for the first time. However, there's no substitute for going out and making your own sketches.

Start by observing a bird near where you live – a robin or a blackbird in your garden for instance. Ask yourself a few key questions: How big is the bird? Is it a similar size to a bird that you are familiar with? What shape is the bill? Is the body rounded, like a robin, or tall and slender, like a heron? How long are the legs in relation to the rest of body?

Instead of taking reference photos, use your eyelids as a 'shutter'. As you see the bird flying, close your eyes and lock the image in your mind; then try and put the image you saw on paper in a very quick 10-second sketch. You're not attempting to draw a masterpiece, but simply trying to record what you saw. You will learn more than you expect and when you come to put a composition together, you will find that you instinctively know what looks right.

Short wings and rounded body ▶
The house sparrow's wing span is relatively small and its body rounded; as it tends to fly only relatively short distances and hops from branch to branch, it does not require a particularly streamlined shape. Note also the short, thick beak.

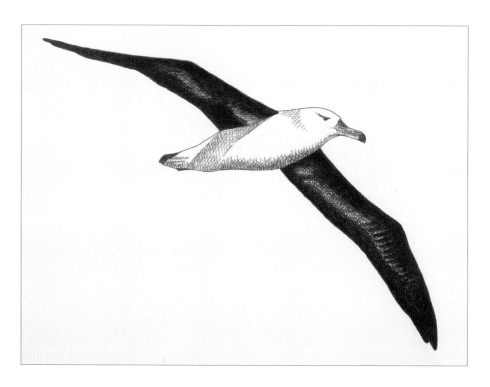

Massive wingspan and streamlined body ▲
Black-browed albatrosses are one of the most marine of all birds, traversing the oceans of the southern hemisphere and only returning to land to breed. Their long, slim wings and streamlined body make it possible for them to spend long periods in the air. When sketching a bird such as this, try to capture it with its wings fully outstretched, so that you convey not only the size of the wings but also the way it appears to glide almost effortlessly through the air.

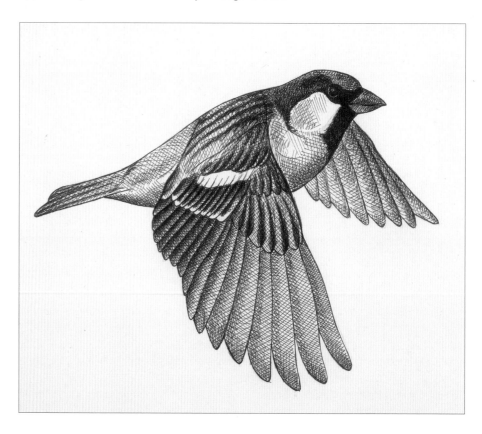

Although birds vary enormously, it's worth knowing a little bit about their general anatomy, as this will help you interpret what you are looking at. The bodies of most birds have evolved largely for one purpose: flight. The skeleton is very lightweight, but strong, and birds that fly have many hollow bones, thus reducing the weight.

Most birds have around 175 muscles, the largest of which are the pectorals, or breast muscles, which are used in flight; these muscles are attached to the sternum, or breastbone, and naturally affect its shape. In flying birds, the width and height of the sternum are nearly equal. Birds that swim tend to have a wide sternum, whereas flightless birds, which do not have highly developed pectoral muscles, generally lack a pronounced keel on the sternum.

Just as mammals' teeth and jaws vary depending on what they eat, so too does the shape of birds' beaks. Birds that need to crack open seeds, such as canaries and finches, tend to have long, thick beaks, while insect eaters such as bee eaters tend to have short, thin beaks. Hummingbirds' bills are adapted to penetrate deeply into the throats of flowers to extract nectar. Birds of prey have sharp, hooked beaks for tearing apart chunks of meat. A pelican's pouch is used to scoop up fish; when the fish is caught, the pouch contracts to squeeze out water. Getting the shape and size of the bill right are crucial in establishing the bird's character.

Most birds have four digits on their feet, with the first one being at the back of the foot and the other three pointing forwards. However, this is something of a generalization and there are many differences between species. In waterbirds, the three front digits are connected by a web and the back 'thumb' is barely visible, while in birds of prey such as eagles, the 'thumb' is used to grip prey and is very powerful.

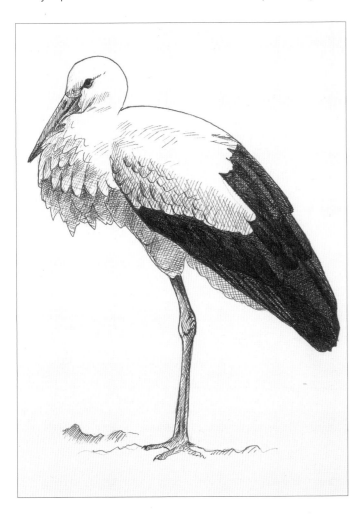

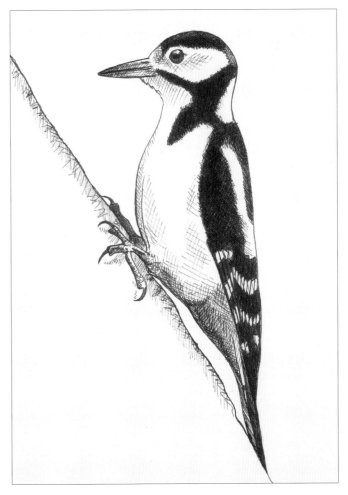

Long legs for wading ▲

The white stork breeds in the warmer parts of Europe, north-west Africa and south-west Asia; like all wading birds, its legs are long in relation to its body size. For long-distance flight during its winter migrations, it relies on movement between thermals of hot air – hence the wide wingspan of 155–200cm (60–80 inches). It feeds on fish, frogs and insects but also eats small reptiles, rodents and smaller birds.

Short-billed insect eater ▲

The great spotted woodpecker lives in woodlands and parks, and depends on old trees for its food (mostly insects and grubs) and nesting sites. Note the beak shape, which is relatively short and thin. It hops rather than climbs along tree branches, leaping forward with one foot just in front of the other, using the 'thumb' at the back of the foot to maintain its balance.

Insects

Insects are the largest and most diverse group of animals on Earth: scientists currently estimate that there are between four and six million different insect groups. The hard, shiny carapace of a beetle, an ant's antennae, the iridescent colours and patterns on a butterfly, the lace-like wings of a dragonfly: in insects, nature has created the most fantastic and beautiful details. With so much diversity, it can be hard to see any resemblance between species – but, in fact, despite the differences, the general anatomy of all insects is remarkably similar.

Insects' bodies are divided into three parts – the head, thorax and abdomen – with each part being further divided into segments. Typically, there are six segments in the head, three in the thorax and eleven in the abdomen. There are three pairs of walking legs on the thorax, one pair to each segment, and two or four wings. As many insects are so small, you may not be able to see all these details easily with the naked eye, but if you know a bit about the general anatomy, you will at least know what to look out for and where the different features are located.

Centipedes, millipedes and spiders are often thought of as insects, but they are, in fact, other types of invertebrate. But, although their anatomy is different to that of insects, the same general principles apply when it comes to drawing and painting them.

The first question you need to ask yourself is how much detail to include. If the insect is only a small part of a larger composition then you do not need to include very much; sometimes, just a flick of colour is enough to suggest that the insect is there.

The closer the insect is to you, the more detail you will see – so if it's to be the main subject of your painting, it's best to place it in the very foreground of the image. If it's taking up most of the picture space, you can put in all the fine detail, from the delicate antennae to the colours on the wings or carapace. In addition, you won't have to worry so much about keeping the background elements in scale with the insect.

Spider ▼
The spider is viewed from directly overhead, its overlapping legs and bold markings making a graphic shape. Here, the artist has used a dip pen, which creates a slightly irregular, scratchy line. Note the tiny individual hairs on the spider's legs; small flicks of the pen are all that is needed to create them, but the effect is very lively.

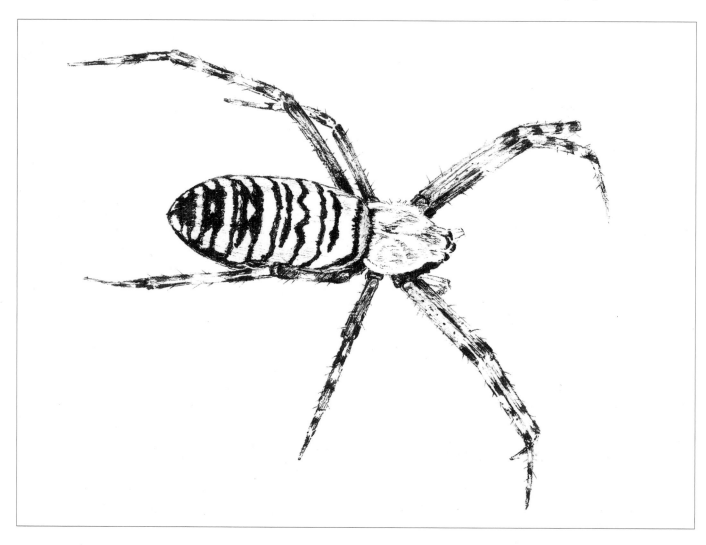

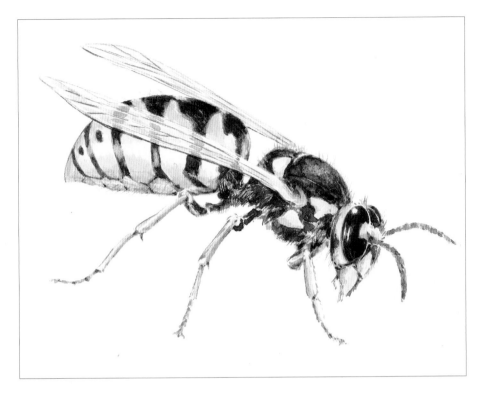

Wasp ◄
Here, the artist has created the soft, fur-like texture of the thorax by using a very fine brush and 'flicking' the paint outwards to create the impression of individual hairs. Contrast this with the harder covering of the abdomen, where there is a very delicate highlight. Note how well the artist has captured the wings by using lighter tones of the colours that can be seen through them.

Ladybird ▼
Here, the artist has put in a bright highlight along the centre of the body, between the two elytra (wing cases), and has painted the body a slightly darker tone of red around the edges, as the body curves away from the light. This, along with the shadow under the body, makes the insect appear three-dimensional.

A word of caution: if you're painting from a close-up or macro photograph as part of a larger composition, beware of putting in too much detail on the insect, even though it may be clearly visible in your reference material. It is difficult to see this much detail with the eye, so if you include it, it will look unrealistic.

One of the most fascinating things about painting insects is the wonderful range of iridescent colours that you see. At first glance, a butterfly's wings may seem to be just a single hue, but the colour will change depending on the angle from which the surface is viewed. Experiment to find which colours work best before you apply them to the canvas. You may find it difficult to match the brightest colours in paint, although some inks and liquid water-colours can come close. For very detailed oil or acrylic paintings where you want to convey the subtle shifts of hue, it's best to stipple the colour on with a brush. In watercolours, build up the layers gradually with very thin glazes. With coloured pencils or soft pastels, use short, fine strokes and allow the colours to intermingle on the paper to create different tones and hues.

When you're painting hard carapaces, remember to look for the highlights that will convey the surface texture.

Fine lines such as antennae need particular care. Don`t be tempted to draw or paint them as a single line. The way the light bounces off the antenna will break up the solid line, so leave tiny gaps where necessary. This will make it look as if the light has bounced off the bits you've left out and create the effect that it's reflecting its surroundings when in reality it's not there at all.

Finally remember that, despite its small scale, an insect needs to be made to look three-dimensional. Look for shadows under the body and legs, however slight they may be, that will help you create this illusion. It's easy to forget about this when painting an insect such as a butterfly at rest, with its wings outstretched, but it's an essential part of making your subject look real.

Fish

Most fish have a streamlined body, which allows them to swim rapidly. The fins are the most distinctive feature; they are made up of bony spines that protrude from the body, with skin covering them and joining them together in a webbed fashion, as in most bony fish.

The arrangement of the fins varies hugely from one species to another, but there are a few general points to note. The dorsal fins are located on the fish's back; there can be up to three of them. There are also two sets of paired fins on the side of the body – the pectoral and pelvic (or ventral) fins. Look carefully to see exactly where they are placed.

Look, too, at the shape of the tail fin. It may be rounded at the end, or end in a more or less straight edge, or it may curve slightly inwards or be shaped like a crescent moon. Remember that you will only see the fins in their entirety if you are viewing the fish from side on: if it is swimming towards or away from you, you may see very little of the fins. Some fins are translucent. To capture this feeling in your drawings and paintings, you need to be aware of the colours behind what you're painting: generally, the fins will be a little lighter.

The body shape varies considerably too. Does the fish have a rounded body or is it flat? If it's rounded, you need to convey this in your painting by looking at how the tone changes as the body is angled towards or away from the light. If it's relatively flat, then the tones are more likely to be uniform across the surface of the body.

Fish vary in coloration and patterning, from pale greys and mottled browns to vibrant, almost psychedelic spots and stripes. It can be difficult to capture the brilliance of these colours in paint, so experiment with different mediums to see what you can achieve.

Most fish move by contracting paired sets of muscles alternately on either side of the backbone. These contractions form S-shaped curves that move down the body. As each curve reaches the back fin, backward force is created which, in conjunction with the fins, propels the fish forwards. If you are looking down on a swimming fish, you may well see these S-shaped curves, and capturing this shape in your drawing will convey a sense of movement.

However, the main challenge in drawing and painting fish is capturing the effect of light on the water. If your

fish is near the surface, consider how the light streaming through the shallow water will dance across the top of the fish's body; leaving this out would be like omitting the shadow of an animal on a sunlit day and would leave the painting looking flat. If the water is shallow, put some refracting light across the ground as well, perhaps picking out parts of the surface. If the fish breaks the surface of the water, try to capture the splashes of water and water droplets: if you're using watercolour or acrylics, spatter masking fluid on to the paper to reserve the white of the paper for the water droplets and let it dry completely before you apply the paint.

Mackerel ▼

For the pale tones on the underbelly, the artist lightly brushed clean water over the paper and then dropped in a pale blue-grey, allowing it to spread wet into wet so that no hard edges were created. On the upper back, the dark markings were applied when the base colour had dried slightly, so that the paint did not spread as much. The fins were painted using an almost dry brush with the hairs feathered out to create thin, individual lines.

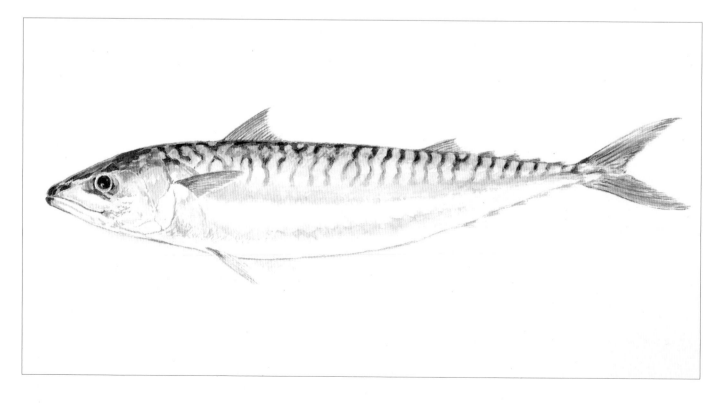

Amphibians

Of the three groups of living amphibians, only two – newts and salamanders, and frogs and toads – are likely to be of interest to you as a painter.

Amphibians, of course, spend much of their time in water, so you might like to try painting the animal as it has just emerged from the water. Unlike reptiles, amphibians do not have a scaly skin.

The light bouncing off a wet body will make a far more interesting painting. In addition to putting in the highlights with white paint (or reserving the highlights with masking fluid if you are using watercolour), where you think the sun is reflecting off the wet body, take note of the subtle changes of colour as the body curves away from the light.

Take care to get the proportions right. Amphibians such as frogs rely on their sight to catch their prey, so have surprisingly large eyes, and their hind legs are designed for leaping, and so may be longer than you expect. The hands generally end in four fingers, and the feet in five toes – but this varies from species to species – so count carefully!

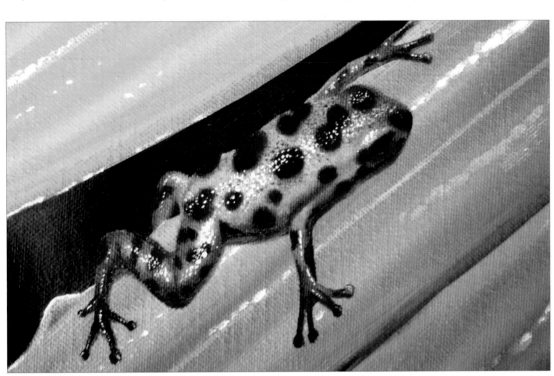

Tree frogs ◄
The most immediately striking thing about these two paintings is the use of colour – the richly saturated orange and red of the frogs set against the vibrant green of the leaves. Look more closely, however, and you will see how skilfully the artist has used highlights to convey the form of the subject: a whole series of tiny white highlights indicates light reflecting off the frogs' wet bodies and the leaves, too, have highlights running across them, showing that they are slightly ridged. Small shadows under the bodies and legs also help to make the frogs appear three-dimensional. Finally, note how the leaves run diagonally through the pictures, creating a very dynamic composition.

Eyes

The success or failure of your painting can depend entirely on how you paint the gaze of your subject, as the eyes are probably the first thing that the viewer will notice.

One of the most common mistakes is to make the eyes too small or too close together; conversely, making the eyes too big will give your painting a cartoon-like effect. However, the position of the eyes varies from species to species: in cats and dogs, for example, the eyes are set on the front of the head, while in horses and sheep they are set on the side of the head. Whatever the position, each eye has to be in the correct position relative to the other and positioned symmetrically in relation to the nose and mouth. Measure the size of the eyes and compare the distance between them. If you take the size of the eye as being one unit, then the distance between them may be as much as four units. You can then follow the same procedure to get the nose, mouth and ears in the correct place.

Putting the pupils in the right place is also an important factor; the painting may look awkward if they do not face in the same direction. Always lightly map out the position, size and shape of the eyes and make sure they are correct before you begin to apply colour.

The shape of the pupils is something to consider, too. In some animals (sheep, for example) the pupils lie laterally, while in others they are vertical.

It's also important to make eyes look rounded. To do this, use light and dark tones to imply the curvature of the eyeball; needless to say, this requires very careful observation.

Note that the eyelid casts a shadow over the eyeball: the eye gets steadily darker nearer the eyelid, and is brighter at the base as less shadow is cast from the eyelid. The white of the eye is often not pure white: like the rest of the eye, it is shadowed by the eyelid. The eyelid also obscures part of the eye: we rarely see the complete circle of the iris.

Reflections are important, too, as light is reflected in the glassy surface of the eyes and this is what makes them look shiny. Take particular care with reflections, however. If you are working from a photograph, then the reflection that you see could be that of the photographer or even, in the case of a zoo animal, the bars of the cage. Try to work out what is being reflected: if you know what you're painting, you'll find it easier to get it right. Remember, everything above the horizon will appear lighter in the reflection.

Similarly with highlights: you need to ask yourself if a highlight really is coming from the light source (the sun). It may just be a reflection of the flash from the camera, and if this is the case, then putting it in will look unnatural.

Tiger eye in watercolour ▲
The dramatic colouring and fine detailing make this a very attractive and lifelike study. Tiny touches of permanent white gouache on the pupil and lower lid reflect the light and help to show that the eyeball is rounded, while feathered brushstrokes, worked wet into wet, soften the transition from one colour to the next in the iris.

Practice exercise: **Eagle eye in oils**

Making a small, quick sketch of individual features such an eye is a great way of sharpening your powers of observation. This sketch was done in oil paints; one benefit of opaque mediums such as oils and acrylics is that if you make a mistake – say, for example, in the shape or tone of a highlight area – it is easy to paint over it. If you were attempting the same exercise in watercolours, you would have to work from light to dark and leave the white of the paper for the brightest highlight.

Materials
• *Canvas paper*
• *3B pencil*
• *Oil paints: lamp black, burnt umber, cadmium red, titanium white*
• *Brushes: selection of filberts*

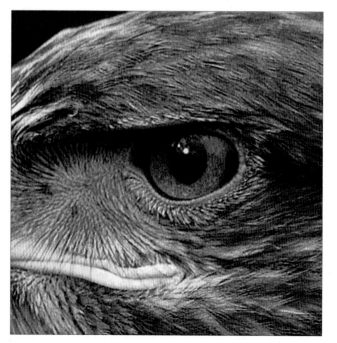

The subject
This is a close-up detail taken from a much larger photograph, but it provides the perfect opportunity to practise painting the detail of an eye; the bird's penetrating gaze also makes a dramatic subject in its own right.

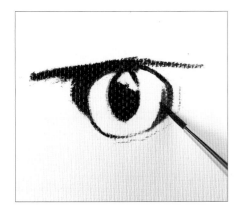

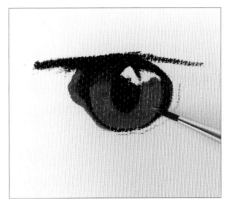

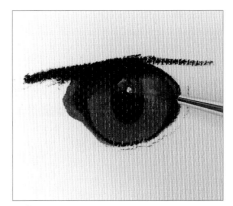

1 Using a 3B pencil, lightly sketch the outline of the eye and mark out any distinct areas, such as the eyelid and the small ring of tiny feathers just under the eye. Using a small filbert brush and lamp black oil paint, paint in the darkest parts of the eye – the pupil, the very dark area under the eyelid and the inside rim – leaving the highlight untouched. Blend in a little burnt umber for the browner tones.

2 Paint the iris in a mix of burnt umber and cadmium red, blending the colour wet into wet into the lamp black just under the eyelid; this area is darker than the rest of the iris, because of the shadow cast by the eyelid. Leave that part of the iris in which you can see a reflection untouched.

3 Now look carefully at where the eye picks up reflections, remembering that any reflection in the eye that is above the horizon line will be lighter than one below it: add more white to lighten the colour. Paint the reflection using a mix of cadmium red, lamp black and titanium white.

The finished painting
Complete the sketch by painting the rim of the eye in a mix of burnt umber and white and by adding feather detail around the eye. This is a lifelike painting in which the colours have been carefully blended wet into wet to create a textured surface. By carefully observing the way the tones change across the surface of the eye, the artist has managed to make the eye look shiny and convincingly realistic and three-dimensional.

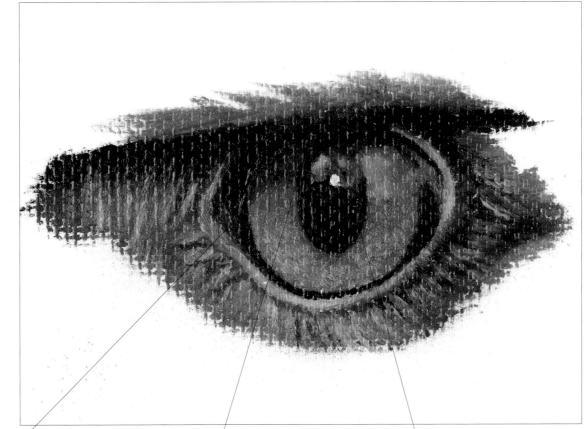

Note how the eyelid casts a shadow on the surface of the upper part of the eye.

It is rare for the entire surface of the eye to be visible: here, part of the upper rim is obscured by the line of the eyelid.

Note that anything reflected in the eye above the horizon line is paler than a reflection below it.

Teeth, beaks, claws and hooves

Teeth, beaks and claws are all hard surfaces that contrast with the softness of fur, feathers and flesh, and if your animal drawings are to look lifelike, it's important that you master these textures.

Within the animal kingdom there are many differences in shape, of course. Specialist meat eaters such as big cats have huge canine teeth designed to hold their prey and carnassial teeth to shear through tough skin and meat, while herbivores get their energy from eating plants and have teeth designed for that purpose. In the same way, birds have the beak and talons they need for the job: birds of prey have sharp talons to grip their prey and beaks that are turned down at the end to rip and tear off meat, whereas insect eaters have long, small beaks designed for catching their prey on the wing but small claws that are only needed to grip the branches on which the bird perches. You can almost guess what a bird eats by the shape of its beak. Despite this, the techniques of drawing and painting these hard surfaces are the same.

Teeth

Teeth can be a real challenge to paint, no matter what medium you choose. They are never just white or any other single colour.

Even the teeth of the same animal will not all be the same colour – particularly if one part of the mouth is in sunlight and another in shade. Take careful note of changes of colour and tone, as these are critical in establishing a sense of form and making the teeth appear three-dimensional.

You will find that the teeth of a carnivore such as a big cat tend to look cleaner than those of herbivores as they are automatically cleaned when they bite against bone and tough meat. Generally, the colours you will need will be white, yellow ochre, cadmium orange, cadmium yellow (medium), burnt umber, cadmium red and a little black. For more heavily stained teeth, you are likely to need raw sienna and raw umber as well. The gums are generally a shade of red – perhaps alizarin crimson or cadmium red mixed with ultramarine, indigo or a little black for the darker areas.

If you want teeth to look smooth and wet, working wet into wet is the best option, lightly blending the colours together where they meet with a very soft brush and careful strokes. If the tooth is wet, more light will be reflected off it and the highlight will seem whiter than the rest of the tooth – especially where the tooth curves nearest to the light source. This may be the whitest part of the scene, so don't overdo the white in other parts of your painting.

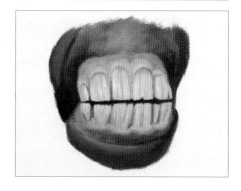

Horse's teeth in oils ▲
The paint has been blended wet into wet to create very subtle transitions in tone. Darker lines indicate the vertical ridges in the teeth. Note, too, the tonal variation in the gums; they are lightest where the teeth protrude from them and darker as they slope backwards into the jaw.

Beaks, claws and hooves

The same is true of beaks, claws and hooves. The hard edge will reflect light in the same way as a wet tooth, getting darker towards the edges and thus giving the beak or claw its shape. You can get a crisp, sharp-edged highlight with subtle darkening of tones towards the edges; this is what helps to convey the impression that the surface is hard and unyielding. Look closely at the way these hard edges reflect light. Pay attention to the colour, too: a very dark shiny surface can reflect the colours from its surroundings.

In pencil and charcoal, you can create this effect by lifting off the pencil with a kneaded eraser to reveal the white paper underneath. You can, of course, avoid pencilling in the lighter areas in the first place by varying the pressure you apply to it. With watercolour, mask off the very brightest area first, so that when you lift away the masking fluid it reveals the white of the paper underneath. For oils, acrylics and pastels the white or the lightest colour is the last thing you add.

When painting or drawing claws or talons, don't be daunted at how many you may have to do. Get them all in the right place first and treat each one separately when you paint them, getting each one right. There may be subtle variations in tones, but you will use the same colours for them all. You may find that the last one you paint will be the best, as you'll have gained experience by the time you get to it.

Cat's paw in watercolour ▲
Note the contrast between the hard claws (where the highlights are left white and a mid-grey line is painted down the shaded side) and the soft pad and surrounding fur. The claws are small, but getting them right is an important part of making the animal look lifelike.

Practice exercise: **Bateleur eagle beak in soft pencil**

A soft pencil was chosen for this demonstration because of its versatility: you can create linear detail with the tip and block in broad areas of tone using the side of the lead, yet it is soft enough for you to be able to wipe out the highlights with a kneaded eraser. Soft pencils can also create a dense, black mark; hard pencils, on the other hand, tend to give a grey, rather than a black, mark.

Materials
- *Good-quality drawing paper*
- *3B or 4B pencil*
- *Kneaded eraser*

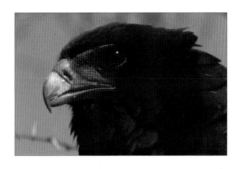

The subject
You need a hard, crisp outline to convey the texture of the beak. Note how the edge of the beak is darker at the point where the eagle turns away from the light.

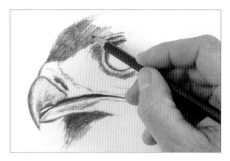

1 Using a soft pencil, lightly map out the overall shapes. Begin blocking in the mid tones on the beak, leaving a gap for the highlight on the edge of the lower beak. Increase the pressure on the pencil and put in the dark feathers on the chest and the top of the head.

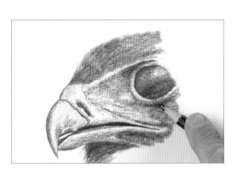

2 Continue blocking in the tones, using the side of the pencil and adjusting the amount of pressure you apply as necessary. Remember to leave spaces for the highlights. As the side of the pencil blunts, you will find that a sharp edge is formed which you can use for the darker tones, such as under the eye.

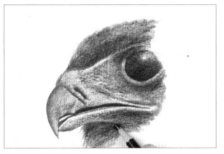

3 When you've put in all the mid tones, assess the tonal values of the drawing as a whole. You will probably find that the darkest areas (the pupil of the eye and the black feathers on the head and chest) need to be darkened still further in order for the brightest highlights to really stand out.

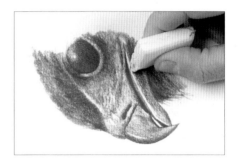

4 Finally, wipe out the highlights on the beak and in and around the eye, using a kneaded eraser. Take care not to overdo the highlights: they're lighter than the rest of the image, but it would be a mistake to make them really stark and bright.

The finished drawing
This simple sketch captures both the texture and the shape of the beak perfectly. Sharp, crisp lines are used for the hard edges of the beak, in contrast to the soft, diffuse edges of the feathers. Although we only see the beak in profile, it still looks three-dimensional: the areas of mid and dark tone next to the highlights indicate the changes of plane as the beak turns away from the light.

Note the mid tone along the edge, indicating the curvature of the beak as it turns away from the light and into shade.

The highlights have crisp, sharp edges, revealing the hard texture of the beak.

Scales

Reptiles and many fish have one thing in common – part or all of their bodies is covered in a series of tiny scales. It is worth knowing a little about how scales are formed, as this may make it easier for you to draw and paint them.

Reptile scales are composed of the protein keratin, just like the keratin that makes up human fingernails. In lizards, a scale typically begins as a fold in the epidermis – the top layer of skin. The upper layer of the epidermis hardens, and the dermis (the bottom layer of skin) withdraws, leaving a series of tough, overlapping scales. Look for slight shadows that indicate these overlaps. In turtles and crocodiles, most scales do not overlap; however, bony plates may develop underneath the scales, so the skin surface will appear bumpy rather than smooth and shiny. Again, look for shadows that indicate minor changes of plane on the surface of the body.

There are two main types of scales found in snakes: smooth scales, which are shiny and reflective, and what is known as keeled scales, which have one or more ridges down the central axis of the scale. Snakes' body scales are packed close together; they overlap and are arranged in diagonal rows. When you're drawing a snake in close-up detail, remember that keeled scales will appear rougher than smooth scales; put in some hint of light and shade to convey a sense of form.

Scale patterns vary just as much as bird feathers. The size and shape, can vary considerably. Remember to take note of how the scales appear to get smaller as they curve around the body. It can be difficult to get this right, so it is important that you take your time.

On the body of a fish or reptile there may be hundreds of scales, in different sizes. All those scales act like mirrors, reflecting the colours around them, especially where direct sunlight hits the fish or reptile's body. Pay attention to these colours, they will be of a much lighter tone but they will all be there. You may think they are too subtle to matter, but it's these little details that will make the scales look correct.

Even if you're aiming for a photorealistic rendition, don't try to draw the detail of every single scale. Instead, try to give a general impression of the shapes and sizes. Try half-closing your eyes and squinting at your subject, so that some of the detail disappears.

Unless there are specific markings that need to be observed, it can be a good idea to put in all the base colours across the entire animal or fish, and then draw or paint in the shape of the scales afterwards.

Applying pencil or pen-and-ink on top of paint to outline shapes works well. Other techniques that you might like to try include sgraffito (scratching into oil paint or oil pastels to create texture), and using an acrylic medium

such as a glass-bead texture gel to create the scaly effect. Alternatively, find something that has the same general shape of the scales (perhaps a net bag of the type in which fruit are often sold), dip it into your chosen paint medium and press it on to your paper or canvas. This is a good subject on which to try out different techniques.

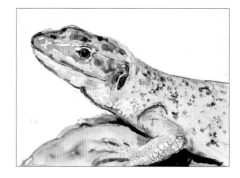

Scales in acrylics ▲
This painting, which is based on the same subject as the step-by-step demonstration opposite, demonstrates several techniques for painting scales. After applying the initial base colours in acrylics, the artist drew in the larger scales on the legs in charcoal. Glass-bead texture gel was used to create shiny, slightly raised patches on the back: when the paste dries, it creates a slightly shiny, knobbly texture. Tonal contrasts – small, light strokes next to dark – indicate minor changes in plane and convey the slightly raised form of the scales.

Practice exercise: **Chameleon in soft pastels**

The base colour of the chameleon's skin is applied first, with the scales being drawn on later. Look for the highlights, as these show you how the skin stretches over the skeleton. Note that the scales tend to be closer together, and smaller, the further away they are.

Materials
* *Pale blue pastel paper*
* *Pastel pencils: dark brown, yellow ochre*
* *Soft pastels: bright green, bright yellow, pale blue, white*

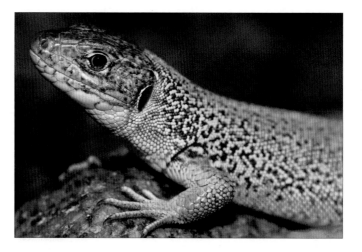

The subject
The scales on this chameleon vary considerably in size and shape. Although it would be a mistake to try and draw every single one, you do need to create a generalized impression of their texture.

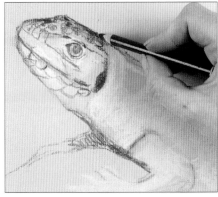

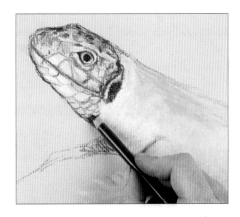

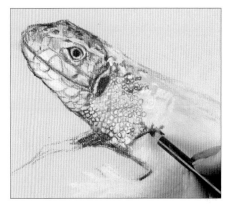

1 Using a dark brown pastel pencil, sketch the outline of the chameleon. Scribble on bright green soft pastel on the back where appropriate, and blend the pigment with your fingers. Repeat, using bright yellow on the underbelly and legs. Apply a little pale blue and white over the head. Begin putting in the larger scales with the brown pencil, as well as the dark markings on the top of the head.

2 Apply other colours to the head where necessary – yellow ochre pastel pencil around the eye, for example. Continue mapping out the scales again using the dark brown pastel pencil and paying careful attention to the shapes and sizes. It is important not to make the scales all the same shape and size – otherwise your drawing will look too mechanical.

3 Put in the scales on the back, using a combination of small, open circles through which the base colours can be seen and filled-in scribbles for the dark brown scales. Begin blocking in the legs, using the side of a bright green soft pastel and allowing some of the 'tooth' of the pastel paper to show through to imitate the rough texture of the legs.

The finished drawing
This is quite a loosely drawn picture, but it demonstrates how effectively textures can be built up when painting a scaly animal such as a lizard or other reptile.

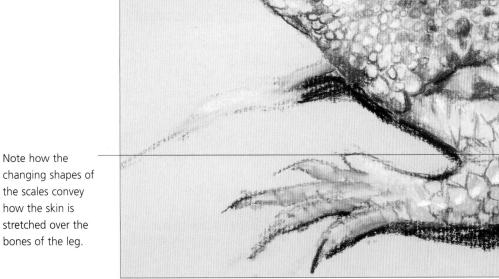

Note how the changing shapes of the scales convey how the skin is stretched over the bones of the leg.

Fur

One of the biggest challenges for any wildlife artist who wishes to paint in a realistic style is how to paint fur. How on earth can anyone paint all the fine hairs on an animal, long or short? The simple answer is that you can't! Instead, you have to learn how to create the impression of the fur though your brush marks and use of colour.

You may find it easier to paint long fur or hair than very short hair, as it's more obvious how the fur flows. Start by putting in the general shape of clumps of fur. Then later on you can flick the brush or pencil outwards at the edges of the animal to create the impression of individual hairs. Look at other artists' paintings of furry animals, then try to analyse exactly how they've painted the fur.

The colour of the fur can also make a difference to how difficult it is to paint. Look at the colours underneath – the bits in between the lighter areas, the shadow areas. Get this colour right from the start and it will save a lot of work later on. It's as if you are working from the inside out. Remember that the fur is just a covering: the viewer should

still be aware of the shape of the skeleton beneath. Even though you cannot see them, you should always think about the shape of the major bones and where they are located.

Even if the whole animal appears to be just one colour, it won't be. The fur of a ginger-coloured cat will be various tones of this colour, while the coat of a white-haired animal may contain shades of grey, blue and purple. This is because the animal's body is turning towards or away from the light and by putting in these different tones you can convey a sense of the animal's form and make it look three-dimensional. In this respect, the fur is rather like clothing on a person – the way it drapes over the body.

Note that each hair or clump of hair may change tone along its length, as it turns towards or away from the light. Don't get carried away putting in lines of a single colour; a hair only looks like this if it's lying flat and is straight – but fur generally doesn't do that.

If you're using pencil or charcoal, do not be tempted to draw in one line to represent one long hair. Look at the hair

and see how the tone changes along its length; you may even need to leave a gap in the line for a very bright area.

Even though fur is not a reflective surface, it will still contain highlights where the light hits the animal. Each medium requires different techniques. With oils and acrylics, work the darker areas first and apply the highlights afterwards. With watercolour, you can mask out the highlights and paint in the darker areas, rubbing off the masking fluid to reveal the white paper underneath. With graphite and coloured pencil, you can use an eraser to create the highlights, although with coloured pencil take care not to press to hard initially. Pastels lend themselves well to fur and can easily be highlighted with lighter tones. Work out where the lighter areas are from the outset.

It's also absolutely essential to observe the direction of the hair. No matter what your medium is, you need to go with the flow. Your brush or pastel marks will become the fur. Moving your brush in the wrong direction means the fur will appear to flow in the wrong direction.

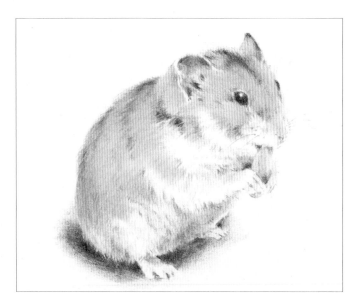

Hamster in coloured pencil ▲
The colour and texture of the fur were built up gradually by applying several layers. On the hamster's chest and along the edge of its back, strokes of grey and reddish brown were 'flicked' on to the white background, so that the spaces in between the coloured strokes stand for white hairs.

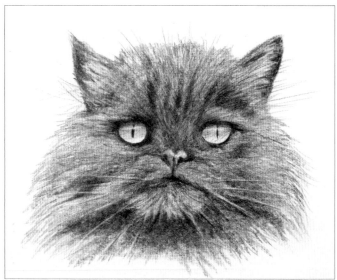

Cat in soft graphite pencil ▲
This sketch was made using just one grade of pencil – a 4B. For broad areas of tone, such as the dense black under the cat's chin, the artist used the side of the pencil lead and smudged the marks with his fingertips. The fine white hairs were 'drawn' using a kneaded eraser pulled to a sharp point.

Practice exercise: **Long fur in oils**

In this exercise, oil paint is used wet into wet to blend areas of different tone together. Don't worry about placing every strand of fur exactly; a general impression of the way it falls is sufficient.

Materials
- *Canvas paper*
- *3B pencil*
- *Oil paints: brown ochre, burnt umber, cadmium red, titanium white, lamp black*
- *Low-odour thinner*
- *Brushes: selection of short flats, small round or rigger, soft round*

The subject
Here, the dog's fur falls in thick, flowing strands and is a lovely rich, reddish brown that glows in the light.

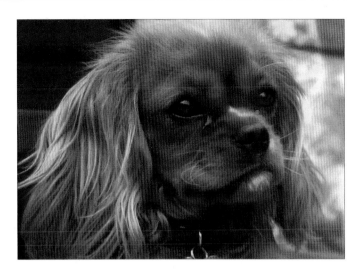

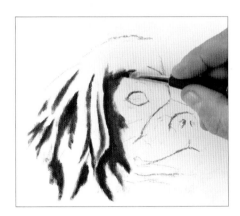

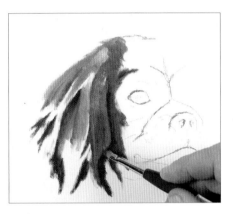

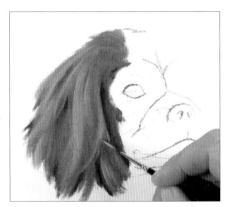

1 Using a 3B pencil, make a light underdrawing to map out the main features. Mix a rich brown from brown ochre, burnt umber and a little cadmium red and, using a small flat brush, put in the darkest areas of fur. Use long, flowing strokes that follow the direction in which the fur grows.

2 Now mix the mid tones from brown ochre, burnt umber and titanium white, varying the proportions of the colours in the mix as necessary. Apply them in the same way as the dark tones, blending the edges of one tone into the next, wet into wet.

3 Add more titanium white to the mix. Using a small round or rigger brush, depending on how fine you need the highlights to be, put in the highlights. Look carefully at how the light falls: the highlights are what will give the fur its sheen.

The finished drawing
This sketch beautifully captures the way the fur falls in flowing strands. The paint has been applied in long, calligraphic strokes and skilfully blended wet into wet, so that the tones merge almost imperceptibly together. The contrast between the highlights and the tones of the dark, shaded areas gives the fur a feeling of volume.

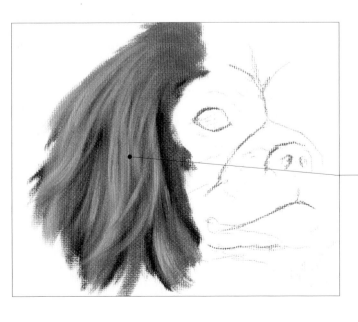

Note that the highlights are not painted as a continuous line; they break as the fur turns away from the light.

Skin

There's something very satisfying about painting or drawing an animal's skin. Whether it's dry, wet or even muddy, getting it right can be a lot of fun.

If you are painting an animal with hide – an elephant, perhaps – you need to decide right from the start how much detail you want to put in. You can't put in some details and leave out others. The ears, for instance, are full of veins and including them will really add to the sense of realism. But if you put in details in the ears, you'll have to do the same for the trunk and the rest of the body.

The best way to approach it is to look at the animal as a whole. Before you start to apply any paint, sketch in where the deeper folds of skin are, as this will help you position the smaller creases in the right place later. If you're making a pencil drawing, the same applies. The darker the pencil lines, the deeper the wrinkles. Don't even attempt to put in every wrinkle and fold; instead, pick out the main lines. If you put in every single line, you'll lose sight of the drawing or painting as a whole. You can add extra details as the whole painting comes together later if you wish.

Remember that wrinkles and folds are not simply lines on the surface – they are crevices, albeit shallow ones.

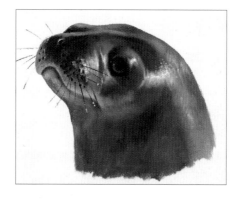

Seal in oils ▲
This sketch was painted wet into wet, the colours blended on the canvas to create subtle tonal variations within the skin. The tiny water droplets on the whiskers complete this study.

One side will be lighter than the other, where the light hits it, although the tonal differences may be quite subtle if the folds are not very deep. So look for the highlights along the edges of the folds. In pencil or charcoal, you can create the highlights by lifting off pigment with a kneaded eraser. When using watercolour, leave the white of the paper showing; in oils, acrylics, coloured pencils and soft pastels, use a lighter tone. If working in charcoal use less pressure at the top of the folds.

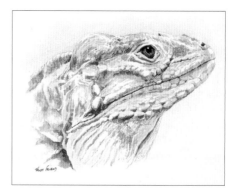

Lizard in watercolour ▲
With very rough, textured skin, pay particular attention to the different tones. Note here how darker tones indicate shaded areas on the surface where folds of skin overhang.

Generally speaking, don't try to complete one section of an animal at a time. Work across the painting as a whole, so that everything progresses at the same rate, slowly building up the complete picture so that you do not overemphasize one part at the expense of the rest. There is a practical reason for doing this, too: if you paint and finish one part of an animal, then you may not be able to recreate exactly the same colour mix again when you need it for another part of the animal.

Practice exercise: **Elephant skin in pencil**

The most important thing to remember in this exercise is that the wrinkles and folds are not some kind of surface decoration: they are three-dimensional, like little ditches or channels in the skin. If you merely draw them as a series of lines without attempting to give them any depth, it'll just look like crazy paving and you'll get no sense of the form of the animal. Take the time to assess how deep the folds are and how dark they need to be.

Materials
• *Good-quality drawing paper*
• *3B pencil*
• *Kneaded eraser*

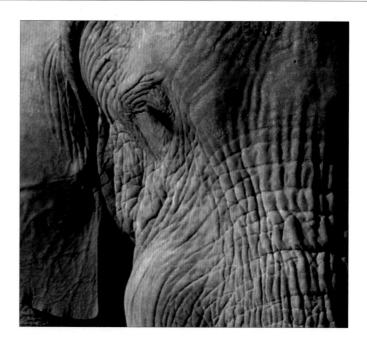

The subject
Strong side lighting from the left clearly shows up the creases in the elephant's skin.

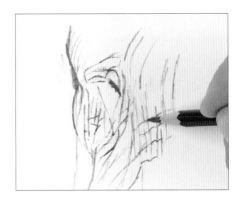

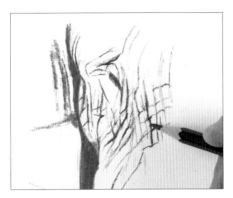

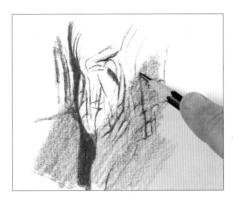

1 Using a 3B pencil, begin sketching the animal. Start from the eye, which is an easily identifiable focal point in an otherwise confusing jumble of lines, and then relate all subsequent lines to that. Put in only the main lines to begin with; then, when you're sure of their placement, you can start putting in more detail.

2 Block in the dark area between the ear and the side of the face and begin putting in the main creases in the skin, using the tip of the pencil sharpened to a fine point. The deeper and darker the crease, the more pressure you need to apply.

3 Shade in the mid tones, using the side of the pencil and varying the amount of pressure as necessary to create lighter or darker mid tones.

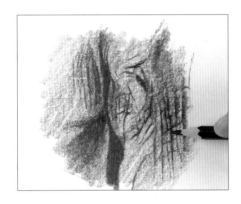

The finished drawing

This is a carefully observed tonal study that makes the animal's skin look convincingly three-dimensional and captures the texture perfectly. The soft 3B pencil has created a surprisingly broad range of tones, from the dense black in the space between the elephant's ear and the side of its face to pale greys in the most brightly lit areas. Without the eye, this sketch would be little more than an abstract pattern; even when closed, as here, the eye tells us that this is a living animal.

4 Finish putting in the creases, again using the tip of the pencil. You may find that you need to strengthen some of the very dark lines that you put in earlier so that they stand out clearly against the mid tones.

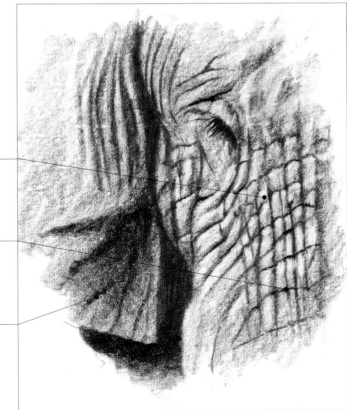
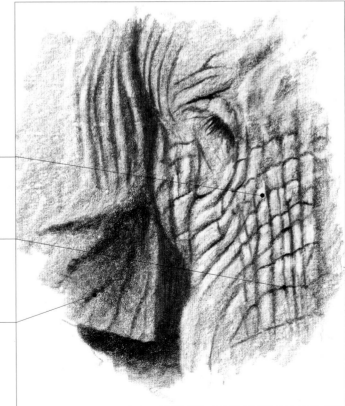

Bright highlights are visible where the skin catches the light.

The dark creases are created using the tip of the pencil.

The veins in the ear can clearly be seen below the surface of the skin.

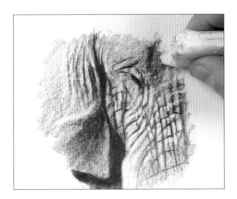

5 In very strong directional lighting, as here, you may see a highlighted edge along one side of a skin wrinkle or fold. Pull the corner of a kneaded eraser to a fine point and carefully wipe off pigment to create the most important of these highlights.

Feathers

With more than 10,000 different species of birds in the world, there is a huge variety of plumage. From the wonderful iridescent markings on a peacock's tail feathers to the feathers of the western screech owl, which are designed to provide camouflage, the plumage of birds is as varied in its coloration and patterning as the fur of mammals. There is the texture to consider, too: compare the large, strong flight feathers of a bird of prey such as an eagle with the soft down of a newly hatched chick. Whatever the species, however, the way you paint feathers depends largely on the amount of detail you portray.

If your composition is a wildlife landscape, then the birds may not be the most important element in the painting. A tropical rainforest scene full of different tones of greens can be brought to life with the splash of colours from a flock of yellow and blue macaws, even if they occupy only a small part of the picture space. But in this scenario, where the birds are just part of a wide composition, you will only need to paint or draw the overall shapes and colours.

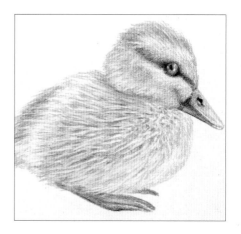

Chick in graphite pencil ▲
This sketch was made using a 3B pencil, which can create a broad range of tones from pale greys to dense blacks. Note how the paper has been left almost entirely white in parts, for the highlight in the eye and beak and the very palest feathers. For a sketch like this, which contains many fine lines, it's vital to keep the pencil tip sharp.

The nearer the bird is, the more detail you need to put in. You have to decide at what distance you start to notice detail and see the shapes of individual feathers. Go into your garden or park and look at the birds there. With some, you'll have to get very near or use binoculars to see the feathers in detail.

Remember that soft feathers of a single colour tend to lose all their detail, even close up; once again, don't put in what isn't there. Your brain tells you that there should be feathers, but your eyes tell you differently: paint what you can actually see.

There are two basic types of feather: vaned feathers, which cover the exterior of the body, and down feathers, which are underneath the vaned feathers. A vaned feather has a main shaft, fused to which are a series of branches, or barbs. These barbs have sub-branches of their own, called barbules, which contain a series of tiny hooks, invisible to the naked eye, that latch on to barbules from the next barb along the feather shaft and keep the feather together. There are about 300 million tiny barbules in one feather alone.

Texture depends in part on the function of the feathers. The outer ends of the flight feathers of an owl, for example, have no barbules and are thus very soft, so that its prey doesn't hear it coming as it swoops down to grab it. Compare this with the wing feathers of swans, where stealth is of no importance: you can hear their large wings coming from a long way off. The main function of down feathers, on the other hand, is to provide insulation: they are fluffy because they lack the barbules of vaned feathers, which allows the down to trap air and thus insulate the bird from the cold.

If you are painting a bird portrait, it's a good idea to practise painting an individual feather first in your preferred medium before committing to canvas or paper – so that you get the markings and colour right. This is important if you are working in watercolour, where there is no going back. After putting down a base coat, use a soft round brush with

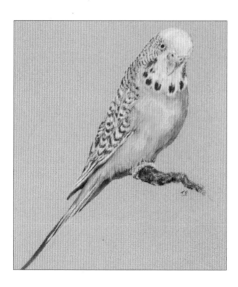

Budgerigar in soft pastels ▲
With soft pastels, you can blend colours to create delicate optical mixes – and that is what the artist has done here, overlaying mid green, light green, yellows and even a hint of orange for the bird's soft chest feathers. The harder wing feathers are scribbled in using short strokes, again overlaying colours to create the desired effect.

hardly any paint on it, lightly brushing across the top of the base coat to create the texture of the feather. Make sure you brush in the direction of the branches of the feather.

If one feather appears as a single colour, a group of the same-coloured feathers may not. The angle of the light hitting the feathers will change depending on the shape of the wing – and so the tone of the feathers will change, too. Pay attention to this, as it gives the wings their form.

Another important thing to note is that feathers are not completely solid. Note how the light filters through the wings of a bird in flight. An egret flying with the sun behind it will come to life, the feathers becoming almost transparent at the ends of the wings where they are less dense. To create this effect, blur the end of the wings with a very soft brush and a small amount of paint. Make sure that there are no hard edges and apply very little paint, so that you can see the background through the tips of the wings.

Practice exercise: **Feathers**

When you are drawing a bird, it is neither necessary nor advisable to put in every single feather – particularly if you are drawing a front view, as the chest feathers tend to be relatively small. Look instead for the blocks of feathers and think about their function: are they strong, primary feathers that are used for steering and to produce the power of flight as the wing is brought down through the air, or the softer, more pliable secondary feathers that lie above the primary feathers? Also think about the skeleton that lies underneath the feathers, as this will make it easier for you to get the shape of the body and head right.

Materials

- *Smooth drawing paper*
- *Fine liner pen*

The finished drawing
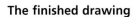
Using a liner pen can give a drawing a rather mechanical feel if you're not careful, and the trick is not to put in too much detail. Here, the artist has created the soft texture by drawing pen lines that follow the direction of the individual strands within the feathers.

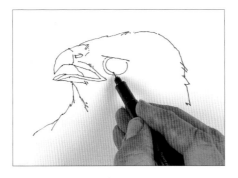

1 Using a fine liner pen, map out the main shape and features of the bird of prey's head. Use small, jagged strokes around the edge to convey the texture of the facial and neck feathers.

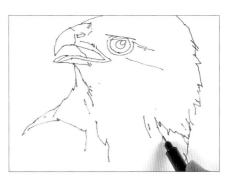

2 Draw in the position and shape of the main feather groups – the feathers at the base of the head and on the bird's chest.

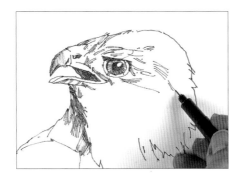

3 Elaborate the main feather groups, defining some of the feathers more clearly than others. Colour in the eye, remembering to leave the highlight untouched.

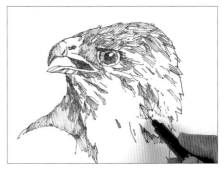

4 Build up the tones by increasing the density of the pen lines, carefully following the surface contours of the underlying body structure.

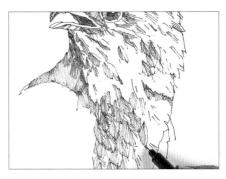

5 Finally draw the cluster of feathers that runs from the bird's neck over its chest. They help to give the subject a sense of solidity.

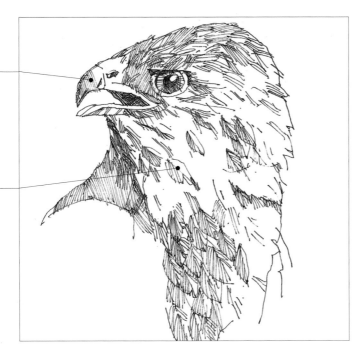

Make sure the beak looks hard and slightly shiny.

Even though some areas are left almost blank, the viewer's eye fills in the missing details.

Hard shells

In crustaceans, turtles, tortoises and some insects, such as stag beetles and ladybirds, the bodies are covered by a hard carapace, or shell. These carapaces are quite simple to draw and paint.

The most important thing is to observe how the light reflects off the shiny, hard surface; if you assess these tones properly, you can convey the curves and the changes of plane within the subject. A ladybird's carapace, for example, is smooth and rounded, but in order to convey the form you need to look for the different tones within it as the body curves gently away from the light. In cases like this, the tonal transition will be very gradual. A crab or lobster shell, on the other hand, is not uniformly smooth: there will be bumps and indentations in the shell and the transition from one tone to another will be far more pronounced.

With a graphite pencil, vary the amount of pressure you apply to create different tones. Start quite softly; once you're happy with the general shape, you can press a little harder. The darker the shell, of course, the harder you need to press. When using oil or acrylic paints, you can cover the whole shell with a mid tone colour and apply the lighter and darker tones once the initial

paint has dried. Always test out your mixes on scrap paper before you apply a dark tone over your base coat, to see if they work.

The shells of tortoises and turtles have interesting patterns. Whatever your chosen medium, it really helps to sketch out the patterns before you begin painting. Begin with very light pencil marks, as you'll probably have to adjust the pattern slightly before you get it right. There's no point in painting part of the pattern and then finding out you've misjudged how big or small it needs to be. Observe how the pieces interlock and how there seems to be a uniformity over the shell. This is the key to getting it right.

Once you've established the basic pattern, you can apply the colour. In oils, pastels or acrylics, try putting down some mid-toned base colours first. Once they have dried, you can apply the lighter and darker colours on top, following the direction of the pattern. In watercolour, allowing the base colours to bleed into each other wet into wet can create a lovely mottled effect.

Generally speaking, the surface of a tortoise or turtle shell is rougher than an insect's shell and therefore less shiny. The ridges on tortoise shells are quite

shallow, but need to be observed. To convey the roughness of the texture, look at the highlights along the edge of the ridges. Although the ridges are small, you'll see that there's a shaded and a lit side. Drybrush techniques (in watercolour or acrylics), sgraffito, pen-and-ink detailing on top of dry watercolour paint and oil pastel on top of watercolour are all techniques that you might like to consider trying.

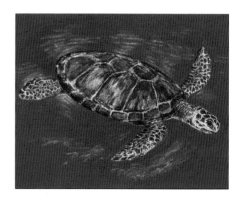

Turtle in mixed media ▲
The base colours of the shell and flippers were applied first, using acrylic paints, and then oil pastels were used for the shell markings. The oil pastels were scribbled on quite loosely, and the colours blended together where necessary using a rag.

Practice exercise: **Beetle in line and wash**

With line and wash, you can combine the fine detailing of pen work with soft washes of colour. You must use waterproof ink for this technique, otherwise the pen lines will smudge when you apply the watercolour. Remember to leave the bright highlights unpainted.

Materials
- *Smooth watercolour paper*
- *Fine-nibbed sketching pen*
- *Black waterproof ink*
- *Watercolour paints: ultramarine blue, alizarin crimson, yellow ochre, lamp black*
- *Brushes: medium round, fine round*

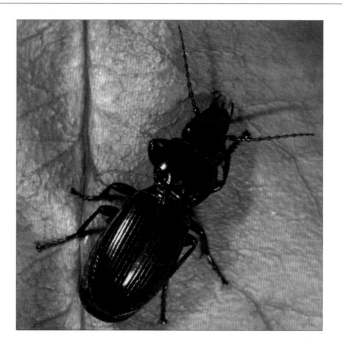

The subject
With their spindly legs and antennae and hard, reflective shells, beetles make fascinating subjects for natural history studies. If you put in the background leaf, as the artist did here, keep the colours muted and the veining on the leaves quite faint, so that they do not detract from the main subject.

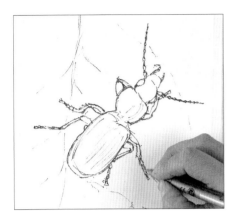

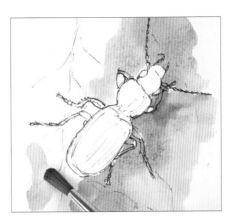

1 Using a sketching pen and black waterproof ink, sketch the subject and put in faint lines for the ridges on the shell. Put in some of the veining on the background leaf, making these lines fainter than those on the beetle so that the beetle stands out.

2 Mix very pale, dilute colours for the background: a purple from ultramarine blue and alizarin crimson and an orangey-brown leaf colour from alizarin crimson and yellow ochre. Using a medium round brush, wash these colours over the background, taking care not to apply any of the wash colours to the beetle.

3 Using a fine round brush and lamp black, block in the beetle, remembering to leave the highlights on the shell white. Add a little alizarin to the wash to soften the colour for those areas that are not quite so sharply in focus.

> **Tip**: Plot the shapes by making tiny dots to check the placement before you commit to strong ink lines. Alternatively, make a pencil underdrawing first and then go over it in ink.

The finished painting
Through fine penwork and by carefully observing the shapes of the bright highlights, the artist has captured the hard texture of the beetle's shell perfectly. The soft washes of colour on the background leaf complement the main subject without detracting from it.

Using a fine-nibbed pen allows you to create delicate lines and fine detailing.

Note how one half of the shell is brighter than the other: this tells us that the shell is rounded, as one side is in relative shade.

A very thin highlight at the base of the shell separates the shell from the body.

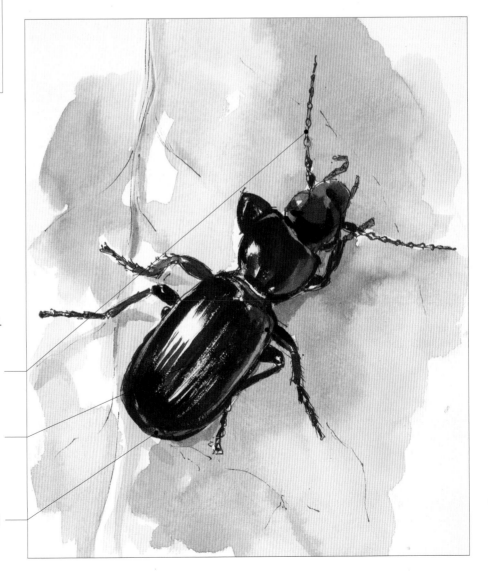

Creating a sense of movement

If you want to draw or paint any animal in motion, you need to know the order in which the legs move or your picture simply won't look right. So how do you go about finding the information you need? This is where photographs in books, magazines and on the Internet really come into their own. Use them to check how the legs are positioned, how many legs are off the ground at any one time, whether the head is held high or low, where muscles are visible in the shoulders, neck and hindquarters and so on. The muscles of a sprinting animal will look very different to those

of a standing animal; they will be more pronounced and stretched – and getting things like this right can make or break a painting. Alternatively, there are many DVDs of natural history programmes; freeze the frame, and then make a quick pencil sketch simply to get the lines of the 'pose' right.

If you're able to take your own reference photos in the field, use a fast shutter speed in order to freeze the action at the crucial moment. Even the most basic of cameras in automatic mode should be able to give you the shot you need in good lighting

conditions. If you have an SLR camera, you'll have more control and more chance of getting a good shot even when the light isn't perfect.

Best of all, whenever possible make quick sketches of live animals in motion, simply to train your eye to capture the essential lines. This is not about making a sketch that captures every single detail; what you need to do is observe how the animal moves – the angles of the legs in relation to the body, how long the stride is, the arc of the back as cat jumps up or a hare bounds forwards, or the way the tail

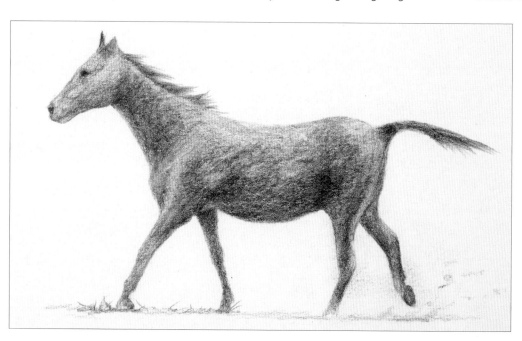

◀ **Horse walking**
If you want to draw or paint animals in motion, find out which order the legs move in. A walking horse's legs move in the following sequence: left hind leg, left front leg, right hind leg, right front leg. When walking, the horse will always have one foot raised and the other three feet on the ground, save for a brief moment when weight is being transferred from one foot to another. A walking horse moves its head and neck in a slight up-and-down motion that helps maintain balance.

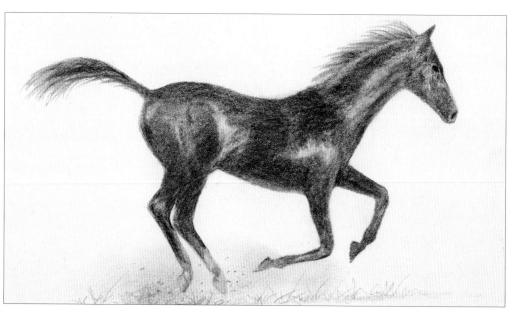

◀ **Horse cantering**
When cantering, one of the horse's rear legs propels the horse forwards. At this moment, the horse is supported only on that single leg. On the next 'beat' of the gait, the horse catches itself on the left rear and right front legs while the other hind leg is still momentarily on the ground. On the third beat, the left front leg will land while the diagonal pair is momentarily still in contact with the ground.

streams out behind a galloping horse, for example. Concentrate on one feature at a time rather than trying to draw the whole thing in one go. Put down marks quickly on the paper, studying the same element over and over until you feel you've got to grips with it. Even if your scribbles mean nothing to anyone else, you'll make sense of them, and the process will sharpen your powers of observation.

If you're relying on photographic reference and the animal image is pin sharp, look for other things that convey a feeling of motion. The photo may have been taken on a slow shutter speed, which blurs part of the image. Perhaps the legs of the animal appear blurred while the rest is in focus, giving the impression that the animal is galloping. Or maybe the animal is sharp and the background is blurred – not because the shot was taken with a narrow depth of field, but because the camera was moved while the photo was being taken, giving the illusion that the background is moving and rushing past. To achieve this effect, make horizontal brush strokes, blurring each one into the next across the painting. Make sure all the brush strokes are level with the horizon; if just a single stroke is not level, it will look odd.

Look at how the animal's movement affects its surroundings, too. If you're painting a duck or a swan gliding across a pond, for example, you probably won't see anything of the feet paddling away below the surface – so the only way to convey a sense of movement is by painting ripples in the water.

Another way to achieve this effect is to paint the whole scene crisply and blur the bottom half of the animal's legs, or even just its hooves. Use a soft brush with just a little paint and scrub in the hooves and bottom part of the legs. Slowly build up the colour and the amount of paint until you get the effect you require. The outer edges of the area that you are blurring need to be more transparent, with the colours of whatever is behind showing through – so you need to apply less paint here. You can do this with any animal, and on any part of that animal, to give the effect of movement.

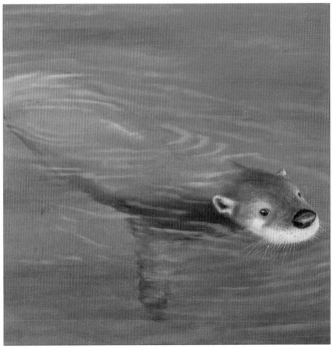

Swimming otter ▲
This otter's limbs are virtually hidden from view, so to demonstrate that it is moving you need to show how its motion affects its surroundings. Note how the ripples spread out from the otter's body. Remember the rules of perspective when painting ripples: ripples in the foreground appear to be closer together than those in the distance.

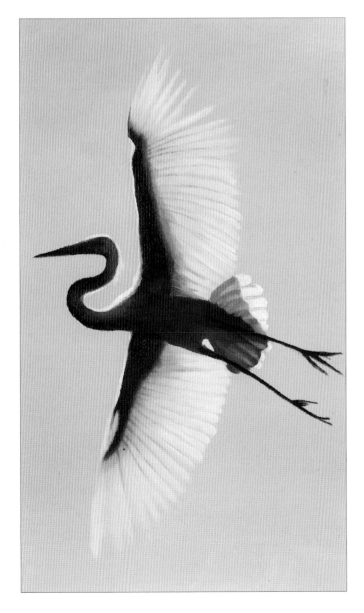

Egret in flight ◀
Even though little detail is discernible in this oil sketch, the streamlined shape of the flying egret creates a strong graphic image. Light filtering through the outspread wings adds to the sense of atmosphere.

Applying dust around the bottom of the legs of the animal will create motion and atmosphere. It's simple to do in any medium and can really add to your painting. It can make a horse look as if it is at full gallop or a rhinoceros appear even more dangerous than it is. Don't forget that dust will look darker at the bottom, as less light filters through.

The same principles apply to drawing and painting birds in flight and, as with any other subject, time spent observing wild birds will prove to be invaluable. Bird identification manuals are another useful source of information, as they often include silhouetted outlines of birds in flight. Naturally, not all birds fly in the same way and if you want to paint a particular bird in flight, then this may require more observation. Any bird or animal will act differently when it's hunting: talons may be extended, or the wings may be further forward or back than usual.

Blurred background, frozen wings ▼
Here, the insect's fast-moving wings have been 'frozen' in motion and are painted with quick, deft brushstrokes of white paint, while the background is a soft, mottled neutral colour that looks slightly blurred. The fly's huge eyes are difficult to study in any detail without magnification, so the artist used a macro photograph as reference, creating an image that looks like an illustration for a work of science fiction.

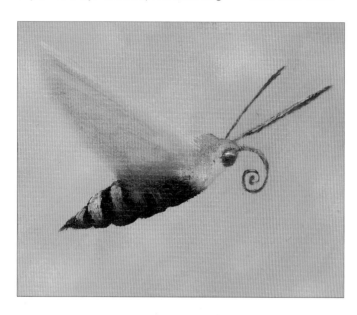

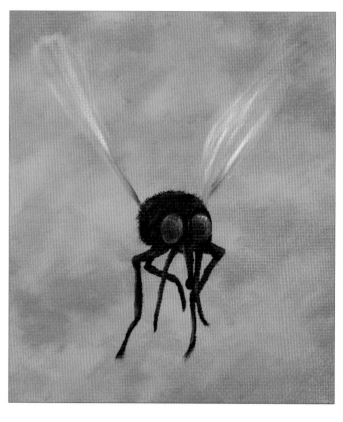

Blurred wings ▲
Here, the artist has blurred the wings of the moth to create a sense of movement. The soft, slightly mottled background allows us to focus on the insect, in much the same way that an out-of-focus background in a photograph does.

Practice exercise: Adding dust to create a sense of movement

In oils and acrylics, you can add the dust at the very end, after you have painted the animal and any background that you want to include. In watercolour, you would need to paint the dust in the early stages, as it is lighter than the animal and you need to work from light to dark.

Materials
• *Primed canvas*
• *Oil paints: titanium white, lamp black, raw umber, raw sienna*
• *Brushes: small filbert, soft brush for blending*

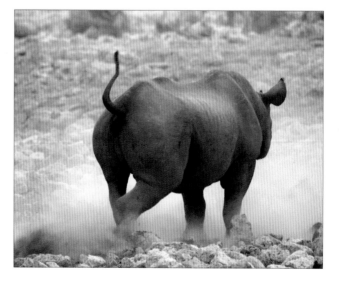

The scene
Although this rhinoceros is moving relatively slowly, the dust being kicked up by the legs imparts a sense of movement to the scene.

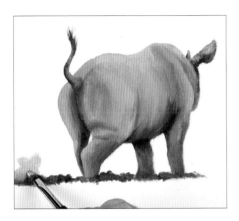

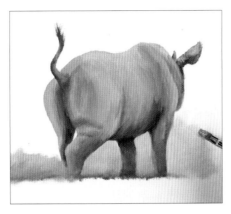

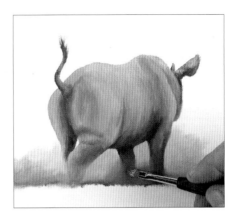

1 Paint the rhinoceros, then leave the painting to dry. Using a small filbert brush and the same colours that you used for the rhino's legs, apply a little paint to the base of the feet, just to wet the surface so that you can work into the paint again. Using a dark yellow-grey mix of titanium white, raw umber, raw sienna and a tiny bit of black, paint in the ground below the rhino's feet. Gently begin to pull the wet paint up to create the dust, using a small circular motion of the brush.

2 The dust gets lighter in colour the higher you go, so add more white to the mix as you work upwards, scumbling the paint on with a circular motion of the brush.

3 Note that the rhino casts a shadow on both the ground and the dust, so the dust immediately under the rhino is darker than the rest. Go over the base of the rhino's legs again, so that it looks as if dust is swirling over them and you lose the hard edges.

The finished painting
This simple little sketch demonstrates how effectively swirling dust creates the impression of movement.

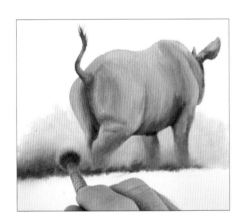

4 Blend the paint with an old, soft brush to get rid of the brush marks, using a gentle, circular motion – rather as if you are dusting for fingerprints.

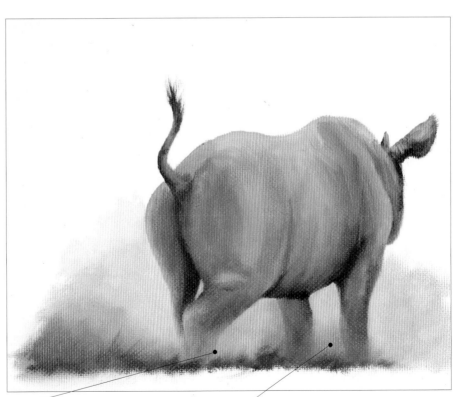

The edges of the rhino's legs are softened to give the impression that they are moving.

Note how the dust under the animal is darker than the rest, as the rhino casts a shadow on both the ground and the dust.

Collecting reference material

As soon as you begin to take an interest in drawing and painting, you'll start to notice things differently. If you paint landscapes, you'll look at the shapes and colours of trees and clouds, and wonder why you never really noticed them before. A portrait painter begins to look at skin tones and becomes interested in faces young and old; sometimes the older the better, as they may be more interesting and tell more of a story. The same applies to you as an artist interested in wildlife: your fascination for creatures great and small will just grow and grow – and so will your never-ending collection of reference material.

There are endless images in wildlife books and magazines and on the Internet and it is fine to copy them for practice purposes. No matter how hard you look at a subject in the field, you will almost certainly need to check certain anatomical facts. Perhaps you are painting a bird flying and you forgot to work out how many flight feathers it has in its wing; maybe you sketched a big cat snarling and you need to know how many teeth there are between the main fangs.

If you start to sell your work, you should obtain your own references for copyright reasons. But even if you're not intending to sell your work, you'll want your own reference material, because you'll want to create a painting that is entirely yours.

First and foremost, it's very important to get into the habit of carrying a sketch pad. You can fit many pieces of useful reference on a single piece of paper or canvas. Don't rely on your memory or on photos for colours: instead, make a sketch in oil, watercolour, coloured pencil or whatever your chosen medium is. This needn't take more than a couple of minutes, but you can get a perfect colour match in that time. Look at cloud and sky colours as well. Note how the colours change at the horizon and in the distance. Reds in the spectrum are lost through the atmosphere, and this is why blue dominates in the far parts of a landscape scene.

If you mix colours to get the one you want, make a note of how you created that mix. Put down a brushstroke of each colour in the mix, and write the colour name alongside; then paint a sample swatch of the mixed colour; this will make it much easier to recreate the colour once you're at home.

Notes about the direction and quality of light are also important, so make a note of the direction and length of any shadows. Even something as simple as drawing an arrow in the margin of your sketchbook, to show the angle of the sun, can be a big help.

Also make sketches of animals that you can work up into more detailed paintings back in your studio. Remember you're not looking for a fine finished work, but just a quick sketch to remind you of what you've seen. It's all about looking at the animal and noting down the shapes and colours. Don't worry if your sketches look nothing like the thing you're drawing, this is all about improving your powers of observation and forcing you to think about what's really essential instead of drawing too much detail. Making your own sketches also sharpens your eye and trains you to observe your subject more keenly. Moreover, because you have to look really hard at your subject to make a sketch, it fixes it in your mind much more clearly than simply pressing the shutter on your camera. And, when you look at your sketch, you'll be surprised at how many other things you remember – the sounds and smells, the whole experience of observing nature in the wild. Although all these things are intangible, they will help bring your painting alive.

Sketchbook page ▶
Fill your sketchbook pages with visual reminders and notes about your observations in the field. You don't need to make detailed sketches – isolated details such as tree and cloud shapes, or the colours of the sky or grasslands, will serve as useful reference material that you can work from when you're back home.

Working from photos

Taking your own photos is another important part of collecting reference material and, with a digital camera, you can shoot hundreds of photos in rapid succession without having to worry about film and processing costs. Some artists prefer to work entirely from life, in the field. Some artists use photos only as an aide-mémoire, simply something to jog their memory when they're back in their own studio. But, particularly when you are just starting out, painting from your own photos can be a rewarding experience – provided you learn to treat them with a certain degree of caution.

When you take a photo, you capture a fleeting moment in time – but sometimes it simply doesn't look right. The eyes may have been moving at the moment you pressed the shutter, or a strange shadow on the animal's body may mislead you into painting in a muscle that just isn't there. The moral is, don't trust your reference material implicitly – the camera can lie.

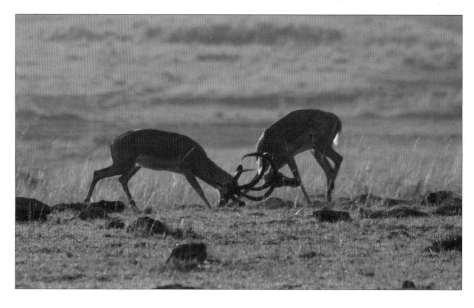

Another thing to beware of is that your camera may misread what you are photographing and overexpose the shot, making everything lighter in tone than it really is. If you replicate these tones in your painting, it will be completely unnatural. A little camera knowledge is an advantage, but

Keep a safe distance ▲
Wild animals can be extremely dangerous, so use a telephoto setting in order to photograph them from a safe distance.

nothing will help you more than seeing the animal first hand and making detailed notes about light and colour.

When you're putting a painting together from several photographs, start by laying them all out in front of you. This will not only give you ideas about the overall composition but will also enable you to work out whether all your references have been shot from the same perspective. If, for example, you're planning to work from two photos of rabbits in a field, make sure that they've both been shot from the same angle: you can't photograph one from low down, from the animal's eye level, and the other from above.

Think about the quality and quantity of the light, too, and make sure they are consistent in all your reference photos. A scene with a small mammal from the northern hemisphere – a racoon, perhaps – might have more atmosphere if there is no direct sunshine in it, although you must take care that your painting doesn't look too flat. If there is no sun on your reference photo of the animal, make sure that your habitat reference photo has not been shot in brilliant sunshine.

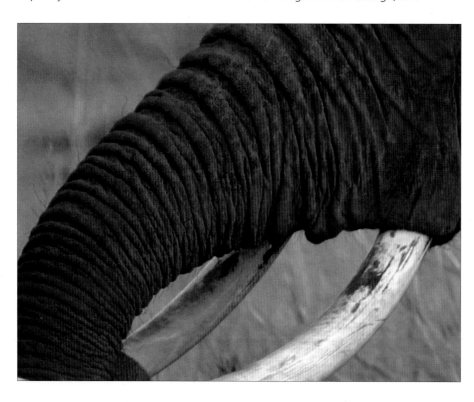

Close-up details ▲
A telephoto lens can be useful as it not only enables you to get good shots of wild animals without getting too close and disrupting them but it also allows you to study details such as skin texture or markings.

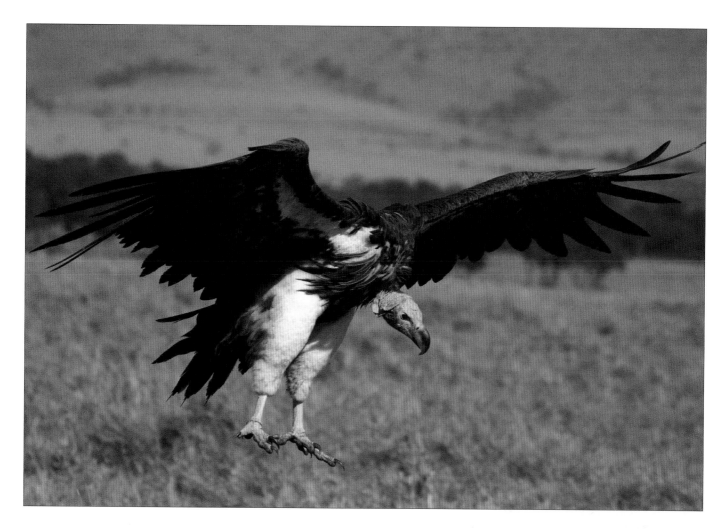

Pay attention to the direction of the light: if the light is coming from above and to the right of the animal, then the shadow will fall to the left, so make sure that shadows run in the same direction and have the same intensity.

It may sound obvious, but make sure that all the elements you're planning to include really would be found in the same place in the wild. For example, if you paint two birds feeding side by side, don't make the mistake of painting two territorial male birds together, rather than a male and a female. Similarly, check the seasonality: don't paint a bird in winter plumage on a tree in spring. And make sure the animal suits the environment: if you have a photo of elephants on a dusty patch of ground and you want to show them at a watering hole, remember that you'll have to make their legs and trunks look wet and muddy. Get things like this wrong and your entire painting will lack verisimilitude.

Fast shutter speed ▲
Use a fast shutter speed – ¹⁄₂₅₀ second at least – to 'freeze' the action of a moving subject.

A final word: think about what it is that makes a painting a piece of art rather than an illustration: it's all about atmosphere – light, shadow, composition and perhaps movement. Work hard at capturing a good likeness of the animal – but then think about how to give the viewer a sense of what it was like to actually be there. If you are painting camels in a desert setting, for instance, put in a dusty background with sand blowing in the wind; if it's seals on a headland, capture the waves crashing against the rocks or dark storm clouds scudding across the sky; if it's deer in a forest setting, try to capture the light filtering down through the trees. All these things will help lift your painting to a picture that's full of life and atmosphere.

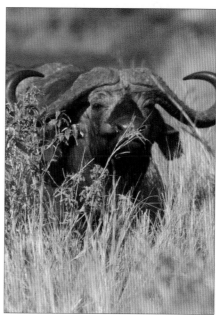

The habitat ▲
Make sure you get reference shots of animals in their natural habitat so that you can paint them in an appropriate and realistic setting.

Composition

Whatever you're painting, whether it's an animal portrait or a wildlife landscape, you need to think about the composition of your work. If you get it wrong, even an untrained eye will know there is something that they don't like about your painting – although they might not know what the problem is.

Composition might sound like quite a rarefied concept, but basically all it means is making sure that your painting looks well balanced and that the viewer's eye is directed to the main subject of the image in some way.

Always roughly sketch your painting first to make sure that all the elements are in the right place. If you're not sure, show a few people your sketch, or put it to one side and look at it later on.

You can also trick your own brain into seeing your sketch for the first time. Look at the sketch in the mirror. Its reflection will be reversed and it will appear to your eye as a brand new image. (This is also a useful final check when you're getting near the end of a painting: by looking at it in this way, you will instantly spot any mistakes. Don't be afraid to change things, even if you've already put hours of work into the piece.)

First, think about how much space your main subject is going to take up. Is your intention to concentrate on the animal, with the natural habitat being of secondary importance? Then the animal will occupy a large proportion of the picture. Or is the landscape itself more important? In this case, the

animal may well be a relatively small part of the image. With practice, and by looking at the work of other artists, you'll develop an instinctive feel for what looks right.

Next, you need to work out where in the picture space your main subject is going to be placed. It's generally advisable to position your subject slightly off centre; if you place it right in the middle of the picture space, it can look rather static. Conversely, placing it very near the edge of the frame can look very unbalanced. Another tried-and-tested method is to mentally sub-divide your picture space into three, both horizontally and vertically, and to place your subject at one of the points where the imaginary horizontal and vertical lines cross.

Elephants in the landscape ▲

The very wide 'letterbox' format of this oil painting is slightly unusual, but it suits the subject perfectly. The focus is very firmly on the line of elephants in the centre of the image, even though they take up perhaps only one-third of the total picture space. Nonetheless, the landscape has been painted in enough detail to tell us a lot about the animals' natural habitat. The sprigs of vegetation in the dusty, sun-bleached foreground provide textural interest and break up the large expanse of light-coloured earth, while the dark background trees counterbalance the brightness of the foreground and help to direct the attention back down to the animals.

Panda 'portrait' ◄
In contrast, this sketch includes relatively little of the habitat – only some foreground vegetation, with the background reduced to an impressionistic blur of colour. This is more of an animal 'portrait' than a wildlife landscape – the intention was to concentrate on the animal rather than the setting, and consequently the panda occupies a larger proportion of the overall image.

Finally, you should find some way of directing the viewer's eye to the subject. This can be either a pathway in the form of a track or river, or an imaginary one that leads the viewer's eye in a curve or a series of diagonal lines through to the main subject.

One of the best ways to learn about composition is to look at paintings by other artists – both old masters and contemporaries. Go to an art gallery or study the fine art books in your local library, particularly the great landscape paintings of artists such as John Constable (1776–1837) or J.M.W. Turner (1775–1851). Analyse the composition and make your own mind up about what does or does not work.

A 'wildlife landscape' is, as the title suggests, a landscape with wildlife in it. But it really isn't as simple as that.

When deciding on your composition, think about where the animal or animals will work best. Don't overcrowd the painting by including too many animals – less may be more.

If you have already painted the landscape and are wondering where best to place your subject, it can be a good idea to do an outline sketch and then cut it out and move it around your painting to see where it will work best. Usually, if you put the animal right in the centre of a landscape painting it may look too contrived. Try and lay it naturally into the setting and this will help your composition. This also allows you to check the animal is in scale with the setting.

When you're painting large animals in a setting, think about how much detail you need to include. An animal in

the foreground should be painted in more detail than one in the distance. This is something to beware of if you're working from a reference photo: if your photo is a close-up, you may well be able to see a lot of detail – but if you're altering the composition and placing the animal in the middle distance or the background, you need to reduce the amount of detail, as you would see very little detail in real life at this distance.

Take note, too, of the perspective of your photograph. If you are looking slightly down on the animal, perhaps from high up from an open vehicle, you will not be able to use the photos as reference for an animal in the distance, which would be viewed from eye level. Remember that everything in your painting has to work from the observer's viewpoint.

The same points about composition apply when you are drawing or painting small animals – but with one major difference: small animals are more likely to be the main subject of the drawing or painting than the setting.

However, the setting is still an important element of the image. Imagine you're making a pencil or watercolour sketch of a dormouse: the dormouse would obviously be the main subject – but on its own it wouldn't make for a very strong picture. But if you include some of the creature's habitat around it – berries or grasses, for example – you place the animal in a recognizable and natural context and the image immediately becomes much more interesting and dynamic.

As with large animals, it's always best to do a rough sketch of your composition first to make sure you've got the balance right. The animal should dominate and the setting should be secondary, which means that you have to think carefully about how much of the picture space to allocate to each.

Because you're painting your subject close up, you also need to pay extra attention to the detail – the texture of the fur on the animal's body, its bright and beady eyes, the individual claws on its limbs – than you would on an animal in a wider landscape.

Whether you choose to portray the setting in the same amount of detail as the main subject or to opt for a looser, more impressionistic approach is entirely up to you. If you opt for fine detail, however, make sure that the setting does not overpower the main subject. If the creature you're painting is surrounded by dense grasses or twigs, for example, you may find that you need to omit some of them to prevent the image from looking overcluttered. You can also reduce the amount of textural detail in the setting as you move from foreground to background, as this will both avoid confusion and create a sense of scale and distance.

If you're taking photos or making sketches of a small animal to use as reference, it's important to get down to the creature's eye level, so that you feel that you are really there with the animal.

Dormouse ▲
This delicate pencil sketch perfectly captures a range of different textures – the soft fur of the dormouse, the hard twigs and the shiny berries. Note how the artist has drawn the sketch from the same eye level as the animal.

The same principles about subject size and placement apply when drawing and painting birds. If you're painting a flock of large birds on the ground, such as birds wading in a lake, or ostriches on the savanna, how much space are you going to devote to the birds and to the surrounding landscape? If they're in flight, how can you use the sky colour to complement them and how might the shape and position of clouds help your composition. It's this attention to detail that will help to make the overall piece look more exciting.

Think, too, about the way light affects the appearance of the birds. Light filtering through wings when they are backlit against the sun, or sunlight glinting off shiny beaks are details that can really bring a bird painting to life.

Barn owl ◀

Here the image of the owl tells us a lot about the bird and its habits and habitat. Barn owls are often seen perched on fence posts in open countryside. Placing the bird near the right-hand side of the picture space, looking outwards in search of its prey, helps to create a feeling of tension. Note how the low viewpoint isolates the bird's head against the dark, brooding sky.

There is a great diversity of marine life. Look at as many photos as you can from underwater photographers and see what works and what doesn't. If you're painting fish from a coral reef, the colours may be so strong and vivid that you find you need to use a palette you have not used before.

Think about how you're going to paint the surrounding water, as well as the marine specimens. It's much more interesting to have shafts of sunlight dancing through the water and across the backs of fish and other marine life, lighting up their colours.

Water is generally seen as quite a difficult thing to paint, although still reflections on the surface – of a lake, perhaps – are basically a mirror reflection with different colours and simple to portray. But where you have reflections on the surface of choppy or rough water you need to study and practise this much more. A fish like a salmon will make some complicated ripples in its wake, as will any fish feeding on the surface of still water. When using watercolour, spatter masking fluid onto the paper for the spray and then remove it to leave the bright highlights of the splashing water. Experiment with different brushes. A large flat soft brush can help you achieve these ripples. Look at all the reflections in front of your subject – not just what made them, but also the sky and everything else.

Swagger perch ▼

The sunlight filtering through from above gives this image a wonderful sense of light and shade and picks up the vibrant orange colour of the fins, while the ripples in the water create a lovely sense of movement.

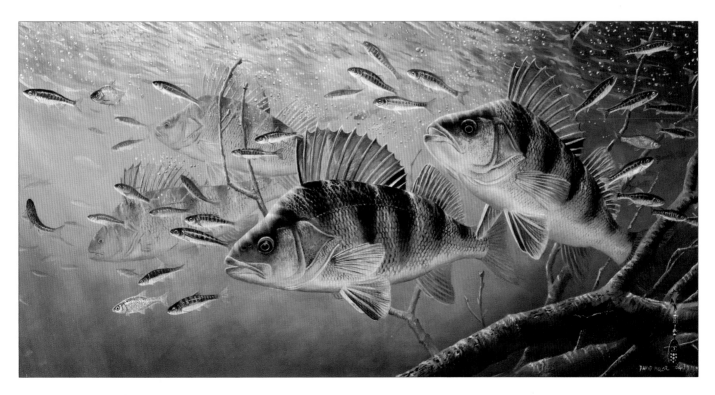

Animal portraits

An animal portrait is all about the animal, even if you include a setting. It differs from a landscape in that everything else should be there to complement the animal and draw the viewer's eye to it.

The first decision that you have to make is how much of the animal to put in – the whole body or just the head. If you opt for just the head, a three-quarter profile with your eye level matching the head height of the animal works well, as this can give more information about the size of its nose, head and so on and give your piece a little more depth. Do a quick sketch first and decide how much of the animal you want to draw. A head shot is better if you include part of the neck. Create a balance: too much body and it'll look like you've cut the feet off, too little and the head will be floating in thin air.

It's also useful to have some directional lighting across the face, as this gives some modelling. Try to include the highlight in the eye as well; not only will this bring the painting to life, but it will also be fun to paint.

Think about the background, too. How much, should you include? You might decide that a little background colour is sufficient, with no suggestion of a setting. In this case, you might paint the background in colours that complement not only the animal but also the décor of the room in which the painting is going to hang. It's also a good idea to include some of the colour from the animal in the background, to unify the painting and bring the whole thing together. A solid, flat application of colour can deaden the effect of the painting as a whole; it's generally better to have a more lively, perhaps slightly mottled background in colours that do not detract from the animal.

Alternatively, you might decide to include some of the animal's habitat. A family pet, for example, could be portrayed in its basket or in a corner of the garden. For a working dog, such as a labrador or a pointer, you could include a wooded setting with a few game birds flying off into the trees.

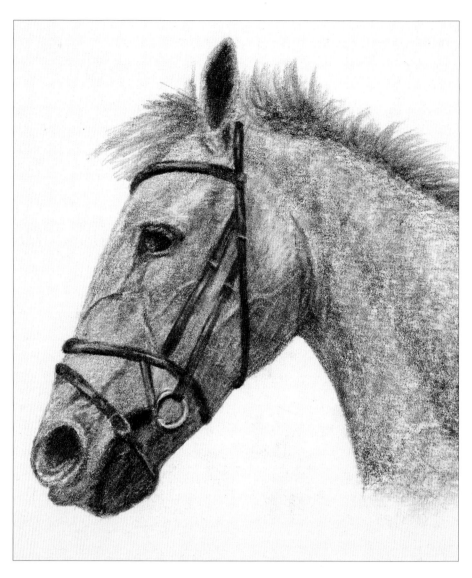

Horse's head ▲

A side view is often a good choice for a horse portrait as it allows you to study the shape of the head in detail. This pencil study is full of textural detail, from the veins on the head to the wispy mane and soft coat.

If it's a wild animal such as a gorilla or a panda, you could show it surrounded by the vegetation on which it feeds.

Whatever you choose, think carefully about how much detail to include. Too much detail could make the painting look cluttered. So how much of the picture space should you devote to the animal and how much to the background? In a portrait, the animal must dominate – taking up, say, two-thirds to three-quarters of the picture space. If the setting is deemed to be important, then the animal might only take up one-third of the picture.

Finally, if you've been commissioned to do a pet portrait, it's a good idea to discuss exactly what is required with the person who is commissioning you. Find out as much as you can about what they want the painting to show before you start work; this will go a long way towards avoiding any potential arguments when you deliver the finished piece. Agree a fee and the dimensions of the painting in advance. Be sure to show your client the photos you're planning to work from. They know the animal well and will know if your photos capture its character.

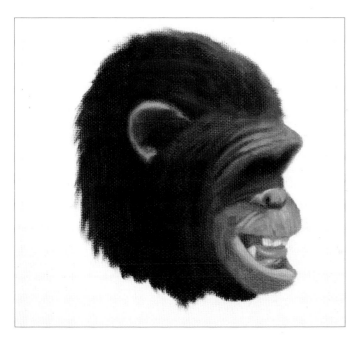

Facial expression ◄

Although one should be very wary of attributing human emotions to animals, many species – particularly primates – are capable of a wide range of facial expressions. Capturing such expressions in a portrait painting can convey a lot about the animal's mood and character. Although the eyes in this portrait of a young chimp are largely overshadowed by the overhanging forehead, the mouth is fairly wide open in a characteristic 'grin' that denotes excitement.

Dog portrait ▼

This dog's alert 'pose' is something that its owner would instantly recognize as being characteristic of the animal. Including just a hint of the garden in the background helps to make the sketch more personal to the owner, without detracting from the portrait of the dog.

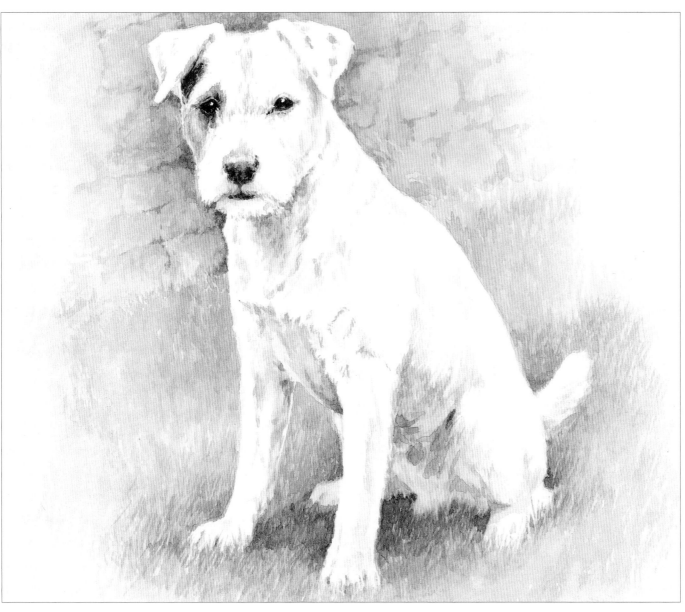

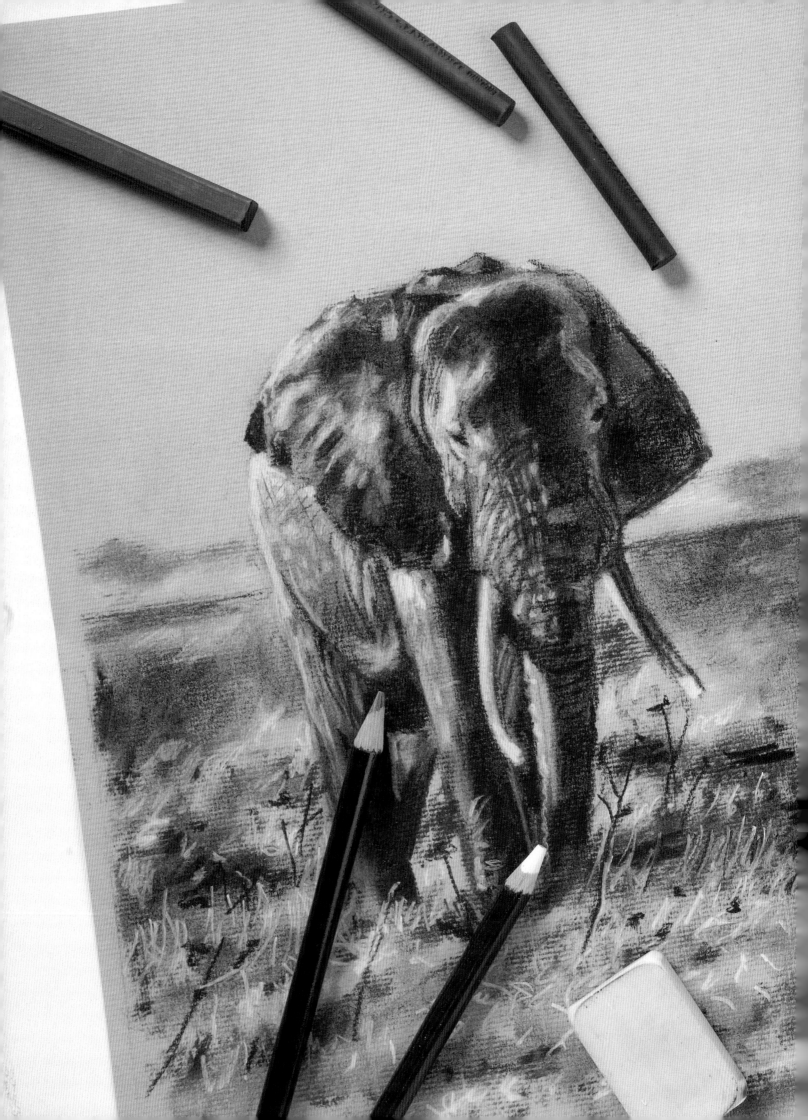

Animals

This chapter begins with a gallery of contemporary animal drawings and paintings by professional artists. Study them carefully and think about the composition and the techniques the artists used to achieve their objectives. You will undoubtedly discover things that you can apply in your own work.

Then there is a series of quick sketches. It's impossible to overemphasize the importance of regular practice, and quick sketches that you can make whenever you've got a few minutes to spare are the perfect way to do this. This is a great way of training your eye and sharpening your powers of observation.

Finally, there are fourteen detailed step-by-step projects in all the main mediums, the subjects ranging from much-loved family pets to a wild lion and an Amazonian tree frog. Even if they're in a different medium to the one you normally work in, take the time to read through them carefully. They're all painted by professional artists with many years' experience, so you'll find that they're packed with useful tips about collecting reference material, capturing the character of an animal and getting the right balance between your subject and its environment.

Gallery

This section features a selection of animal drawings and paintings by professional wildlife artists and natural-history illustrators working in different media and styles. They range from loose and very spontaneous-looking pen-and-ink and pencil drawings to incredibly detailed watercolours and oil paintings that capture the texture of the animal's fur to perfection. Study the images carefully, and try to analyse what the artist has done. Think about the composition. Why is the subject placed in a particular part of the picture space, for example? Why might the artist have decided not to paint the whole animal?

Then try to work out how you might approach a similar subject. Would you opt for a close-up of the animal's head or would you want to paint the creature's natural habitat? How much of the surroundings would you include? Where would you choose to position the animal in the picture space? Some artists have an almost photo-realistic style, using very precise, fine brushstrokes, whereas others opt for more stylized illustrations. The approach you use is entirely down to personal preference but, even if a particular style does not appeal to you, you may well learn something that you can adapt and apply in your own work. The time that you spend looking at other artists' work is never time wasted.

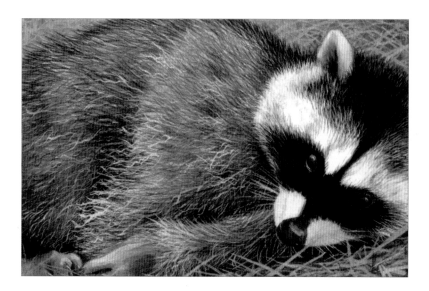

Racoon – Tracy Hall ▲

This painting measures only 9 x 6.5 cm (3½ x 2½ inches), but the detail is exquisite. Using a very fine, almost dry brush and a limited palette of colours, the artist has painstakingly built up the texture in the racoon's fur and the spiky grass on which it is lying. The composition is bold: many artists might have been tempted to include the whole animal and more of the surroundings, but cropping out the racoon's left ear and the top of its back makes this a much more striking and intimate animal portrait. Note that when it is lying down, the animal's head is on a slight diagonal: this angle helps to create a more dynamic picture than a straight, head-on view.

Leopard – David Stribbling ▶

Like the racoon painting (above), this is a beautifully detailed animal portrait. Oil paints are a wonderful medium for painting a subject such as this, as the soft, buttery consistency makes it possible to blend colours with ease to create subtle tonal shifts – a technique the artist has exploited to the full here in painting the leopard's fur. The composition is classic, with the key points of the portrait – the ears, nose and far eye – falling on the intersection of the thirds. Another classic compositional device used here is the use of a strong diagonal line – the animal's neck and head; this runs from top left to bottom right and helps to lead the viewer's eye through the image. The background foliage is soft and diffuse, so as not to detract from the leopard. The grey rock on which the animal is lying is painted in muted colours that complement the beautiful markings of the fur.

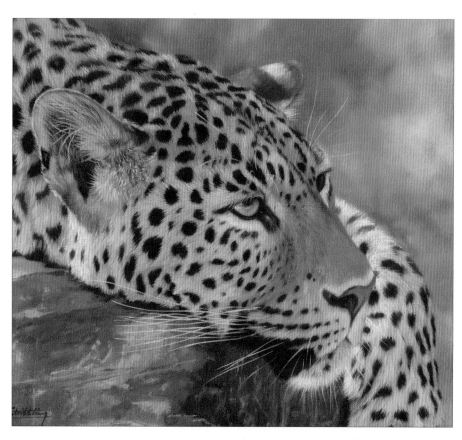

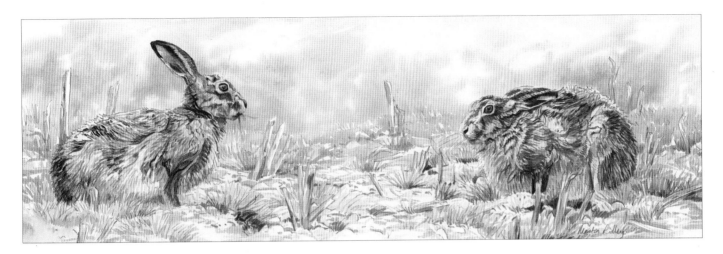

Brown hares and kale stems – Martin Ridley ▲
This watercolour is painted in quite a loose style, with the background behind the hares being little more than an impressionistic blur of very dilute burnt sienna. Nonetheless, there is a surprising amount of textural detail – particularly in the animals' coats, with the different tones being picked out in deft strokes of burnt umber, burnt sienna, and mixes of

these two colours with a little ultramarine blue. Note, too, how the white of the paper has been left to stand for the lightest parts of the animals' fur. The low eye level helps to draw us into the scene, as we see it from the animals' viewpoint. The letterbox format of the composition is unusual but effective, and one well worth experimenting with for subjects such as this.

Shire horse – Jonathan Latimer ▶
This deceptively simple-looking painting of a brewery drayhorse, done in pencil and acrylic paints, captures the animal's build and strength beautifully. The three-quarter viewpoint allows the artist to show the power of the neck and shoulder muscles; a straight, head-on viewpoint would have placed the emphasis on the facial features, relegating the neck and shoulders to the background. The relatively low viewpoint, looking up at the horse's head, also emphasizes its height. The artist could have chosen to include more of the horse's day-to-day environment – the dray that it normally pulls, for example, or the yard of the brewery – but the harness and blinkers are enough to tell us immediately that this is a working animal.

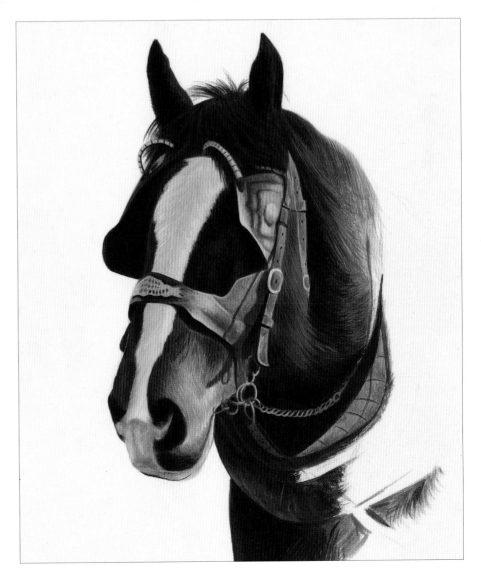

▶

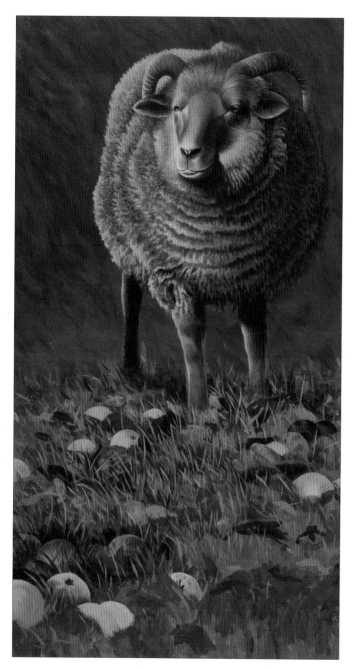

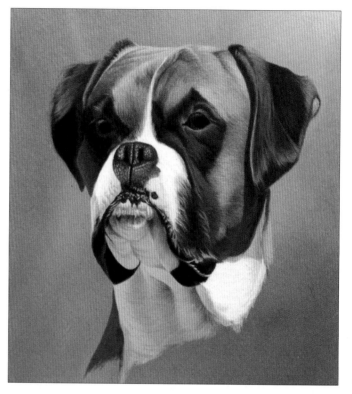

***Boxer dog* – Jonathan Latimer** ▲
This very traditional-style portrait is a vignette of a much-loved family pet, showing the head and chunky neck of the animal rather than the whole body – a good way of depicting the animal's character and expression. The artist has chosen to paint a three-quarter profile, with his eye level matching the head height of the dog. This provides a more interesting and dynamic image than a head-on viewpoint. Note how well the artist has captured the texture of the smooth, silky fur: the different tones reveal the form of the head.

***Portland sheep and windfalls* – Jonathan Latimer** ▲
Both the composition and format of this acrylic painting are a little unusual, but sometimes breaking with convention can pay dividends. Here, the picture space is divided vertically into two almost equal parts, with the bottom half of the image being devoted to the fallen apples on the grass and the top half to the main subject, the sheep with its beautifully curved horns and curly coat. The grass and apples in the immediate foreground are painted as soft blurs of colour, which helps to create a sense of scale and distance. The vertical letterbox format is perhaps more often used for tall subjects such as trees or buildings, but here it enhances the unusual composition. Had the sheep been placed in the very centre of the image, with an equal amount of space above and below it, the picture would have looked very static and the apples would have been a less important part of the overall painting.

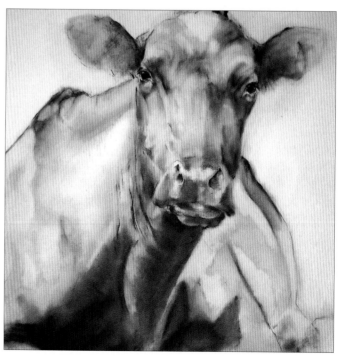

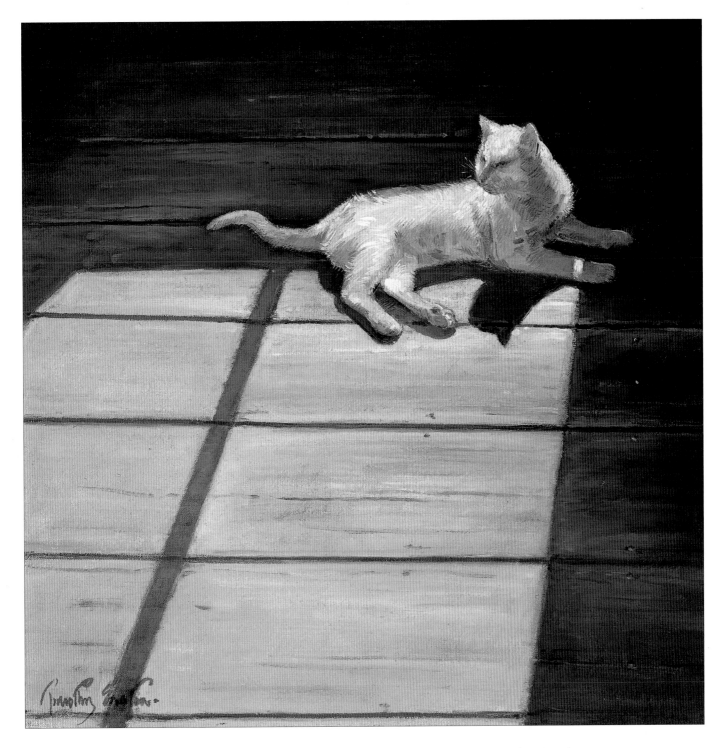

Cow – Pat Ellacott ◄

In this characterful sketch, made using pastels on oiled paper, the artist has blended the pastel marks with her fingertips to create not only delicate, almost watercolour-like transitions of tone but also the texture of the animal's coat. Although we do not see the whole animal, its bulk and weight are immediately apparent. Note how the top of the cow's head is very close to the edge of the picture space; there is also a strong diagonal line running through the picture, from the dark shadow under the chest (bottom left) up to the tip of the left ear (top right). Both these factors make for a dynamic composition.

Studio window reflected – Timothy Easton ▲

Anyone who owns a cat will recognize this as a typical cat pose. Although the cat occupies only a small part of the space, there is no doubt that it is the focal point of the image. The artist has used the patch of sunlight reflected from his studio window on to the floor as a means of directing the viewer's attention toward the cat. Both the overall window shape and the shadow of the glazing bar are at a slight angle, which adds interest to what might otherwise be a very static scene. The very bright sunlight has bleached out some of the detail in the white fur, but note the number of different tones within it: pale pinks, greys and even browns are all visible.

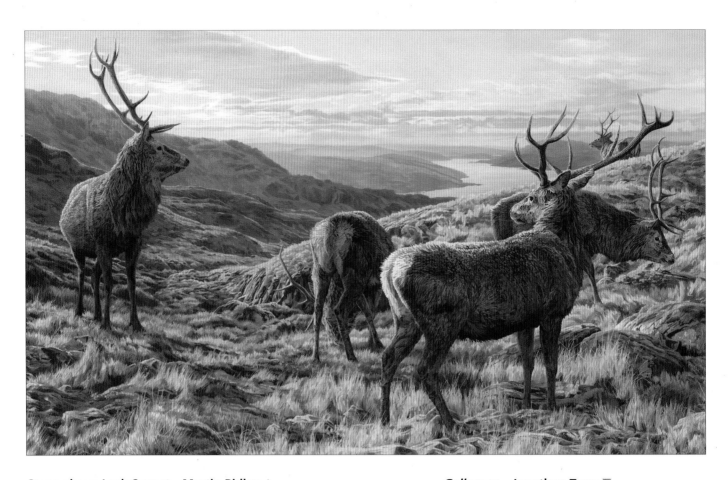

Stags above Loch Sunart – Martin Ridley ▲

Painted in the Scottish Highlands, this modern oil painting harks back in style to the romantic landscapes of the nineteenth century. The viewpoint, from behind the deer, makes the viewer feel as if he or she has just stumbled across the scene by chance. This is a beautiful example of a wildlife landscape: the animals and rugged terrain balance one another perfectly. The colours – the browns, purples and yellows of the landscape, the soft pinks and blues of the distant loch and sky, the rich browns and ochres of the stags – give the scene a warm glow that is very appealing.

Gallopers – Jonathan Truss ▼

This oil painting of zebras galloping across the plain has a wonderful sense of motion. Note, in particular, how well the artist has observed the powerful leg and shoulder muscles under tension. The angles of the heads and legs, too, show that the zebras are moving quickly, and the dust being kicked up by the animals' hooves also contributes to the feeling of movement.

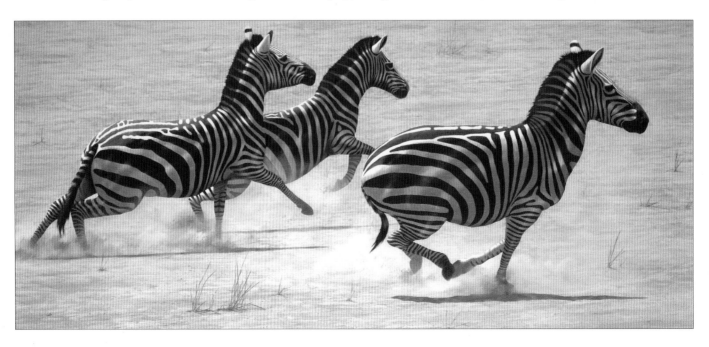

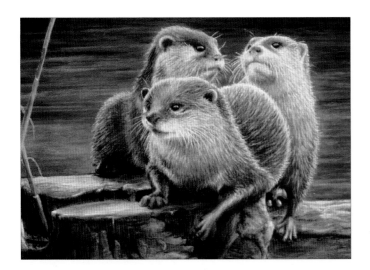

Young otters – **Tracy Hall** ◄
Measuring just 7.5 x 5cm (3 x 2in), this miniature watercolour painting captures the inquisitive nature of this group of young otters beautifully. The artist has included just enough of the surroundings to set the animals in their natural habitat, without drawing attention away from them. The composition is apparently very simple and uncontrived, but it has been carefully planned. As with human portraits, a group of three makes for a more interesting composition than just two animals. Here, two animals are peering over the back of the third; when the group is viewed as an overall shape, they form a circle which helps to lead the viewer's eye around the image. The foreground log provides a strong base, the solidity of which counterbalances the loose wet-into-wet washes of the water in the background.

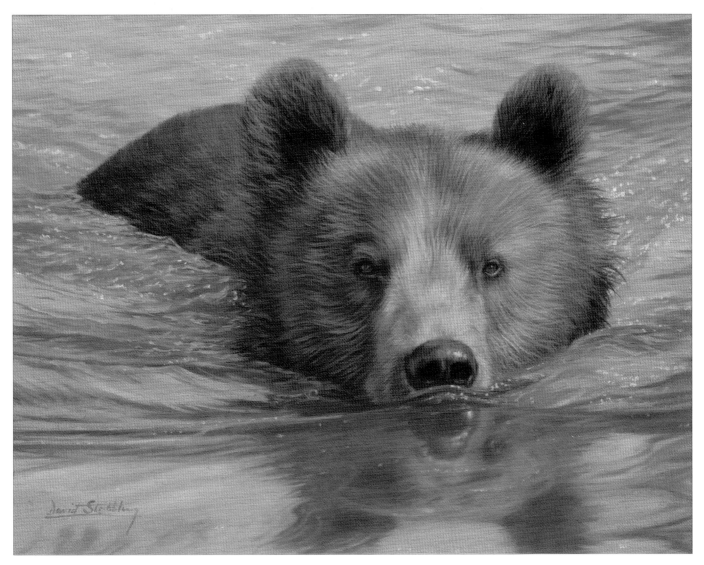

Bear – **David Stribbling** ▲
Painting animals in motion is often more to do with the way the movement of the animal affects the surroundings rather than with the movement of the animals limbs. Here, the brown bear's legs and powerful shoulders are completely hidden from view, but the motion of the ripples in the water clearly show that the bear is swimming. Note how well the artist has given the water a sense of form: dark tones indicate the side of a ripple that is in shadow while light tones are used for the side of a ripple that catches the sunlight. Note also the smooth water in front of the bear: the reflection is virtually unbroken.

Quick sketches: Zoo leopard

Whatever your views on the morality of keeping animals in zoos, it certainly gives you the opportunity to study at first hand animals that are extremely difficult to get close to in the wild. Just like domestic cats, big cats spend a lot of their time drowsing or sleeping, which is the perfect time to sketch them. Even in this situation, however, you need to convey a sense of their strength and power – so think about the skeleton underneath the fur and about where the largest muscle groups are situated. And as in any portrait, human or animal, the eyes are vital in conveying the character.

When you're drawing fur or hair, look at the direction in which it grows and make sure your pen or pencil marks run in the same direction. Think about the quality of the fur and alter your marks accordingly: are the hairs small and tightly compacted, as on the top of the animal's head, or longer and farther apart, as around the bridge of the nose? Remember that you do not need to put in every single hair: a suggestion is enough, as the viewer's brain will fill in the missing details.

10-minute sketch: soft pastels ▼

Soft pastels are a wonderful medium for portraying the beautiful markings and the soft texture of the fur, as you can overlay one colour on top of another and blend the marks with your fingertips to create subtle optical mixes, while also putting down stronger marks for the dark spots. If you are pushed for time, try sketching just part of the face as a practice exercise, as the artist did here. Note how including just one eye immediately brings the 'portrait' to life.

The 'relaxed pose' of the subject ▼

This apparently relaxed pose, with the leopard draped over the branch of a tree from where it can survey its surroundings, is very characteristic of this large cat – and there's no mistaking the alertness in the eyes or the power of those huge neck muscles and jaws.

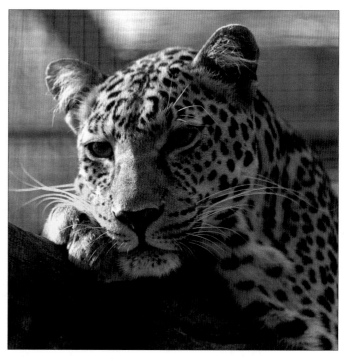

15-minute sketch: pen and ink ▼

This is an exercise in creating the texture of fur using the harsh, linear medium of pen and ink. The sketch is incomplete, which is fine for a quick practice exercise in which you want to concentrate on just one aspect – but note how the artist has put in faint pencil guidelines marking the position and shape of the eyes. Getting the eyes right is critical in any portrait, human or animal.

30-minute sketch: charcoal ▼

Like soft pastels, the powdery medium of charcoal is perfect for rendering the texture of fur. Here, the artist worked on a pale but warm-toned grey pastel paper, so that she could start from a mid tone. A brilliant white paper would have been too stark and unsympathetic. Note how she has captured the shape and form of the animal's skull through her use of shading: the left-hand side of the head and what we can see of the body are in shade, while the left eye is more deeply recessed still. As in the pastel drawing opposite, the artist has blended the charcoal marks with her finger or a torchon to create the softness of the fur, adding dark scribbles on top for the actual markings.

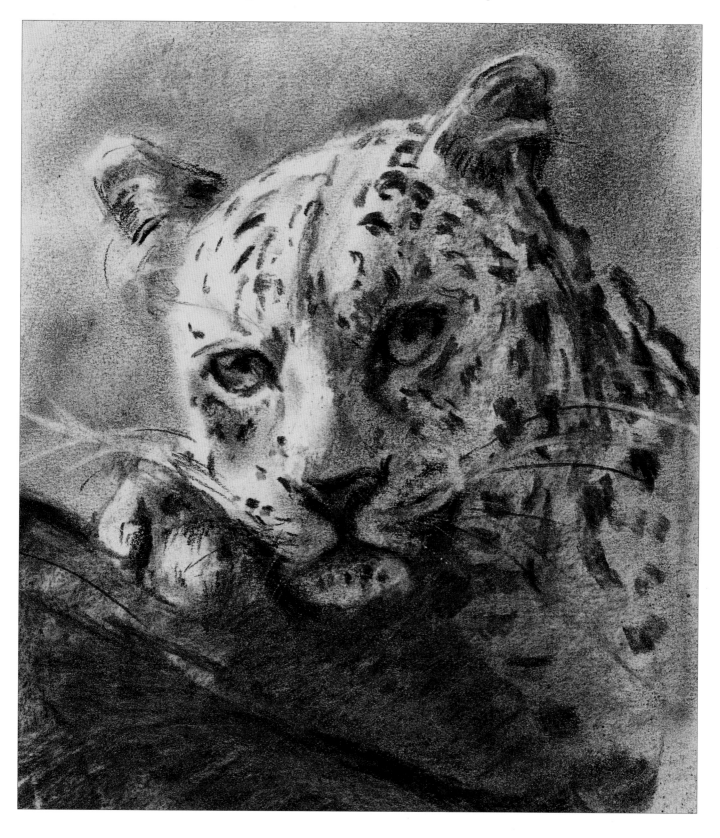

Quick sketches: Baboons in the wild

It's harder to make quick sketches of animals in the wild than in a domestic or zoo setting – largely because wild animals are wary and it can be difficult to get close enough. However, if you're at all serious about being a wildlife artist, then it's something that you really should attempt. Remember, you're not aiming to create a finished work to hang on your wall. The purpose is to improve your powers of observation and force you to think about what's essential in a scene, and to put down enough visual information to work up in more detail later. Making sketches is a lesson in looking, in training your hand and eye to work together.

Set yourself small, attainable targets to begin with. Select a relatively large animal that you can comfortably observe from some distance away, without disturbing it. Watch the animal for a while before you begin sketching, and take measurements using your pencil to work out the size of the body, the length of the legs in relation to the body and so on. If the animal is moving around, see if you can discern a repeating pattern in the movement.

Then set yourself short time limits for each sketch – perhaps just 10 or 15 minutes. It's surprising how tiring it can be to really concentrate and look hard at a subject. Choose a monochrome medium that you feel comfortable and confident with and begin making your first sketches. Start by making small marks to establish the extremities of the subject. Then look for strong lines, such as the arch of a back, the curve of a

10-minute sketch: charcoal ▶
The artist began by setting down the outline of the animals, taking care to make the baby the right size in relation to the mother. He then blocked in the different tones, using the side of the charcoal stick to cover the paper quickly and varying the amount of pressure to create the mid and dark tones. Note how the texture of the paper contributes to the overall effect. A few spiky marks were sufficient to imply grasses in the foreground.

tail, or the angle of the legs. Then think about where the light and dark tones occur. Only near the end should you put in any textural detailing.

Above all, keep looking at your subject: you should spend as much time looking as you do drawing. If you just take a quick glance at the animal and spend the rest of the time looking down at your paper, you'll be sketching from memory, which will do nothing to help your powers of observation.

The scene
This baboon mother and baby were some distance from the artist and completely unconcerned by his presence, so he was able to make a number of quick but reasonably detailed sketches. Although the mother was moving across the grass, she was in no hurry, so the artist had plenty of time to observe the animals and decide which elements to emphasize in his sketches.

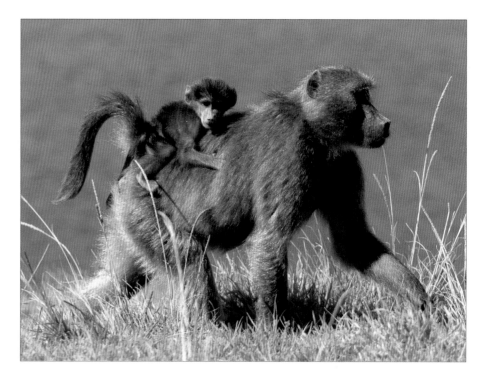

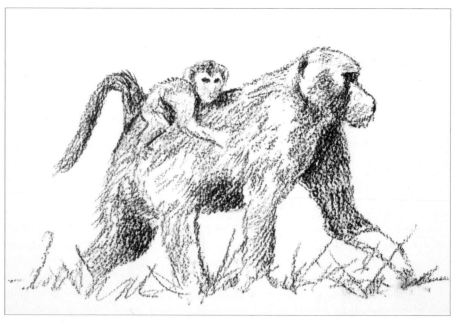

15-minute sketch: graphite pencil ▶
This sketch was done using a 4B pencil. The artist took a little longer this time, so that he could develop more texture within the fur. The large areas of tone on the mother's body were blocked in using the side of the pencil, varying the pressure to create the mid and dark tones. Note how some areas of the paper have been left white, for the highlights. Short pencil marks around the edges of the animals' backs and heads, made using the tip of the pencil, create a more spiky texture.

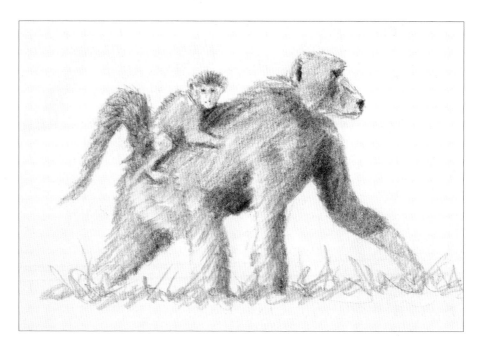

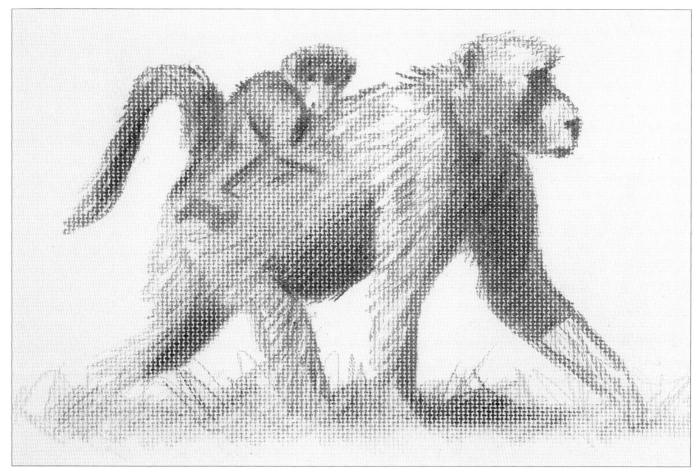

15–20 minute sketch: coloured pencil ▲
In this sketch, the artist used just two colours of pencil – a brown and a dark green. The exact colour isn't too important with such a quick sketch, although you could make colour notes in the correct tones on the same pad – but do observe the tones carefully to create a sense of light and shade, and the form of the animals. As in the graphite pencil sketch, the pencil strokes follow the direction in which the fur grows, and gaps were left for the highlights. Note how some green has been used on the underside of the mother's body, as some colour is reflected up from the grasses. Note, too, the strong shadow cast by the mother on the ground below: seemingly small details such as this really help to anchor the subject and make it look more solid and three-dimensional.

Tabby cat in watercolour

Cat fur is fascinating to paint and you will find a huge variety of markings, from tortoiseshell and tabby cats with their bold stripes to sleek, chocolate-point Siamese and long-haired Maine Coons. The key to painting fur is being able to blend colours in a very subtle way, without harsh edges. Even pure white or black cats, with no obvious markings, have their own 'patterns': because of reflected light and shadows, the fur of a pure white cat will exhibit clear differences in tone which you need to convey in your paintings.

Fur markings also reveal a lot about the shape of the animal. You need to look at an animal's fur in much the same way as a portrait painter looks at how fabrics drape over the body of a model: changes in tone and in the direction of the fur markings indicate the shape and contours of the body underneath. Always think about the basic anatomy of your subject, otherwise the painting will not look convincing. If you concentrate on the outline shape when you are painting a long-haired cat, for example, you could end up with something that looks like a ball of fluff with eyes, rather than a living animal. The cat in this project has relatively short hair, which makes it easier to see the underlying shape.

Cats seem to spend a lot of their time sleeping or simply sprawled out, soaking up the sunlight and, if you are lucky, you might have time to make a quick watercolour sketch. For 'action' pictures – kittens batting their paws at a toy or adult cats jumping from a wall or stalking a bird in the garden – you will almost certainly have to work from a photographic reference.

Materials
• *HB pencil*
• *140lb (300gsm) rough watercolour paper, pre-stretched*
• *Watercolour paints: yellow ochre, raw umber, alizarin crimson, ultramarine blue, cadmium red, Prussian blue, burnt sienna*
• *Gouache paints: Chinese white*
• *Brushes: medium round, fine round*

The subject
This is a typical cat pose – the animal is relaxed and sprawled out, but at the same time very alert to whatever is happening around it. The markings on the fur are subtly coloured but attractive. The face is full of character, and this is what you need to concentrate on in your painting. If you can get the facial features to look right, you are well on the way to creating a successful portrait.

A plain background allows you to concentrate on the subject.

The eyes, the most important part of the portrait, are wide open and alert.

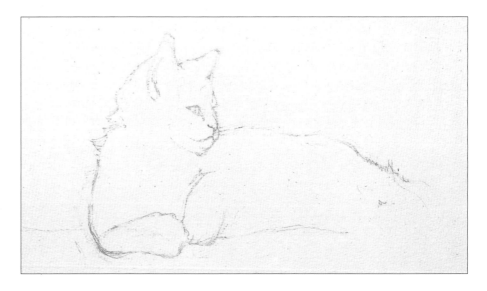

1 Using an HB pencil sketch the cat, making sure you get the angle of the head right in relation to the rest of the body. Start with the facial features, sketching the triangle formed by the eyes and nose, then work outwards. This makes it easier to position the features in relation to each other. If you draw the outline of the head first, and then try to fit in the facial features, the chances are that you will make the head too small.

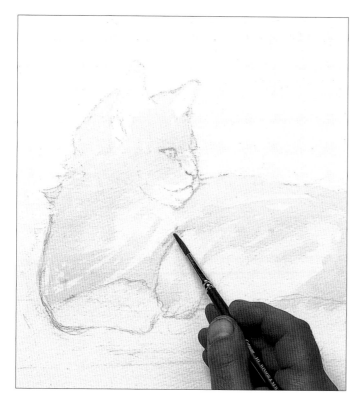

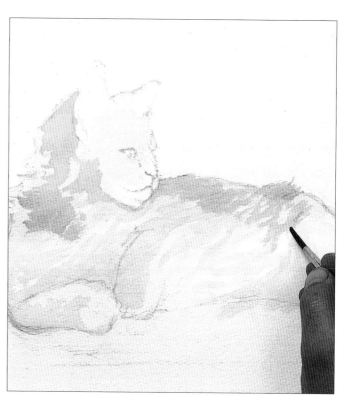

2 Mix a pale wash of a warm brown from yellow ochre and raw umber. Using a medium round brush, wash the mixture over the cat leaving the palest areas, such as the insides of the ears and the very light markings, untouched.

3 Add a little more raw umber to the mixture to make a darker brown and paint the darker areas on the back of the head and back.

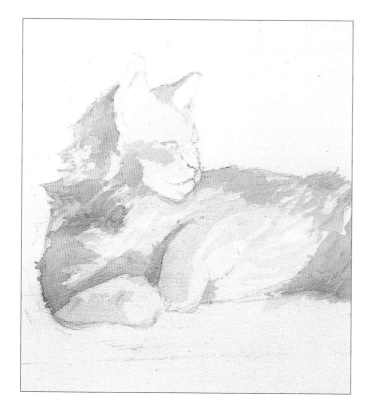

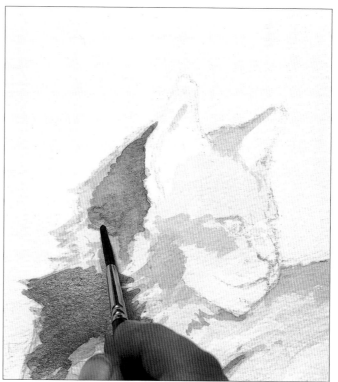

4 Continue applying the darker brown mixture, which gives the second tone. You are now beginning to establish a sense of form in the portrait.

5 Add a little alizarin crimson and ultramarine blue to the mixture to make a dark, neutral grey. Begin brushing in some of the darker areas around the head.

▶

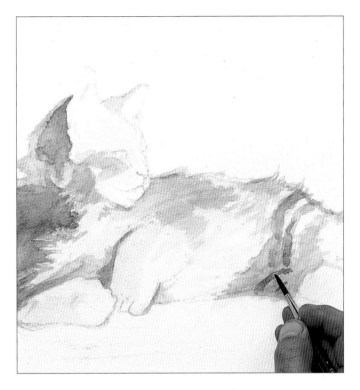

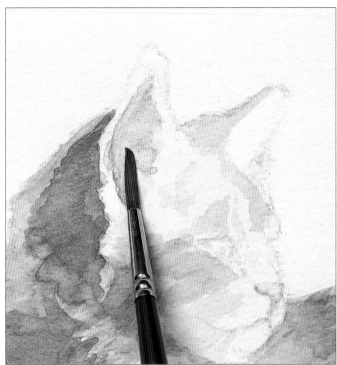

6 Add more water to the mixture and paint the cat's back, which is less shaded. Start painting some of the markings on the hind quarters, using short, spiky brushstrokes along the top of the cat's back. This indicates that the fur does not lie completely flat.

7 Mix a warm brown from yellow ochre and raw umber and brush it loosely over the mid-toned areas. Mix a warm pink from alizarin crimson and a little yellow ochre and, using a fine round brush, paint the insides of the ears, the pads of the paws, and the tip of the nose.

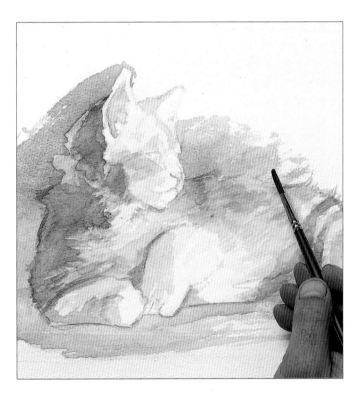

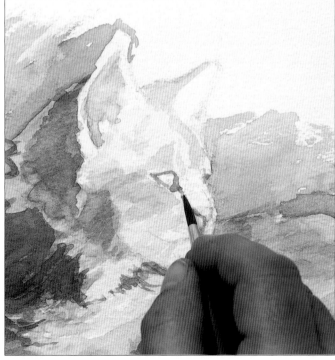

8 Mix a warm maroon colour from cadmium red, yellow ochre and alizarin crimson and paint the surface on which the cat is lying. Add ultramarine blue to darken the mixture and paint the background, carefully brushing around the cat.

9 Mix a purplish blue from ultramarine blue and cadmium red. Using a fine round brush, paint the dark fur on the side of the cat's head, the nostril, the area under the chin and the outline of the eye.

Assessment time

Although the broad outline of the cat is there, along with some indication of the markings on the fur, the painting does not yet look convincing because the body looks flat rather than rounded. In addition, the cat's head is merging into the warm colour of the background, when it needs to stand out much more clearly.

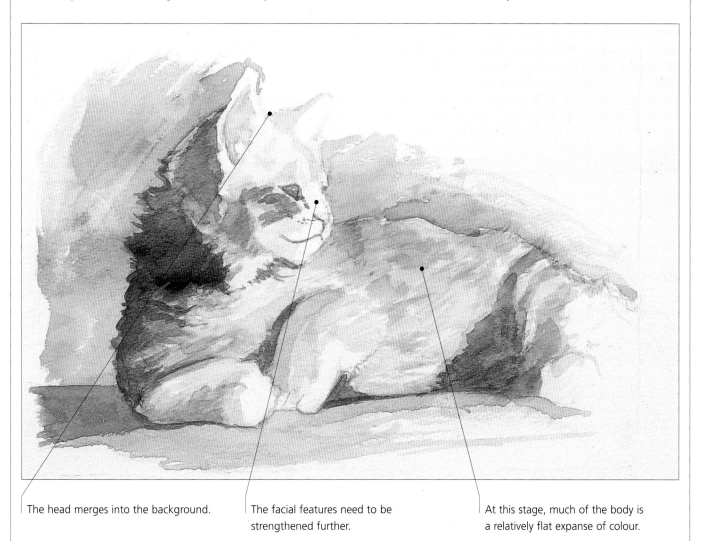

The head merges into the background.

The facial features need to be strengthened further.

At this stage, much of the body is a relatively flat expanse of colour.

10 Mix a greenish black from Prussian blue, burnt sienna and cadmium red and paint the pupil of the eye, leaving a white highlight. Brush more of the purplish-blue mixture used in Step 9 on to the shaded left-hand side of the cat and strengthen the shadow under the chin and on the back of the cat's head.

Tip: Pay careful attention to the highlight in the cat's eye. The shape and size of the white area must be accurate in order to look lifelike.

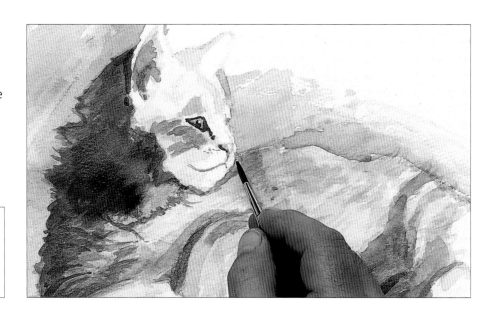

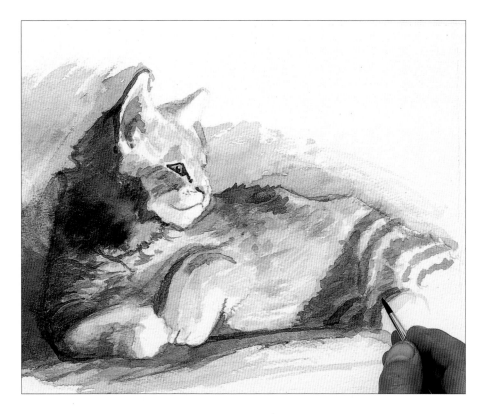

11 Using the same purplish-blue mixture, put in some of the stripes on the hind quarters and darken the tones on the back, paying careful attention to the direction of the brushstrokes so that the markings follow the contours of the body.

12 Using the same mixture, continue darkening the tones on the back to give a better sense of form.

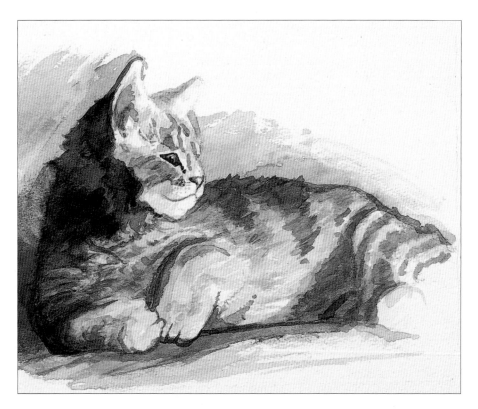

13 Adjust the tones where necessary. Now that you have put in lots of darks, you may need to tone down some of the bright areas that have been left unpainted by applying a very dilute wash of the first pale brown tone.

14 Darken the insides of the ears with alizarin crimson. Using a very fine brush and Chinese white gouache, paint the whiskers.

The finished painting

This is a lively and engaging study of a favourite family pet. All portraits, whether they are of humans or animals, need to convey the character of the subject. The artist has achieved this here by placing the main focus of interest on the cat's face and its alert expression. The fur is softly painted, with careful blends of colour, but the markings are clearly depicted.

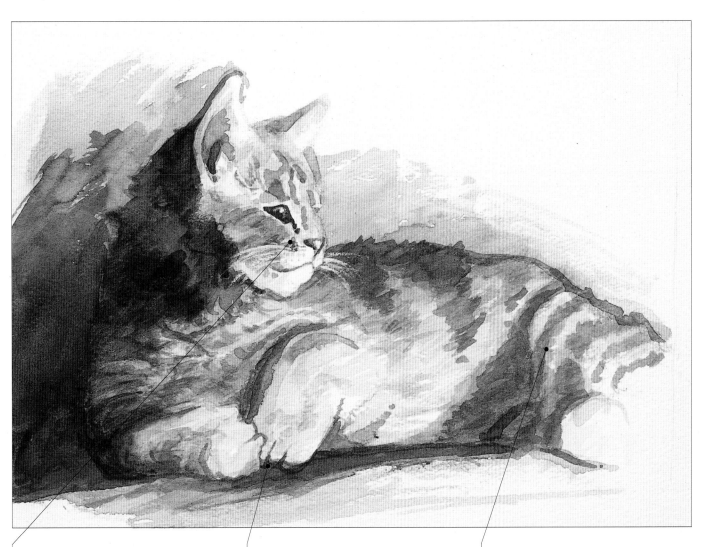

The facial features are crisply painted.

Deep shadow between the paws helps to create a sense of depth in the painting.

The markings change direction, following the contours of the body beneath.

Sleeping cat in gouache

It is lovely to be able to put your painting skills to good use to paint a portrait of a cherished family pet. Because you know your animal so well, you will easily be able to find a pose that sums up its character, and a painting like this would make a wonderful gift for another family member. Here, the artist combined a quick snapshot of the sleeping animal with a background of brightly coloured leaves from his garden.

There are several ways to approach painting fur. In a water-based medium such as acrylic, you might choose to apply loose, impressionistic washes of colour wet into wet, so that the paint blends on the support to create subtle transitions from one tone to another, perhaps lifting off colour with clean water to create lighter-toned areas. In this project, we build up the colour in thin glazes, gradually darkening the shaded areas until the right density is achieved, with each layer of paint being allowed to dry before the next one is applied. Use short brushstrokes that follow the direction in which the fur grows, and an almost dry and very fine brush. This creates the impression of individual strands of hair and is an effective way of conveying the texture of the fur.

The project also gives you the chance to practise masking. Because you need to mask out large areas in the early stages of the painting, use masking (frisket) film rather than tape or fluid. Masking film is available from most good art supply stores. To ensure that the film adheres firmly to the support and that no paint can seep under the edges, choose a smooth surface, such as illustration board.

Materials
- *Illustration board*
- *Masking (frisket) film*
- *Craft (utility) knife*
- *Gouache paints: cadmium yellow deep, flame red, burnt sienna, Vandyke brown, indigo, permanent white*
- *Brushes: medium round, fine round*

The subject
The artist used this photograph as reference material for the cat's 'pose' and for the colour and texture of its fur. However, the striped wallpaper does not make a very exciting or an attractive background.

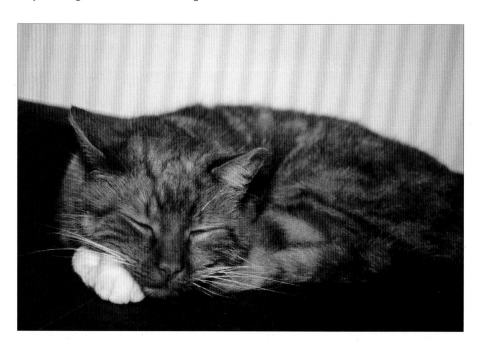

The background
Using this photograph of garden leaves provided a colourful and natural-looking background against which to position the cat.

Compositional sketch ▼

When you are combining two or more references in a painting, you must give some thought to the relative scale of the different elements. Make a quick sketch, in colour or in black and white, before you begin painting.

Tonal sketch ▼

This cat is predominantly ginger in colour, but there are many different tones within the fur. Making a tonal sketch in pencil or charcoal enables you to work out not only the different tones but also the composition of your painting.

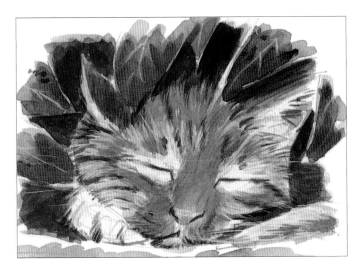

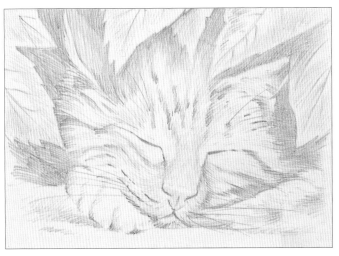

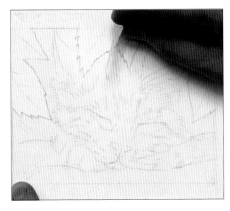

1 Referring to your initial sketch, lightly draw the cat using an HB pencil, indicating the main clumps of fur. Draw the veins on the leaves. Place masking (frisket) film over the sketch and, using a craft (utility) knife, cut around the outline of the cat. Peel away the masking film that covers the leaves.

Tip: The last thing you want is for paint to seep under the masking film on to the area of the painting that you are trying to protect. Working in one direction only, wipe a clean tissue or soft rag over the film to smooth out any wrinkles and ensure that the film is stuck down firmly. It is best to work towards the cut edges of the film.

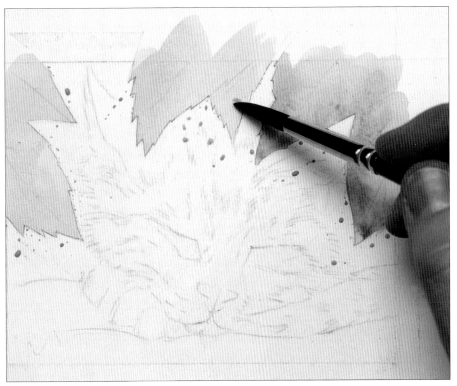

2 Using a medium round brush, brush cadmium yellow deep gouache paint over all the leaves to establish the underlying colour. While the paint is still wet, rinse your brush in clean water and drop flame red over the tips of the leaves. The two colours will combine wet into wet to make a warm orange, creating soft-edged transitions of colour. It is important that you leave the paint to dry completely before you move on to the next stage; like watercolour, gouache paint dries very quickly, so this should only take a minute or two, but if you want to speed up the drying time, you can use a hairdryer on a warm setting. Hold the dryer well away from your painting so that you do not accidentally blow the red paint away from the tips and into the centre of the leaves.

▶

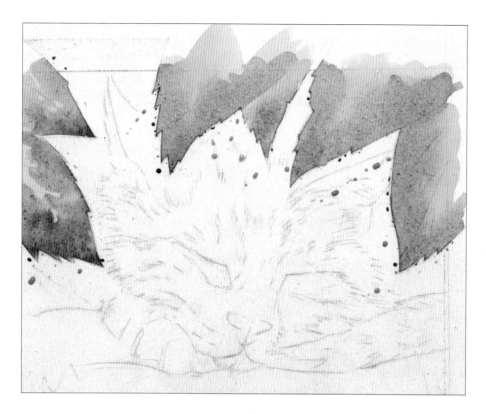

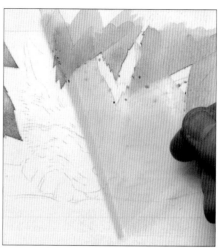

4 When you are sure that the paint is completely dry, carefully peel the masking film back from the cat. You can see how the leaves have crisp edges: it is easy to achieve this using a mask.

3 As you can see, the yellow and red merge together on the support in a way that looks completely natural. It does not matter if the colour is darker in some parts of the leaves than in others.

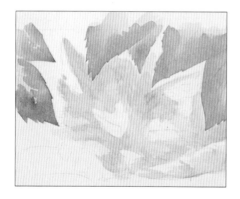

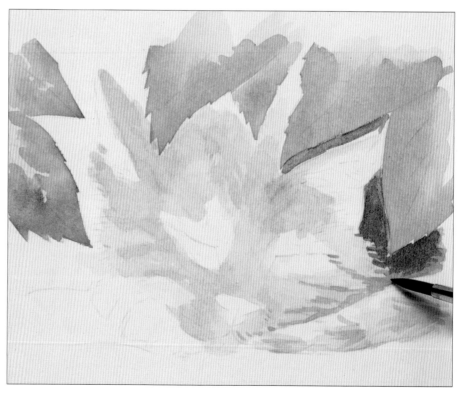

5 Mix a warm, yellowish brown from cadmium yellow deep and burnt sienna. Using the medium round brush, brush this mixture over the cat, leaving the white fur untouched. Your brushstrokes should follow the direction in which the fur grows. Leave to dry.

Tip: If you are worried about accidentally splashing colour on to the leaves when you paint the cat, cover them with the masking film that you removed in Step 1.

6 Mix a rich, chestnut brown from burnt sienna and Vandyke brown. Using a fine round brush, put in the dark fur on the cat's face, again using short brushstrokes that follow the direction in which the fur grows. Mix a darker brown from Vandyke brown and indigo and paint the dark fur around the edges of the ears.

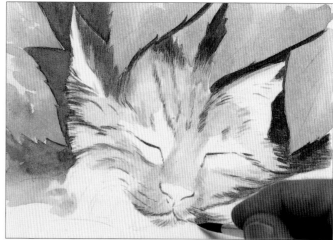

7 Use the same colour to paint the dark spaces between the leaves, so that the individual leaves stand out clearly.

8 Using Vandyke brown and the tip of the brush, start putting in the dark brown markings on the cat's face.

Assessment time

Brush a dilute version of the cadmium yellow deep and burnt sienna mixture used in Step 5 over the non-white areas of the cat's face to warm up the tones overall.

The painting is starting to take shape but more detail is needed to bring out the roundness of the face and the texture of the fur.

The fur contains little texture.

The cat merges with the background; the leaves do not yet look like leaves.

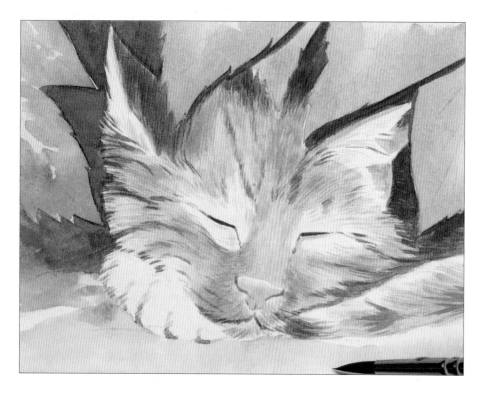

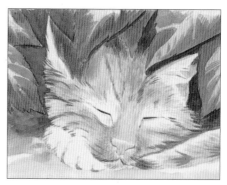

10 Mix flame red with a little cadmium yellow deep. Using a medium round brush, brush this colour over the leaves, allowing some of the original pale yellow colour to show through as the veins in the leaves.

9 Mix a very pale pink from flame red and permanent white and brush it on to the tips of the ears, which are slightly pink, and the tip of the nose. Using the Vandyke brown and indigo mixture from Step 6, put in the dark spaces between the claws. Add more water to the mixture. Brush clean water over the foreground and dot the indigo and Vandyke brown mixture into it.

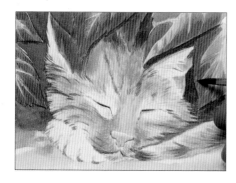

11 Using the same mixture, build up the intensity of the red, taking care not to go over the veins.

Tip: Remember that gouache looks slightly darker when it is dry than it does when it is wet, so wait until the paint is dry and assess its colour before you add another layer. It is better to build up the density of colour gradually: if you make the leaves too dark, they will overpower the cat, which is the main focus of the painting.

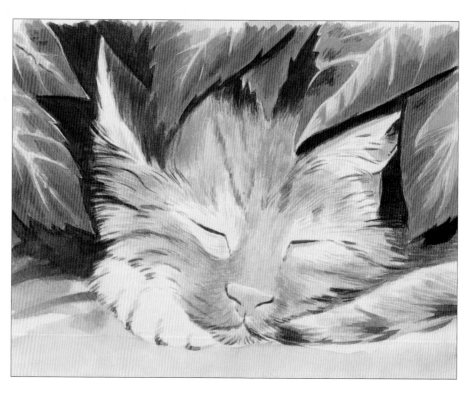

12 Using the indigo and Vandyke brown mixture, deepen the colour of the leaves. Note that the edges of the leaves are slightly serrated; use a fine brush to paint the serrations. Use the same colour to darken the very dark fur markings and the outlines of the mouth and nose.

The finished painting

This is a slightly whimsical but very appealing painting of a cherished family pet in a characteristic 'pose'. The leafy background provides a colourful foil for the animal and focuses attention on its face, while delicate brushwork captures the texture of the fur. Here, the artist has used white gouache and a very fine brush to put in the whiskers and more fur texture in the final stages. It is up to you how much detail you put in: you might choose to build up the tones and textures more than has been done here.

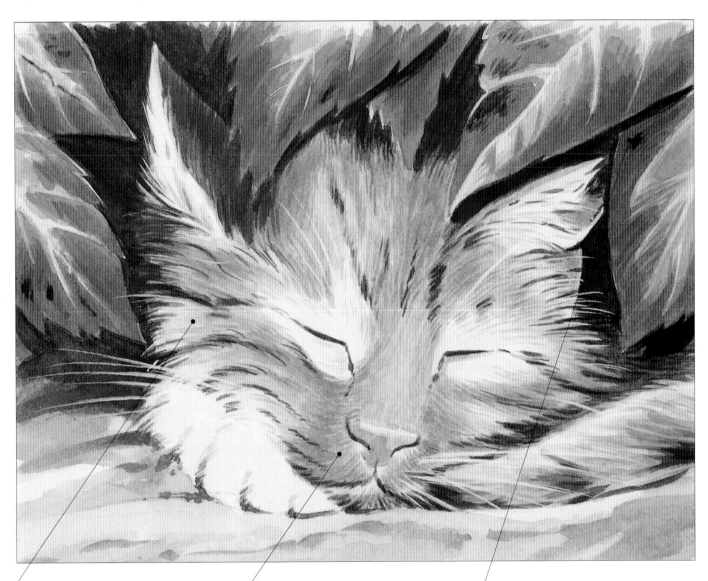

The texture of the fur has been built up gradually, using fine brushstrokes that follow the direction in which the fur grows.

Small details – the pink of the nose and the outline of the mouth – convey the character of the sleeping cat.

The richly coloured, textured autumn leaves provide a simple but dramatic backdrop to the portrait.

Old English Sheepdog in pencil

Old English Sheepdogs as a breed are delightful and their faces are full of character. A textural study seems particularly appropriate for this breed, whose whole character is defined by its long, flowing fur. For a short-haired breed such as a Whippet or a Great Dane, a more linear drawing that emphasizes the muscles might be more suitable.

When you're drawing long-haired animals such as this, however, it's very easy to be seduced into concentrating on the wispy, flyaway fur and to forget about the bone structure of the animal underneath. Always start by establishing the underlying structure, then add the decorative and textural detail on top. Start by drawing prominent features such as the eyes, nose, mouth and any bony protuberances near the surface. Once you've got their shape, size and position right, the rest will follow much more easily.

When drawing any kind of portrait, be it human or animal, it is a good idea to begin by positioning the facial features. Think of the eyes and nose as an inverted triangle: establish the outer point of each, as this will make it easier to get the rest of the features in the right place. If you start by drawing the outline of the head, you may find that you haven't left enough space to fit in the features.

In a monochrome drawing, you also have to think carefully about tone. Monochrome might seem ideal for an animal whose coat consists almost entirely of white and grey tones, but a very common beginner's mistake is to make the greys too light: consequently, the whole image can appear to be lacking in contrast. Reassess the tones continually, and be prepared to adjust them as you work and to darken the dark areas in order for the light tones to sparkle and shine through.

Materials
- *Smooth drawing paper*
- *Graphite pencils: HB, 6B*
- *Torchon*
- *Plastic eraser*

The subject

When you're drawing an animal (or a person, for that matter) always look for a characteristic pose or expression. The lolling pink tongue is typical of this breed of dog and gives the animal a quizzical, slightly comical expression that is very appealing. You can't rely on animals to stay still for long, however, so (unless you're an experienced artist and can draw quickly) you'll probably find it easiest to work from a reference photograph.

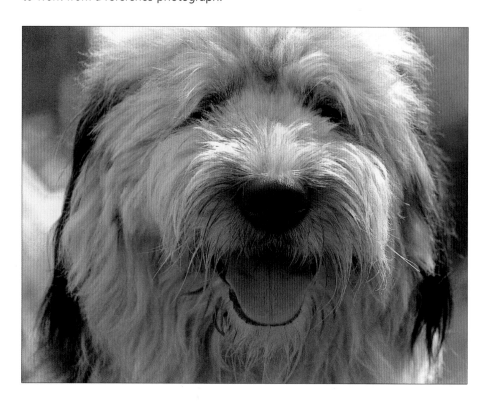

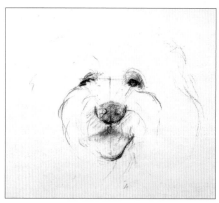

1 Using an HB pencil, lightly sketch your subject. Start with the facial features, as once you get these right, the rest will follow relatively easily. Note that the eyes and nose form an inverted triangle and begin by putting down the outer points of each as a guide. Roughly shade the eyes, nose and tongue, and indicate the direction in which the fur grows around the head.

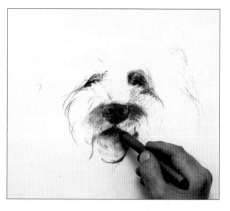

2 Using a 6B pencil, darken the nose and the sockets of the eyes. Note that, because the dog's head is turned ever so slightly to one side, one eye appears to be fractionally larger than the other. Use a torchon to blend the graphite on the nose and tongue to get a smooth, soft coverage. Also use the torchon as a drawing tool to apply some tone to the fur around the nose.

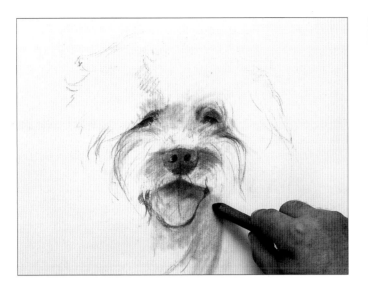

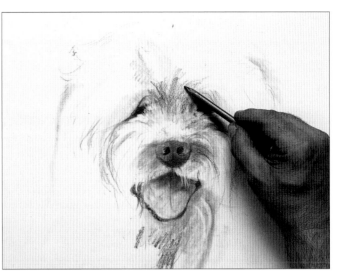

3 Again using the 6B pencil, draw the mouth (which can just be glimpsed around the tongue) more clearly. As in the previous step, use the torchon as a drawing tool to apply some tone to the fur on the dog's face and body. Your strokes should follow the direction in which the fur grows.

4 Loosely define the outer limits of the fur around the head to give yourself a boundary towards which to work. Using a 6B pencil, put in the darkest areas of fur on the dog's face, always making sure your pencil strokes follow the direction in which the fur grows.

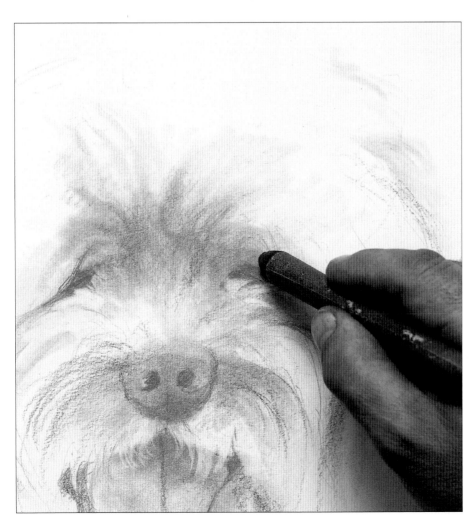

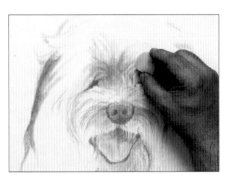

6 Using the edge of a plastic eraser, wipe off fine lines of graphite to create the white hairs around the eyes. (It is easier to wipe off white details than to apply dark tones around them.)

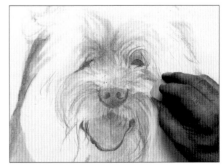

5 Blend the graphite marks with a torchon to create smooth areas of tone between the eyes and on the face.

7 Using an HB pencil, draw more mid-toned hairs around the mouth. Wipe the eraser across the dog's face above the mouth to create the lighter-toned fur in this part of the face.

▶

Assessment time

The sheepdog's eyes, nose and mouth areas are prominent points that establish the structure of the dog's skull; the surrounding shaggy fur, by comparison, can be regarded as little more than decorative detail. For the rest of the drawing, concentrate on looking at the tones within the fur. Your shading in this area will convey the colour of the fur and also, because of the way the fur falls, imply the bony structure of the skull underneath.

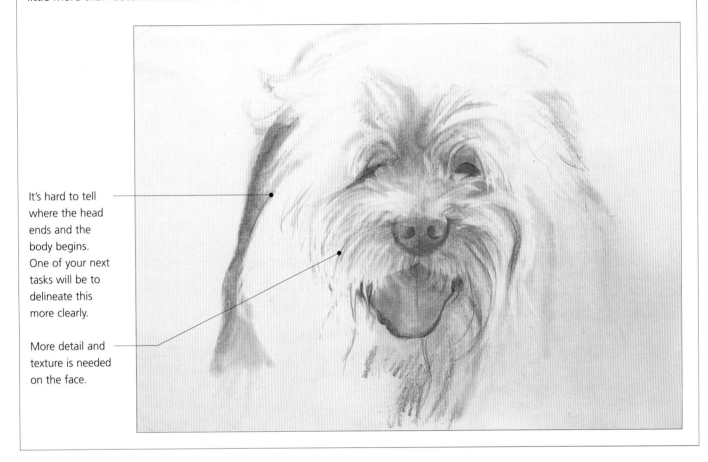

It's hard to tell where the head ends and the body begins. One of your next tasks will be to delineate this more clearly.

More detail and texture is needed on the face.

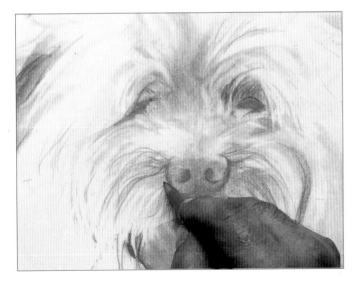

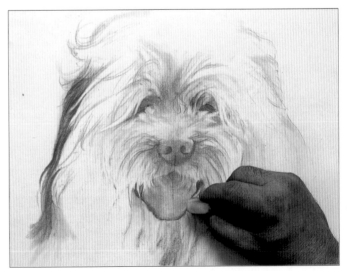

8 Now you can complete the textural detail of the fur. Using an HB pencil with a fine point, draw more individual wispy hairs – particularly around the nose and eyes. Beware of applying too much detail to the body; this would detract from the head, which is the most important part of the drawing.

9 Using a 6B pencil, reinforce the dark line on the left-hand side to try to make it clearer where the head ends. Assess the drawing as a whole and readjust tones by blending graphite with a torchon or lifting out tone with an eraser wherever you judge it to be necessary.

The finished drawing

This is a charming study of a well-loved family pet, and an interesting exercise in texture. The texture of the fur is created through a combination of softly blended pencil marks and more linear strokes for individual hairs on the face. The fact that the dog is looking directly at us immediately engages us in the portrait.

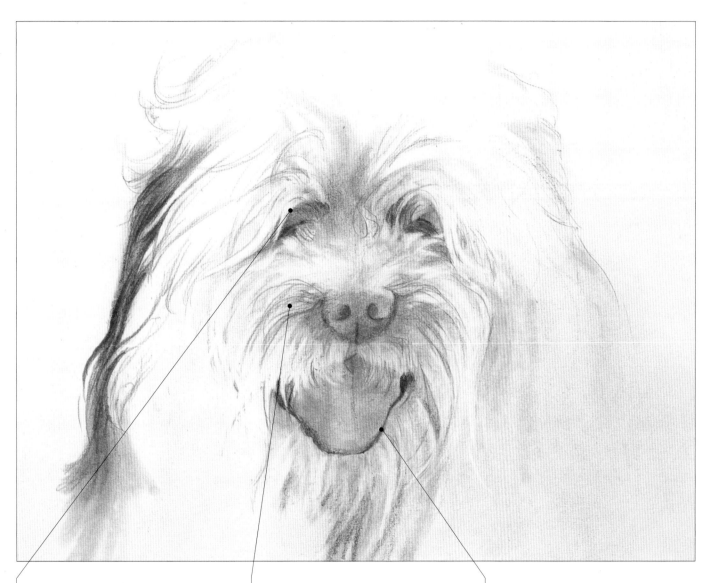

The eye socket has depth; it appears as a rounded form rather than a flat circle on the surface of the face.

The texture of the fur is created through a combination of marks blended with a torchon and individual linear strokes.

The dark line of the lower lip helps to make the lolling tongue stand out more clearly in the drawing.

Dog in acrylics

It's difficult to capture animals in motion and, particularly if you're a beginner, you will almost certainly have to work from a photograph. However, an 'action' painting of a much-loved family pet is a great way of capturing the animal's character – perhaps even more so than a conventional portrait, which can sometimes look rather static.

Start by taking as many reference photos as you can, so that you've got plenty to choose from, and use a fast shutter speed to freeze the action. It's incredibly difficult to capture exactly the right moment in a stills photo and it's surprising how much difference a slight change to the angle of the head or the twist of the body can make. You know your pet better than anyone, so you'll know when you've got something that looks 'right' for that particular animal.

Make sure that the setting does not dominate the painting. If you're painting a dog chasing a stick, for example, an open field or a beach would be a better setting than a forest, where the trees might distract from the main subject. The same applies to an indoor scene: if you want to paint a kitten chasing a ball across the floor, a plain background such as a painted wall or a varnished wooden floor will work better than a highly patterned wallpaper or carpet. Feel free to alter the background, or even omit it.

In this demonstration, the artist opted for a fairly loose painting in order to create a feeling of spontaneity and to capture the energy of the scene. You might prefer a more photo-realistic rendition, making very fine brush strokes to create more detail; however, your approach – analysing the tones on the animal to create a rounded form and observing the fall of light very carefully – should remain the same.

Materials
- *Primed board*
- *Black Conté pencil*
- *Acrylic paints: light blue violet, alizarin crimson, yellow ochre, cadmium red, titanium white*
- *Brushes: large filbert, small round*

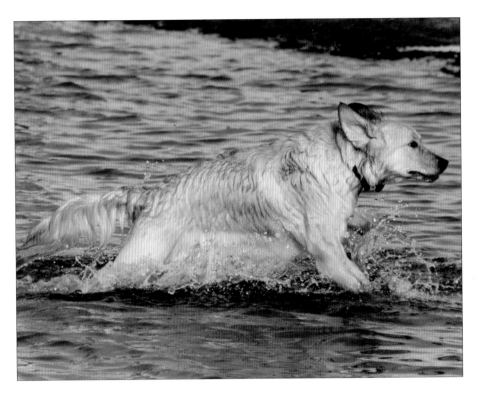

The subject
Here, the artist managed to capture the dog in mid-stride; the raised left foreleg and the ripples and splashes of water impart a lovely sense of movement to the scene. The water provides an interesting backdrop without detracting from the animal, while the use of complementary colours – the blue of the water and the orange-brown of the dog's shaggy coat – also adds to the dynamism of the picture.

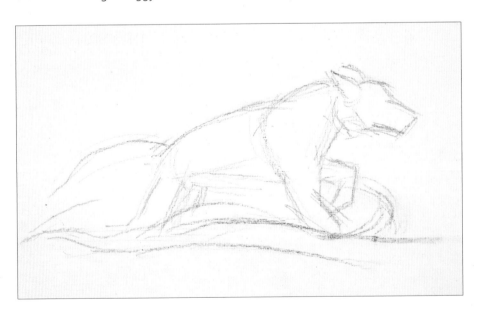

1 Using a black Conté pencil, lightly sketch the scene. Try to see the dog as a series of geometric shapes, so that you get a sense of the rounded form of the animal – the body and muzzle, for example, can be seen as cylinders. As you work, look at how different features align and use these as points of reference: for example, the base of the tail is almost directly over the front of the right hind leg, and the base of the right ear lines up with the raised right foreleg.

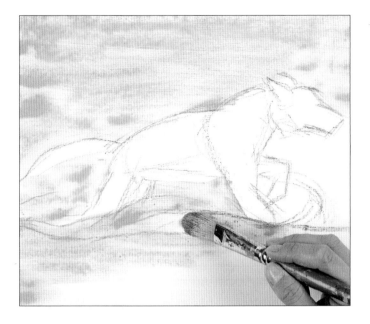

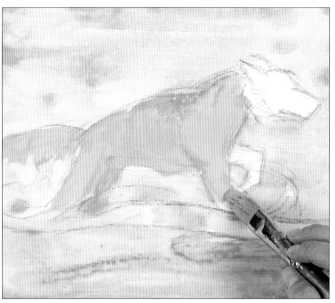

2 Mix a soft blue from light blue violet and a little alizarin crimson, using plenty of water to keep the mix very wet. Using a large filbert brush, block in the background. Use horizontal strokes to echo the ripples in the water and aim for quite a patchy coverage to allow some of the white of the board to show through for the highlights.

3 For the base colour of the dog's fur, mix an orangey-brown from yellow ochre, cadmium red and a little titanium white. Brush this over the dog, making directional strokes that follow the direction in which the hair grows so that you begin to establish a sense of form, even at this early stage in the painting.

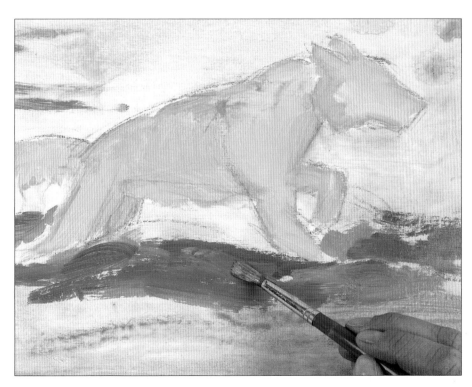

4 Mix a darker, thicker blue from light blue violet, alizarin crimson and a little yellow ochre and, using a small round brush, begin putting in some of the darker areas and ripples in the water – particularly where the dog's body casts a shadow on the water. Make sure your brushstrokes run in the same direction as the ripples. Vary the proportions of the colours in the mix, depending on whether you need a cooler blue (add more yellow ochre to 'green' the mix) or a warmer blue (add more alizarin crimson).

5 Continue putting in the ripples in the water, paying attention to the different tones – they are not all a uniform blue. For the lighter areas behind the dog, which catch more of the sunlight, mix light blue violet with titanium white.

▶

6 Once you've established the mid tones, you can start adding lighter and darker tones to create some modelling. Add a lot more titanium white to the orangey-brown from Step 3, to create a paler mix, and begin putting in the highlights on the dog's coat.

7 Continue building up the dog's fur, adding more cadmium red, yellow ochre and a tiny bit of ultramarine blue for the richer mid tones, which are a rusty brown. Use a very dry mix and 'feather' your brushstrokes to suggest some texture in the fur.

8 Using the same mix, put in the dog's reflection in the water, allowing some of the watercolour to show through in places. Note that the dog's reflection is not solid, as it would be in calm water: it is broken up by the ripples in the water.

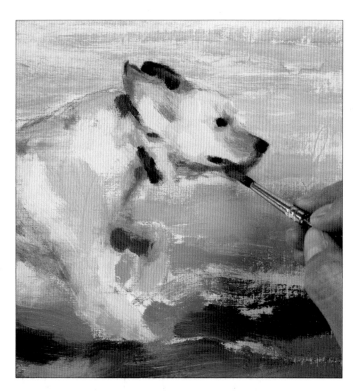

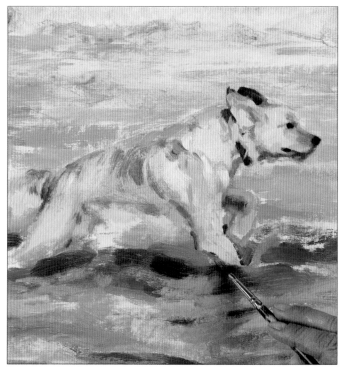

9 Mix a dark, purply-black from ultramarine, cadmium red and a little of the orange-brown mix. Combining colours in this way to make a dark tone gives a more natural result than simply picking out details in black. Using a fine round brush, put in the darks around the dog's head – the eye, nose and mouth, the tips of the ears, around the neck and on the underside of the left foreleg.

10 Using the same mixes as in Step 9, refine the details on the head and body. Mix a dark blue from ultramarine and light blue violet and use it to define the edges of the dog.

Tip: Try to look at the negative shapes – the spaces between the dog's legs, for example – rather than at the dog itself.

Assessment time

All the main elements of the painting are in place and, from this point onwards, you can concentrate on making relatively minor adjustments to build up the modelling and texture on the dog and create more of a sense of movement. However, it's important to remember that this is intended to be a fresh, spontaneous-looking image that captures a sense of fun and energy; if you overwork one area, you may find that it's too detailed and fussy in comparison with the rest. So take the time to really think about any changes you may need to make.

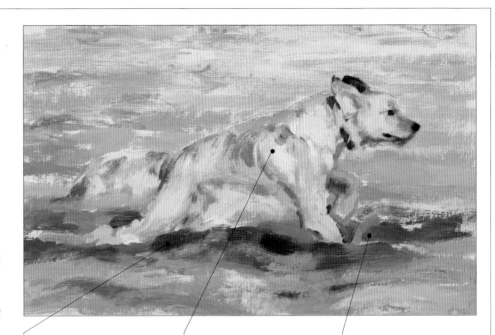

The shadows under the dog are too pale and insubstantial.

More texture and modelling are needed in the dog's fur – use dry brushwork to build up the texture and assess the differences in tone carefully to create more of a sense of form.

The water looks as if it is merely gently rippling; add more highlights and sparkling droplets to create more of a sense of movement.

11 Mix titanium white with a little light blue violet. Using a combination of very light strokes that barely touch the paper and tiny dots, apply this colour to create the impression of water splashes and sunlight sparkling on the water. Do not make the paint too thick, or the water splashes will dominate the painting.

12 Mix a thick, dark blue from ultramarine blue and alizarin crimson and, using a small round brush, darken the shadow that the dog's body casts on the surface of the water.

13 Using a lighter version of the pale blue mix from Step 4, go back to touching in the bands of mid tone in the water, using short, curving horizontal strokes to create a sense of movement. Use the same colour to dot in more light highlights and create 'trails' of water droplets dripping from the dog's body.

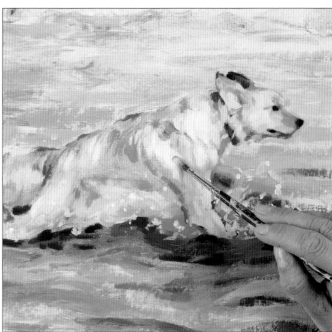

14 Refine the shapes of the dog's reflection, using a slightly wetter mix than before. Remember to look at the tones carefully – there are darker and lighter patches within the reflection, so add more cadmium red for the darker areas and more white for the lighter ones.

15 Using the same orange-brown mixes as before, build up more texture and modelling on the dog's fur. Add titanium white to the mix to strengthen the highlights. To create the impression of individual strands of hair, use an almost dry brush and splay the bristles out with your fingertips.

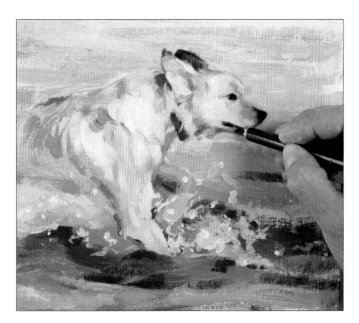

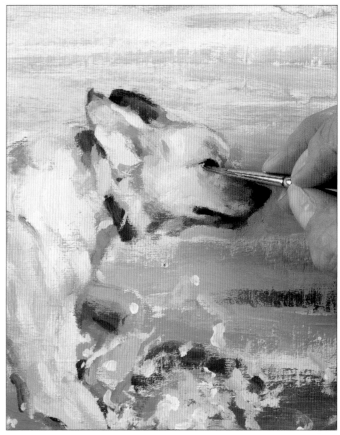

16 Refine the detailing on the head if necessary, making subtle adjustments to the tones to improve the modelling. For areas where you need a really sharp, dark line, such as the mouth and muzzle, use the black Conté pencil.

Tip: Take care not to overwork things at this stage, or to get too lost in intricate detail. You need to keep the overall balance of the painting in your mind throughout.

17 If necessary, dot in the white of the eye to give it a bit of 'life' and sparkle.

The finished painting

Although it is quite loosely painted, this picture has a lovely feeling of spontaneity that suits the subject. The artist has positioned the main subject just to the left of centre, leaving more space in front of the animal than behind it. This suggests the continuing movement of the animal, rather than closing the composition by placing the subject close to the edge of the frame. The dog has been captured mid stride, giving the picture a feeling of great energy and vitality. Although the water makes up a large part of the picture space, the artist has varied the tones and brushstrokes, so that there is enough detail to hold the viewer's interest without detracting from the main subject.

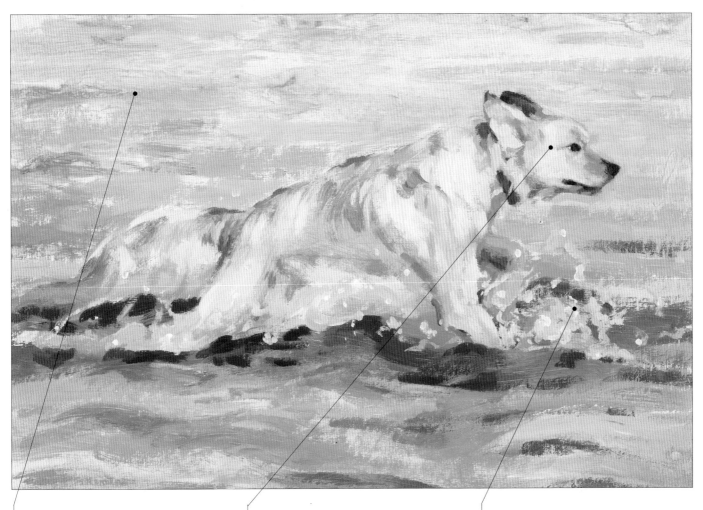

The background water is both paler and less detailed than the foreground, which helps to imply that it is further away.

The different tones on the dog's face and body have been carefully observed, creating good modelling.

The bright splashes convey a feeling of movement, as do the different tones of the ripples in the water.

Rabbit in coloured pencil

Coloured pencil is a wonderful medium for capturing the subtle colour combinations and texture of fur. By overlaying one colour on another you can create shimmering optical mixes that are often far more lively than a colour mixed on a palette. And, because pencils can be sharpened to a fine point, you can draw crisp, fine lines to depict individual hairs.

As in watercolour painting, the white of the paper has to be reserved for the whites and very brightest highlights. This means that you have to use the negative shapes – the spaces around the white elements – in order to define them. Along the edge of the rabbit's back, for example, this entails 'flicking' strokes of the greens and yellows of the background inwards, towards the animal, so that the white spaces in between the green and yellow strokes stand for the white hairs.

The soft, short fur in the ears and muzzle is drawn using a combination of very light short strokes and circular movements to give a smooth finish with no individual pencil marks being visible.

The longer hairs on the rabbit's back require a different treatment. Although they're coarser than the hairs in the ears, this coarseness is purely relative; the fur in this area still needs to look soft to the touch. Use hard strokes for the individual dark hairs, then go over a

Materials
- *Tracing paper (optional)*
- *Smooth illustration board*
- *HB pencil*
- *Coloured pencils: cadmium yellow lemon, lemon, apple green, black soft, burnt sienna, burnt umber, chrome oxide green, brown ochre, pale warm grey, Payne's grey, raw umber, medium flesh colour*
- *Kneaded eraser*

Tip: Keep a small piece of kneaded eraser in your hand so that you can lift the HB pencil marks off the areas that are to be white fur.

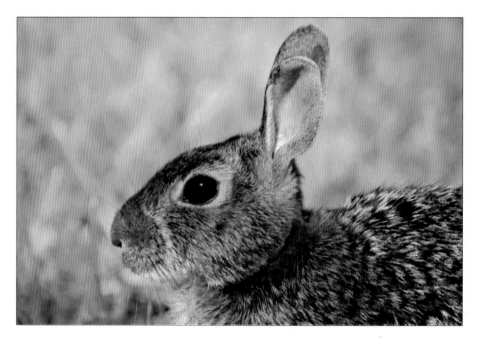

wider area than the initial stroke with the same pencil to blend the colours. This is like applying a wash to give a base colour, as in watercolour – but here the 'glaze' is applied on top of the pencil strokes.

Most importantly, make your pencil strokes follow the contours of the body and run in the direction of hair growth to create a 3-D feel.

The subject
Note the rabbit's different fur textures – the short, velvety fur on the insides of the ears and the longer, rougher fur on the back. The low viewpoint is a good choice for a relatively small subject such as this, as it brings you down to the animal's eye level enabling you to create a small-scale, intimate animal 'portrait'.

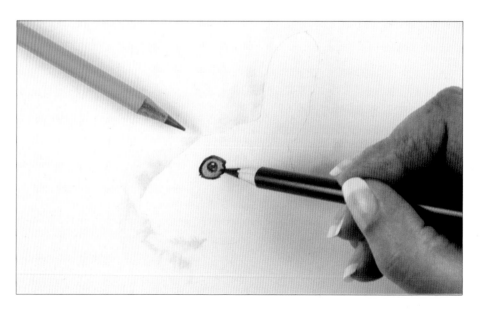

1 Using an HB pencil, trace or draw the outline of the rabbit. Block in the background with very light layers of cadmium yellow lemon, lemon and then apple green, making small, smooth strokes and circular movements of the pencil. Lightly block in the eye, using black soft for the outline and pupil and burnt sienna and burnt umber for the iris. Leave the highlight white.

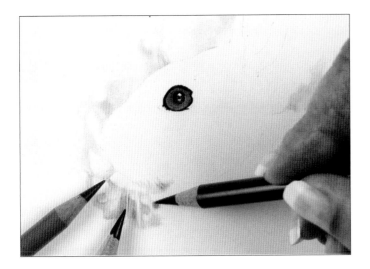

2 Develop the eye further, deepening and blending the burnt sienna and burnt umber together to create a rich brown. Deepen the pupil colour and outline with black soft, ensuring you have a sharp point so that the highlights are crisply defined. Develop the background colour further, introducing chrome oxide green and brown ochre – but remember to leave space for the white whiskers.

> **Tip**: If you need guidance with the shapes of grass in the background, place a piece of tracing paper over your picture and use this as a guide to pick out the dominant shapes.

3 Using an HB pencil, very faintly sketch the areas of pale fur. Apply a light coat of pale warm grey to all except the very palest of these and the eye. As you reach any white areas, let your soft pencil marks soften to nothing so that you do not get harsh edges. Apply a little more pressure in the dark areas of the ears, leaving the paper white in the centre.

> **Tip**: Do not worry if small areas of the white board show through the pale grey – just aim for a base colour.

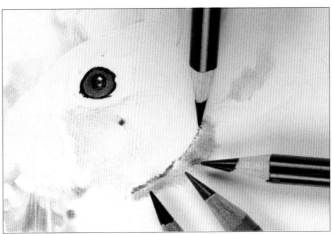

4 Pick out areas of stronger fur colour on the muzzle and cheek in brown ochre. Use close, soft strokes, allowing part of the grey underneath to show through to give the effect of different tones within the fur. Establish the position of any very dark areas, such as the spot just under the eye, with Payne's grey.

> **Tip**: Use the pencil to make strokes in the direction of hair growth, turning the paper as necessary.

5 Apply burnt sienna and then burnt umber over the neck, which is redder in tone, blending with small circular movements for a good coverage of warm colour. In some areas, allow the lighter colours underneath to show through. Use Payne's grey to make tiny, firm strokes into the edges of the white and brown areas, following the direction of the rabbit's fur growth.

▶

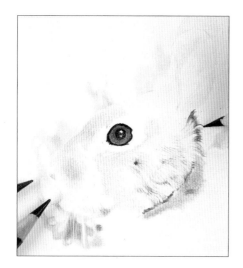

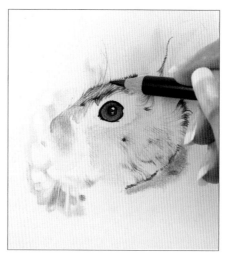

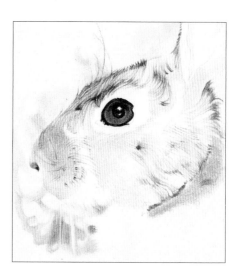

6 Build up the fur on the head, alternating between the three browns (burnt sienna, burnt umber and brown ochre) and using longer stroke marks as the fur gets longer. At the back of the head, start flicking the colour over onto the background to show the individual hairs. At the back of the head, under the ear, fill in between the dark brown lines with Payne's grey.

7 Put in longer strokes of Payne's grey over the eye and soften them afterwards with a light layer of brown ochre. Introduce some very fine black hairs on the top of the head, putting them in more strongly than they actually are. Use small strokes of black soft above the eye to darken that area of fur.

8 Draw in the nostril in Payne's grey, with burnt umber blending into the septum. The white line on the edge of the lip is now more apparent. Soften the muzzle with burnt umber, burnt sienna and brown ochre, optically blending a small area at a time. Use black soft and burnt umber for the whisker follicles. Use longer strokes in burnt umber for the darker hairs on the nose and under the eye.

Assessment time
Working in coloured pencil is a slow, painstaking process, as you gradually build up the layers of colour to the required density. It's always important to work on a picture as a whole, alternating between the subject and the background, so that you maintain the tonal balance of each part in relation to the rest. Although this drawing is still very far from finished, a lot of the basic groundwork has been done: the shape and position of the animal have been established, as have the light, mid and dark tones on the head – although all need to be strengthened further, and the longer, rougher fur on the back is still to be drawn in. As you build up the texture in the fur, the animal will begin to look more three-dimensional.

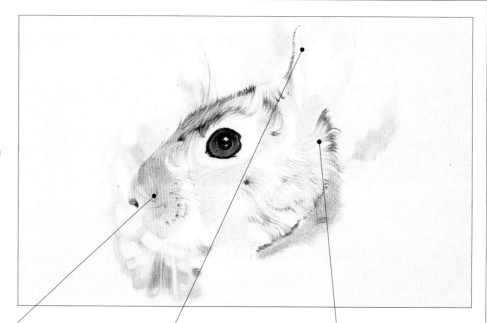

Short pencil strokes on the muzzle, layered and blended to achieve the right colour, create the impression of soft, short, velvety fur.

Only the very lightest tones on the ears have been blocked in; at this stage the colour is barely perceptible, but the artist has laid down a base colour that can be developed further.

Longer pencil strokes on the head are beginning to hint at the texture of the fur in this area.

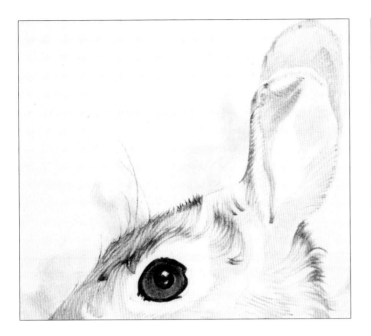

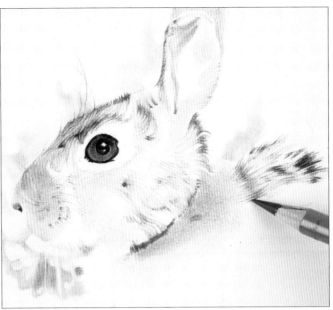

9 The ears are softer and more velvety in texture than the rest of the animal so use shorter strokes and layer the colours. On the inner near ear, which is paler in tone, apply warm grey, with brown ochre blended very lightly over the top and burnt umber strokes where necessary to add depth and tiny individual hairs. The far ear is browner and darker in tone: blend raw umber and brown ochre as you did on the face, to create a velvety texture, and apply fine strokes of burnt umber to pick out some of the darker areas. Soften the edge of the ear with very tiny flicks of warm grey.

10 Mark out the distinctive fur markings on the back with touches of burnt umber, and use very pale brown ochre for the creamy coloured fur, leaving the palest areas untouched. Use heavier strokes here, as the hairs are coarser. For the darkest tones, stroke black soft over the burnt umber to blend the colours.

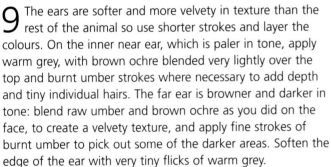

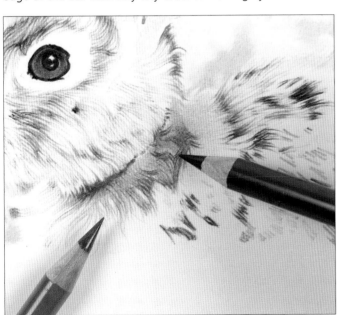

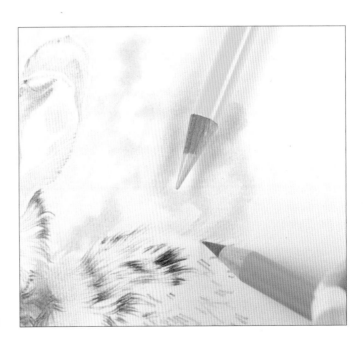

11 Continue to alternate between burnt umber and raw umber on the face and neck to create the dark and mid tones of the fur. Towards the back of the neck, introduce burnt sienna to add to the red tint of the fur. Begin blocking in the pattern of dark areas, using raw umber, so that you can work one area of fur into the next.

12 Develop the background further, using the apple green and lemon pencils, as before. Flick some of the background colour into the fur: the white paper stands for the white of the fur, so the flicks of colour define the shape of these hairs.

▶

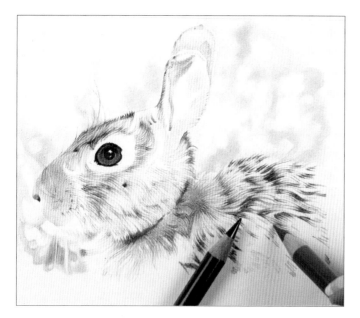

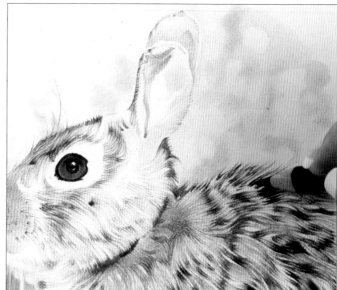

13 Continue developing the fur on the rabbit's back, using the same colours as before and working from dark to light. Around the ruff of the neck, alternate between raw umber and burnt sienna, using very light strokes and blending the marks, as the fur is very soft in this area. Leave some whites within the fur to give the impression of light hairs and highlights. Note that the fur on the back is longer and more coarse; use longer, more decisive pencil strokes here.

14 Strengthen the apple green around the rabbit's back. Using burnt umber, put in the very dark hairs around the edge, next to the background. Alternate between this and black soft, keeping a few whites on the paper. On the back, go over the burnt umber very lightly with a little black soft for the very darkest parts – the coverage should be very soft. When the individual strokes are blended together, this creates the soft texture of dense, dark patches of fur.

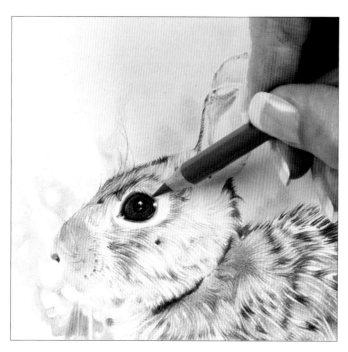

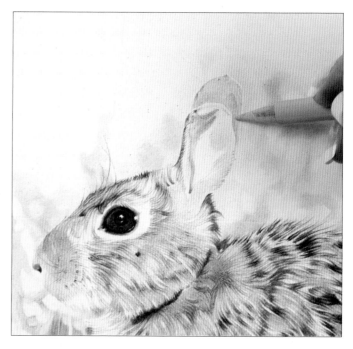

15 Draw a faint line of raw umber around the eye for the eyelid. Use medium flesh colour within the line around the eye, alternating between the two and leaving some little highlights as white. Soften the outer edge of the eye with black soft and add burnt umber to define the eye more. Stroke raw umber around the top of the eye to depict the individual hairs growing around the eye area.

16 Darken the mid tones on the head with raw umber, leaving some white showing through. Using burnt umber, lightly redefine the darker areas with short strokes. Go over the far ear using a flesh colour, then cover it with warm pale grey – but make sure that you do not darken the far ear too much or it will advance and appear to be in front of the near ear.

The finished drawing

This drawing demonstrates what a skilled artist can achieve using the medium of coloured pencil. It has a lovely tactile feel – you can almost reach out and stroke the rabbit's fur! The textures range from a soft, velvety covering on the ears to much longer, rougher fur on the animal's back. The soft, short fur is created by layering colours on top of one another to create exciting optical mixes on the paper, while the longer fur is drawn with heavier individual pencil marks. By carefully studying the different tones within the fur and by making her pencil strokes follow the contours of the rabbit's body, the artist has managed to make the animal look fully rounded and three-dimensional. The soft, mottled green background hints at an outdoor setting and complements the subject perfectly without distracting from it.

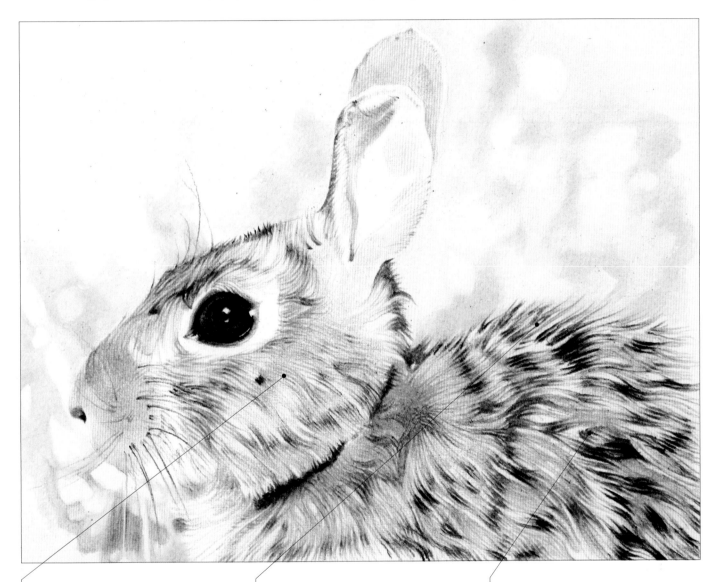

Note how the pencil strokes follow the direction in which the hairs grow.

The white hairs are not drawn in: the paper is left blank in these areas to create the impression of white hairs.

The dark tones within the fur are not just coloured markings: they are also the shadow areas that help to give the fur real depth and three-dimensionality.

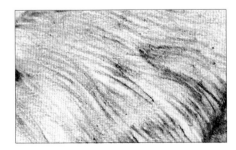

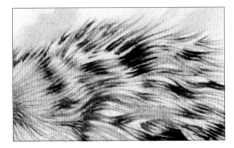

Otter in watercolour

This delightful study of an otter, peering inquisitively out to sea, is an exercise in building up textures. You can put in as much or as little detail as you wish, but don't try to finish one small area completely before you move on to the next. Go over the whole painting once, putting in the first brush marks, and then repeat the process as necessary.

Remember to work on a smooth, hot-pressed watercolour paper or board when using masking (frisket) film. If you use masking film on a rough-surfaced paper there is a risk that the film will not adhere to the surface properly, allowing paint to slip on to the area that you want to protect. Smooth paper also enables you to make the fine, crisp lines that are essential in a detailed study such as this.

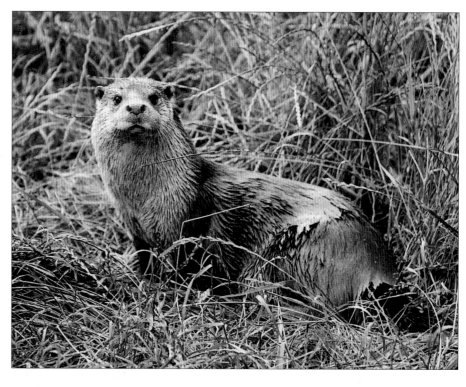

Materials
- *HB pencil*
- *Hot-pressed watercolour board or smooth paper*
- *Watercolour paints: ultramarine blue, cadmium yellow, burnt sienna, Vandyke brown, Payne's grey, cadmium red*
- *Gouache paints: permanent white*
- *Brushes: medium flat, medium round, fine round, very fine round*
- *Masking (frisket) film*
- *Scalpel or craft (utility) knife*
- *Tracing paper*

The subject and setting
Here the artist worked from two reference photographs – one for the otter's pose and fur detail, and one for the seaweed-covered rocks in the foreground. When you do this, you need to think carefully about the direction of the light. If you follow your references slavishly, you may find that sunlight appears to hit different areas of the picture at different angles, which will look very unnatural.

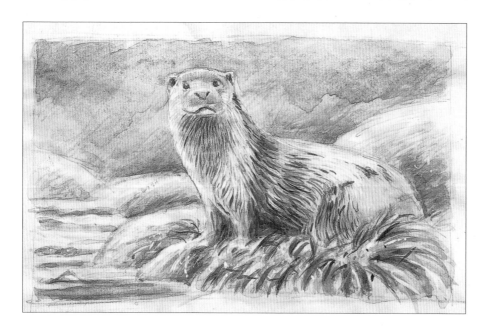

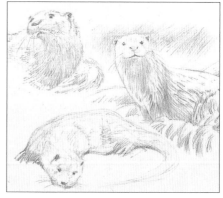

Preliminary sketches
Quick pencil sketches will help you to select the best composition, while a watercolour sketch is a good way of working out which colours to use.

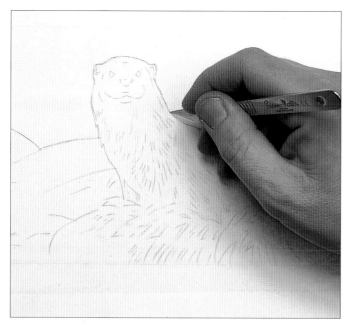

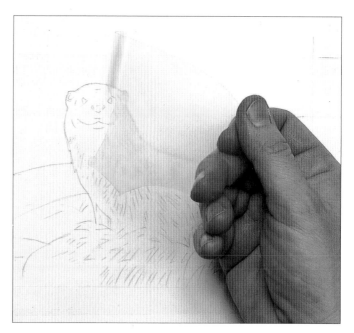

1 Using an HB pencil, copy your reference sketch on to watercolour board or smooth paper. Place masking film over the picture area. Using a sharp scalpel or craft (utility) knife, cut around the otter and rocks. To avoid damaging your painting surface, trace your pencil sketch, then place the masking film over the tracing paper, cut it out, and reposition the film on the painting surface.

2 Carefully peel back the masking film from the top half of the painting. You may need use a scalpel or craft knife to lift up the edge. You can now work freely on the sky and background area, without worrying about paint accidentally spilling over on to the otter or foreground rocks – though it is worth rubbing over the stuck-down film with a soft cloth or piece of tissue paper to make sure it adheres firmly to the surface and that no paint can seep underneath.

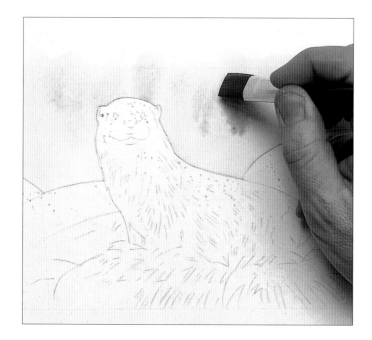

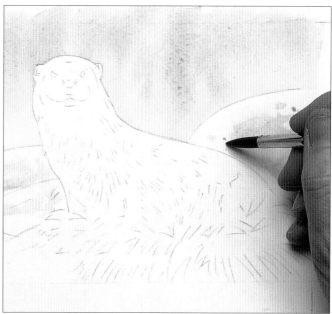

3 Mix a pale blue wash from ultramarine blue with a hint of cadmium yellow. Using a medium flat brush, dampen the board above the masking film with clean water and then brush in vertical strokes of the pale blue mixture. While the first wash is still damp, brush more vertical blue strokes along the top of the paint and allow the paint to drift down, forming a kind of gradated wash. Leave to dry.

4 Once the top area is dry, carefully peel back the masking film from the bottom half of the painting, revealing the otter and rocks. Using a medium round brush, dampen the rocks with clean water and dot on the pale blue mixture used in Step 3.

▶

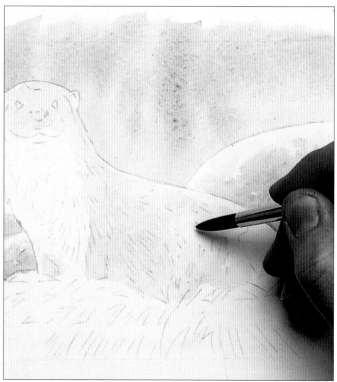

5 While the paint is still damp, use a fine round brush to dot in a darker mix of ultramarine blue and start building up tone on the rocks. Because you are working wet into wet, the colours will start to blur. Stipple a very pale cadmium yellow onto the rocks in places and leave to dry.

6 Mix a pale wash of burnt sienna and brush it over the otter's head and body. Brush over the chest area with the pale blue wash used in step 3. Leave to dry. Mix a darker brown wash from Vandyke brown and Payne's grey, and brush from shoulder to abdomen. Add a line around the back legs.

Assessment time
The base colours have now been established across the whole scene. Using the same colour (here, ultramarine blue) on both the background and the main subject creates a colour harmony that provides a visual link between the background and the foreground. You can now start to put in detail and build up the fur. In the later stages of this painting, you will want lots of crisp detail, so it's important to let each stage dry completely before you move on to the next – otherwise the paint will blur and spread.

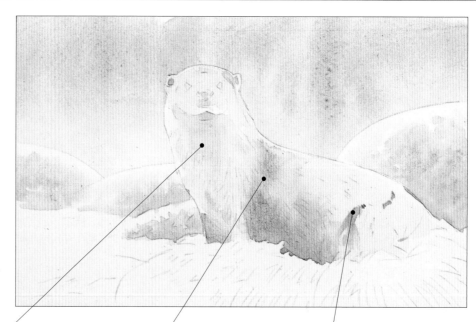

The chest, which is in shadow, is painted in a cool, pale mixture of ultramarine blue.

This darker brown helps to show the direction in which the fur is growing.

This dark line around the otter's back legs starts to establish the rounded form of the body.

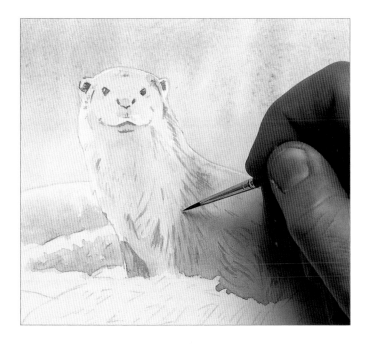

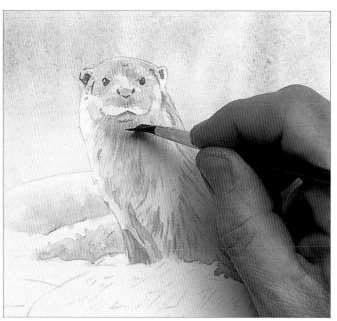

7 Mix a very dark brown from Vandyke brown and Payne's grey and, using a very fine round brush, put in the dark detail on the head – the inside of the ears, the eyes and the nose. Using the same colour, start to put in short brush marks that indicate the different directions in which the fur grows.

8 Mix a warm grey from Payne's grey and a little Vandyke brown. Using a fine round brush with the bristles splayed out in a fan shape, drybrush this mixture on to the otter's chest, taking care to follow the direction of the fur.

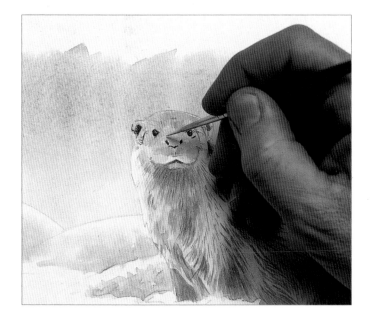

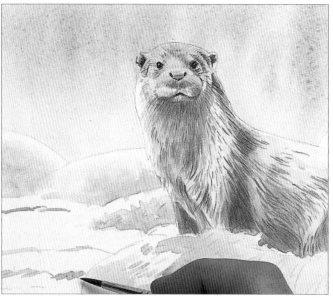

9 Continue building up tones and textures on the otter's chest and body. Paint the lightest areas on the otter's face with permanent white gouache. Mix a light, warm brown from burnt sienna and Vandyke brown and build up tones and textures on the otter's body. Darken the facial features.

10 Mix a bright but pale blue from ultramarine blue with a hint of cadmium yellow and, using a fine round brush, brush thin horizontal lines on to the rocks on the left-hand side of the painting. This blue shadow colour helps to establish some of the crevices and the uneven surface of the rocks.

Tip: The facial features help to establish the animal's character. If you can get these right, it will make it easier to overlook slight mistakes elsewhere. Spend plenty of time on this stage.

▶

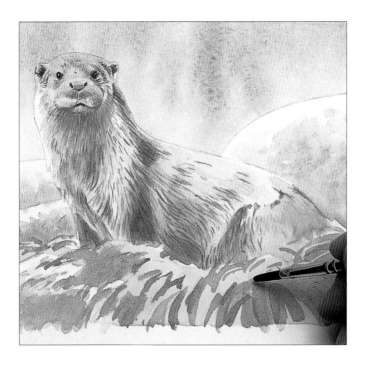

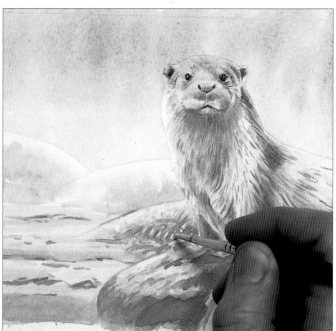

11 Mix a dark, bluish grey from Payne's grey and Vandyke brown and, using a medium round brush, paint the strands of seaweed on the rocks on the right of painting with loose, broad brushstrokes of this mixture. Leave to dry.

12 Brush a little ultramarine blue into the bottom left corner. Mix a warm brown from cadmium yellow and cadmium red and brush this mixture on to the rocks. Leave to dry. Paint lines of sea foam in permanent white gouache.

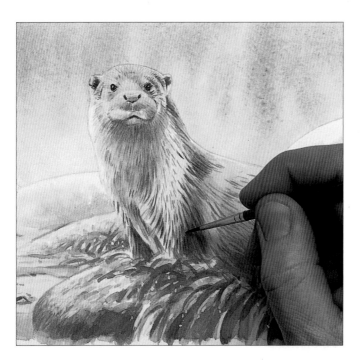

13 Now add more texture to the rock on the right, behind the otter, by stippling on a dark mixture of ultramarine blue. Note that the top of the rock, which is hit by the sunlight, is very light while the base is much darker. Using the drybrush technique, continue to add tone and form to the body of the otter, using a warm mixture of burnt sienna and ultramarine blue. Build up tone and texture on the otter's chest in the same way, using a mid-toned mixture of ultramarine blue.

14 Using a fine round brush and very short brushstrokes, paint white gouache to form the highlights along the top of the otter's back and on the body, where water is glistening on the fur. Use white gouache to paint the otter's whiskers on either side of the muzzle.

The finished painting

This is a fresh and lively painting that captures the animal's pose and character beautifully. The background colours of blues and greys are echoed in the shadow areas on the otter's fur, creating a colour harmony that gives the picture unity.

By including a lot of crisp detail on the otter itself and allowing the background colours of the sky and rocks to blur and merge on the paper, the artist has made the main subject stand out in sharp relief.

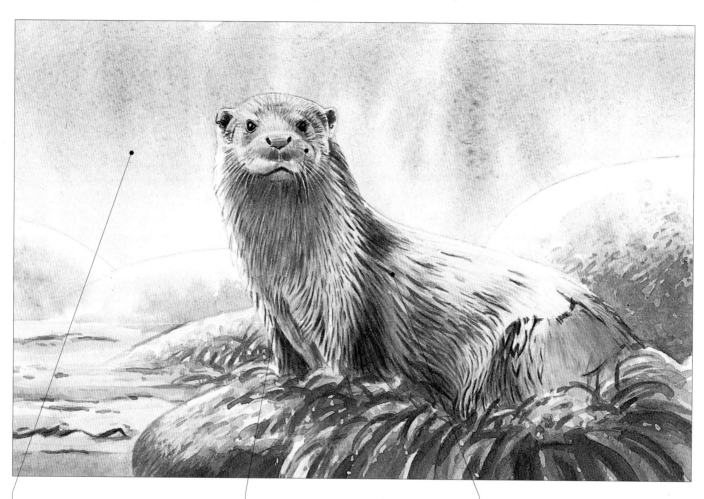

The background is painted in translucent, wet-into-wet washes that blur into indistinct shapes.

White gouache is used for very fine details such as the whiskers, which would be very difficult to achieve simply by leaving the paper white.

The crisp fur detail on the otter is made up of several layers of tiny brushstrokes, worked wet on dry – a painstaking technique but one that is well worth the effort.

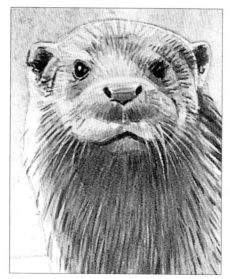

Sheep in watercolour

This painting demonstrates the importance of good composition. Animals often tend to congregate together in an untidy throng, making it difficult to pick out individuals. They may all be some distance away with nothing else to attract the eye.

You may need to move elements around, or even omit some things altogether. It's often a good idea to place one animal in the foreground and others in the middle or far distance, to create a sense of scale.

Whatever group of animals you're painting, be it a flock of sheep or a herd of wild deer, your first task is to decide on where you are going to place the focal point. Using the rule of thirds – dividing the image into nine parts – is a classic way of creating a composition.

This scene is as much about painting the setting as it is about painting the animals, so think about how you can use the landscape to enhance your composition. How much sky are you going to include? Can you use an element of the setting to direct the viewer's attention to a specific part of the image? Here, for example, the large, overhanging branch of the tree on the left-hand side of the picture space directs our eye in towards the animals in the centre of the painting; a furrow or the line of a stream could serve the same function.

In a wider landscape such as this, remember a few basic perspective rules: the sky appears paler closer to the horizon, the animals will appear to diminish in size the further away they are, and more texture will be evident in the foreground than in the distance.

Although the sheep in this demonstration have white coats, it's a distinctly off-white. This is partly due to dirt on their coats, and partly to the way the shadows fall, and the colours reflected up into the sheep's coats from the ground. Only the very brightest highlights on the sheep's coats should be reserved as pure white – and even these highlights may need to be knocked back with the application of a pale glaze in the final stages.

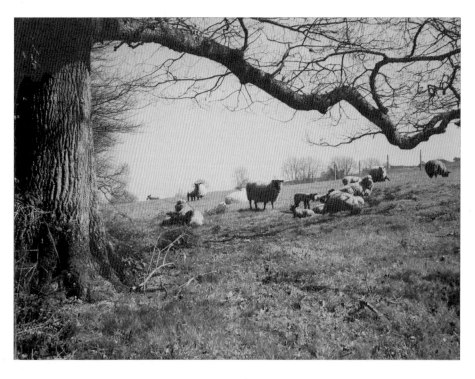

Materials
- *Good-quality watercolour paper*
- *2B pencil*
- *Masking fluid*
- *Ruling drawing pen, dip pen or old brush*
- *Watercolour paints: cobalt blue, cerulean, burnt sienna, lemon yellow, olive green, yellow ochre, sepia, blue violet, Naples yellow*
- *Brushes: medium round, rigger*

The setting
This photo shows the composition that the artist selected – a flock of sheep in a sloping field, with a tree 'framing' the image and directing the viewer's eye in toward the centre of the painting.

The detail
A close-up shot of sheep was used by the artist as a reference to capture some of the detail in the animals' coats.

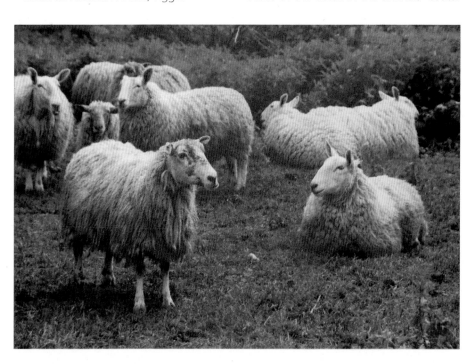

1 Using a 2B pencil, sketch the scene. With a pale-coloured subject such as this, you may find that some of your initial marks show through the watercolour glazes in the finished painting, which can be a very effective way of creating texture; if you want these linear marks to remain visible, apply more pressure to the pencil – or even go over your pencil lines in pen and waterproof ink.

2 Using a ruling drawing pen, a dip pen or an old brush dipped in masking fluid, mask out the highlights on the tree trunk and the backs and ears of the sheep. Use bold, scribbly marks so that you create some texture in these areas.

3 Dot some masking fluid into the foreground, also, for the light grasses and pebbles on the ground. Leave it to dry completely. If you're short of time, you can speed up the drying process by using a hairdryer – but make sure you do not accidentally blow the masking fluid on to areas where you do not want it to go.

4 Using a medium round brush, wet the sky area with clear water. Mix dilute washes of cobalt blue, cerulean and burnt sienna. While the paper is still wet, brush cobalt blue over the top one-third of the sky, fading into cerulean further down as the sky pales towards the horizon, and going into burnt sienna at the base of the sky to add a touch of warmth. The paint will spread wet into wet, leaving no brush marks or hard edges.

5 Add a little cobalt blue to the burnt sienna to make a warm grey. While the sky is still wet, brush on small vertical strokes for the trees in the distance. The paint will spread and blur, wet into wet, to create the effect of distant tangles of branches.

6 Mix a bright, yellowy green from cobalt blue and lemon yellow, and a mid green from cobalt and olive green. Working around the sheep and tree trunk, brush the bright yellow-green over the distant field and the darker green over the foreground.

▶

7 Wet the foreground with clean water. While the paper is still damp, drop yellow ochre and burnt sienna into the immediate foreground, where patches of bare earth can be seen.

8 Wash yellow ochre over the tree trunk and main branch, as a warm undercolour, dropping in burnt sienna and the mid green mix from Step 6 at the base of the tree, which is much darker in tone.

9 Mix a pale, warm orange from yellow ochre and a little burnt sienna. Brush this mix over the darkest parts of the sheep's coats. The masking fluid applied in Step 2 will preserve the white highlights.

Assessment time
Underpainting has set the warm tones of the scene. Already the strength of the composition is clear, with the tree trunk on the left holding in the image and the overhanging branch leading our eye through the picture and in to the sheep in the centre. From this point onwards, you can concentrate on building up the necessary depth of colour, adding texture and detailing, and making both the sheep and the tree look three-dimensional.

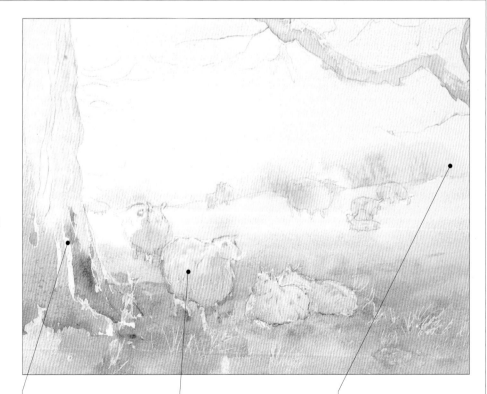

Once you've established the basic tones of the tree, you can add textural detailing to the bark.

By building up layers of colour, you can make the sheep look rounded and three-dimensional.

Note how both the sky and the grass pale towards the horizon.

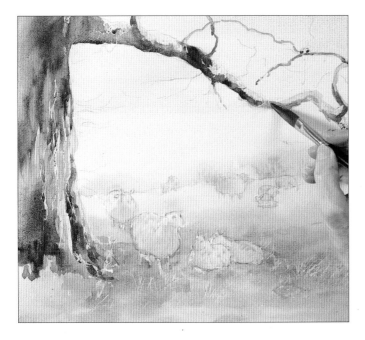

10 Mix a warm brown from sepia and a little burnt sienna. Wash this colour over the tree trunk and overhanging main branch, adding more burnt sienna to the mix for the underside of the branch, which is in shade. Allow some of the underlying colour to show through, so that you begin to develop some texture on the trunk.

11 Using a rigger brush, paint in the smaller branches, varying the proportions of the colours in the mix as necessary to get darker or lighter tones. Use warmer, darker tones for the nearest branches and cooler, lighter ones for those that are slightly further away so that you create some sense of distance.

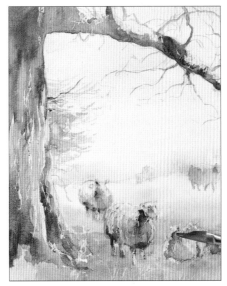

14 Using dilute cobalt blue, brush in the shadows on the ground under the sheep. Use the same colour on the underside of the overhanging branch and the tree trunk, which are in shadow, so that the tree begins to look more three-dimensional.

12 Add blue violet to the sepia and sienna mix for the darker areas. Put in the small branches protruding from the right-hand side of the trunk; this area is still wet, so the colours will blur together creating a soft, diffuse effect that will contrast well with the firmer, more deliberate brushstrokes used on the tree trunk.

13 Mix a warm, blue-grey from blue violet and a tiny bit of cobalt. Brush this colour mix over the darkest areas of the sheep to develop the form. Although we think of the sheep as being white, it is surprising how dark the shaded areas actually are. Leave the paint to dry before you make a final assessment about the tone; you may find that you need to darken it still further.

Tip: Drag the brush down, in long vertical strokes, to create the ridges and crevices in the tree trunk.

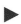

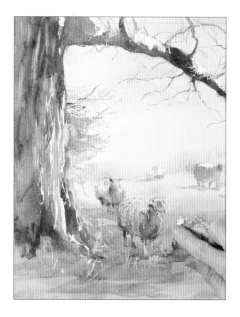

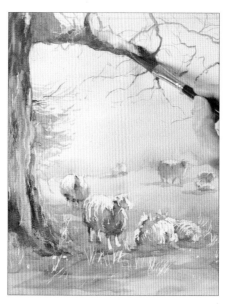

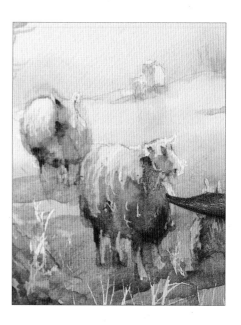

15 Using your fingertips, carefully rub off the masking fluid to reveal the white highlights on the tree trunk, sheep and foreground area.

16 Wash a thin glaze of very dilute yellow ochre over the tree to knock back the very bright highlights. The colour should be so pale that it is barely perceptible.

17 Brush very dilute Naples yellow over the exposed white parts of the sheep. Again, the colour should be barely perceptible – just enough to 'kill' the bright white of the paper, which would otherwise stand out too much.

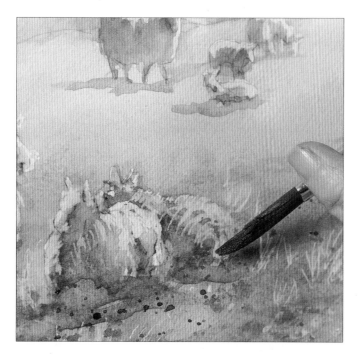

18 Spatter a warm brown mix of cobalt blue and burnt sienna over the immediate foreground to create a pebbly texture on the ground.

19 Use the warm brown mix to add a just little extra texture to the sheep's coat with a few short paint strokes. Mix a dark indigo from blue violet and burnt sienna. Using a rigger brush, put in the detailing on the sheep's faces – the eyes and noses.

Tip: To spatter, either tap the brush handle with your fingertip or drag your finger lightly across the tips of the brush hairs so that tiny droplets of paint fly off onto the surface of the painting. Do not overload the brush with paint, or the droplets of spattered paint may be too large.

The finished painting

This is an atmospheric painting of a tranquil rural scene. The burnt sienna and yellow ochre washes on the tree, along with the bright, yellow-green grass, create a feeling of warm afternoon sunlight; the pale but bright blue sky enhances this. Note how well-balanced the composition is: our eye is led from the standing sheep to the kneeling sheep in the foreground, and then around almost in a circle to the animals in the distance – and this circular motion imparts a feeling of great calm to the scene. Beyond this, the tree on the left 'frames' the subject and adds a lovely textural contrast.

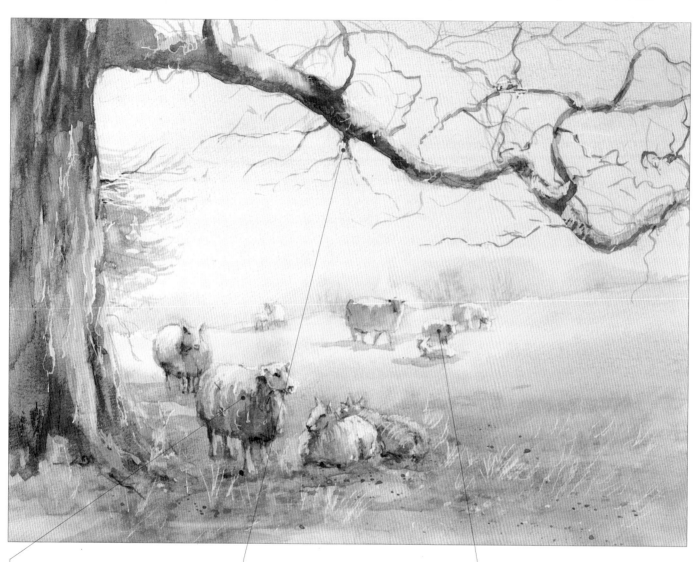

Rough, downward brush strokes create the shaggy texture of the sheep's coats.

The overhanging branch points downwards, directing the viewer's eye towards the centre of the image.

The background sheep are painted quite loosely and freely; they are pale in colour, almost hazy, and this enhances the impression of distance.

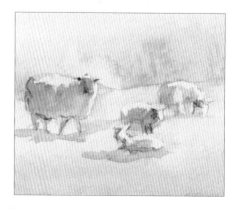

Fighting stags in oils

With an 'action' scene such as this, you will have to combine observations made in the field with reference photos and sketches. The benefit of photos, of course, is that you can 'freeze' the action at its peak. However, there's really no substitute for doing at least some of the work from life, even if you only make a few quick compositional sketches. Not only does the very act of looking and sketching imprint the scene much more vividly on your mind than taking a photo, but you will also be able to conjure up other memories of the day – the cold, frosty morning, the bellowing of the stags, and the clash of antler on antler.

Although these two animals appear to be locked head to head and barely moving, it's vital that you get a feeling of energy and the sheer physical strength of the stags into your painting. To do this, you need to show how the muscles are tensed as the animals push against each other. Look at where the muscles are visible on the surface – in the shoulders and powerful hind quarters – and observe how the shadows on the skin reveal what is going on underneath.

At first glance, the antlers look very complicated in shape. The trick is to block them in as one single unit to begin with, without attempting to define how one set relates to the other or where the areas of light and shade lie. In oils, it's very easy to paint a light colour over a dark one, so you can refine the tones in the later stages of the painting to make the antlers look three-dimensional.

Note how many different colours there are in the stags' coats – different tones of dark chocolate brown, reddish brown, cream and grey can all be seen. The fur is mostly short, and the best way to paint it is wet into wet, blending the marks so that no brush marks are visible and the texture looks soft and velvety. For longer fur use a very small amount of thinner with the paint to help it flow (take care not to thin it too much) and feather the brushstrokes to look like long strands of hair.

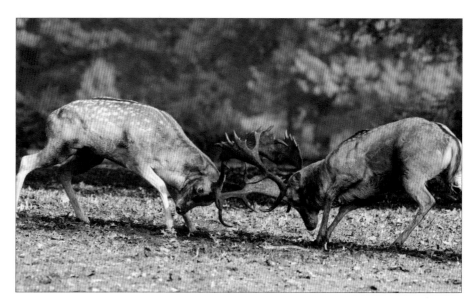

Materials
- *Stretched primed canvas*
- *3B pencil*
- *Oil paints: indigo, yellow ochre, titanium white, raw umber, cadmium yellow medium, lamp black, chrome green, brown ochre, burnt umber, cadmium orange*
- *Brushes: selection of small and medium filberts, rigger*

The subject
This is a dramatic image of two stags in their prime, antlers locked together as they do battle at the height of the mating season. The stags' antlers are somewhat lost against the leaf-strewn foreground, so the artist decided to bring the wooded background down lower, so that the antlers would stand out against the green of the trees.

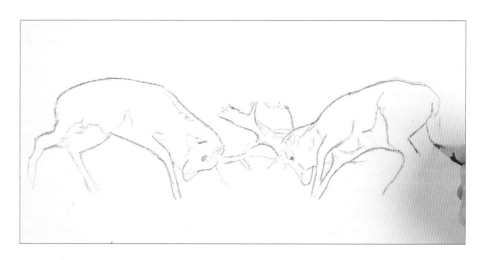

1 Using a 3B pencil, lightly sketch the stage to establish the main shapes and the composition of the picture. The benefit of using a relatively soft pencil, rather than an HB, is that it is easy to erase the marks from the canvas if you get something in slightly the wrong place.

> **Tip**: It's up to you whether you paint the background in detail, or opt for a vignette effect, as the artist did here, but whatever you choose, make sure you leave space on either side of the stags, as well as above and below – otherwise the composition will look cramped.

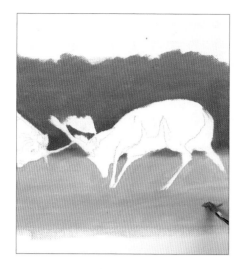

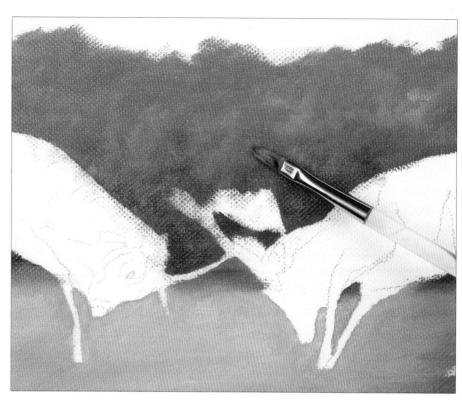

2 For the green background, mix a dark, blue-toned green from indigo, yellow ochre and a little white. For the foregound, mix a pale brown from raw umber and white. Using small filbert brushes, block in the background and foreground around the stags by paint the colours on quite roughly. Don't worry if some of the background colour goes over the antlers, as you can paint over it later.

3 Mix a bright mid-toned green from cadmium yellow medium, a little lamp black and indigo and dot it into the background to create a mottled, leafy effect, adding more yellow and white as you work up the picture.

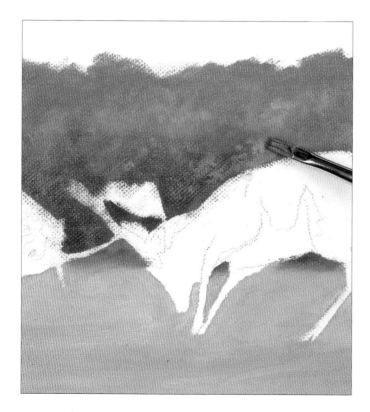

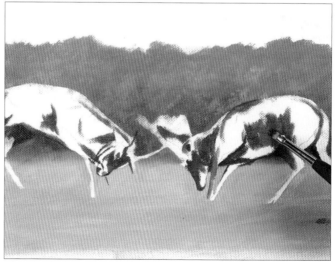

5 Now begin working on the stags. Mix a very dark brown from raw umber and a tiny bit of lamp black and, using a filbert brush, put in the darkest parts. The next darkest tone is a redder brown, mixed from brown ochre and burnt umber. Apply this colour, blending it into the first mix wet into wet so that you do not get any hard edges.

4 Repeat Step 3 using a lighter, brighter green mixed from chrome green and cadmium yellow medium. You are gradually beginning to build up some texture and form in the woodland background.

 Tip: Vary the size of the brush as necessary, depending on how fine a mark you need to make.

▶

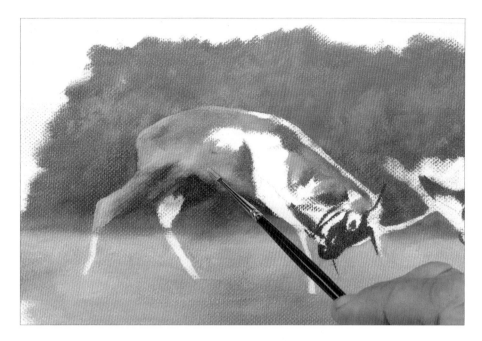

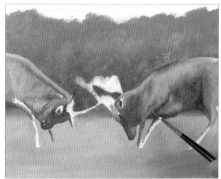

6 Mix a mid-toned base colour for the stags from brown ochre, white and a little raw umber and burnt umber. Lightly brush this across the stags, leaving the very lightest parts untouched. Smooth out the brushstrokes to blend the edges where one colour meets another, taking away any hard edges.

Tip: The light spots will be applied on top of this mid-toned base colour, so it's important to get it right – otherwise the spots will look wrong.

7 Add more white to the base colour for the lightest tones. Blend the mix wet into wet into the existing colours, taking care not to obliterate any definite lines such as the crease of the legs. You can build up more tone later to get more of a 3-D effect. On the belly and upper legs of the right-hand stag, there are some patches of fur that are grey rather than brown: put these in using a mix of white and lamp black.

Tip: Do not paint the stag's legs at this stage as the colour would merge into the background.

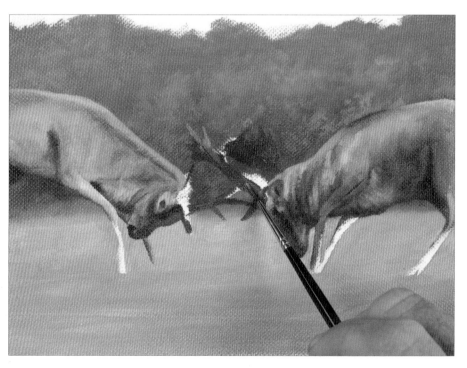

8 Brush a little of the brown ochre and white base colour mix around the eyes, to begin to define their form. Add yellow ochre to the base colour from Step 6 and put in the paler fur on the underbelly.

9 Mix a rich reddish brown from burnt ochre and raw umber and block in the antlers, including the points where they overlap. (This is the mid tone of the antlers. The shape and structure will become clearer later when you put in the dark and light tones.) Add white to the mix for the lighter tones at the tips of the antlers.

Assessment time

Ask yourself whether you need to do any more work on improving the sense of form. Here, the shadows on the legs and hind quarters hint at the muscles lying beneath the surface and imply the strength of the animals as they push against one another, and only minor adjustment to the tones is required. The most obvious omission is that the lower legs have not yet been painted: this is because the foreground needs to dry first, otherwise the legs would blend into it. The antlers look rather flat and seem to merge together – it is hard to tell where one set ends and the other begins. Refining the tones by adding more yellow ochre or white to the mixes will separate them from each other and make them look three-dimensional. The final stages will be to put in the missing details – the spotted markings on the stags' bodies, some foreground texture, and shadows underneath the animals to 'anchor' them in the scene.

Pale spotted markings are characteristic of this species of deer; these can be added almost as the final stage of the painting.

The antlers need more tonal differentiation in order to look fully three-dimensional and to stand out from each other.

The lower legs can be painted once the background is dry.

There is no detail in the foreground; adding texture to this area will help to imply that it is closer to the viewer.

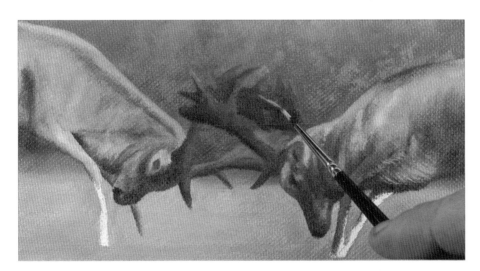

10 Using a rigger brush (or an old brush with very few hairs left on it), put in the light areas such as the back-lit hairs on the right-hand stag's rump in a pale mix of brown ochre and white. Refine the tones on the antlers to make them look more three-dimensional and to separate the two sets of antlers visually from one another. For the darker areas, use a mix of raw umber with a tiny bit of lamp black; for the lighter areas, use a mix of white, yellow ochre and brown ochre.

11 Using a fine brush, paint the spots on the animals' bodies in a pale mix of yellow ochre and white with a little brown ochre. Note that the spots are not uniform in size or shape; nor do they sit in neat rows.

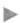

12 For the base colour of the brown leaves in the foreground, mix a rich brown from yellow ochre, a little brown ochre and white. Loosely scrub this colour on using a scribbly circular motion to create the effect of scrunched-up fallen leaves. Add touches of cadmium orange for the more golden leaves and touches of raw umber for the darker patches.

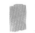 **Tip**: Don't worry if the foreground base colour goes over the stags' legs; you can easily paint in the legs again once the foreground colour has dried.

13 Mix a very pale, thin brown from raw umber and white (dilute with linseed oil if necessary) and dot it into the foreground to create the pebbly texture of the ground. Paint the shaded parts of the stags' lower legs in a mix of brown ochre, white and a tiny bit of lamp black. Mix a pale cream from white and yellow ochre and, using a fine brush, paint the lower part of the stags' legs so that the shape of the legs stands out against the background.

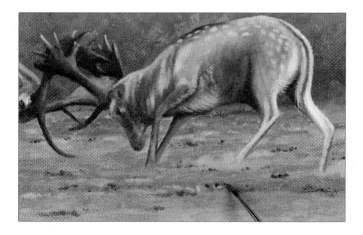

14 To create the impression of movement, mix a very pale dust colour from raw umber and white and dab it in around the stags' feet. Using a soft brush, smooth out the brushstrokes. Add a tiny amount of black into the mix to create shadows in the dust. Also dab on small dots of cadmium orange for the warmer, golden-coloured leaves on the ground.

 Tip: Try not to overdo the orange dots of leaves on the ground; this is a very strong colour and could easily dominate the foreground, pulling attention away from the stags.

15 Using a warm brown mix of raw umber with a tiny bit of black, lightly stroke in the shadows under the stags, using short, scribbly strokes to retain the rough texture in the scuffed earth of the foreground.

The finished painting

A relatively restricted palette of colours – mostly soft browns and greens – has been used for this painting of two rutting stags. This colour mix gives a gentle colour harmony to the painting that belies the tension in the scene itself. Most of the painting was done wet into wet, allowing the artist to create subtle blends of colour on the canvas without any harsh edges or obvious brush marks. There is enough detail in the background and foreground to evoke the woodland setting, while the animals form the main focus of the picture. The vignetted edge is a nice effect, although you could take the background right up to the edge of the picture to produce a squared-up image if you wish.

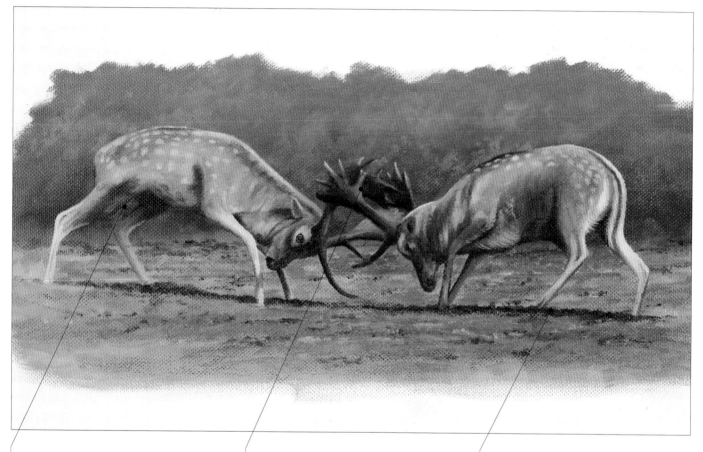

The shadows have been carefully observed to imply the tension in the muscles and create a good sense of modelling on the animals.

The contrast between the light and dark tones makes the antlers look three-dimensional and establishes the spatial relationships between them.

The shadow on the ground anchors the animals in the landscape.

Horse in pastels

At first glance, the horse in this demonstration appears to be a rich, chestnut brown colour. Look closely, however, and you will see not only different tones of brown, but also different hues – reddish browns, pinks, oranges and even peachy yellows. Soft pastels and pastel pencils are a wonderful medium for conveying these subtle shifts of hue, as you can overlay one colour on another and gently blend them with your fingertips so that they merge almost imperceptibly.

Note, in particular, how the highlights and shadows on the horse's body indicate the bones and muscles that lie just below the surface of the skin and convey the horse's form. The entire painting is about building up tones to the right density to make the horse look three-dimensional.

When painting a moving animal, you must know the order in which the legs move and whether they are bent or extended. In this demonstration, the artist worked from a photograph taken on a fast shutter speed.

Whatever you're drawing or painting, careful measuring is essential. Here, the horse's body is slightly foreshortened. First, decide on a unit of measurement against which you can measure the size of other features. The artist used the length of the head, from the tip of the ear to the nose, as her basic unit of measurement. She discovered that the distance from the tip of the nearside ear to the top of the hoof of the near foreleg is equivalent to two 'heads'. From this viewpoint the distance from the foremost point of the chest to halfway along the flat part of the tail is also two 'heads' – although one might expect the body to be longer.

Materials
- *Cream/buff-coloured pastel paper*
- *Pastel pencils: dark brown, permanent rose, orange, Indian red, flesh, black, white, Naples yellow*
- *Soft pastels: sandy orange, pinky-brown, mid green, bright yellow, bright olive green, light green*
- *Cotton bud (cotton swab)*

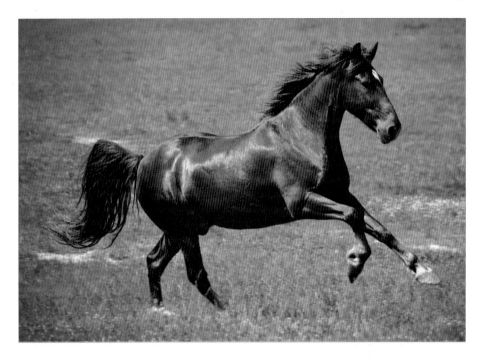

The scene
All the emphasis in this scene is on the moving horse – there is nothing in the background to distract from it. Although the photograph 'freezes' the horse mid gallop, the flowing tail and mane help to show how quickly it is moving, as do the muscles and tendons under tension.

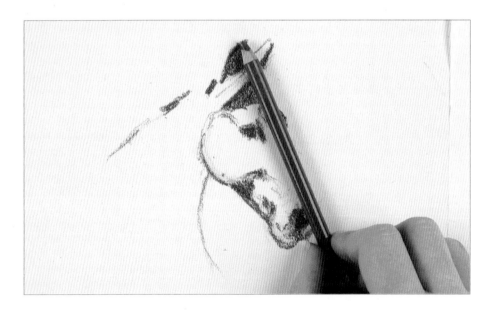

1 Using a dark brown pastel pencil, sketch the horse's head and put in the darkest tones, between the ears and under the mane. Measure the length of the head on your pencil, so that you can gauge the size of other features in relation to it.

> **Tip**: Before you put pencil to paper, check the proportions and lightly mark the highest, lowest and widest points of your subject, to make sure you leave enough space on the paper to fit the whole animal in.

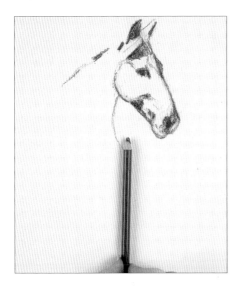

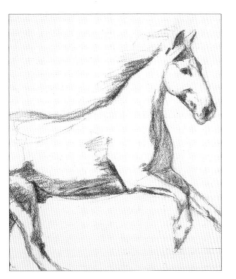

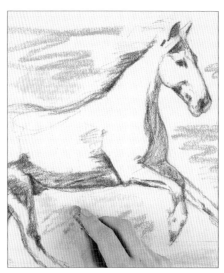

2 Continue sketching the horse, using the length of the head as your basic unit of measurement. Here, the distance from the tip of the near ear to the top of the hoof of the near foreleg is equivalent to two 'heads'.

3 Complete the sketch, measuring carefully throughout. Here, the distance from the foremost part of the horse's chest to the rump is just under two 'heads'. Block in the most deeply shaded areas on the chest and under the belly. Pay particular attention to the angles of the legs: getting this right is an essential part of conveying a sense of motion.

4 Although the background appears at first glance to be a lush, green meadow, there are small patches of earth show through in places. Put this underlying colour in first, before you begin to apply the green. Loosely scribble a sandy orange soft pastel over the background, followed by a pinky-brown.

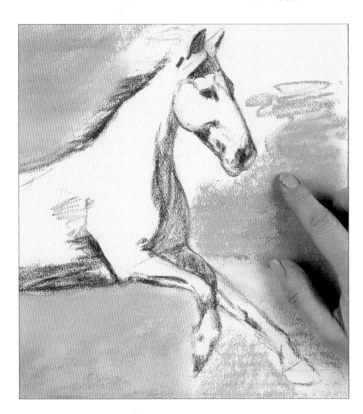

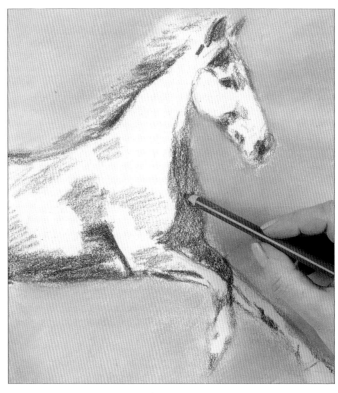

5 Apply a bright mid-green on top, then blend all the colours together with your fingertips, rubbing right up to the edge of the horse. Put in some bright yellow, too, for the little clump of flowers in the grass.

6 Scribble a permanent rose pastel pencil over the darkest parts of the horse – around the chest and underbelly – so that you begin to create the warm chestnut colour of the horse's coat.

▶

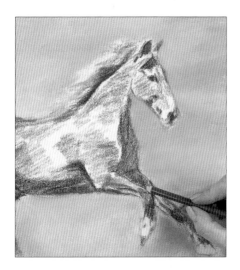

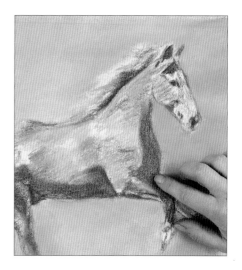

7 Block in the mid tones on the body and legs with an orange pastel pencil, then go over these areas with an Indian red pencil. Already, you are beginning to develop some modelling on the horse, indicating where bones and muscles lie just below the surface.

8 Using a flesh-coloured pastel pencil, go over the previous colours, going right up to the edges of the very brightest highlights. This softens the transition from mid to light tones. Leave the very brightest highlights untouched. They may look stark and bright at present, but the tones will be adjusted as you work on the drawing; getting them right is a gradual process.

9 Fingerblend the darkest areas, and then the lightest ones.

Tip: When fingerblending, work on either the dark areas or the light areas at one time. Don't switch from one to the other, or you may transfer pigment to an area where it's not wanted.

Assessment time
The light and dark areas have been established and already the horse is beginning to take on more of a three-dimensional feel – although the colours are far too pale overall and the transitions from dark to mid and light tones are too abrupt. From this point onwards you can start to be more precise about your marks as you continue to refine the modelling on the horse.

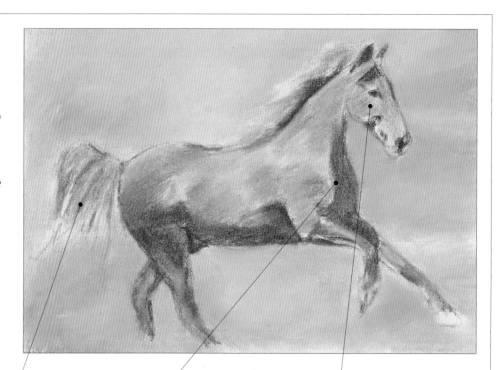

The underlying colours of the tail and mane have been blocked in, but the texture of the long, flowing strands of hair needs to be developed much further.

The transition from dark to mid tones is too abrupt.

Much more modelling is required on the head and body to prevent them from looking flat and one-dimensional.

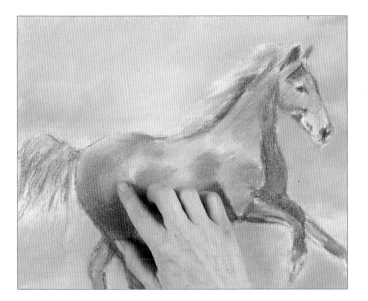

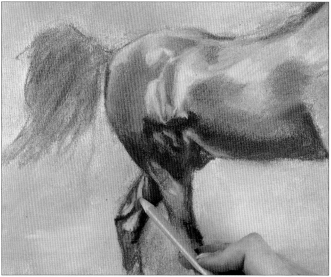

10 Using a pale orange pastel pencil, scribble in the light chestnut mid tones on the horse. Then go over the darker mid tones with an Indian red pastel pencil, and fingerblend the colours together. Go over the head, too, to match the tones to those on the body.

11 Go over the most deeply shaded areas again with brown pastel pencil. Using black or dark brown as necessary, put in the creases around the back legs. Put in the very brightest highlights on the body with a white pastel pencil. For the highlights on the hocks, use a mid orange. Keep fingerblending as you go.

Tip: It's a good idea to work on the head at the same time as the body. If you leave the head right to the end of the drawing, you may forget which colours you used.

Tip: Keep assessing the tonal values of the picture as a whole as you work the pastels. A drawing like this has to be a continual process of adjustment.

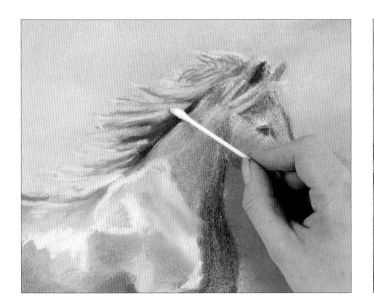

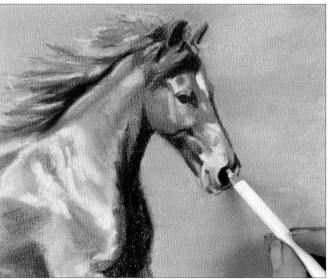

12 Use a black pastel pencil to put in the dark detailing on the inner ears and the underside of the mane. Apply permanent rose, orange and Naples yellow for the mid tones in the mane, using pastel pencils for more linear marks and soft pastels for the underlying soft hair. Blend the colours carefully, using a cotton bud and taking care not to smudge dark colours into the light areas or vice versa.

13 Continue building up the form on the shoulder, flanks and head. Darken the area between the ears with a black pastel pencil, and use the same pencil for the dark shadows in the mane. Go over these areas with pink to reduce the intensity and solidity of the black without affecting the darkness of the tone. Put in the details of the eye and nostrils in black, then add the highlight in the nostril in white.

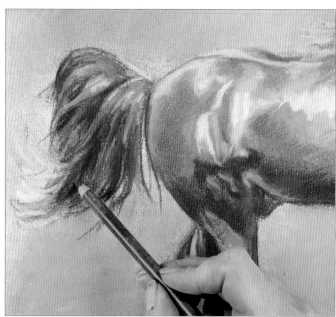

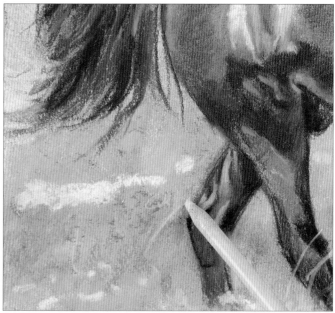

14 Put in the dark recesses on the legs in black and the highlights in white. Look carefully at where the bones and tendons are visible just below the surface of the skin; observe the shadows carefully and use crisp, sharp lines, so that these areas look really hard.

15 Using the same colours as on the mane, put in the long, flowing strands of the tail. Note that the strands of hair are much thicker on the tail than they are on the mane, so you can afford to make your pencil strokes much stronger and bolder.

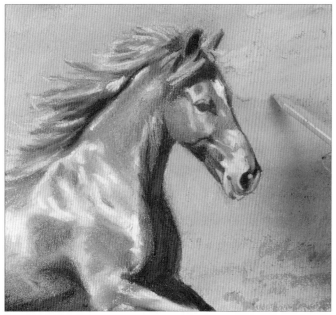

16 Scribble a bright olive green soft pastel over the background, as the base colour for the grass. Add a lighter green on top, particularly in the background behind the horse, then use your fingers to blend. Having a lighter colour behind the horse implies that this area is further away.

17 Dot and scribble some shorter white and yellow pastel marks into the background to give the impression of small meadow flowers. Gently stroke a little pinky-brown pastel into the foreground to give the effect of patches of exposed earth. Using a yellow pastel pencil, draw in some spiky grasses. You don't need to be too precise with your marks here; all you're aiming for is a general impression of the meadowland setting.

 Tip: Do not overblend the colours, or you will lose the texture. Allow some of the underlying colour to show through.

The finished drawing

This is a deceptively simple-looking drawing that has a wonderful feeling of movement, which comes partly from getting the lines and balance of the horse right and partly from the flowing mane and tail. The pastel marks have been skilfully blended to create a surprisingly wide and rich range of colours and tones, which capture the horse's shiny coat to perfection. The rich, reddish browns of the animal are complemented by the mid greens of the background.

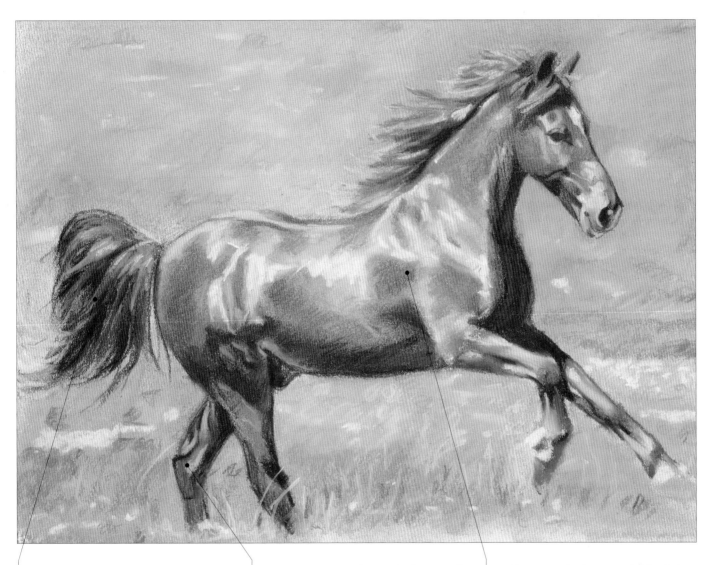

Long, flowing pencil strokes capture the texture of the thick strands of hair in the tail and mane.

Sharp, crisp marks delineate the bones and tendons in the legs.

A wide range of colours, gently blended with the fingers, captures the subtle tonal differences in the coat.

Fox in soft pastels

Soft pastels are a lovely medium for drawing fur. You can overlay one colour on another and blend the pigments on the paper to create subtle optical mixes and transitions of tone. You can also use the tip of the pastel to create short, spiky lines that capture the texture and the direction in which the hair grows.

The fox in this demonstration has relatively short, flat fur. This makes it easier to see the shape of the animal, as you're not confused by the sheer volume of the fur in the way that you might be with a long-haired animal such as an orang-utan or a fluffy cat. Whatever animal you're drawing or painting, however, think of the fur in much the same way as clothing on a human being and look at how it 'drapes' over the body beneath. Observe carefully and you will see shadowed areas within the mass of fur which help to make it look three-dimensional and suggest the underlying anatomy of the animal.

Deciding how to treat the background is as important as deciding how to treat the subject itself. In this drawing, the landscape is secondary and so the artist deliberately left much of the background behind the fox as little more than a flat expanse of colour, so as not to detract from the animal. She did, however, put in some of the immediate foreground – the spiky grasses poking up through the snow – in order to place the animal in a recognizable landscape setting.

Note the use of complementary colours – the violet/blue of the background next to the rusty orange of the fur. These colours work well together and can give a sense of energy.

Materials
- *Blue pastel paper*
- *Conté pencils: brown ochre, black, white*
- *Soft pastels: white, rusty brown, creamy yellow, chocolate brown, black, blue-grey, blue-violet, dark olive green, yellow-olive green, apricot*
- *Kitchen paper*

The subject
In this image, the fox's head is slightly lowered and the left foreleg raised off the ground as it stealthily stalks its prey – a stance that is typical of the animal. Note that, because we're looking at the fox from head on, the body appears slightly foreshortened. The low viewpoint focuses attention on the fox's head and eyes, adding to the drama of the composition; had the artist been looking down on the animal, the composition would have had far less of an impact.

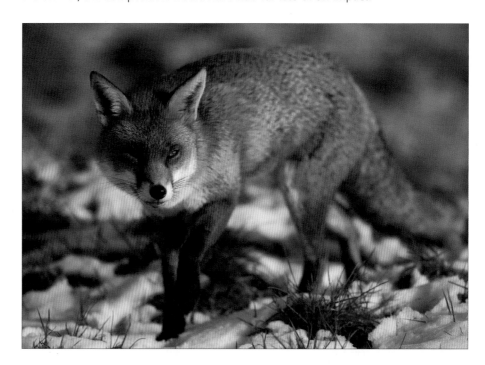

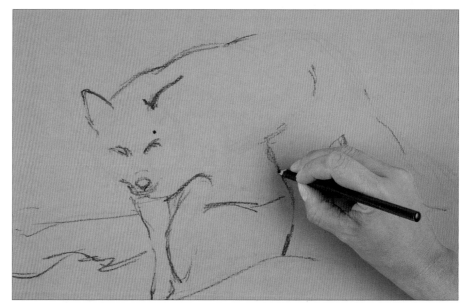

1 Using a brown ochre Conté pencil, sketch the fox. Look for where features align to help you place things correctly; here, for example, the tip of the nose is almost directly above the paw of the right foreleg, while the tip of the right ear is roughly level with the top of the tail. Switch to a black Conté pencil and put in the areas that create the movement in the pose: the tensed back, the lowered head and the delicately raised front paw.

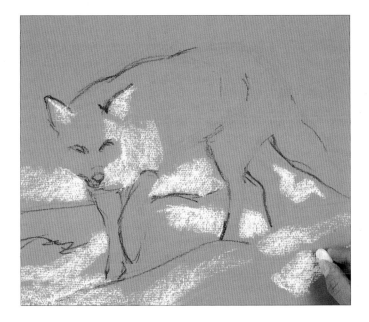

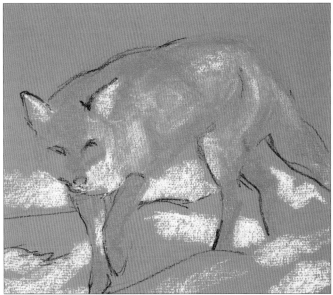

2 Using the side of a white soft pastel stick, roughly block in some of the whites on the fox's fur and the patches of snow on the ground. Use the negative shapes – the spaces around the fox – to help define the shape of the animal more clearly. Note that you are not attempting to create any texture at this stage, but simply blocking in the lightest tones and establishing the highlights.

3 Roughly block in the mid tones in the fox's fur with a rusty brown soft pastel, making loose scribbles with the side of the pencil. Do not cover the paper completely – allow some of the paper colour to show through so that you can build up a range of fur tones. Note how different the colour looks depending on whether it's applied to blank blue paper or over the white pastel marks from the previous step: already, you are beginning to develop some form in the fur.

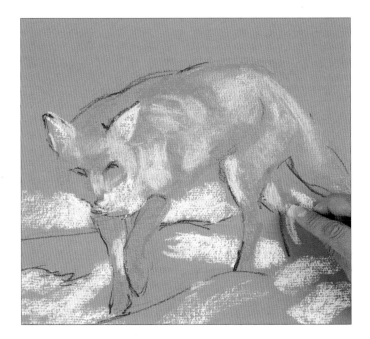

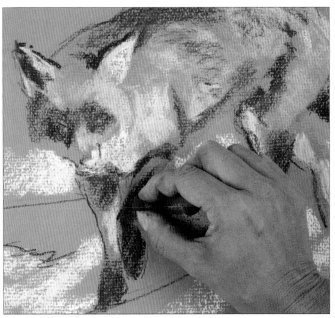

4 Scribble over the rusty brown with a creamy yellow soft pastel to create some of the lighter mid tones, allowing some of the underlying colour to show through so that you get some tonal variation within the fur. In a subject such as this, you do not want any one area to appear completely flat and a single tone. Touch a little of the creamy yellow into the snow, too, picking up on any areas where you can see the same colour, as this helps to unify the picture.

5 Using the tip of a chocolate brown soft pastel, put in the darkest patches of fur and those areas of the fur that are in deep shadow. The fox's fur is now beginning to look much more three-dimensional.

▶

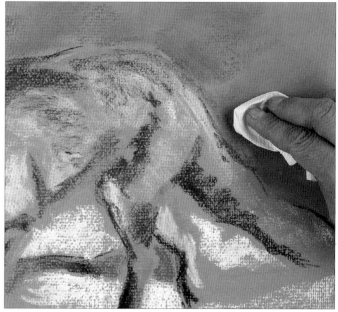

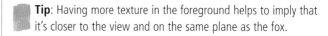

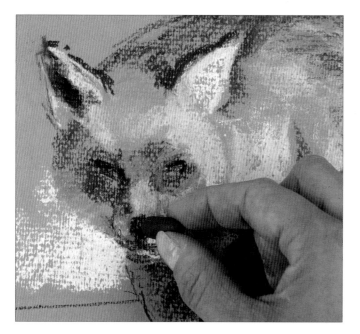

6 Put in more mid tones on the head, using the rusty brown pastel. Outline the eyes and put in the nose using the tip of a black pastel.

7 Put in the darkest tones in the foreground with a black pastel, so that you begin to get some sense of the way the land undulates, then scribble in the background and the mid tones in the foreground with a pale, bright blue-violet. Blend the background with kitchen paper or your fingertips to get rid of any textural marks that might detract from the fox.

> **Tip**: Having more texture in the foreground helps to imply that it's closer to the view and on the same plane as the fox.

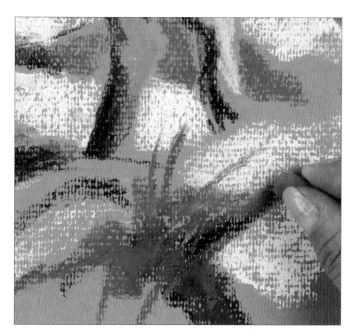

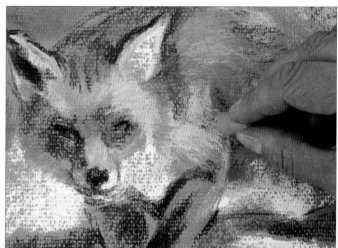

8 Using a dark olive green pastel, block in the clumps of low-lying grass in the foreground. Use short, vigorous, upright strokes for the blades of grass that poke up through the snow in the immediate foreground.

> **Tip**: If you're finding it difficult to 'see' the exact shape of the head, work up to it with a blue-grey pastel that's similar to the colour of the paper. Using the 'negative' shapes (the spaces around the subject) is a good way of defining 'positive' shapes like the head.

9 Continue building up the tones on the head, using finer, shorter strokes to develop more texture. Gently stroke a yellowy olive green into the fur for some of the lighter mid tones on the body. It might seem strange to use a green tone on a subject that is basically red or rust in colour, but colours in nature are not pure, unlike artists' pigments, so adding a touch of a complementary colour can really enliven and enhance the overall effect.

Assessment time

At this stage, all the main elements of the drawing have been put in and the tonal values carefully assessed. However, more texture and detailing are required on the fox – particularly on the head, as this is both the focal point of the image and the part of the animal that is nearest to the viewer. The foreground, too, looks a little flat and empty. Adding more texture (in the form of grasses) and mid tones (the blue-violet colour) will help to bring it forwards in the image and make the spatial relationships clearer.

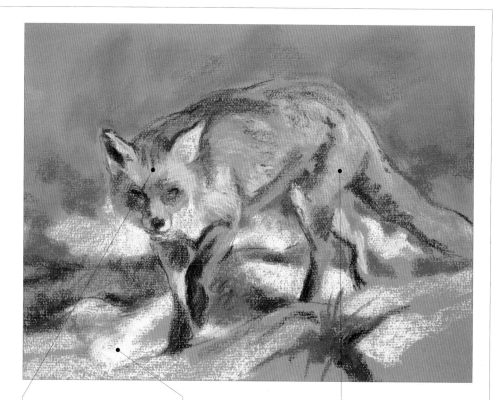

More detail and texture are needed on the head, in order to make it the focal point of the drawing.

This area attracts attention because it is so bright. Counteract this – and add that all-important foreground detailing at the same time – by adding a few blades of grass.

This area of fur has received little more than a base colour and requires more layers of colour.

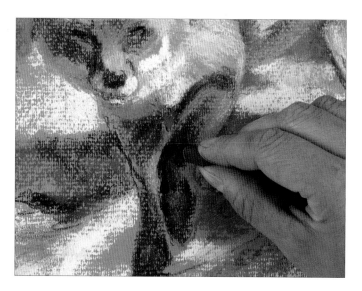

10 Using the same colours as before, continue building up texture in the fur. Take care not to obliterate the underlying colours: you need to keep some variety in the fur tones so that it doesn't look flat and lifeless. Where necessary, block in more grass with a dark olive green pastel to help define the shape of the fox more clearly.

11 Part of the background behind the fox is in shadow. Block this in lightly using the side of a dark olive green pastel, then blend the marks with a scrunched-up piece of kitchen paper, a torchon or your fingertips, so that there are no obvious marks or hard edges.

▶

12 Now turn your attention to the foreground, which needs to have more texture and detail than the background so that it comes forwards in the image. Make short, vertical strokes of olive green for the blades of grass, adding a little yellow-olive to the right-hand side of some blades, which receive more direct light. Using blue-grey and blue-violet pastels as appropriate, block in the mid tones of the snow, and then blend the marks with your fingertips. Work in between some blades with a blue-grey pastel, if necessary, to define their shapes more clearly.

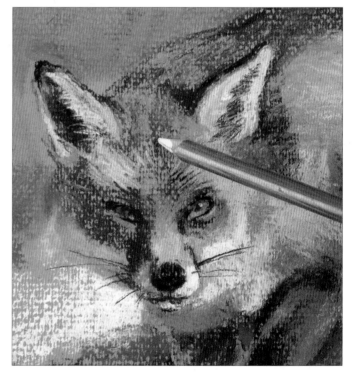

13 Using a white pastel, sharpen up the edges around the fox to anchor it in the landscape so that it doesn't appear to be floating. Put in any bright patches of snow that are missing.

14 Strengthen the shadows on the fox's head to bring more three-dimensionality to it: this is the most important part of the image. Using the tip of an apricot-coloured pastel and a white Conté pencil, make a series of short strokes for the brightest hairs on the head; immediately, this area takes on more texture. Refine the shape of the muzzle and the eyes, and draw in the whiskers, using a black Conté pencil. Using a rich apricot-coloured pastel, put in the irises of the eyes, remembering to add a tiny dot of white for a highlight in the left eye.

The finished drawing

Ears pricked up, eyes alert, this is a very lifelike portrayal of a fox in characteristic stalking mode. The artist has included just enough of the surroundings to tell us the season of the year and reveal something of the habitat, but the focus of the image is very much on the animal. The different tones and textures have been carefully observed without being overworked or laboured. On the head, short pastel and pencil strokes, which follow the direction of the fur growth, give the general impression of the fox's short and softly textured fur – although the artist has sensibly refrained from attempting to put in every single hair. Elsewhere, broad pastel strokes, with colours overlaid on one another and then gently blended, create vibrant optical mixes that capture the many different tones within the fur.

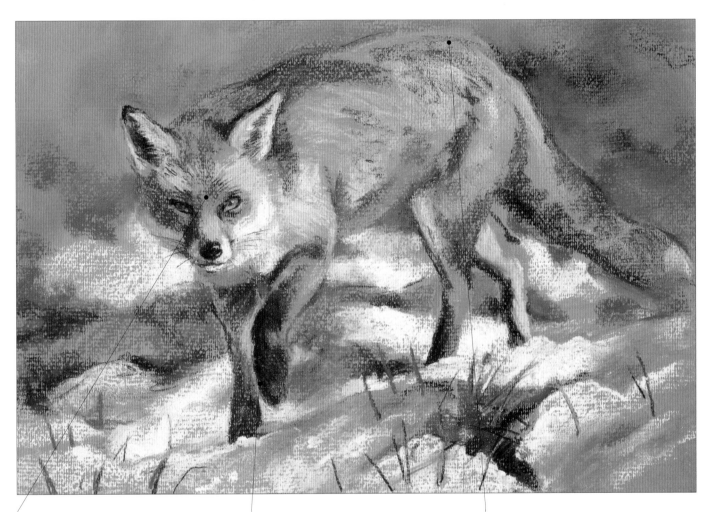

Short strokes of both soft pastels and Conté pencils create delicate textures on the head.

Note how the tones on the left front leg are warmer than those on the right front leg; this helps to bring the left leg forwards in the image and imply that it is closer to the viewer.

Note the effective use of complementary colours – blue/violet in the background and rusty orange on the fox. This adds a dynamic quality to the drawing.

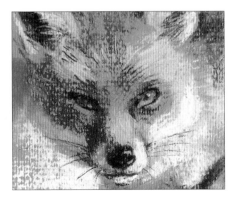

Lion in oils

This demonstration was done using fast-drying alkyd oils, although you could use conventional oil paints if you wish. Bear in mind, however, that if alkyds are painted on top of conventional oils, there may be more risk of the paint cracking.

You will need to assess the tones very carefully in order to make the fur look sufficiently bulky and three-dimensional. Start by putting in the darkest areas using long, flowing brushstrokes that follow the direction in which the hair grows. Then add the mid tones and finally the highlights. Don't be afraid to wipe off the paint if you make a dark mark in the wrong place – that's the beauty of working in oils. You may be surprised at how dark the dark

areas really are; be prepared to go over them again once you've put in the mid and light tones and are able to assess the tonal values of the painting.

Work wet into wet, so that you can smooth out the transition between one tone and the next and avoid making any harsh lines. If you find that the alkyd paint is drying too quickly, go over the initial colour again so that you can blend subsequent colours wet into wet in to the edges of the first colour. (Unlike watercolour, applying a second layer of the same colour of paint will not create a darker tone.)

Remember that your aim is to create a general impression of the fur: even with the finest brushes in the world, and an unlimited amount of time and

patience, you couldn't possibly paint every single hair. (The coat of a Siberian tiger, for example, contains about 3000 hairs per square inch!) And don't worry about placing each hair exactly: this is not intended to be a photo-realistic interpretation.

It's also worth spending time on the mouth and teeth, as that is what this painting is all about. Teeth are never just one colour and, although the differences in tone between one part of a tooth and another may be very slight, these differences are what give the teeth their form and make them look so fearsome. Similarly, the lips and gums have small highlights that, if captured accurately, will help to make the mouth look rounded.

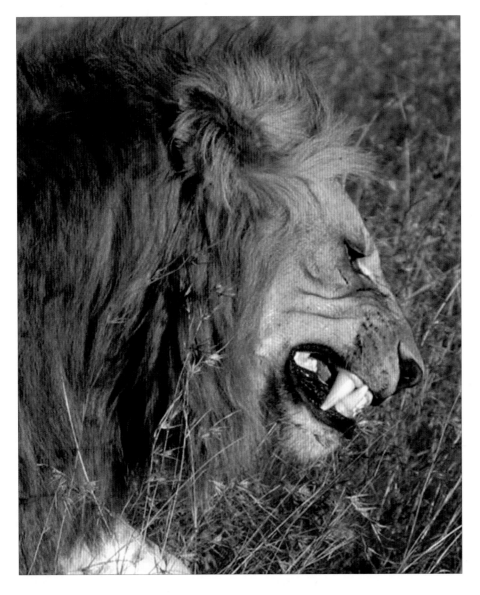

Materials
- *Stretched oil canvas*
- *4B pencil*
- *Alkyd oil paints: cadmium red, titanium white, burnt umber, lamp black, brown ochre, chrome green, cadmium yellow medium, raw umber, yellow ochre, alizarin crimson, ultramarine blue, cadmium orange*
- *Brushes: selection of small rounds and filberts, rigger (or old round brush with just a few hairs)*
- *Low-odour thinner*
- *White spirit (paint thinner) for cleaning brushes*

The subject
With his massive jaws and dagger-sharp teeth, there's no mistaking the strength and power of this lion. The low viewpoint makes the viewer feel almost a part of the scene. Here, the animal is well camouflaged against the background; however, the artist decided to intensify the greens of the grasses in his painting in order to make the lion stand out more. Pay particular attention to details such as the dots of the whiskers: each lion has a specific pattern of whiskers, just as every human has his or her own fingerprint, and this pattern can be used by scientists to identify particular animals.

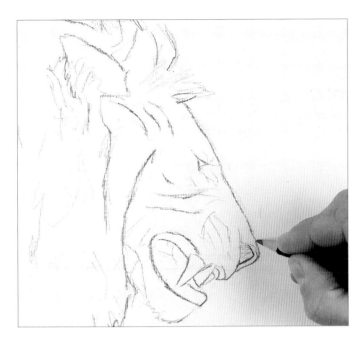

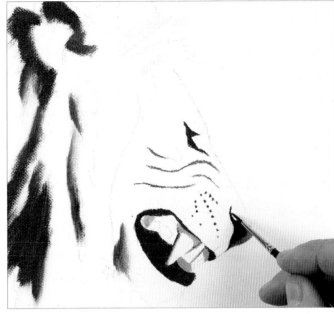

1 Using a 4B pencil, lightly sketch the lion. The benefit of using a soft pencil is that it's easier to rub out if you make a mistake. Look at how different features align and use these as points of reference: here, for example, the eye is roughly in line with the outermost point of the lower lip, and the foremost point of the ear aligns with the base of the mane.

2 Using a small round brush, paint the pink of the nostrils and gums in a mix of cadmium red and titanium white. Mix a very dark brown from burnt umber and a little lamp black and put in the darkest marking of the fur, the facial markings and the dots for the whiskers. Add more black for the nose, the lips and the inside of the mouth.

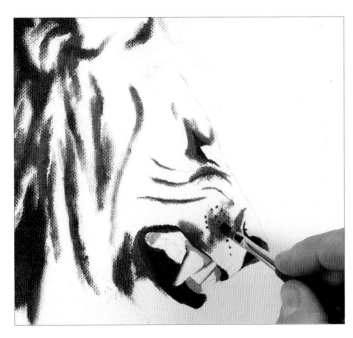

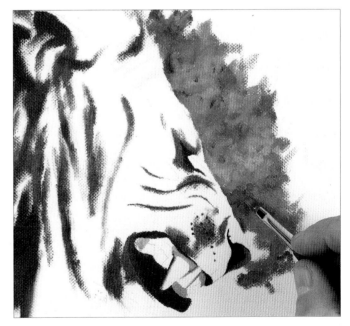

3 Mix a slightly lighter and redder brown from brown ochre and burnt umber and, using a small filbert brush, pick out the dark areas of the mane. Alternate between this mix and the dark brown from the previous step as necessary, Apply the paint quite roughly, using vertical strokes that follow the direction in which the hair grows. Allow the key triangle of the face – the eyes, nose and mouth – to dry, so that the paint cannot be moved wet into wet when you start to paint the fur on the face.

4 Mix a dark, olivey green from chrome green, cadmium yellow medium and raw umber. Using short, vigorous strokes, scumble on the background colour varying the proportions of the colours in the mix and adding a little yellow ochre in parts to create some tonal variation. Don't attempt to create any texture at this stage – simply try to see the background as random blocks of colour.

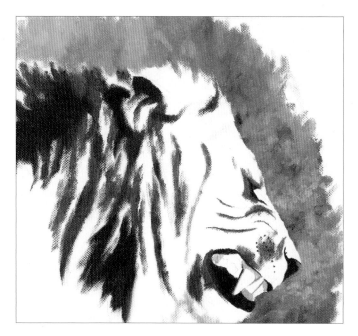

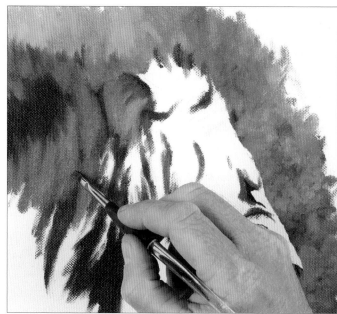

5 Continue with the background, creating a 'vignette' effect around the head. Make the background slightly darker at the base and lighter (with more yellow ochre) at the top. Try not to clean your brush when painting the background; you'll get a more random and spontaneous effect. If you do clean it, make sure it's completely dry before you apply more paint – otherwise the solvent will thin the paint too much and cause the colours to blur uncontrollably.

6 To create the mid tones, add titanium white to the burnt umber/lamp black and brown ochre/burnt umber mixes from Steps 2 and 3, and yellow ochre to the brown ochre/burnt umber mix. While the first colours you put down for the mane are still wet, put in these mid tones, blending the colours smoothly wet into wet so that you do not get any hard edges and making your brushstrokes follow the direction in which the fur grows.

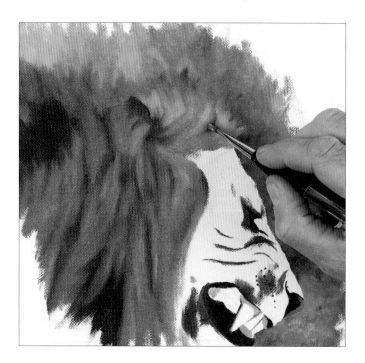

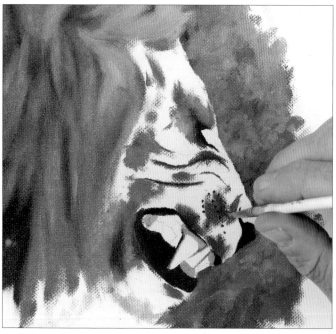

7 Continue working on the mane, blocking in a base colour over which you can then begin to develop more texture. Use broad, flowing brushstrokes to suggest the thick clumps of shaggy hair.

8 Using mid-toned mixes of raw umber and a little white and a small round brush, dab the paint onto the face, varying the tones as necessary. Dab with a stippling motion: the fur in this area is quite short and flat, and stippling creates a velvet-like texture that gives the impression of short, individual hairs without attempting to show every single one.

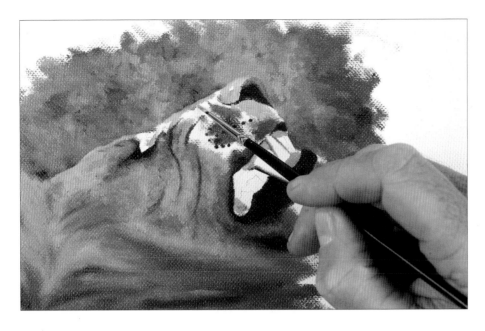

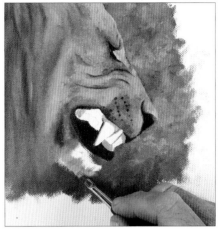

9 Continue stippling mid and pale tones on to the face, working up to – but not over – the dark markings that you put down previously and making sure you don't blend the different fur colours together too much. If necessary, touch in the dark folds in the skin with the dark brown mix from Step 2, using a thin rigger brush so that you don't lose them. Turn the painting around or even upside down as you work to avoid smudging wet paint with your painting hand.

10 Using a small filbert brush, scumble over the background at the base of the image again if necessary, making it slightly darker than before so that the lion stands out. Mix a greenish grey from titanium white, lamp black and raw umber and scumble it over the chin. (This grey picks up some of the background colour and helps to unify the picture.)

Assessment time

The mane and face have been blocked in and from this point onwards you can concentrate on refining those all-important details. Here, the mane is predominantly dark and mid tones; adding highlights will improve the feeling of depth and volume. Adding another layer of stippled colour to the face will also give it more texture and tonal contrast. The fearsome-looking teeth and mouth require most work, as this area is the main focus of the painting.

The mane needs to have more depth; this can be achieved by adding more highlights to contrast with the dark and mid tones.

The face looks a little flat because the tones are too similar; by increasing the tonal contrast, and adding another layer of stippled paint to create more texture, you can improve the modelling in this area.

The teeth have not been painted at all and are too stark and white; assess the shaded areas and highlights very carefully to make the teeth look rounded and three-dimensional.

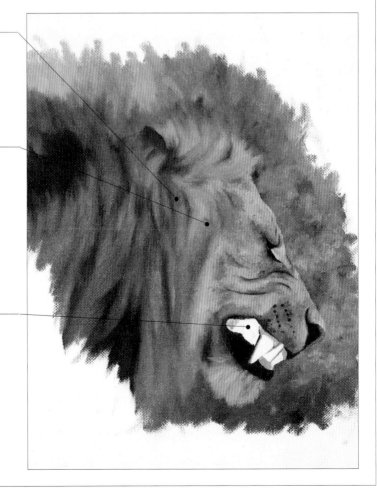

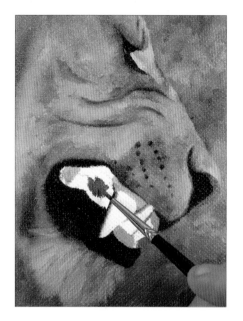

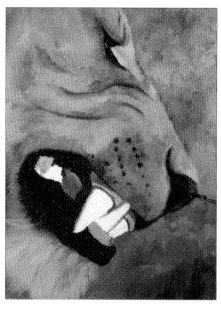

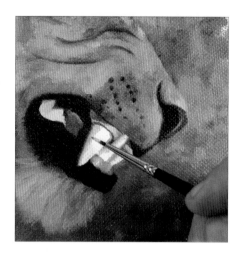

11 Using a fine round brush, paint over the gums and around the edge of the mouth in a mix of lamp black with a little burnt umber, blending the colour into the wet paint that you applied previously so that there are no hard edges. Mix a bluish purple from alizarin crimson and ultramarine blue and paint the underside of the curled tongue.

12 Where the gums are in shadow – directly under the upper lip, for example – go over them in the same purple mix used for the tongue. Use the same colour for the nostril, blending it into the surrounding black so that the nostril appears rounded. These are very subtle adjustments, but they are important in creating a sense of the form of the mouth.

13 Using a slightly paler version of the cadmium red and white mix that you used for the initial gum colour in Step 2, paint the highlights on the gums and nostrils. Mix a very pale orangey brown from cadmium red and cadmium orange and put in a fine line along the left-hand edge of the teeth to begin to create some modelling. This colour should be so pale that it is barely perceptible. Add white to the orangey-brown colour already on the brush and brush this over the rest of the teeth. Then apply any highlights on the teeth using pure white.

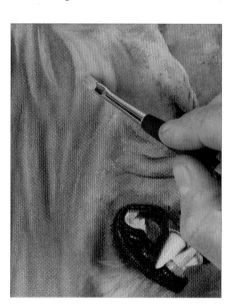

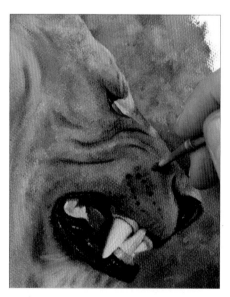

14 Mix a light-toned brown from yellow ochre, brown ochre and raw umber and, using a small filbert brush, put in the highlights on the mane to add more texture and increase the three-dimensional feel. Hold the brush almost vertically and make flowing, calligraphic strokes that follow the direction of the hair growth.

15 Go over the face again, using the same colours and stippling action as before. Now that the underlying paint has dried, this stippling gives the effect of short fur; if the underlying paint was still wet, the broken brush marks would merge together on the canvas and much of the textural effect would be lost.

16 Mix a pale, yellowy green from yellow ochre, a little of the green mix used on the background and lots of white. Using a very fine brush, draw in some of the individual grasses in the foreground to create some texture and visual interest. Note that the grasses are not constant, unbroken lines: occasionally, where the grasses are bent or turn into the shade, the lines break.

The finished painting

This 'portrait' really captures the strength and ferocity of the animal as the viewer's attention is drawn to those razor-sharp teeth and powerful jaws. It is also a skilled demonstration of how to paint both long and short fur, with the artist exploiting the potential of the medium by working both wet into wet to create the long flowing mane and wet on dry for the velvet-like texture of the short fur on the face. Note how the background has been painted a darker green than it was in reality, in order to allow the lion to stand out.

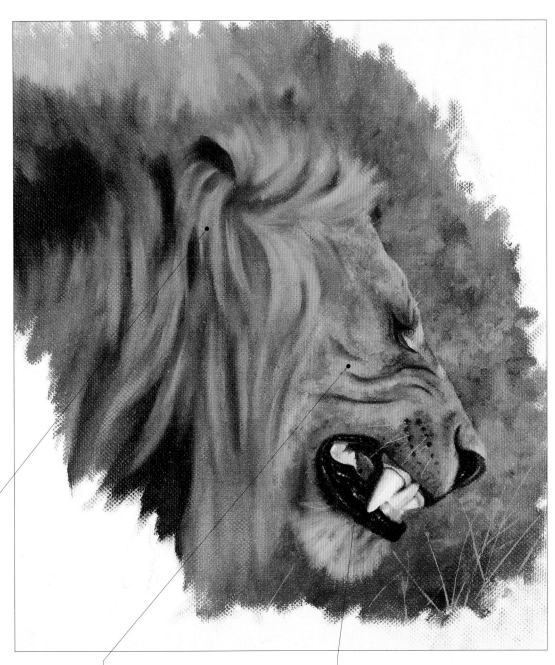

Flowing, calligraphic brushstrokes and the careful blending of tones wet into wet create the long fur of the mane.

The facial markings are allowed to dry completely before the fur is painted, so that they retain their shape.

Subtle highlights on the lips and gums and barely perceptible shading on the teeth make the mouth look rounded and the teeth three-dimensional.

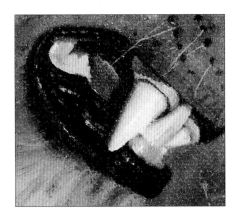

Elephant in charcoal and pastel pencil

In this demonstration, the artist used charcoal for most of the drawing, with the addition of black and white pastel pencils for the very darkest areas and the highlights. She worked on a grey pastel paper, which enabled her to use the colour of the support for the mid tones in the subject – a traditional technique in pastel drawing.

This project is really an exercise in assessing tone. You may find that it helps to half-close your eyes when looking at the scene, as this makes it easier to see the differences and transitions between light and dark without getting distracted by the detail of the subject.

Although it might seem tempting to begin by drawing the elephant in outline, simply to establish the shape,

it is worth noting that some parts – the right flank and right side of the head for example – are very brightly lit. Were you to enclose such areas with a dark outline, the impression of strong side lighting would be lost. It is better to draw the outline only in those places where a dense, dark line is appropriate (the edges of the ears, for example) and to block in the rest with approximately the right tone, using your fingers to blend and move the pigment around on the paper and position it in the right place.

Materials
- *Grey pastel paper*
- *Thin willow charcoal*
- *Pastel pencils: black, white*
- *Kneaded eraser*

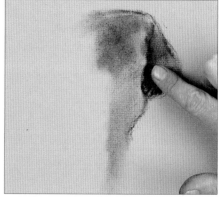

1 Using thin willow charcoal and working on grey pastel paper, which approximates to the mid tones in the subject, begin sketching the elephant. Instead of adopting a linear approach and drawing the whole animal in outline, try to see this as a tonal study from the outset. Work your way gradually around the elephant: very lightly map out the position of the head and the animal's left ear and then block in the dark tones with the side of the charcoal before blending the pigment on the paper to get a smooth coverage.

Tip: Measure carefully and make sure that you can fit the full width of the elephant on the paper, with room to spare on either side. You may find it helps to make small dots on the paper to mark the widest points – the tips of the ears.

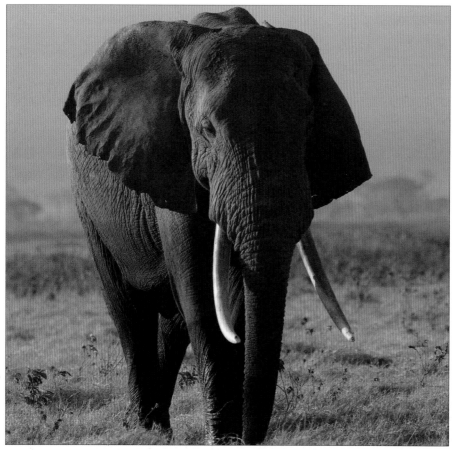

The subject
This is a dramatic viewpoint, with the elephant looking directly at the viewer. The light comes from the left, picking out textural detail in the skin on one side of the animal while leaving the right-hand side largely in shadow. Had the light been the same on each side of the animal, the texture would be less evident.

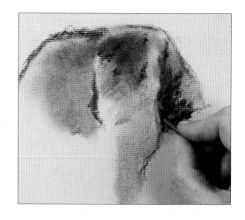

2 Continue mapping out the elephant by adding the right ear and the trunk, and scribbling in the very darkest tones with the tip of the charcoal.

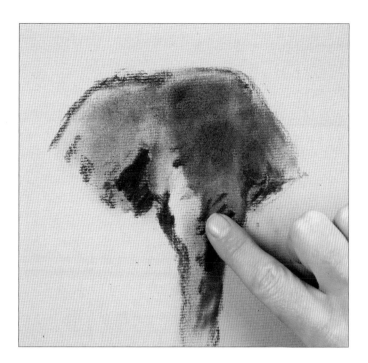

3 Work down the trunk, scribbling in the darkest tones and blending them with your fingertips as you go. You are, in effect, drawing with your fingers to establish the different tones and begin to develop a sense of the form of the animal.

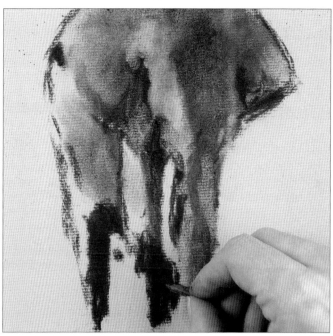

4 Add the body and legs, always assessing the tones carefully and blending the charcoal marks as you go. Note that the lower legs are much darker than the rest of the animal, as they are covered in mud, so you can scribble quite hard with the charcoal. The tusks are relatively thin and you may find it hard to draw them precisely; instead, define their shape by blocking in the legs around them – by using the negative shapes, in other words.

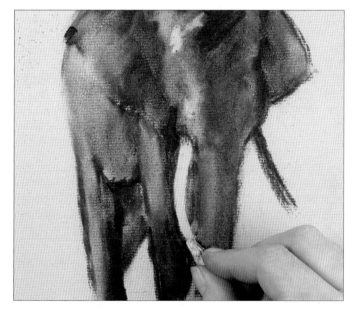

5 Blend the charcoal marks on the legs, as before. Note that the inside edge of the right back leg is darker than the left back leg; this difference in tone makes it clear which leg is in front. Pull a small piece of kneaded eraser to a fine point and wipe it over the tusks to reveal the colour of the paper.

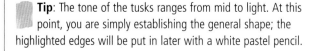
Tip: The tone of the tusks ranges from mid to light. At this point, you are simply establishing the general shape; the highlighted edges will be put in later with a white pastel pencil.

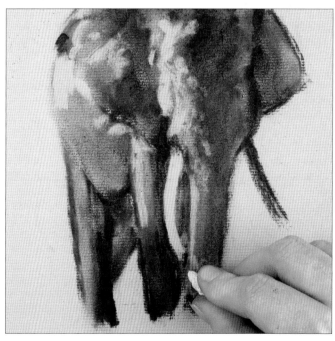

6 Use the eraser to wipe off pigment and create more mid tones on the head and down the highlighted side of the trunk, twisting and rolling the eraser in your fingers as necessary to create a point so that you can make a range of curved and straight marks with it.

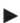

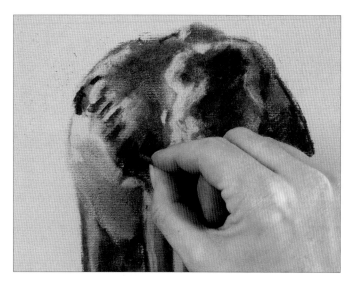

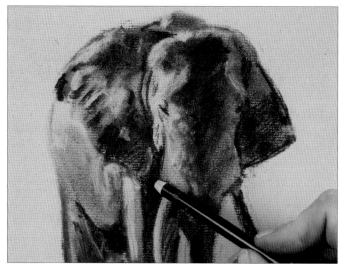

7 Using the tip of the charcoal, put in the dark folds in the ears and blend the marks as before, so that you gradually begin to build up the textural detail.

8 Scribble in the dark tones on the trunk, avoiding the tusk. Using a black pastel pencil, put in the eyes and some of the very dark fold lines around the eyes. Still using the pastel pencil, hatch in the shaded sides of the right tusk and the elephant's right foreleg.

Assessment time

By this stage, the main areas of dark and mid tone have been established and we are beginning to get a sense of the form of the animal. From this point onwards, you can concentrate on putting in the highlights, which will make the subject look really three-dimensional and will also give the impression of strong sunlight, enhancing the mood of the scene. Before you put in the highlights, take the time to make sure that all the dark and mid tones are where they need to be. (Remember that the highlights will be put in with white, whereas the mid tones are created by wiping off pigment to reveal the grey of the paper.)

Textural detail – the folds in the elephant's skin and the grasses in the foreground – is also important in this scene. However, it's very easy to get carried away and put in so much detail that you lose sight of the drawing as a whole. Your aim should be to create a general impression rather than to put in every single line. You also need to put in the foreground in order to 'anchor' the animal in the picture space.

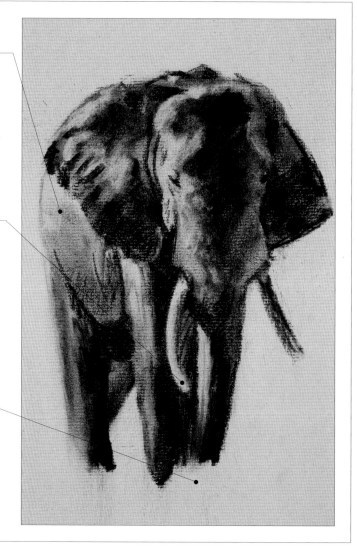

The elephant's skin looks too smooth; putting in the highlights in the folds of skin will create the necessary texture.

Pigment has been wiped off to reveal the mid tones of the tusks. Adding a highlight along one edge will make the tusk look three-dimensional.

Adding the foreground will 'anchor' the elephant in the scene.

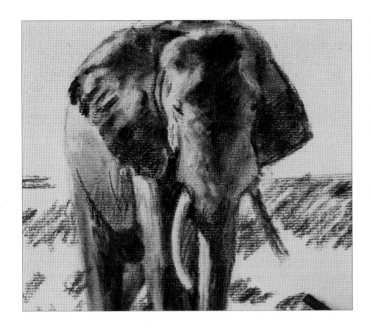

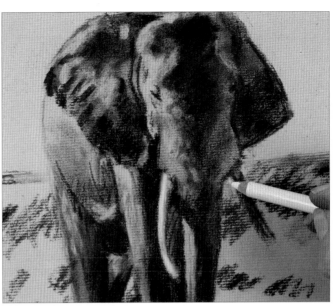

9 Using the charcoal, put in the horizon line and then smudge it with your fingertips to soften it. Scribble in the clumps of grasses in the foreground. There's no need to try to include every single one – a general impression will suffice.

10 Using a white pastel pencil, put in the highlighted edges of the tusks. Remember that it's only the edge that is highlighted: if you make the whole tusk white, it will not look rounded.

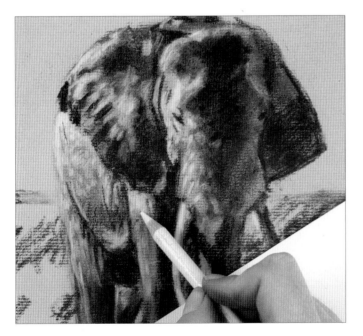

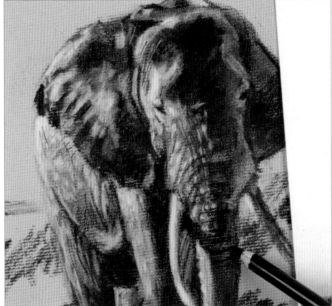

11 Using a white pastel pencil, put in the highlights on the head and right flank, to create some texture in the folds of skin. Vary the amount of pressure you apply to the pencil, depending on how bright you want the highlights to be. These highlights are the edges of the skin creases, which catch the light.

12 Using the black pastel pencil, lightly put in some textural markings on the flank, right foreleg, head and trunk – the deep creases and folds in the skin. Note that there is no real 'line' around the edge of the brightly lit flank. If you put in a dark outline, you would not be able to get rid of it.

Tip: Place a piece of scrap paper over the part of the drawing that you're not working on, this will help to prevent you from accidentally smudging it with your drawing hand.

Tip: Don't press too heavily on the pencil: you need to put in some light markings first to assess exactly how deep and dark these creases and folds in the skin need to be.

▶

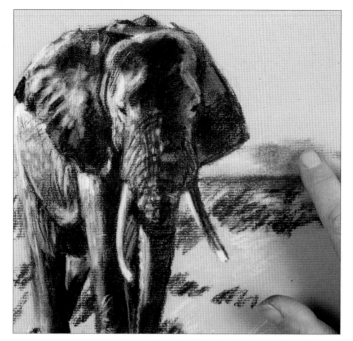

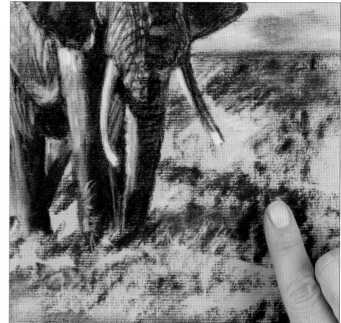

13 Using the white pastel pencil, lightly scribble in some light tones in the foreground. Using the side of the charcoal, block in the shapes of the mountains in the background, then blend the marks with your fingers.

> **Tip**: Make sure that you make the background mountains lighter in tone than the foreground, as this helps to create an impression of distance.

14 Using the side of the charcoal, roughly block in the mid tones in the foreground, leaving the earlier marks for the clumps of grass showing through and leaving some gaps for the lighter parts. Blend the marks with your fingertips. Note that the elephant's body casts a shadow on the grass; this area needs to be darker than the rest of the foreground.

> **Tip**: It is easier to assess the tones if you half-close your eyes.

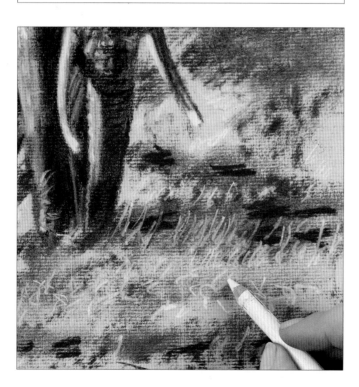

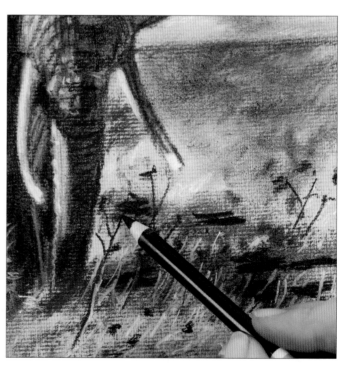

15 Using a white pastel pencil, scribble in only the most brightly lit grasses.

16 Using the black pastel pencil, put in some of the tall, dark grasses to add more texture in the foreground.

The finished drawing

This deceptively simple-looking charcoal study is full of interest. By carefully observing the different tones, the artist has created a real feeling of the bulk and solidity of the animal. The skin textures are convincing, but not overworked or fussy. The bright light on one side gives an impression of the strong African sunlight and contributes to the overall mood of the scene. The surroundings have been kept simple, so as not to detract from the elephant, but there is enough detail to place the animal in a recognizable environment and create an impression of scale and distance.

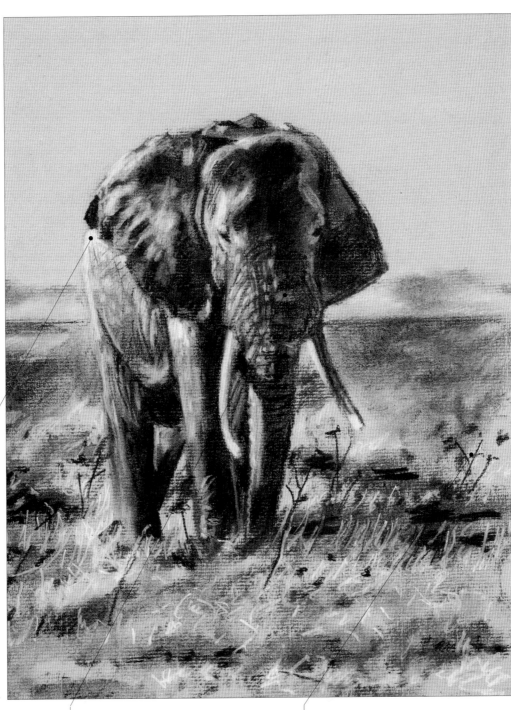

Note how the absence of a dark outline around this area conveys the feeling of strong sunlight hitting the animal.

The contrast between deep, dark creases and sharp, highlighted edges beautifully conveys the texture of the elephant's skin.

The contrast between the textured foreground grasses and the smooth background creates a sense of distance.

Tree frog in gouache

With its emerald green head and back, bright blue inner legs, orange toes and huge, comically bulging eyes, the red-eyed tree frog is tremendously appealing to paint.

You can see from the photograph on the right how well the green coloration of the frog blends in with the foliage on which it spends much of its life. Your main challenge here is to create subtly different tones of green so that the frog stands out sufficiently from the background. Careful assessment of the tones and colour mixes is essential; test your mixes on a piece of scrap paper before you apply them.

Here the artist elected to use a beginner's 'starter set' of ten gouache paints. The set included just one ready mixed and relatively dark green, so virtually all the greens had to be mixed from scratch. This is a really useful exercise; why not try to see how many different greens and tones of green you can mix from the colours in your own set of paints.

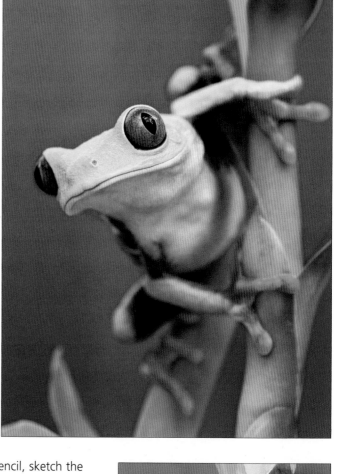

Materials

- *NOT or cold-pressed fine-grain watercolour paper*
- *6B pencil*
- *Gouache paints: permanent green, permanent yellow deep, yellow ochre, zinc white, primary yellow, primary blue, spectrum red, primary red, ivory black, ultramarine*
- *Brushes: selection of rounds and flats*

The subject

The most important thing with this subject is to take note of how many different tones and shades of green there are, from blue-tinged greens near the base of the main stalk to yellowy greens in the more brightly lit upper sections and the pale green of the frog's body.

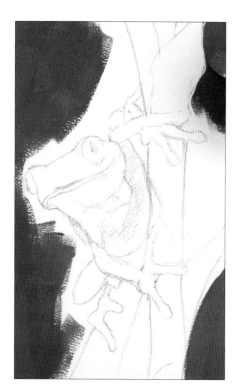

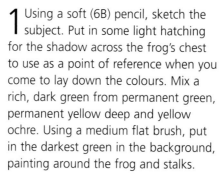

1 Using a soft (6B) pencil, sketch the subject. Put in some light hatching for the shadow across the frog's chest to use as a point of reference when you come to lay down the colours. Mix a rich, dark green from permanent green, permanent yellow deep and yellow ochre. Using a medium flat brush, put in the darkest green in the background, painting around the frog and stalks.

2 Add white and a little primary yellow to the background mix to make a paler green, and put in the mid green of the leaves. Add more yellow as you work towards the top of the stalks. Mix a pale blue from primary blue and white and put in some of the blue-tinged leaves at the base of the stalks. Add blue to the dark green mix from Step 1 and put in the dark green of the curled, shaded leaves.

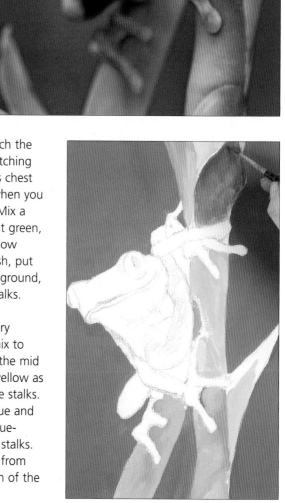

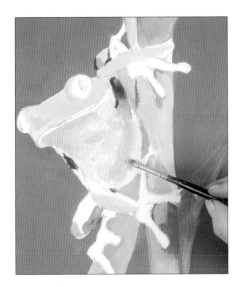

3 Using a paler version of the green from Step 2, block in the green of the frog. Add primary yellow for the edges of the arms. Mix a purple from spectrum red and primary blue and put in the most darkly shaded parts of the frog's body. Add white and scrub this colour on the frog's chest, leaving the highlights white. Mix a pale pink from spectrum red and white and paint the shadow on the frog's chest.

4 Parts of the feet and 'hands' are more pink than orange; paint them with a pink mixed from primary red and white. Mix a bright orange from permanent yellow deep, primary red and a little primary yellow and paint the orange parts of the feet and hands, blending the orange into the pink so that there are no hard-edged transitions between the two colours.

5 Mix a rich orange from spectrum red and permanent yellow deep and paint the orange of the eyes, leaving the pupils untouched. Apply pure ivory black for the pupils, leaving a tiny highlight in the left pupil untouched.

6 Parts of the frog are a surprisingly bright and rich blue. Mix ultramarine blue and primary blue together to create this colour and touch in this blue wherever necessary on the arms and legs. If you want a paler blue, add water rather than white. If you add white, you won't get the degree of brightness that you require.

7 Using a slightly darker version of the purple and white mix from Step 3, put in the shadows under the toes, fingers and mouth and across the chest.

▶

Assessment time
The painting is nearing completion and it's time to step back and work out what final refinements are required. The background and foliage are complete, but the frog still looks rather flat and one-dimensional – almost like a cartoon caricature. Putting in highlights on the head and shadows under the mouth and across the chest will make it look more three-dimensional and lifelike.

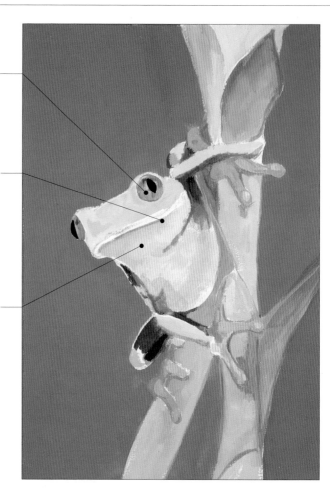

With no highlight, the eye looks dull and lifeless.

Shadows are needed under the upper lip and chin to make the mouth appear three-dimensional.

More modelling is required on both the head and chest.

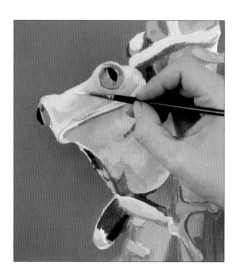

8 Add lots of white to the pale green mix from Step 2 and, using a fine round brush, put in the lightest tones on the frog's head, so that you begin to create more modelling in this area.

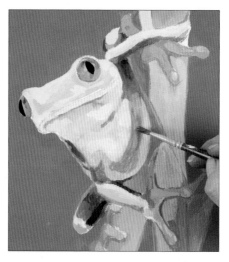

9 Mix a very pale yellow from permanent yellow deep and white and put in a line under the mouth. Use very dilute white for the highlights on the body to create more modelling. Apply fine lines of blue to the edges of the frog's legs and some of the leaves to make the edges recede. Deepen the colour of the pink shadow on the chest.

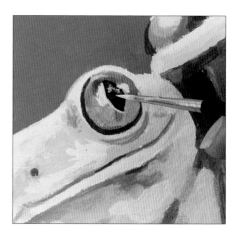

10 Strengthen the purple shadow under the mouth and across the chest. Using the same pink and orange mixes as before, improve the modelling on the arms and legs. Paint around the inside edge of the eyeballs in black. Note that this black line does not go all the way around the eye, but only halfway: only part of each eyeball is visible. Add the highlight in the left eye, using white.

The finished painting

This is, at first glance, a deceptively simple-looking painting, but it requires very careful observation of the tones in order to look convincing. It is normally not recommended that a subject is placed in the very centre of the picture space, but here the approach works; it imparts a feeling of calm to the composition. Note how the artist has slightly exaggerated the tonal differences in the greens – a bit of artistic licence that is essential in order for the stalks and the frog to stand out from each other and from the dark green background. The highlights and shadows on the frog are subtle, but make it look really three-dimensional.

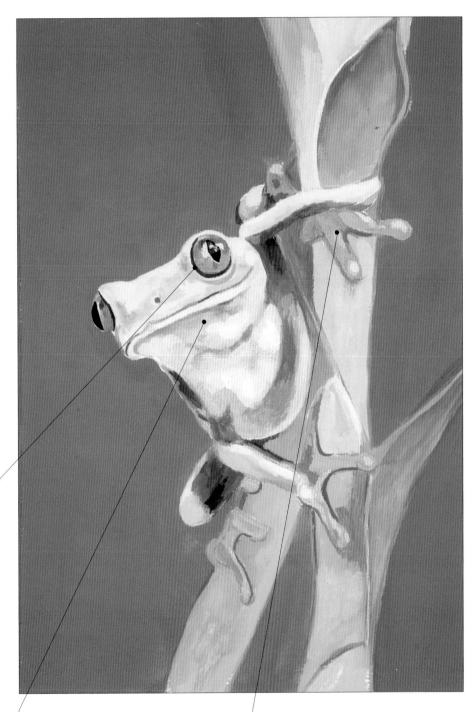

The black line around the rim and the highlight in the centre of the eye are vital in bringing the subject to life.

Shadows on the chest and under the chin reveal the form of the frog's body.

Note the shadows and highlights on the feet – essential to making the frog look three-dimensional.

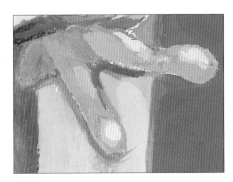

Tortoise in mixed media

Tortoises and turtles have striking and often quite intricate shell markings. As they age, ridges are formed on the shells in much the same way as growth rings form year by year in a tree. Along with scuffs and scratches acquired along the way, these ridges create fascinating textures that are a delight to draw and paint. This mixed-media demonstration combines watercolour and oil pastel, together with several textural techniques.

Watercolour washes in the initial stages provide a warm undercolour, with oil pastel being stippled on top for the scales on the animal's head and legs. The ridged highlights on the shell are created in two ways. First, masking fluid is used to preserve the white of the paper. Second, in a variation on the traditional sgraffito technique, lines are carefully incised into the paper and then it is covered with oil pastel; the oil pastel adheres to the surface of the paper but not to the incised lines, creating thin lines for the ridges on the tortoise's shell. It's absolutely vital that you are not heavy-handed: if you

scratch too vigorously you will tear the paper, and if you press too heavily on the oil pastel, the pigment will sink into the incised lines.

Do not attempt to put in every single line, highlight or scratch that you can see – otherwise you'll get bogged down in a plethora of detail and will lose sight of the painting as a whole. Instead, aim to create a general impression of the lines and textures, and treat the subject in quite a loose way. Above all, keep looking at your painting as a whole throughout the process, so that you do not fall into the trap of overworking one part at the expense of the rest.

Materials
- *Watercolour paper*
- *HB pencil*
- *Masking fluid with applicator (or old brush)*
- *Watercolour paints: cadmium yellow, yellow ochre, indigo, alizarin crimson*
- *Brushes: medium round, fine round*
- *Oil pastels: dark grey, blue-grey, pale grey, off-white, yellow ochre*
- *Scraperboard tool*

1 Using an HB pencil, lightly sketch the subject and begin marking in the triangular sections of the shell.

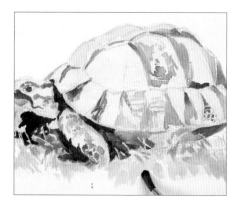

2 Carefully apply masking fluid over the highlit ridges on the shell and some of the paler grasses under the tortoise's body and leave to dry.

3 Mix a dilute warm yellow from cadmium yellow and yellow ochre watercolour paints. Wash it over the tortoise and grass to give a warm-coloured undertone. Mix a dark blue-black from indigo and alizarin crimson. Put in the dark shadow under the shell and head, then paint in the dark markings on the head and shell. Mix a dark green from cadmium yellow and indigo. Put in the foreground grass, using jagged, spiky strokes.

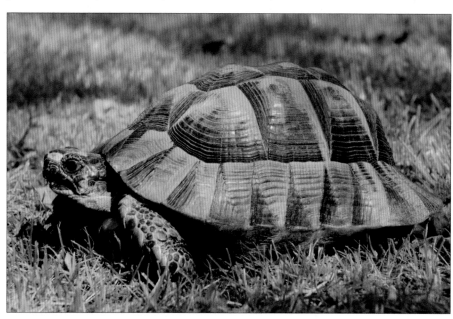

The subject
With relatively small animals such as this tortoise, your viewpoint can make a huge difference. Here, the artist crouched down in order to be able to view the tortoise more or less at eye level and from the side; as a result, the head, front legs and a small portion of the underbelly are all visible. This provides a more engaging image than an overhead viewpoint.

Assessment time

The watercolour stage of the painting is now complete, with the warm base colour and the dark areas of the shell and head applied as very light watercolour washes. From this stage onwards, you need to concentrate on developing the tonal contrasts, so that the shell looks three-dimensional, and on picking out the textural detail on both the shell and scaly head and legs.

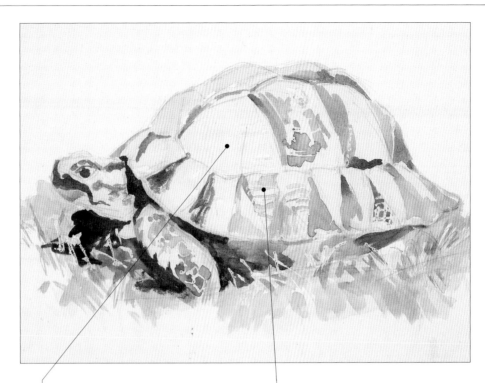

The different planes of the shell are not clearly defined.

The masking fluid preserves the white of the paper for the very brightest highlights on the shell.

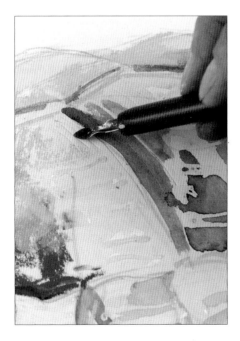

4 Using a scraperboard tool, scratch thin lines into the tortoise shell.

Tip: Use the back of the blade, so that you don't tear the paper.

5 Gently stroke dark grey, blue-grey, pale grey and off-white oil pastels over the scratches. The oil pastel will adhere to the surface of the paper but not to the indentations, leaving a series of thin, bright lines for the ridges on the shell.

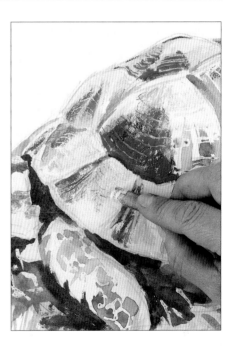

6 Continue using the scraperboard tool and oil pastels to create textural marks all over the shell.

▶

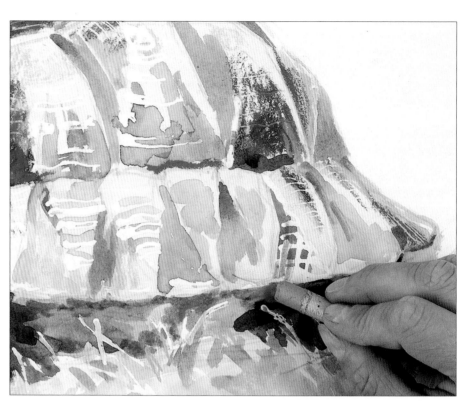

7 Using your fingertips, carefully rub off the masking fluid to reveal the white of the paper for the very brightest highlights.

8 Strengthen the shadow areas and paint the tortoise's back legs, using the blue-black colour mix from Step 3. Where the masking fluid has been rubbed off in the foreground grasses, touch in a watered-down version of the green colour mix from Step 3. Apply more warm yellow tone to the shell and underbelly using a yellow ochre oil pastel.

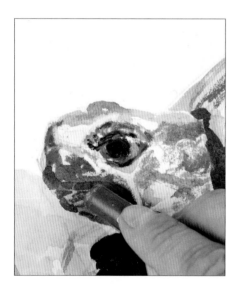

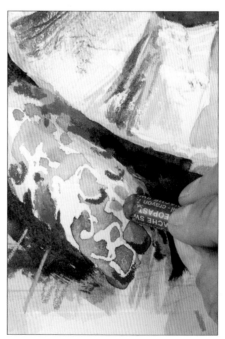

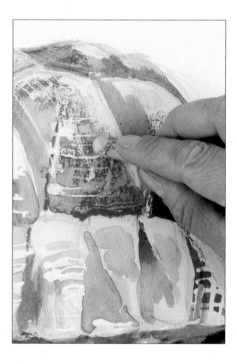

9 Colour the iris of the eye with a yellowy olive green oil pastel, remembering to leave some tiny flecks of white paper showing through for the highlights. Reinforce the detail on the head with grey and blue-grey pastels, paying careful attention to the tones to describe the different planes of the head.

10 The left front leg is a little too bright and distracting; stipple on dark grey pastel to tone down the brightness and create the scaly texture of the skin.

11 Using the grey oil pastels, tone down any overly bright areas on the shell.

The finished painting

This study exploits the translucency of watercolour and the smooth, opaque nature of oil pastels without allowing either medium to dominate. The ridges and scratches on the tortoise's shell add interesting textures to an otherwise simple painting. Note how well the artist has observed the light that reflects off both the scaly skin and the shell, indicating minor changes of plane; these highlights, created by using masking fluid to preserve the white of the paper, contrast with the darker tones to create a realistic and convincingly three-dimensional study.

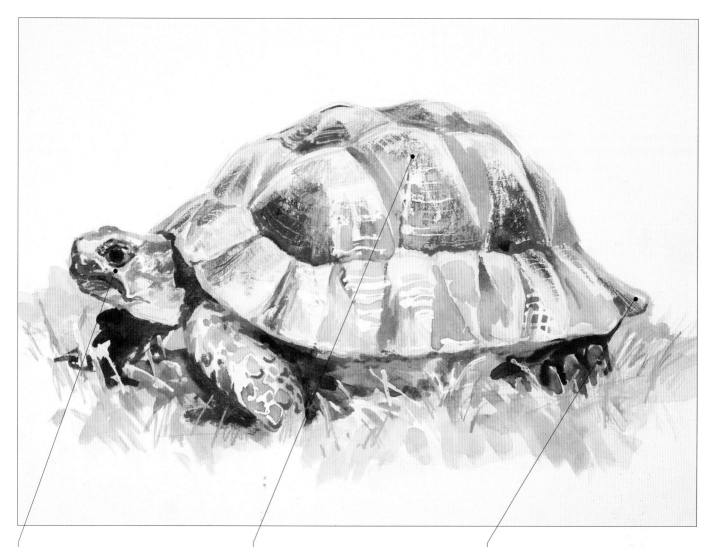

The head and eye are the focal points of the painting; had the eye been closed, the image would not have had nearly so much impact.

The highlights on the shell are created by using masking fluid and by scratching into the support.

The background has been deliberately left untouched, so as not to detract from the tortoise.

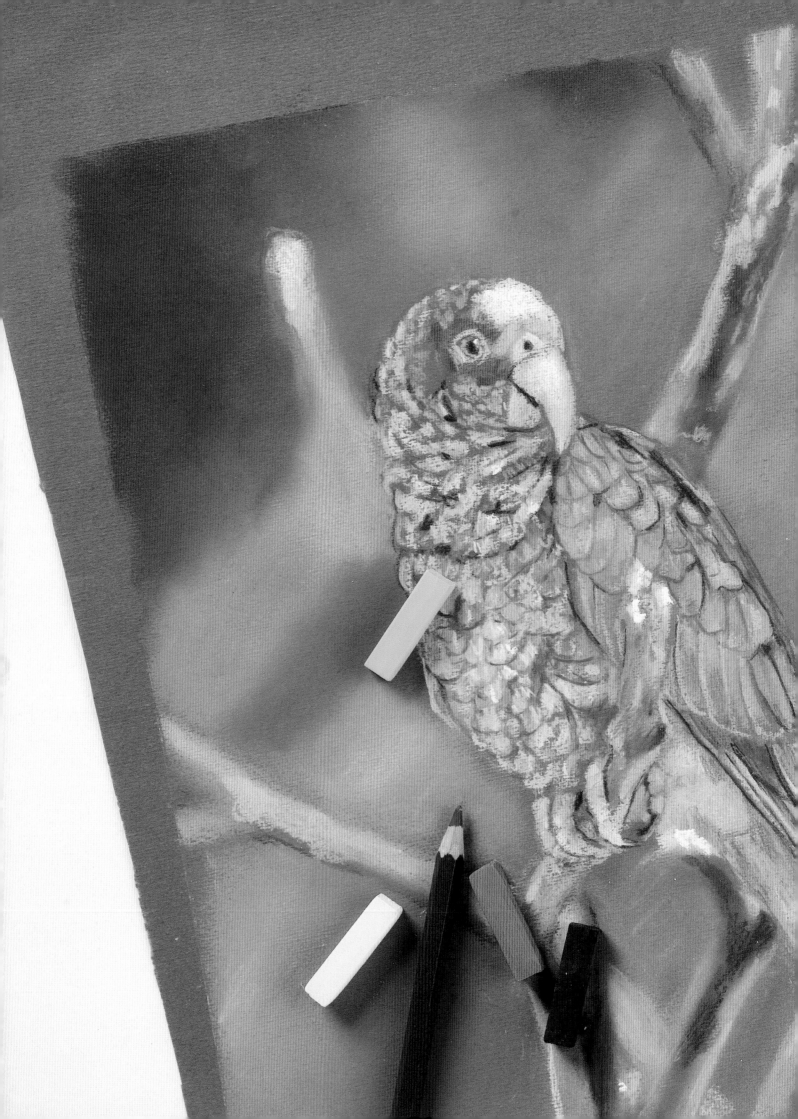

Birds, marine life and insects

The natural world is infinitely varied and, although you may never have considered painting something as apparently insignificant as a beetle from your garden, this chapter demonstrates the potential for finding fascinating subjects in even the most mundane of settings.

The chapter begins with a gallery of paintings, which gives you the opportunity to study the style and techniques of professional artists working in a number of different media. This is followed by a series of quick sketches – a great way of grabbing a few minutes' drawing practice when you're short of time.

Finally, there are fifteen detailed step-by-step drawings and paintings in all the main media, covering everything from farmyard chickens and wild pelicans to a vibrantly coloured butterfly. Copy them to hone your own skills, or simply study them closely to find out to how another artist (whose style may be very different from your own) has tackled the subject.

Gallery

From a large-scale oil painting of a flock of gannets to a finely detailed study of a bumble bee, this section features works by a number of professional wildlife artists and illustrators. Some of the paintings depict birds and insects that you may come across every day in your garden or local park, such as swans on a river or a butterfly that has alighted in a colourful corner of a summer garden. Others may surprise you: who would have thought, for example, that a disease-carrying mosquito would make such a beautiful subject for a drawing?

The purpose of this section is to inspire you to experiment with both subjects and techniques that you may not have previously considered. Take the time to study these drawings and paintings carefully and see what you can learn from them. If you like an artist's style, try to work out what it is that appeals to you; similarly, think about why you may find other paintings less appealing. All these things will help you gradually to develop your own artistic style and vision.

Robin – **Paul Dyson** ▼

A wide, panoramic format has been chosen for this painting of a robin on a branch. At first glance, it might seem that the subject is quite insignificant and does not warrant such an extreme format, but exaggerating the width of the painting has introduced a tension that would be lacking if the more usual landscape format had been used. The clever device of the arching branch, which runs the entire width of the image, prevents the picture from appearing one-sided: the eye wanders along it and across the picture, but always returns to the brilliant flash of red on the robin's breast.

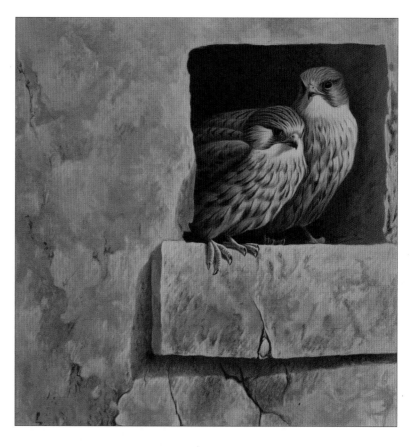

Common kestrels – **Jonathan Latimer** ▲

Placing the main subjects in the top right of the picture space is an unconventional composition, but here it suits the subject perfectly; as well as being a study of the birds themselves, it also tells us something about their nesting habits. Although the birds are almost the same colour as the stonework, they stand out well against the dark interior of the barn in which they are nesting and we can clearly see the difference in plumage between the male and the female. The stonework is loosely painted, but the texture of the walls is well conveyed.

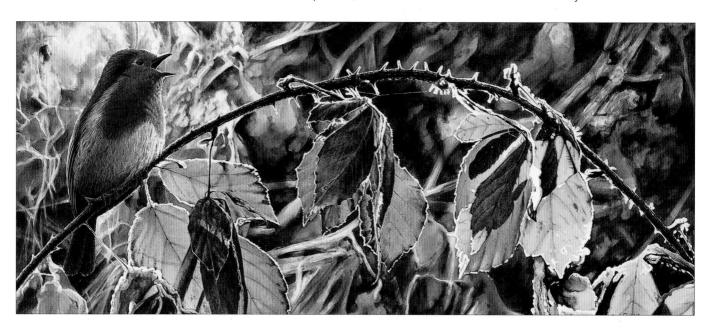

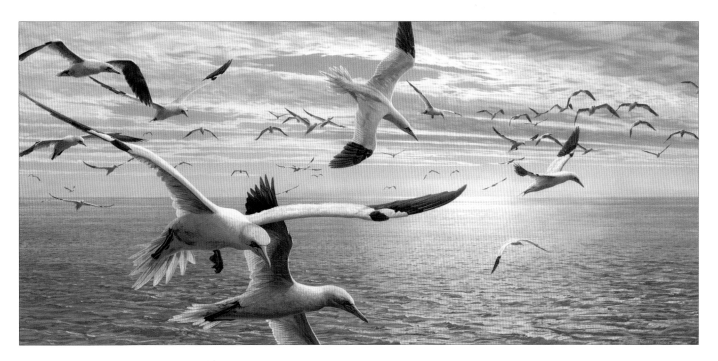

Over the shoal – Martin Ridley ▲

This large-scale oil painting of a flock of gannets has a wonderful sense of light, with sunlight sparkling on the water and the pink glow of a late afternoon sun reflected in the gently rippling waves. The birds in the distance are little more than silhouettes; only in the foreground birds can the true coloration of the feathers be seen. By deliberately excluding any land from the composition, the artist has created the feeling that the viewer is almost part of the flock, a feeling enhanced by the high viewpoint, which places the viewer virtually level with the birds.

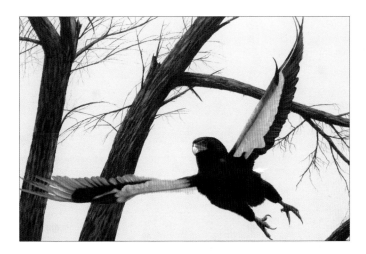

Bateleur eagle – Jonathan Truss ▲

This oil painting captures a precise moment during the bird's flight, when both wings are fully outstretched, allowing us to see the detail of the feathers. Note how the artist has used the branches of the trees to 'frame' the bird and direct our attention around the image: our eye is led up the second tree trunk, along the main branch and back around again in a kind of circle, which echoes the curving sweep of the bird's wings.

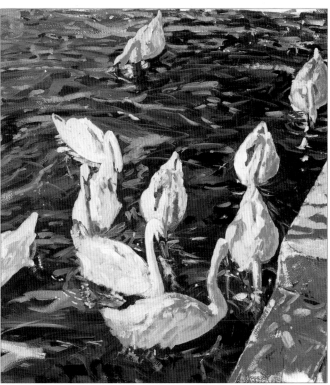

Swans – Martin Decent ▲

The ripples in the water and the sparkling sunlight give this gouache painting a lovely feeling of movement. Note how the artist has cropped out part of the two swans on the far left of the image: this enhances the feeling of movement, with the two birds moving out of the frame. The relatively high viewpoint, looking down on the birds from the river bank, makes this more of a pattern picture than a straightforward depiction of the swans. Although the birds are instantly recognizable, the painting also has a slightly abstract quality that is very appealing.

▶

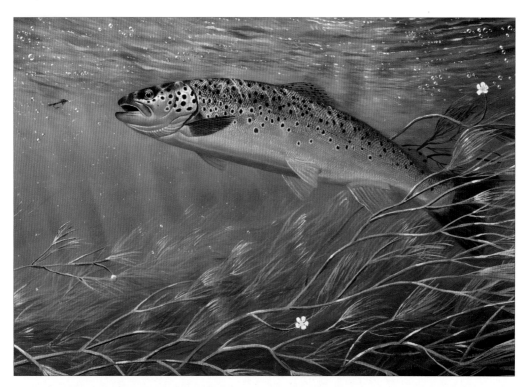

***Chalk stream trout –
David Miller*** ◄
This underwater painting
enables the viewer to enter
the fish's world. In contrast
with the sense of speed
shown in the marlin painting
(below), the artist has here
conveyed the gentle and
relatively slow-moving current
by showing how the
underwater vegetation is
bent by the flow of the water.
The base colour of the fish
itself was painted largely
wet into wet, allowing subtle
transitions of tone and
colour without any hard
edges, while the markings
on the skin were added once
the base colour was dry.

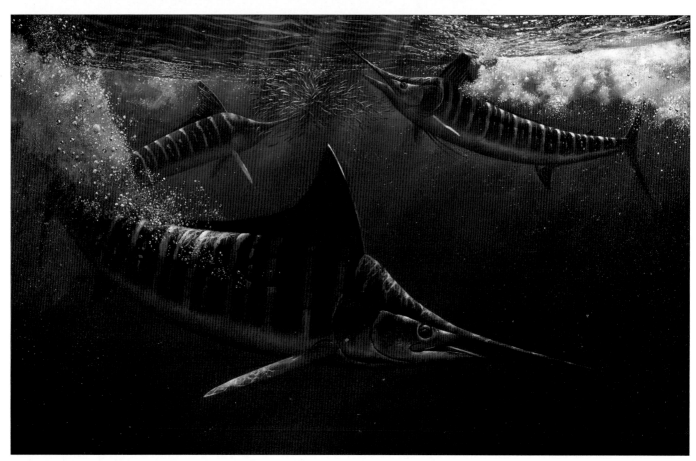

Marlin attack – David Miller ▲
Marlin are known to be incredibly fast swimmers, reaching
speeds of about 68 miles (110 kilometres) per hour, and the
white water in this painting, whipped up as the streamlined
fish hunt their prey, certainly conveys that capacity for speed.

The viewpoint, from just below the surface and level with
the fish, adds to the sense of drama. Note how the three
fish are arranged almost in a circle: this is a very effective
compositional device, which helps to lead the viewer's eye
around the image.

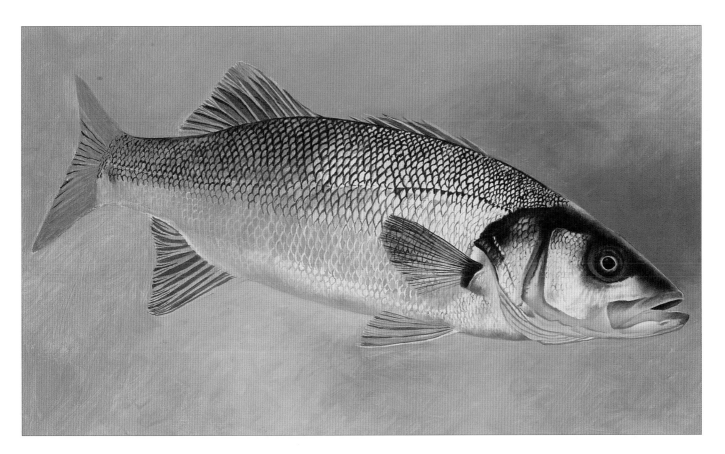

Bass study – David Miller ▲

This is a beautifully observed oil study of a saltwater bass. The silvery scales have been rendered in fine detail: note how the artist has made them appear three-dimensional, rather than as flat markings, by painting a slightly thicker line on one side than on the other. The background for natural-history studies such as this is often left white, but here it is a watery blue, with the proportions of titanium white and ultramarine blue being varied to add visual interest.

Turning fish – Timothy Easton ▶

This oil painting is, above all, a study of the effect of light on water. The fish are reduced to generalized shapes, their colours muted and their exact outlines distorted by the ripples; it is the ripples that convey the fact that the fish are moving. The artist's high viewpoint, looking directly down into the water, increases the semi-abstract quality of the work.

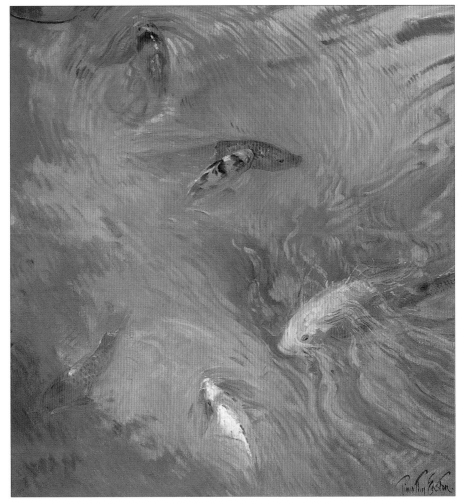

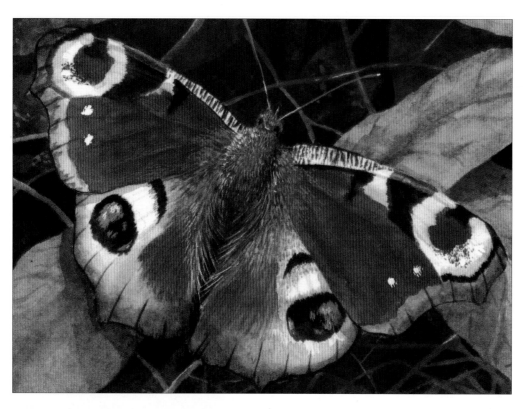

***Peacock butterfly –
Tracy Hall*** ◄
This watercolour painting measures only 9 x 6.5cm (3½ x 2½in), so the butterfly is almost life size and the amount of detail in its wings is incredible. Placing the insect on a slight diagonal adds visual interest; note how the angle of the wings (sloping downwards, from top left to bottom right) is counterbalanced by the line of the leaf on the right, just under the butterfly's right wing. The background foliage is quite muted in colour, so nothing detracts from the vibrant markings of the butterfly.

Secret garden (detail) – Tracy Hall ◄
At first glance, it might appear as if the artist has simply painted the brightly coloured flowers as she found them, with little thought for the composition, but in fact this is a carefully thought-out arrangement. The riotous profusion of flowers and overlapping shapes in the top two-thirds of the painting are offset by the relatively uncluttered foreground; had the whole image been as 'busy' as the top part, there would have been nowhere for the viewer's eye to rest.

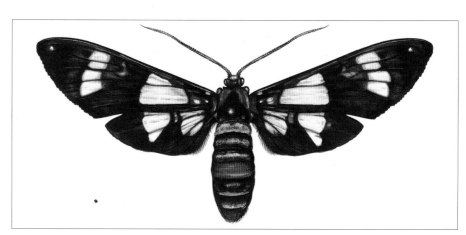

Basker moth – Jonathan Latimer ▲
Painted in acrylics on smooth white illustration board, this is a very traditional-style natural history illustration, the subject being viewed from directly overhead with its wings fully outstretched. Many moth and butterfly wings are covered in millions of tiny scales, arranged in partially overlapping rows, and one of the keys to painting them successfully is to have slightly wobbly lines where one colour changes into another, as the artist has done here. If you paint solid, straight lines, you will end up with something that looks more like a piece of stained glass than a real insect. Note how intense the tiny patches of iridescent blue are: if you find it hard to get anything near the right colour using acrylic paints, try using acrylic inks instead.

Asian tiger mosquito – Pat Ellacott ▶

One of the artist's aims is to make people look closely and see an inner beauty in something that is abhorrent, and this pencil and graphite drawing of a mosquito has a graphic quality that is very appealing. The solid mass of the head, body and wings is counterbalanced by the delicate spindly legs; note, in particular, how the legs and the spaces between them form jagged inverted V-shapes that help to give the drawing a wonderful sense of energy.

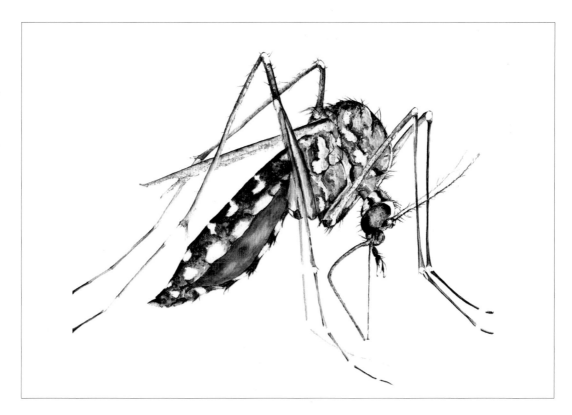

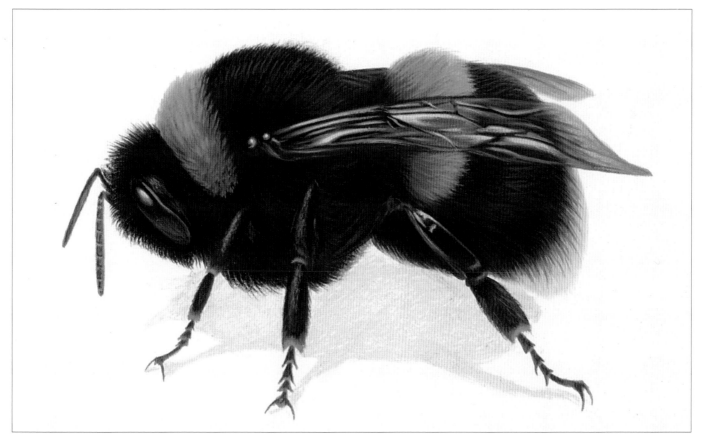

Bumble bee – Jonathan Latimer ▲

Painted on primed board that has been sanded down to give an absolutely smooth surface, this image has something of the feel of a traditional natural-history illustration – but what makes it different is the side-on viewpoint and the slight shadows under the bee's legs. Note how well the artist has captured the furry texture of the bee's body by 'flicking' tiny strokes of other colours in the yellow and black stripes to give the impression of lots of very fine hairs.

Quick sketches: Birds in flight

Most birds are designed for flight and it's only when they are in the air that one can truly appreciate their streamlined shape and wing structure. Before you make any sketches in the field, it's worth spending time studying a bird identification manual that includes the species you can expect to see in a given location. These books often contain silhouetted outlines showing the shape of the bird when its wings are fully outstretched; the leg and beak shapes are also useful clues when it comes to identifying a species.

Drawing or painting any kind of feather detail on a flying bird when you're working outdoors is a tall order, so you'll probably only manage very quick outlines and tonal sketches. However, it's still worth using the information you gather on field trips to make quick sketches back at home. Working quickly and setting yourself a time limit really forces you to concentrate on the essentials, without getting too caught up in the details of the feathers and coloration – and you may even find that your quick sketches have a spontaneity that more considered works are lacking.

The key to painting birds in flight is to capture them at exactly the right moment – and this is generally when the wings are at the highest or lowest point in the wing stroke. Anywhere in between and it's likely that the wing will appear to merge into the body, making it difficult for you to see exactly what's going on. Alternatively, if the bird you are studying is gliding on thermal currents with its wings fully outstretched, a viewpoint directly under (or from above) the bird will probably provide the best overall view.

But the whole point of making quick sketches is to sharpen your powers of observation and enable yourself to pick out the essentials of a given scene. Little by little, you'll gain the confidence to use your own artistic judgement, rather than relying on a photo: photos can capture the action, but the result may be too messy and confused to be useful as a source of reference.

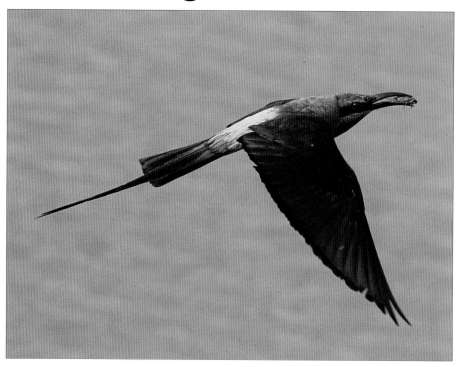

The subject ▲

The feathers of the carmine bee eater are vibrantly coloured, making it a wonderful subject for a painting. Here it has been photographed with its large wings at the end of their downward stroke.

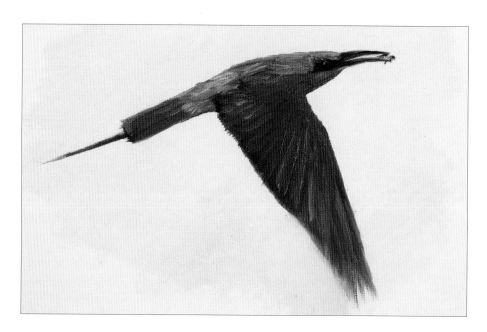

15-minute sketch: oils ▲

Don't be tempted to make all the red feathers the same tone: because of the way the light hits them, they range here from a relatively pale, almost pinky red on the bird's back to deep, rich purply reds on the wings. These colours were created by adding a little white to cadmium red for the pink tones, and by mixing alizarin crimson with a touch of manganese blue and black for the purple tones. Similarly, tiny strokes of titanium white were overlaid on the blue on the head and back to create the lighter tones.

The subject ▼
When birds are flying in a flock, it is often possible to photograph them at different stages of the wing motion in the same shot. Here we can see two pelicans, their wings at the highest and lowest points of the wing stroke.

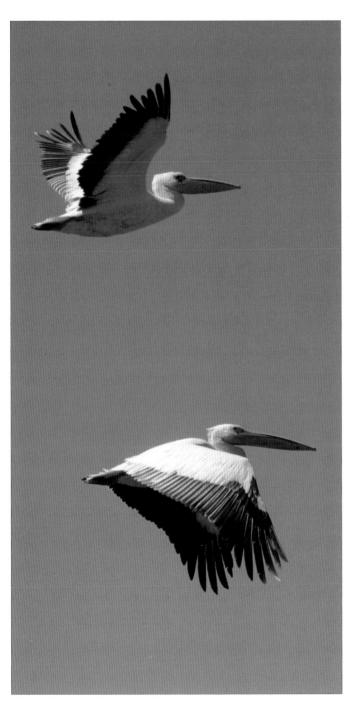

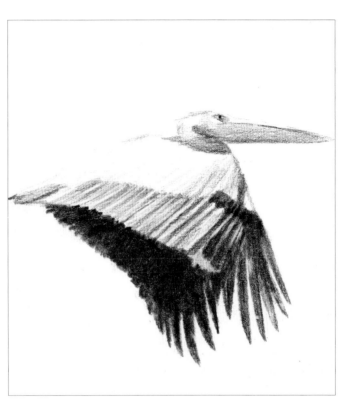

15-minute sketch: pencil ▲
This simple monochrome sketch clearly shows the different tones of white, grey and black on the bird's feathers. The range of tones is surprisingly wide, but was created by using just one pencil (a 6B) and varying the amount of pressure applied. In a sketch such as this, where the large individual primary feathers need to be clearly delineated, it's important to keep your pencil tip sharp.

15-minute sketch: coloured pencil ▶
On the underside of the wings, the feathers appear to be a light pinky-brown, rather than white or grey. Even within this, however, there are darker patches that imply the structure of the bones beneath. The chest, too, is the same pinky-brown colour, because of the way colours are reflected up into it. Use light pencil strokes, gently laying other darker colours over lighter ones to find different tones.

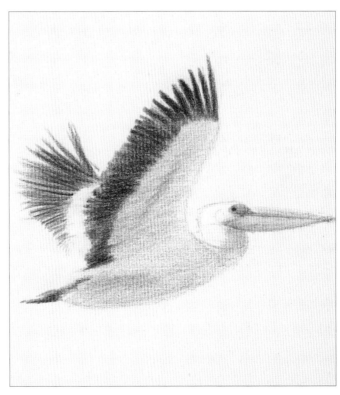

Quick sketches: Ants

Many artists draw and paint colourful insects such as moths, butterflies and dragonflies, but there are other species that are worthy of study. Although they might not seem like the most attractive insect to draw and paint, ants can make a fascinating subject.

Ants' bodies consist of two segments, joined by a node-like structure that forms a slender 'waist'. The head has two strong jaws, known as mandibles. At the end of each of the six legs, there is a hooked claw, which helps the ant to climb and hang on to surfaces. Like other insects, ants have an external covering that provides a protective casing around the body. This covering is hard and shiny, so look for crisp-edged highlights that will convey the texture of the casing and help to make the body look rounded.

Artistically, your main challenge in drawing such a small subject is selecting the right viewpoint. If you draw the insect from directly overhead, you may not see the whole of the legs and antennae; even the huge eyes, which are one of the most interesting features visually, may be largely hidden from view, as they tend to be positioned on the side of the ant's head. Try instead to get down to the ant's eye level and view it from the side; this will be much easier for you to do if your subject is in a glass-sided tank or vivarium. It is also best if the insects are on a plain and light-coloured background, as you will be able to pick out the features easier.

Ants move very quickly, so to begin with you will need to jot down quick marks indicating the position and angle of the legs and the different segments

of the legs; make a quick mark, then wait until the insect returns to the same point in its pattern of movement and make another mark. Gradually you will build up an entire picture.

The subject ▼
The photographer who created this image combined four separate images of ants taken from different positions into one main image. As you can see, the huge eyes and powerful mandibles are more clearly visible in shots that are taken from the side and from the insect's eye level. The position of the legs and antennae in a subject like this can make for a potentially confusing image, so look at the negative shapes – the spaces between different elements – when selecting a reference photo from which to draw.

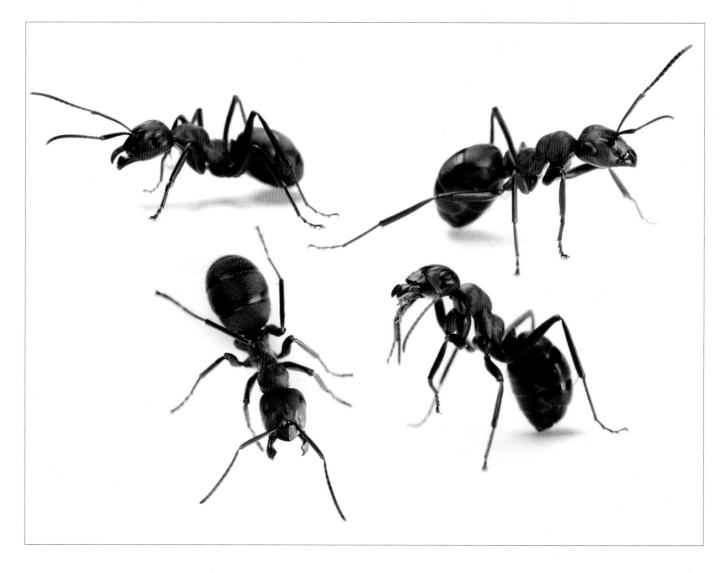

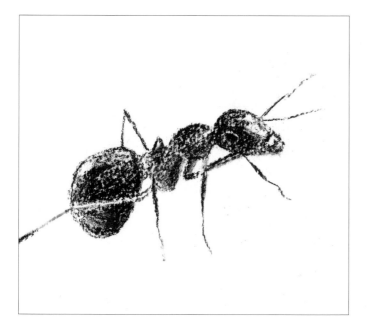

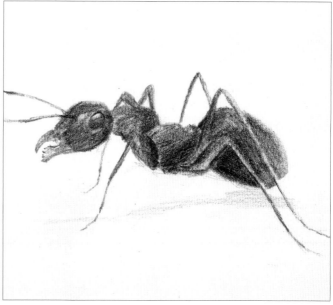

5–10-minute sketch: charcoal ▲
Using a thin stick of willow charcoal, the artist began by drawing the outline of the ant, noting carefully the angles of the legs and antennae. He then blocked in the head and body, pressing extra hard for the very dark areas of the shell and the eye. The highlights were created by wiping off pigment, using a small piece of kneaded eraser pulled up into a very sharp point.

5-minute sketch: graphite pencil ▲
This sketch was made with a soft 6B pencil, using the side of the pencil to block in large areas of tone. Keep turning the barrel of the pencil around in your fingers as you work, so that the lead wears down evenly; you may also find that you need to resharpen the pencil to maintain a fine point for details such as the sharp mandibles.

15–20-minute sketch: coloured pencil ▶
The artist approached this sketch in much the same way as the pencil sketch, but the addition of red somehow makes the creature look altogether more menacing! Note how little touches of black have been overlaid on the red of the insect's body, creating optical mixes that are far more lively than one colour on its own would be. The inclusion of a light shadow under the body anchors it on the paper.

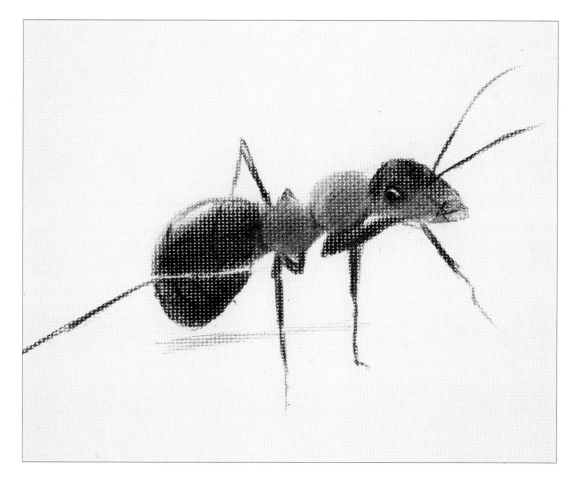

Farmyard chickens in acrylics

Whether you are painting wild or domesticated animals, it can be interesting to paint them in their own environment – in this case, a corner of a farmyard, where the chickens are allowed to roam freely, pecking at grain from an old wooden wheelbarrow.

Before you begin painting, spend time observing how the chickens move. Although you might at first imagine their movements to be completely random, you will soon see a regular pattern emerging – a staccato rhythm of strutting and pecking, stabbing at the ground to pick up grains of wheat before throwing the head back to swallow. Try to fix this rhythm in your mind, as it will help you to anticipate what the bird is likely to do next. Look, too, at the way the movement of the head and legs affects the rest of the bird's body: when the head is tilted down, the rest of the body tilts up – and vice versa. Accurately capturing the angle of the body in relation to the head will give added veracity to your work.

This project also gives you the opportunity to practise a number of different ways of capturing texture in acrylics. By applying very thin layers of paint in glazes, you can build up the slightly uneven coloration of the rusting cartwheel in the background, while the woodgrain on the wheelbarrow is painted using just the tip of the brush. Spatters of paint on the gravelled area in the foreground and thick dabs of paint applied to the chickens with a painting knife also add textural variety to the painting.

Materials
- *300gsm (140lb) NOT or cold-pressed watercolour paper*
- *HB pencil*
- *Masking fluid*
- *Ruling drawing pen*
- *Acrylic paints: yellow ochre, raw sienna, burnt sienna, cadmium orange, cadmium yellow, Hooker's green, burnt umber, light blue violet, violet, cadmium red*
- *Brushes: medium chisel or round*
- *Small painting knife*

The scene
Although this is an attractive scene, with lots of detail, the colours are a little subdued. The artist decided to boost the colours a little and make more of the sense of light and shade in her painting, in order to make a more interesting and better-balanced picture.

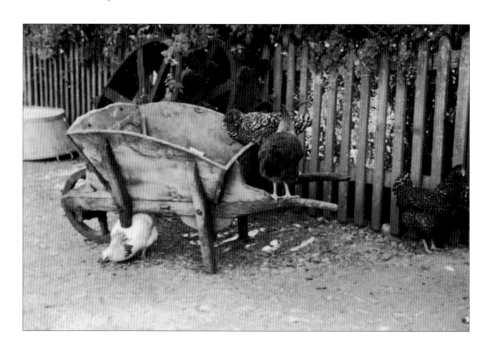

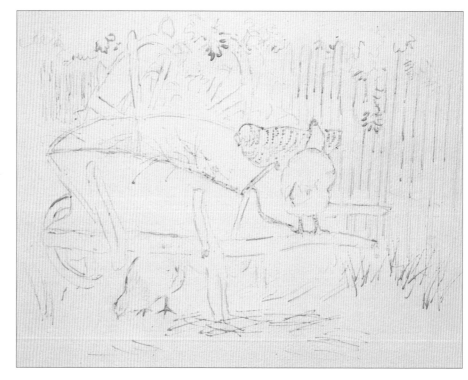

1 Using an HB pencil, make a light underdrawing of the scene to use as a guide. Dip a ruling drawing pen in masking fluid and outline the chickens. Mask out the lightest areas – the white dots on the chickens' feathers, the bright wisps of straw on the ground, and the brightest bits of foliage. Leave the masking fluid to dry completely.

2 Mix up a dilute wash of yellow ochre and another one of raw sienna. Using a medium round brush, wash yellow ochre over the side of the wheelbarrow and the background foliage. Loosely brush raw sienna over the foreground, which is darker than the rest of the image. These two loose washes of warm colour establish the overall colour temperature of the scene.

3 Brush raw sienna over the fence posts. Add burnt sienna to the mixture and paint the triangular-shaped wedges inside the background cartwheel. Use the same mixture for the shaded portion of the wheelbarrow wheel and for the wooden supporting struts and handle of the barrow. In effect, what you are doing in these early stages is making a tonal underpainting of the scene.

4 Brush a dilute mixture of cadmium orange over the straw lying in the wheelbarrow and on the ground, using short brushstrokes. Brush the same colour over the spokes of the cartwheel and the body of the brown hen perched on the wheelbarrow handle. Add more pigment to the mixture and paint the brown hen's head.

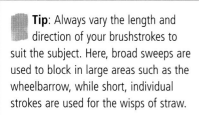
Tip: Always vary the length and direction of your brushstrokes to suit the subject. Here, broad sweeps are used to block in large areas such as the wheelbarrow, while short, individual strokes are used for the wisps of straw.

5 Mix a very pale yellowy green from cadmium yellow and a little Hooker's green and wash this mixture over the bushes behind the fence. Add a little burnt umber to the mixture in places to get some variety of tone. Leave to dry.

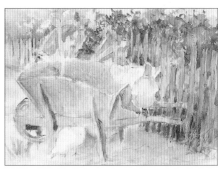

7 Mix a purplish grey from light blue violet and burnt sienna and paint the shaded wheelbarrow interior and the shaded parts of the fence posts.

Tip: Neutral greys can be created by mixing together two complementary colours. This scene is relatively warm in temperature, and therefore two warm colours (light blue violet, which is a warm, red-biased colour, and burnt sienna, a warm reddish brown) were combined to produce the shadow colour. For a cool shadow colour (a snow scene, for example), mix cool, blue-biased complementaries.

6 Mix a dark green from Hooker's green and burnt sienna and dab this mixture over the bushes, twisting and turning the brush to create leaf-shaped marks and allowing some of the underlying yellowy green from the previous step to show through. Note that some of the foliage pokes through the gaps and obscures part of the wooden fence posts.

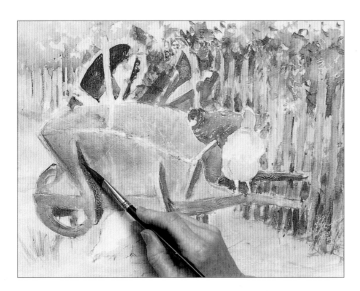

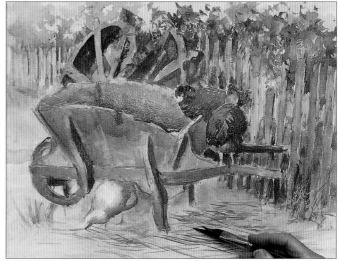

8 Mix a warm grey from violet and a little Hooker's green and paint the grey chicken on the wheelbarrow, leaving the beak untouched. Add burnt sienna to the mixture and paint the dark shadow areas inside the cartwheel and on the struts of the wheelbarrow.

9 Paint the dark feathers of the white chicken in light blue violet and brush the same colour loosely over the grey chicken on the wheelbarrow to create some variety of tone in its feathers. Mix a warm brown from burnt sienna and cadmium orange and paint the rim of the cartwheel. Brush burnt sienna over the body of the brown chicken on the wheelbarrow, allowing some of the underlying colour to show through. Splay out the bristles of the brush and brush thin lines of burnt sienna over the foreground.

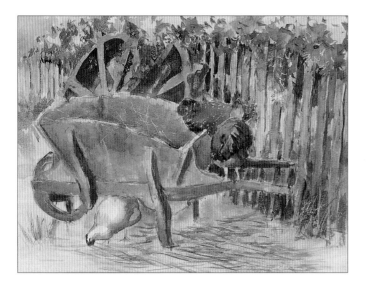

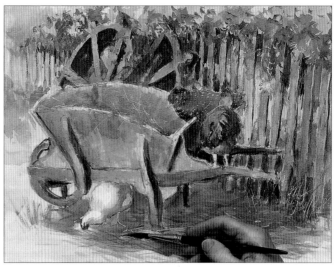

10 Paint the chicken combs in cadmium red. Mix a very dark green from violet and Hooker's green and dot this colour into the foliage, wherever there are really dark leaves or shaded areas. The different tones of green help to create a feeling of dappled light in the foliage.

11 Mix a purple shadow colour from violet and light blue violet, adding lots of water so that the mixture is very dilute, and brush this colour over the shadowed area underneath the wheelbarrow. When this is dry, brush thin, straw-like strokes of yellow ochre over the foreground.

Assessment time

Rub off the masking fluid. At this stage, the painting still looks rather flat and lifeless; the wheelbarrow and chickens do not stand out sufficiently from the background. You need to add more texture to both the foliage and the foreground areas and increase the contrast between the light and dark areas.

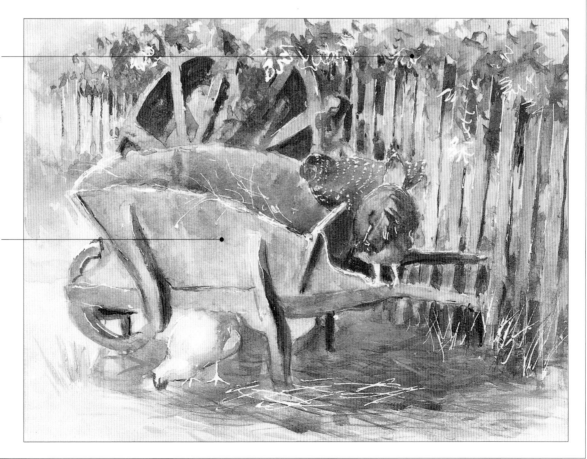

Stronger tonal contrast is needed in the foliage to help create a sense of light and shade.

More texture is needed – particularly on foreground elements such as the wooden wheelbarrow.

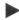

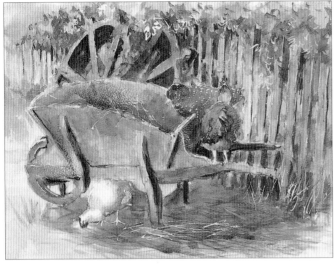

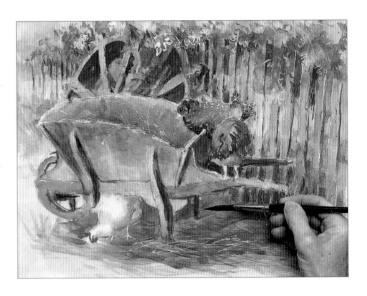

12 Mix a very dilute yellowy green from cadmium yellow, Hooker's green and a little yellow ochre and brush the mixture over the greenery at the top of the image to warm it a little. Brush pale yellow ochre over the exposed straw in the wheelbarrow and in the foreground. Brush very pale light blue violet over the grey chicken to tint the exposed dots.

13 Brush the purple shadow colour mix from Step 11 over the foreground to deepen the shadows and improve the contrast between the light and dark areas.

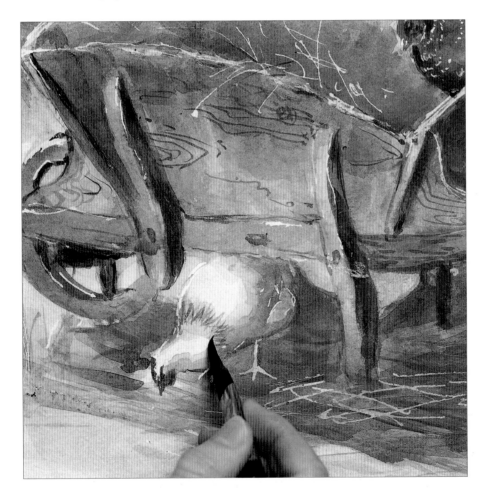

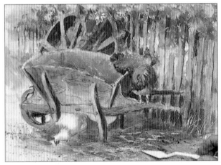

15 Spatter dark brown mixture over the foreground. Use the same colour to paint dark feathers on the brown chicken. Mix cadmium yellow with yellow ochre and apply light, textured strokes to the foreground.

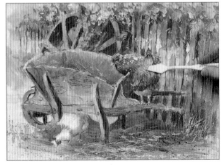

14 Mix a dark brown from burnt sienna and violet and, using the tip of the brush, 'draw' in the wood grain on the wheelbarrow. Use the same colour to paint the 'ruff' of dark feathers on the white chicken in the foreground.

16 Dot thick white paint over the grey chicken's body and yellow ochre over the brown chicken's body.

The finished painting

This is a charming farmyard scene that exploits the versatility of acrylics to the full. The paint on the rusty metal cartwheel and wooden wheelbarrow is applied in a similar way to watercolour – in thin layers, so that the colour and subtle variations in tone are built up gradually. Elsewhere – on the bodies of the chickens and the straw-strewn ground, for example – relatively thick impasto applications create interesting textures that bring the scene to life.

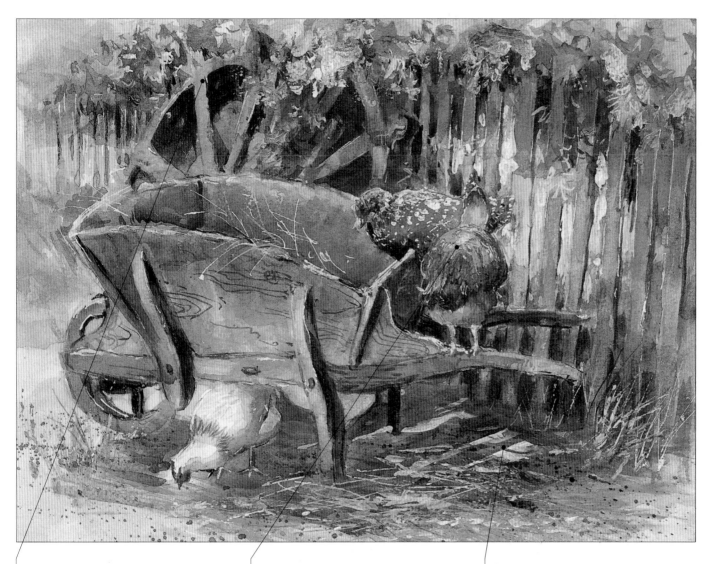

Note how the application of layers of colour, wet on dry, creates the texture of rusty metal.

Thick paint, applied using the tip of a painting knife, shows the texture of the ruffled feathers.

A range of techniques, from fine spatters to thick impasto work, is used to paint the pebble-strewn ground and loose straw.

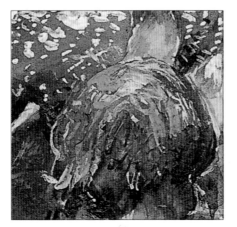

Spotted eagle owl in coloured pencil

Feathers and fur make wonderful subjects for a drawing. You don't even need to draw the whole animal: close-up details concentrating on the colours and patterns can make very striking semi-abstract works of art.

This drawing is made using coloured pencils, the fine tips of which enable you to capture the subtle coloration to perfection. Although on first glance it looks as if the bird is predominantly white and brown, there are many different colours within the dark areas – blue-greys and blacks as well as a range of browns. Paying attention to these differences will give your drawing depth and form, as they reveal the shaded areas within the feathers. Beware of using pure black for the very darkest areas, however, as it is a very harsh and unforgiving colour, whereas using a combination of indigo and a very dark brown will give you a softer, more sympathetic result.

Take plenty of time to build up the texture. Get it right and you'll almost feel as if you could ruffle the feathers with your fingertips. Use short pencil strokes that follow the direction in which the feathers grow. The highlights are not very obvious in the reference photograph, so you need to work out where they would appear: as any light source is likely to be above the subject, they are normally in the upper part of the eye. Note also that the owl's head is turned slightly to one side, so we can see more of one eye than the other.

The important thing in a drawing like this is to keep referring to your reference photograph to ascertain the lights and darks. Stand back from your drawing regularly and assess it as a whole. It's easy to get caught up in detail rather than see the overall effect.

Materials

- Smooth, heavy drawing paper
- 2B pencil
- Coloured pencils: primrose yellow, olive green, gold or mid yellow, gunmetal or charcoal grey, blue-grey, indigo, chocolate brown, sepia
- Tracing paper
- Pencil sharpener
- Kneaded eraser

The subject

You'd have to be very lucky to get so close to such a magnificent bird in the wild. This owl was photographed at an owl sanctuary. Whatever you think about zoos and wildlife parks, they do provide an opportunity to admire and draw specimens that might otherwise be difficult to see.

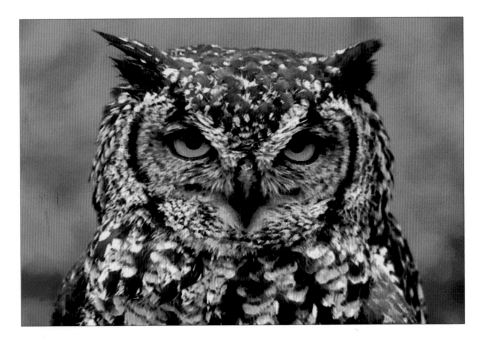

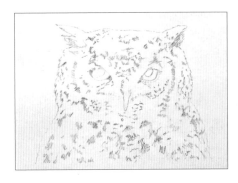

1 Using a 2B pencil, lightly sketch the subject. Map out the blocks of dark-coloured feathers across the bird's head and body with light, gentle strokes.

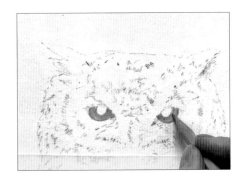

2 Using a primrose yellow pencil, colour in the iris of the eye and put tiny strokes of olive green over the darkest part (the part immediately below the pupil) to darken the yellow. Go over the iris again with gold or a mid-yellow pencil.

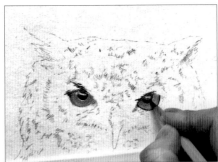

3 Colour in the pupils of the eyes, using a gunmetal or charcoal grey pencil and leaving a highlight in each pupil untouched. Go over the pupil again with a blue-grey pencil. Using an indigo pencil, put down the first indication of the feathers that grow around the eyes.

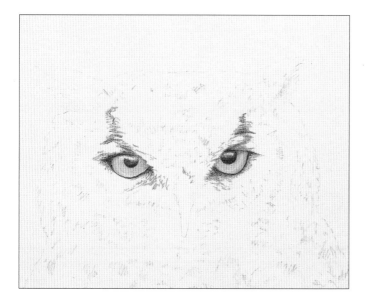

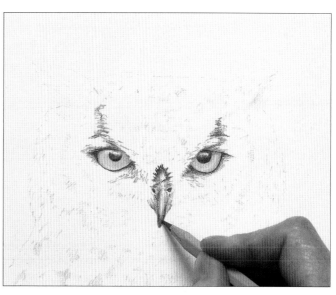

4 Go over the pupil again with indigo and the iris with mid-yellow. Note how these successive layers build up, creating a smooth, almost glossy surface colour. Outline the eyes with an indigo pencil and put in some of the feather detail around the eyes with the same colour.

5 Put in the beak with a blue-grey pencil, leaving the bright highlight untouched. Go over the darkest part with a chocolate brown pencil. Use tiny pencil strokes for the feathers that overlap the top of the beak. Take care not to make the beak too dark or it will overpower the whole image.

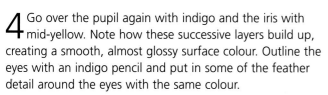

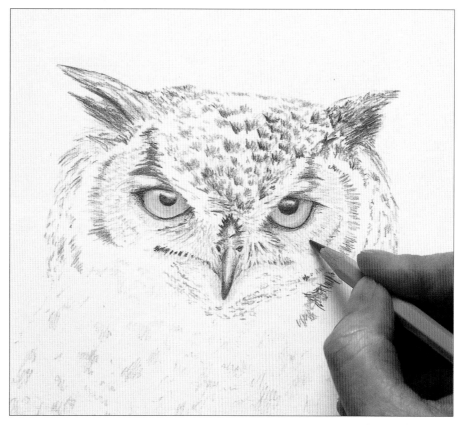

6 Using a sepia pencil, put in the dark feathers on the owl's face and head. Use little, jagged scribbling strokes that follow the direction in which the feathers grow so that you begin to get some realistic-looking texture into the feathers. Look at the relative length of the feathers, too: those around the ears are longer, so make long pencil strokes, using the side of the pencil rather than the tip.

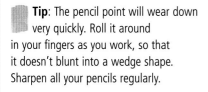

Tip: The pencil point will wear down very quickly. Roll it around in your fingers as you work, so that it doesn't blunt into a wedge shape. Sharpen all your pencils regularly.

7 At this point you need to define the outline of the bird without creating a rigid line. Use short, wispy, horizontal strokes around the edge of the face and vertical strokes for the body behind, as the difference in direction helps to define the form, and leave some gaps around the outline for the white feathers. Continue mapping out the dark areas of feathers on the face, using blue-grey and sepia pencils as before.

▶

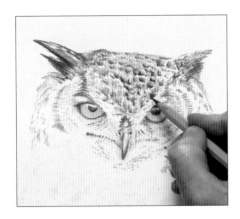

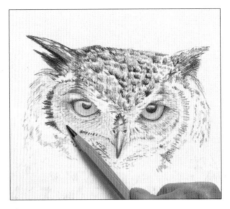

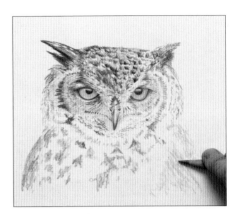

8 Continue working around the top of the head, using jagged, scribbling strokes as in Step 6 and alternating between charcoal grey and sepia pencils as appropriate. For the very darkest feathers, use chocolate brown. This immediately gives the feathers more depth and we can begin to see the different layers.

9 Darken the side of the face with sharp, jagged strokes of indigo, so that it stands out more clearly from the body. Some areas within the face are still completely empty of pencil marks. Using the side of the pencil, make light strokes for the feathers in this area. Although the feathers are largely white, you need to introduce some tones of pale grey here as there are shadows within them.

10 Build up the colours on the owl's face using the same pencils as before – indigo and chocolate brown for the very darkest areas, and blue-grey and charcoal grey elsewhere. The area around the eyes is particularly important: build up the dark feathers here so that you see the eyeball as a rounded form rather than as a flat circle on the surface of the face. Begin mapping out the darkest blocks of feathers on the body, using the side of a chocolate brown pencil. The feathers are bigger here than on the face, so you can be less precise about their placement and shape.

Assessment time
The drawing is progressing well, but more detailing is needed on the side of the head and the body. Work slowly and deliberately: it is amazing how much texture you can create by building up the layers of pencil work.

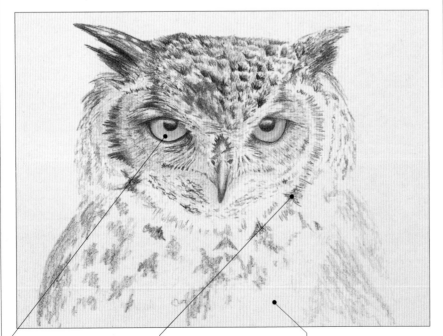

Our attention is drawn to the eyes, but the vivid yellow needs to be still more vibrant.

The face is in danger of merging into the body and needs to stand out more clearly.

Only the main blocks of feathers have been put in on the body. More detail and texture are required.

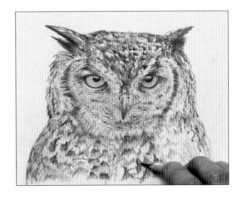

11 Go over the irises again with another layer of primrose yellow and olive green to intensify the colour and create a smooth, glossy surface that contrasts well with the soft ruffles of the feathers. Reinforce the dark feathers on the owl's face with indigo and chocolate brown. Repeat the process on the body, using the side of the pencil rather than the tip to create broader marks. (The clumps of feathers are larger here, so you can be less precise with your marks.)

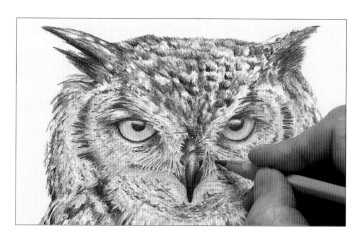

12 Darken the beak with indigo, so that it stands out from the feathers, taking care not to obliterate the highlights. Use long, smooth pencil strokes to create the hard, bony texture. Reassess the feathers on the face, and add more definition if necessary.

The finished drawing

This drawing is a perfect demonstration of how successive layers of coloured pencil marks can create detailed textures and depth of colour. The key is patience: if you rush a drawing like this, you will not achieve such subtlety and detailing. Contrasts of texture – the hard, shiny beak versus the soft, ruffled feathers and the shiny, moist eyes – are vital.

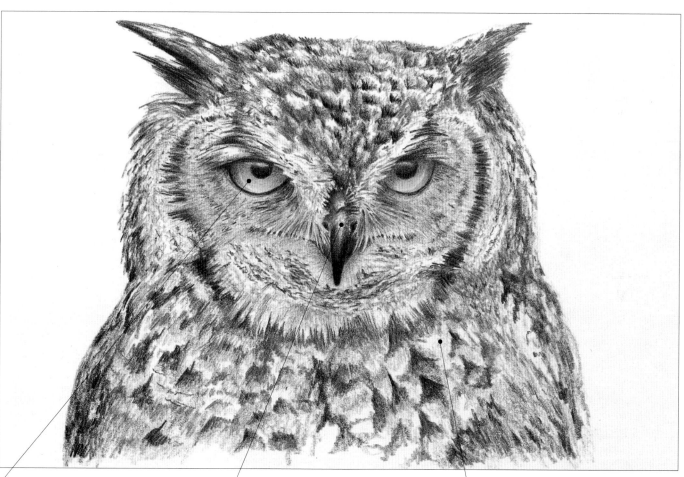

Note the intensity of colour created by gradually building up successive layers of different colours.

The highlight on the beak helps to indicate its curving shape, hard, bony texture and slightly shiny surface.

The face stands out well from the body, thanks to the jagged pencil marks used for the feathers in this area.

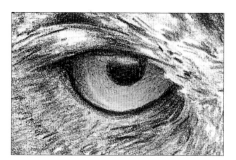

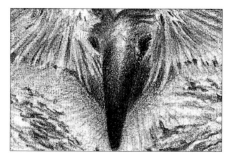

Flamingo in watercolour

This project offers you the opportunity to practise building up layers of colour and to use your brush in a controlled way. You need to assess the tones quite carefully when you are painting a subject that is mostly just one colour. It may help to half close your eyes, as this makes it easier to see where the lightest and darkest areas are.

It is often a good idea to keep the background soft and blurred by using wet-into-wet washes when you are painting a textured subject like this, as the detail of the subject stands out more from its surroundings.

Materials
- *HB pencil*
- *Hot-pressed watercolour board or smooth paper*
- *Watercolour paints: viridian, Payne's grey, cadmium red, ultramarine blue, ivory black, cadmium yellow*
- *Gouache paints: permanent white*
- *Brushes: large round, medium round, fine round, small flat, very fine*
- *Masking (frisket) film*
- *Scalpel or craft (utility) knife*
- *Tissue paper*

Preliminary sketches
Try out several compositions to decide which one works best before you make your initial underdrawing.

The subject
This shot was taken in a nature reserve as reference for the feather colours. Wildlife parks and nature reserves are good places to take photos of animals and birds that you might not be able to get close to in the wild.

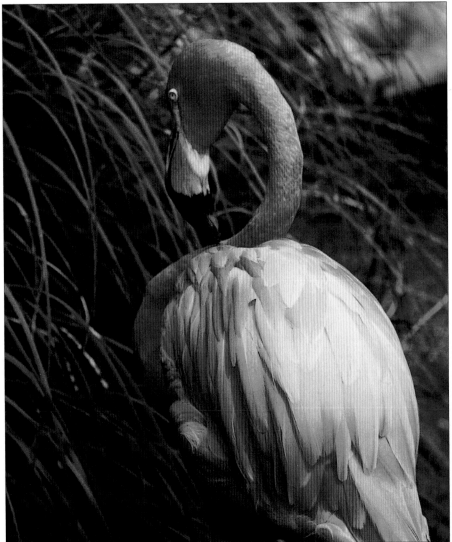

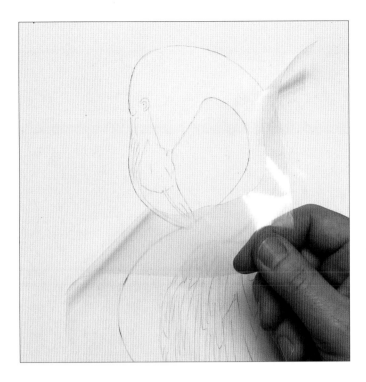

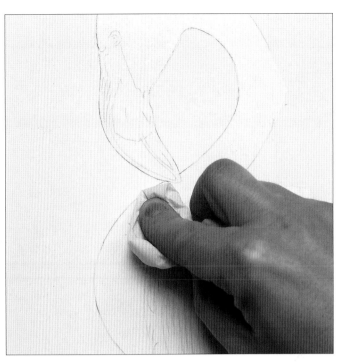

1 Using an HB pencil, trace your reference sketch on to hot-pressed watercolour board or smooth paper. Place masking (frisket) film over the whole picture area. Using a sharp scalpel or craft (utility) knife, carefully cut around the outline of the flamingo and the oval shape which is formed by the curve of the bird's neck. Peel back the masking film from the background, leaving the flamingo covered.

2 Take a piece of tissue paper and gently rub it over the film to make sure it is stuck down firmly and smoothly. It is essential that the background wash can't slip under the mask and on to the flamingo's body.

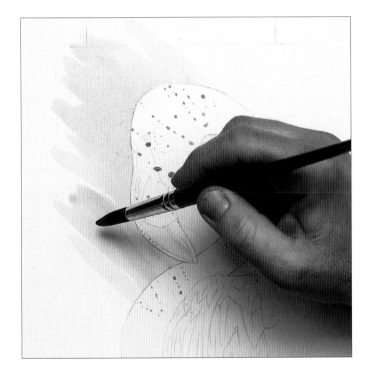

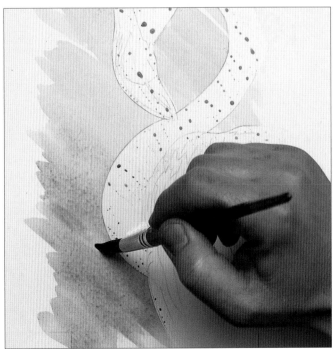

3 Mix a pale, watery wash of viridian. Using a large round brush, brush it over the background in long diagonal strokes, stopping about halfway down the paper.

4 Mix a pale wash of Payne's grey. While the first wash is still damp, working from the bottom of the painting upwards, brush the Payne's grey over the background, stopping at the point where it overlaps the viridian a little.

▶

5 Using a medium round brush and holding the brush almost vertically, brush long strokes of Payne's grey over the damp wash to suggest the foreground grasses. The paint will blur slightly, creating the effect of an out-of-focus background. Leave to dry.

6 Remove the masking film from the flamingo. Mix a pale, watery wash of cadmium red. Using a medium round brush with a fine point, carefully brush the mixture over the flamingo's head and neck, leaving the bill and a small highlight area on the top of the head unpainted. Make sure none of the paint spills over on to the background.

7 Strengthen the colour on the bird's head and neck by applying a second layer of cadmium red. Paint the pale pink wash on to the central part of the face.

8 Using the first wash of pale cadmium red, move on to the body, making broad strokes that follow the direction of the wing feathers. Leave the highlight areas unpainted. Add a wash of Payne's grey to the bill. Leave to dry.

Assessment time

The overall base colours of the painting have been established and we are beginning to see a contrast between the blurred, wet-into-wet background and the sharper, wet-on-dry brushstrokes used on the bird, which will be reinforced as the painting progresses. Much of the rest of the painting will be devoted to building up tones and feather texture on the flamingo.

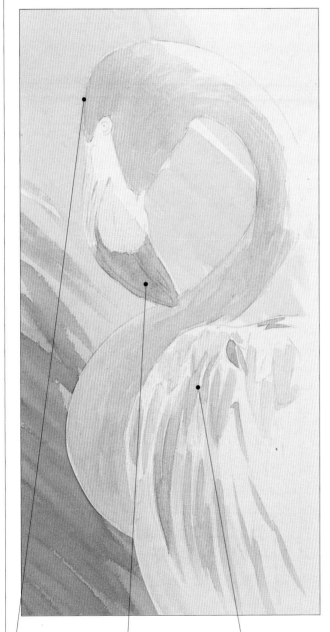

Note the use of complementary colours – red on the bird and green on the background.

The bill has been given a pale wash of Payne's grey.

The strokes follow the direction of the feathers.

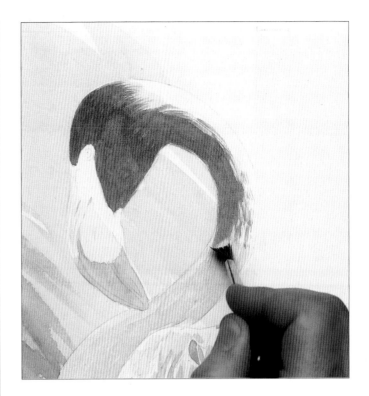

9 Mix a stronger wash of cadmium red and, using a very small, almost dry, round brush, start building up the colour on the head, making tiny, evenly spaced brushstrokes to create the feeling of individual feathers. Using a small flat brush with the bristles splayed out, start working down the neck, again making tiny brushstrokes.

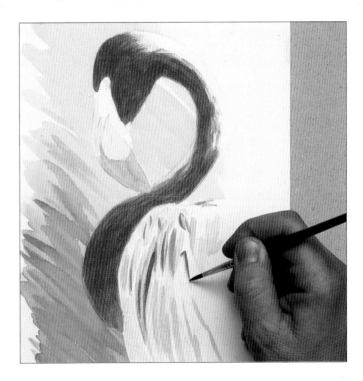

10 Continue painting the flamingo's neck, making sure that your strokes follow the direction in which the feathers grow. Using a fine round brush, paint over the main wing feathers again. Leave to dry.

▶

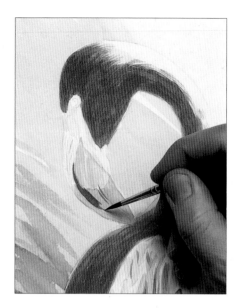

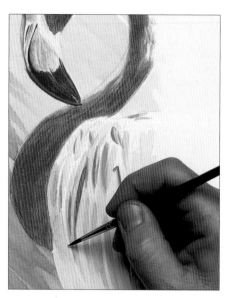

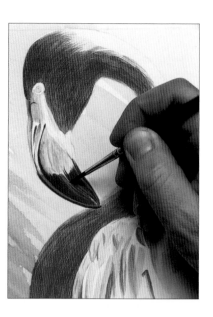

11 Mix a very pale pink from pale cadmium red with a little permanent white gouache and, using a fine round brush, carefully paint the area around the eye. Mix a mid-toned wash of Payne's grey and, using a fine round brush, paint the detailing on the bird's bill. Leave to dry.

12 Continue building up detail on the bill. Add a little ultramarine blue to the Payne's grey mixture and paint the shadow cast by the beak and the shadowed area on the outer edge of the bird's body. Leave to dry.

13 Mix a wash of ivory black and paint the bill, leaving spaces between your brushstrokes in order to give some texture and show how light reflects off the shiny bill. Add a dot of pale cadmium yellow for the eye.

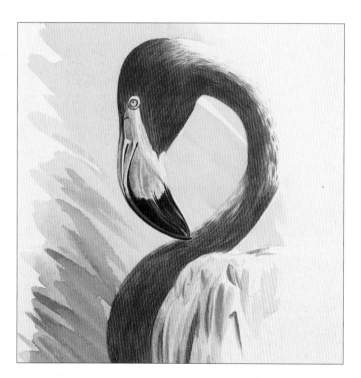

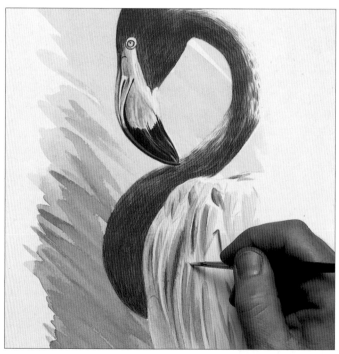

14 Mix cadmium red with a little cadmium yellow and, using a very fine round brush, dot this mixture on to the bird's neck, just beyond the point where the initial cadmium red washes end, so that there isn't such a sharp transition from red to white. Use a fine round brush to add detail in ivory black to the eye.

15 The body looks very pale compared to the head and neck so, using a fine round brush and cadmium red, continue to build up tone on the body with tiny brushstrokes that follow the direction of the feathers. Touch permanent white gouache into the white spaces on the bird's body, leaving white paper on the right-hand side so that the image appears to fade out on the lightest side.

The finished painting

This is a beautiful example of the effectiveness of building up layers of the same colour to achieve the desired density of tone. The lovely soft texture is achieved through countless tiny brushstrokes that follow the direction of the feathers.

The shape of the painting leads the viewer's eye in a sweeping curve from the bottom right-hand corner to the focal point – the bird's head.

Softly feathered brushstrokes soften the transition from red to white.

Paying careful attention to where the highlights fall has helped to make the bill look three-dimensional.

Note how gouache gives you much more control over the exact placement and size of highlights than simply leaving the paper unpainted, as you can paint over underlying colour with a very fine brush.

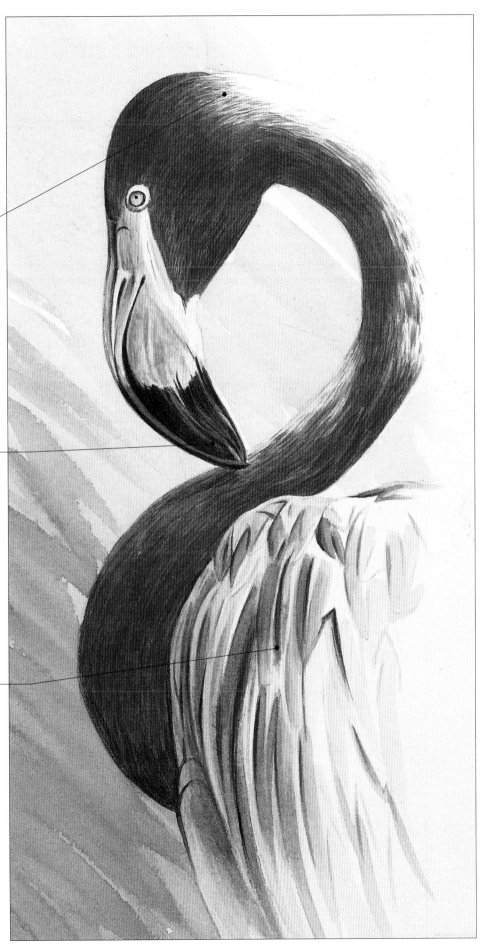

Flying pelicans in acrylics

If you're serious about being a wildlife artist, there's no substitute for observing and sketching animals and birds in the field and learning as much as you can about their shapes, textures, behaviour and habitat. However, many artists also work from photographs, often taking elements from several images in order to create their painting. This demonstration was done using three separate photographs as reference, in order to portray the wings at different stages of flight.

One of the main challenges of this painting is that you have to contend with several different greys. Not only are some of the feathers grey in colour, but the white feathers also contain grey tones in the shaded areas. Although

you might be tempted to put in the feather detail right from the start, you must get the basic tones right to begin with. If you do not, then no amount of textural detailing will make your painting look right. Establish the tones first, then gradually add more detail and texture.

In this demonstration, the artist applied a very thin layer of white acrylic paint over the paper, left it to dry, and then lightly sanded the paper before painting the birds. This gives a very smooth surface on which to paint although the pencil underdrawing is still visible. However, this is entirely optional and you may work on a conventional, unprimed watercolour paper if you prefer.

The artist who painted this demonstration opted for a smooth coverage of paint in the background so as not to detract from the birds, with no visible brush marks, but you could include details such as clouds in the sky.

Materials
- *2H or HB pencil*
- *HP pre-stretched watercolour paper*
- *Gum strip*
- *Masking fluid and old brush*
- *Fine sandpaper (optional)*
- *Acrylic paints: titanium white, yellow ochre, ultramarine, cerulean blue, burnt umber, cadmium yellow, cadmium red*
- *Brushes: fan-shaped hog brush, soft badger brush, fine round*

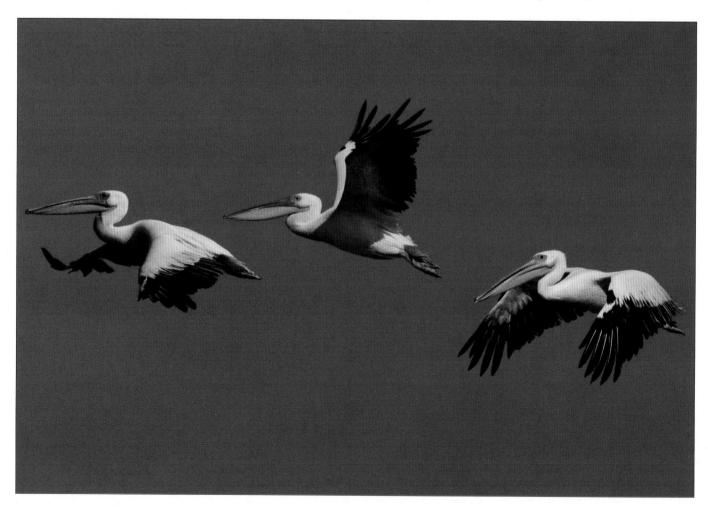

The subject
In his painting the artist wanted to show how the birds' wings move in flight. He combined three digital photos of birds showing different flight movements on the computer and tidied up the background to get a uniform colour in the sky. As the original sky was a dull grey, he decided to lighten and brighten it in the painting.

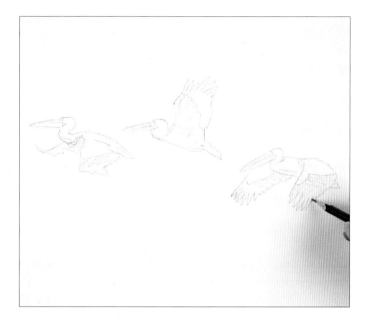

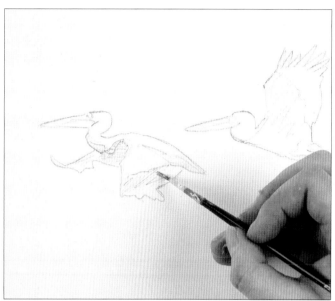

1 Pre-stretch your watercolour paper and tape it to a drawing board with gum strip, to prevent cockling. Using a 2H or HB pencil, sketch the birds.

2 Using an old brush, paint over all the birds with masking fluid and leave to dry. The masking fluid must be completely dry before you move on to the next stage.

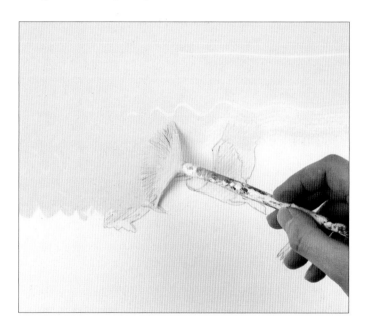

3 Mix a blue-grey sky colour from white and small amounts of yellow ochre, ultramarine and cerulean blue. The paint should be the consistency of pouring cream. Wet the paper, using a brush dipped in clean water; acrylic paints dry very quickly, but the damp paper prevents any hard lines from forming. Using a fan-shaped hog brush, brush the sky colour over the whole painting, including the masked-out birds, making sure you work it well into the fibres of the paper.

4 Go over the painting once more, applying your brushstrokes vertically instead of horizontally this time, to ensure a good, even coverage. Using a clean hog brush, gently brush over the painting to remove any excess paint, then use a badger brush to get rid of any brushstrokes. Leave to dry.

Tip: Mix plenty of paint. Acrylic paints dry very quickly, and if you have to stop halfway through applying the initial wash to mix more paint, you'll get hard lines in the sky.

Tip: Remember to thoroughly clean the badger brush immediately after use so that it retains its softness.

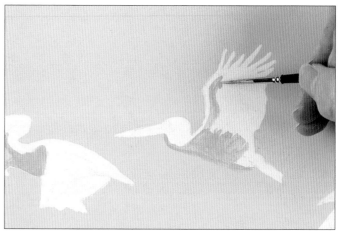

5 Using an eraser or your fingers, gently peel off the masking fluid from the birds. You may find that you need to use the tip of a craft (utility) knife to lift up the edge of the fluid to begin with.

Tip: Have some of the background colour to hand in a sealed container, in case some of the background paint peels off along with the masking fluid and you need to touch it up around the edges of the birds.

6 If you wish, apply a very thin layer of white paint over the birds, leave it to dry, then gently sand it to create a completely smooth, primed surface similar to illustration board that can hold lots of crisp detailing. Then begin putting in the mid tones, as this will make it easier to assess whether you need to go darker or lighter on the other areas of the birds. Mix a neutral grey from white, yellow ochre, burnt umber and ultramarine. Using a fine round brush, block in the mid-toned feathers and shadow areas.

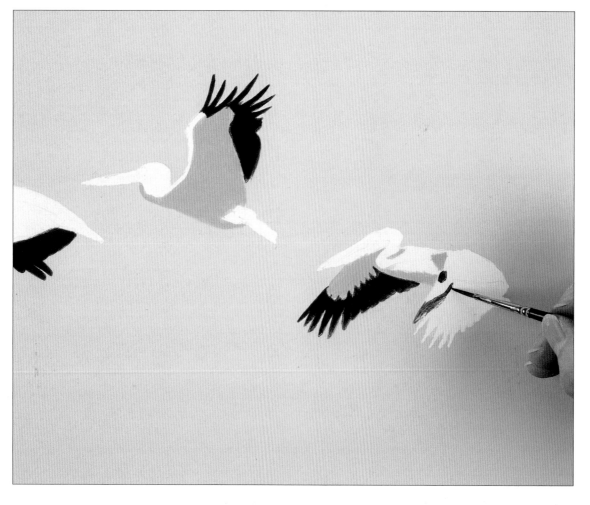

7 Mix a dark blue-black from burnt umber and ultramarine. Using a fine round brush, begin putting the black on the wings. At this stage, do not try to put in any texture; you should simply be aiming to get the right tone.

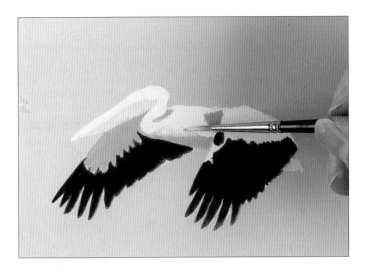

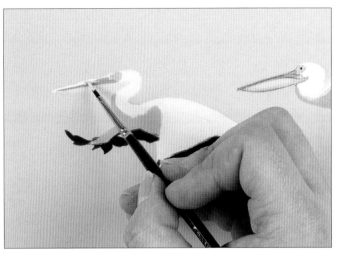

8 Mix a warm yellow from cadmium yellow, yellow ochre and white and then block in the beaks. Add a little cadmium red to the mix and paint the feet. There is also a yellow-grey tone on the birds' chests. Touch this in very lightly; you will paint over it later in grey, but it will provide a warm undertone.

9 Paint the area around the eyes in an orangey-pink mix of cadmium red, white and yellow ochre. Using the neutral grey from Step 6, paint the grey of the beaks.

Assessment time
Once you've established all the basic shapes and tones, you can begin to think about putting in some textural detail and making the birds look more three-dimensional. As always, careful assessment of the tones is the key. Look at the reference photo and you will see that there are different areas of the light and mid tones; you need to be aware of these in order to give the birds form and make them look three-dimensional.

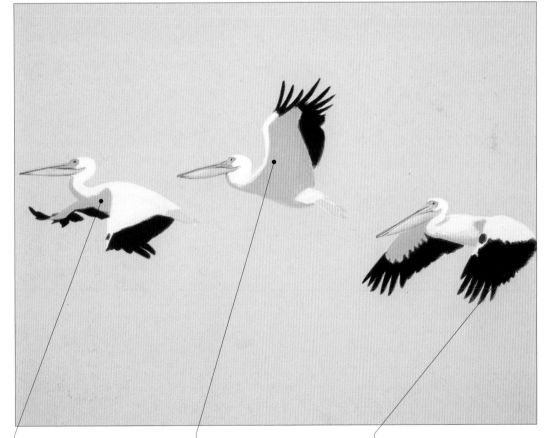

The basic light, mid and dark tones have been put in as flat blocks of colour, but the birds do not yet look fully rounded and three-dimensional.

Some shading is required within the wing to hint at the muscles and bones beneath the surface.

So far, the large primary and secondary feathers have been painted as solid blocks of tone; some texture needs to be put in here.

▶

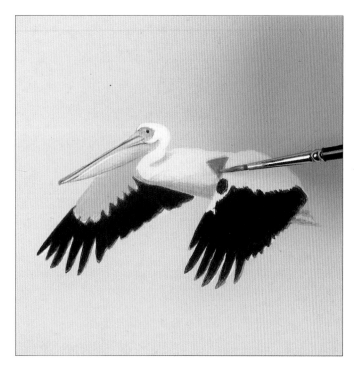

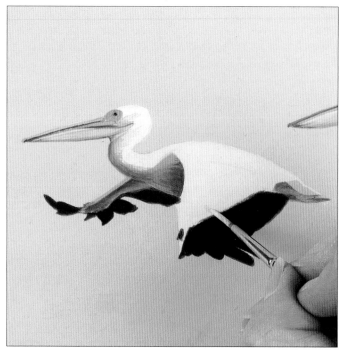

10 Add a little burnt umber and yellow ochre to the mid-toned grey mix from Step 6 to warm it up a little and paint the shadows on the birds' wings. Assess the tones carefully: some of the initial grey that you applied in Step 6 needs to remain visible.

11 Go a shade darker still, adding a tiny bit of burnt umber, ultramarine and yellow ochre to the mix. You are gradually developing more form and texture on the birds. Touch up the white of the wings with a very pale, warm grey shadow to make the birds' bodies look more rounded.

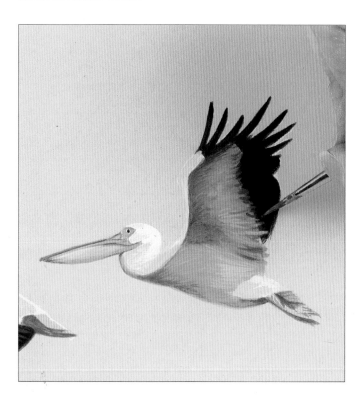

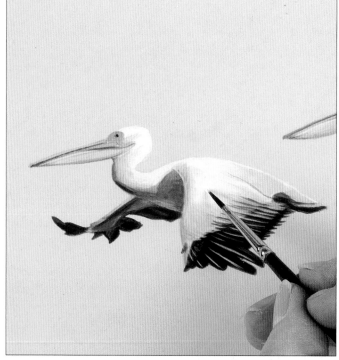

12 Carefully draw the main primary and secondary wing feathers, using the grey mix of white, burnt umber, yellow ochre and ultramarine to show where the feather veins are. The wings are no longer just blocks of solid colour: we are beginning to see some real texture here.

13 Continue putting in the veins on the feathers. Darken the wing tips with the blue-black mix of burnt umber and ultramarine from Step 7. Finally, apply pure white to the very brightest feathers on the wings and heads so that they stand out from the mid tones.

The finished painting

This deceptively simple-looking painting captures the way the birds fly beautifully. The colour palette is limited, but the tiny touches of burnt umber and yellow ochre in the grey mid tones adds warmth to what might otherwise be a rather cold image. The tonal differences in the greys and shadow areas are very subtle, but they make the painting more lifelike. The sky, too, is a warm blue and complements the orangey-yellow of the birds' beaks and feet.

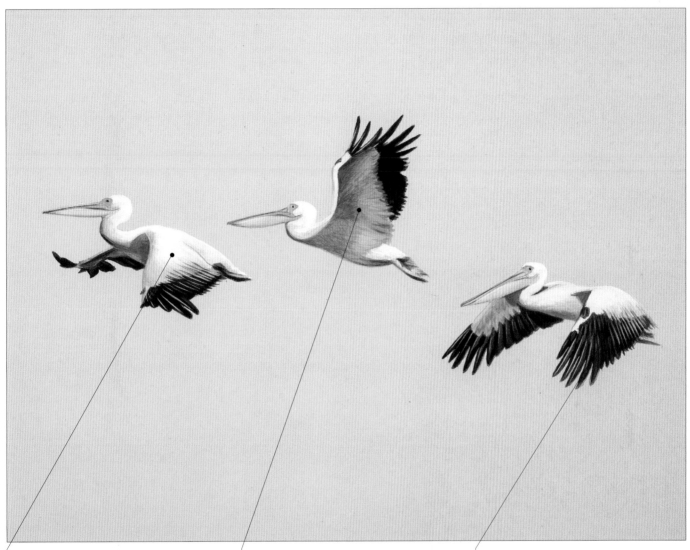

Note that the white feathers are not completely white: the use of very pale greys indicates shaded areas and implies the curve of the birds' bodies and wings.

Putting a little burnt umber and yellow ochre into the greys gives tonal variety and adds warmth to the image.

The feather detailing is painted using a very fine brush and adds all-important texture.

Parrot in pastels

This demonstration uses both soft pastels and pastel pencils. Soft pastels and pastel pencils can be blended both physically (using your fingertips or a torchon) and optically (by applying a thin layer of one colour over another). Both approaches are used here. Soft pastels blend better than pastel pencils, but the colours can be very strong. Try blending colours on a scrap piece of paper before you commit to using them on your drawing.

The feathers of this bird are very vibrantly coloured – almost iridescent in places. It's hard to capture iridescence in any drawing or painting medium, but soft pastels offer more scope than most. When colours are laid down close together and on top of one another, they combine optically on the paper and seem almost to shimmer.

Note that the feather textures vary: the feathers on the chest, for example, are smaller and softer than those on the wings. For the softer feathers, apply small dots and dashes of pastel and overlay other colours on top or very close by. For the larger wing feathers, use linear marks to delineate the individual feathers and blend the colours physically on the paper, so that the coverage is smooth. Build up the colours and textures gradually – and remember to look at the shaded spaces between the blocks of feathers, as well as at the feathers themselves.

On first glance, the background in this scene appears to be very dark, but it contains many different colours – some of them very bright. You'll find that half closing your eyes makes it easier to see the background as blocks of colour or tone. Take care not to overblend the pastel marks, however, or you'll end up with a murky mess. Wipe your fingers regularly, and use different fingers for light and dark areas so that the colours remain separate.

With soft pastels, it's all too easy to smudge what you've already done and 'muddy' the colours. A useful tip is to place a piece of clean paper over the part you are not working on to protect it from being smudged.

Materials

- *Charcoal-grey pastel paper*
- *Pastel pencils: light blue, mid blue, brown, pinkish red, orange, yellow, aquamarine, bright green, dark green, purple, reddish brown, salmon pink, peach, pink-brown, fuchsia pink, sage green, olive green*
- *Soft pastels: bright blue, bright green, dark green, peach, pink, purple, lilac, blue-green*

The subject

Here, the bird's head is turned so that it is looking directly at us, and this really brings the subject to life. The most striking thing, of course, is the brilliantly coloured plumage. Study the colours and the relative shapes and sizes of the different blocks of feathers carefully and establish where the shaded areas are, as this will help to make the bird look three-dimensional.

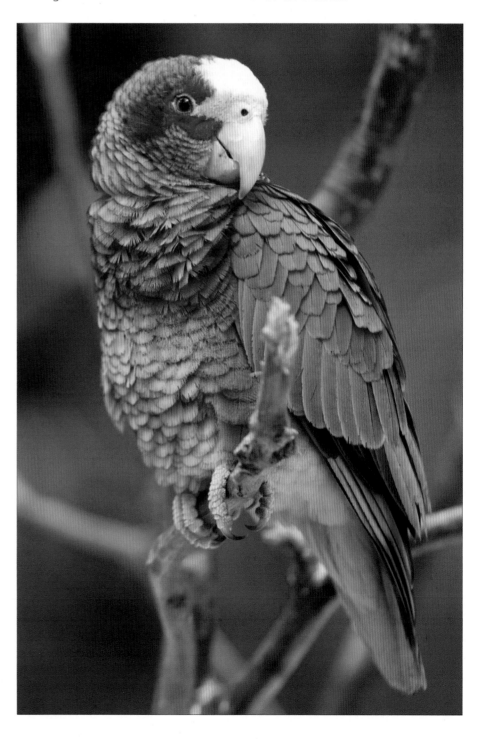

1 Using a light blue pastel pencil, roughly sketch the main shapes of the bird and background branches. Blue is one of the mid tones in the subject: it will be used in both the foreground and the background, so using this colour for the initial sketch will help to unify the drawing. A mid tone is also easy to work over: if the initial sketch were done in black, this would tend to 'grey' any other colours worked over it.

2 Loosely scribble colour into the background, using bright and light blue, bright and dark green, peach, reddish brown, pink, purple, lilac and ultramarine soft pastels. Begin blending the marks with your fingertips.

> **Tip**: You don't need to be too specific about which colours you use where, as the background is mostly a dark, out-of-focus blur: just put down the colours you perceive coming through.

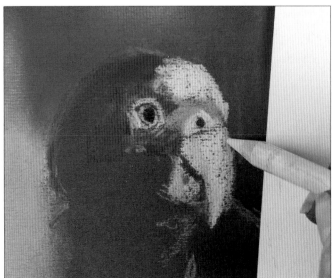

3 Continue blending the background, adding whatever colours you feel are appropriate.

4 Using a mid blue pastel pencil, scribble in the blue patches in the bird's head feathers. The top of the head and parts of the beak are very bright: put these parts in with a white pastel pencil. Colour in the eye with brown, with white around, and use the same brown for the nostril. Apply a pinkish red, orange and yellow to the head and beak.

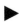

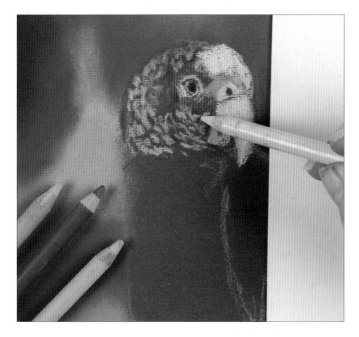

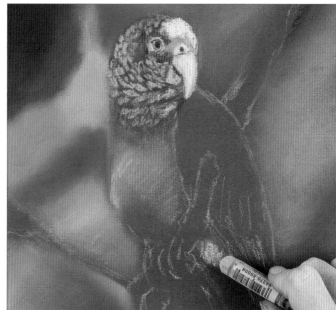

5 Using bright green, dark green, aquamarine and pale blue pastel pencils, scribble in blocks of different greens for the feathers on the head, overlaying colours to create optical mixes and leaving the grey paper colour showing through in between to create some sense of the shadows. For the very brightest greens, add a little yellow on top.

6 Lightly hatch over the bird's chest with pale blue pastel pencil, then apply a little blue-green soft pastel, with bright green on top, and gently blend the colours together with your fingers. Use bright green pastel, overlaid with touches of yellow where necessary, on the wing and the underside of the tail feathers.

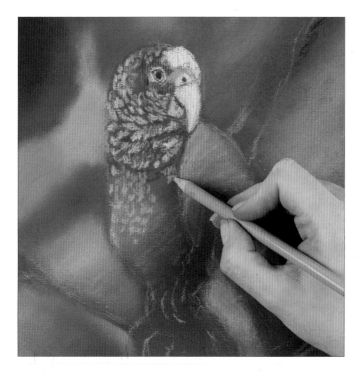

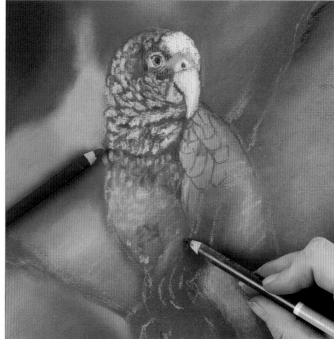

7 Scribble in blocks of greens on the chest, just as you did on the head, overlaying yellow soft pastel for the lighter greens and bright blue for the bluer greens. Already, you are beginning to develop the iridescence of the feathers, as the colours intermingle optically. Scribble red-brown pastel pencil between the blocks of green for the dark areas between the feathers.

8 Put in the spaces between the long wing feathers using a mid blue pastel pencil. Scribble blue into the spaces between the chest feathers, then go over the blue with a reddish-brown pencil to create the shadows.

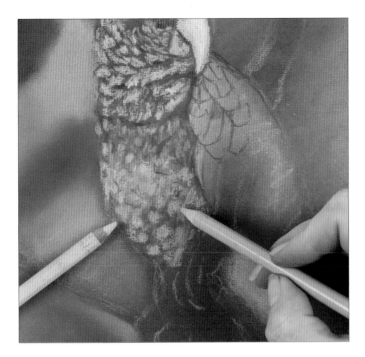

9 Continue applying blocks of bright green, aquamarine and yellow to the chest feathers as before, overlaying the colours where necessary to create lively optical mixes and blending them with your fingers. Don't worry too much about getting the colours exactly right at this stage, as you can refine them later; simply try to see the bird as blocks of light and dark feathers.

10 Block in the branch on which the bird is perched, using purple and brown pastel pencils for the darkest parts and salmon pink, peach and pink-brown for the lighter areas. If you need warmer browns in parts of the branch, overlay a little orange on the paler colours. Even though you have not yet put in any textural detail, the use of light and dark tones is already making the branch appear rounded and three-dimensional.

11 Draw in the highlighted edges of the large individual wing feathers using a yellow pastel pencil, and map out the darker shadow areas between the wing feathers in mid blue. Remember that you're still mapping out shapes and blocks of tone at this stage, and not attempting any fine textural detailing yet.

12 Block in the wing feathers with mid green and aquamarine, blending the marks but taking care not to lose the highlighted yellow edges. There are some flashes of very bright blue, light blue, fuchsia pink and bright green on the tail feathers. Put these in with soft pastels or pastel pencils. These echo the colours on the head.

13 Intensify the colours on the upper part of the wing by overlaying bright green, yellow, aquamarine and white. Lower down the wing, where it is more in shadow, use more muted sage and olive greens. You may find that you need to reinforce the yellow highlight lines that you added in Step 11.

▶

Assessment time

Building up the colours in the feathers has to be a slow, gradual process if you are to create the right optical mixes on the paper, but in the final stages of the drawing you can make sure the textures are right, too. Here, the colours of the chest feathers are correct, but the blocks of feathers appear to merge together; this is because the shadows between the feathers have not been put in strongly enough. To complete the drawing, you need to add the branches and any missing patches of background colour; at the same time, check whether or not you need to adjust the background colours now that the bird is complete.

The eye looks dull and lifeless; adding a white highlight will solve this.

The chest feathers look soft in texture, but all seem to merge together.

Adding the branches will make the setting look more realistic – but make sure you get the warm and cool tones right, so that the branches look rounded and three-dimensional.

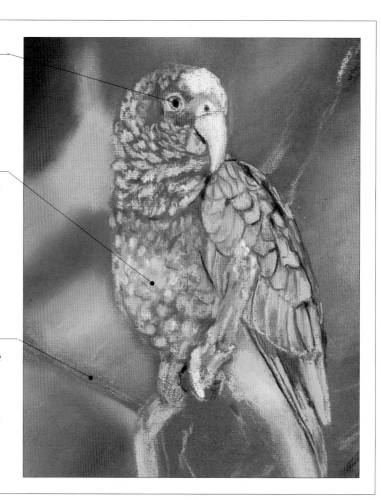

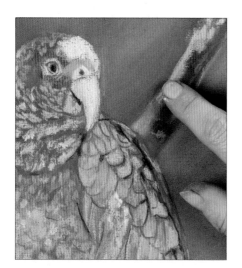

14 Block in the shapes of the background branches using lilac, purple and white soft pastels (for the brighter parts) and brown for the shaded undersides, then fingerblend the marks to smooth them out. Using the same colours as before, adjust the background as necessary to fill in the spaces between the branches and strengthen the colours.

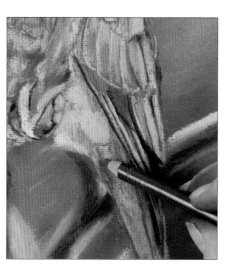

15 Using brown and black pastel pencil, put in the dark, shaded areas on the long tail feathers. Darken the underside of the tail feathers where necessary by adding touches of brown and orange.

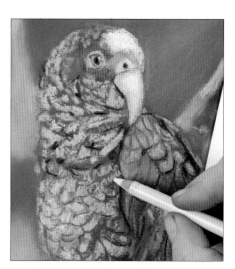

16 Using a white pastel pencil, dot in a highlight in the eye and on the chest. If necessary, dot more bright green on to the chest, with yellow on top for the brightest greens, to build up the tones and texture. Add touches of bright blue between the feathers, too; this helps to separate the blocks of feathers and contributes to both the texture and the iridescent effect.

The finished drawing

This is a colourful drawing that captures the bird's plumage beautifully without getting bogged down in detail. The pastels have been physically blended on the paper to create smooth patches of colour on the large wing feathers. They have also been optically blended, both by overlaying colours and by laying down small blocks of colour very close together so that they play against one another and create a lively, shimmering effect. The background, too, is a lively mix of all kinds of different colours, creating the effect of out-of-focus foliage or flowers that allows the bird to stand out in all its glory.

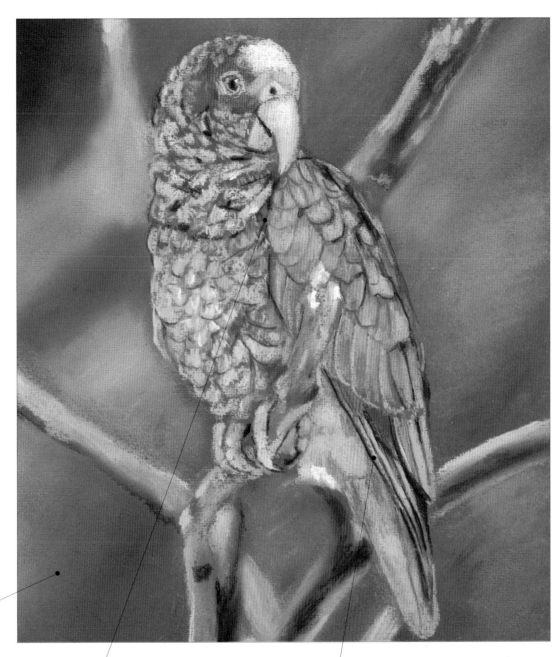

The background colours suggest out-of-focus foliage or flowers: the detail is not important, as the purpose of the background is to provide a foil for the bird.

Note the different textures on the feathers – soft, downy feathers on the chest and longer, stronger feathers on the wing.

Note the contrast between the bold linear work on the large wing feathers and the softly blended colour on the underside of the tail.

Geese in watercolour

Your main challenge in this painting is to paint white birds without using white-coloured paint, using only the white of the paper for the brightest areas. You might expect that such a light, delicate subject would require a very pale palette of colours but, the way to make the birds look really white is to make the surrounding areas dark, so that they stand out. Assess the tones carefully: you may be surprised at how dark the background really is.

The colours of the water are built up gradually in light washes and layers (glazes). Remember that, as watercolour is a transparent medium, any colours that you add will always be modified to

some extent by the colours underneath. Don't worry too much about recreating the colours of the scene exactly: it is more important that the colours work well together to create a harmonious whole than to slavishly imitate nature.

Note that in the background, the water takes much of its colour from the surrounding trees. Even though the artist has chosen not to include them in the painting, their effect on the water must still be obvious.

Use as large a brush as you feel comfortable with, as it will enable you to make bold, confident brushstrokes. If you use a small a brush, you might get carried away with the tiny details

instead of seeing the broader picture; as a result, your painting will become tight and laboured. You can always switch to a smaller brush for putting in details such as the eyes of the geese, if necessary, but a good-quality large or medium brush that comes to a fine point should do the job perfectly well.

Materials
- *Heavy watercolour paper*
- *4B pencil*
- *Watercolour paints: yellow ochre, Indian red, cerulean, ultramarine, light red, cobalt, cadmium yellow, alizarin crimson*
- *Brushes: large or medium round*

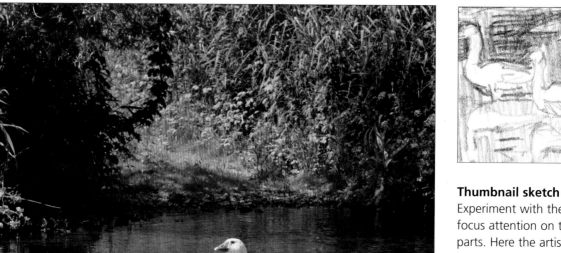

Thumbnail sketch
Experiment with the composition to focus attention on the most important parts. Here the artist left out the background trees, so that the birds could occupy more of the picture space. He also decided to omit the fifth goose, which is straggling some way behind the rest, in order to tighten the composition.

The subject
The deceptively simple-looking scene of a gaggle of geese crossing a shallow stream requires careful planning: in watercolour, the first step is always to decide which areas of the paper need to be left untouched, as the very brightest parts of the image.

1 Using a soft (4B) pencil, sketch the scene. The advantage of using a soft pencil is that it is easy to erase the marks if you make a mistake. Here, the artist made his pencil marks quite dark so that some would remain visible in the finished painting, adding texture and linear detailing.

> **Tip**: Don't attempt to put in every ripple; instead, look at the overall pattern that they make and use them to help you map out the light and dark areas within the water.

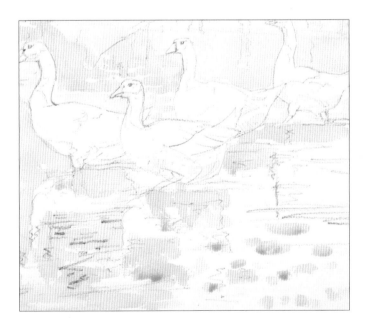

3 Continue putting in the background colour, remembering to leave the white of the paper for the geese's reflections. Add more Indian red to the mix as you work your way down the paper, to make the mix warmer and imply that this area is closer to the viewer. Use short dabs and dashes of the brush to create the effect of the ripples in the water.

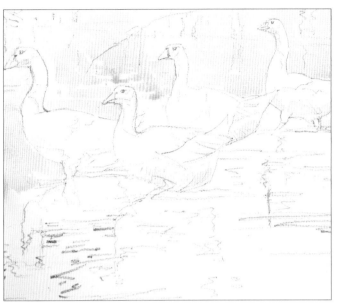

2 Mix a pale, sandy orange from yellow ochre and Indian red. Using a large round brush, carefully wash it over the background, leaving gaps for any really bright patches such as the flowers on the left-hand side. Brush a little of the same colour on to the underside of the birds' bellies, as some colour is reflected up from the stream bed.

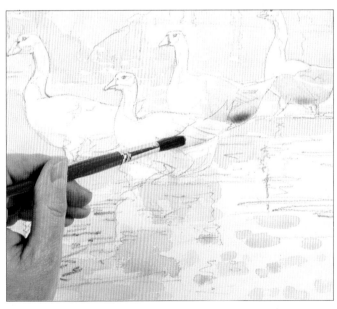

4 Mix a very pale blue-grey from cerulean, ultramarine and a little Indian red. Carefully touch in the shaded areas of the geese's wing feathers.

> **Tip**: Note that the shaded parts of the wing feathers are lighter at the top: use more cerulean in the mix for these parts and add more ultramarine as you work down. Dab off excess paint with kitchen paper if necessary.

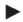

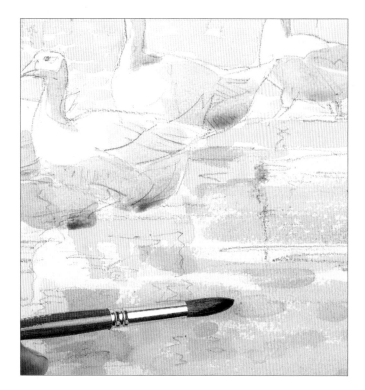

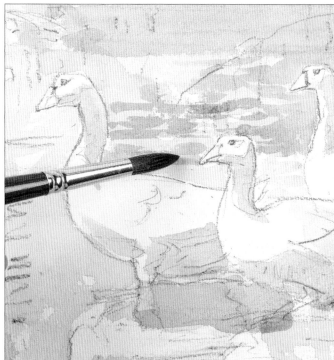

5 Overlay the same colour on the water on the right-hand side of the image, dragging the brush across the paper very lightly to get a slightly mottled, broken effect like sunlight sparkling on the water. Use horizontal brushstrokes to echo the direction of the ripples in the water.

6 Continue overlaying the blue-grey mix in the background behind the geese. Note how the colour is modified by the yellow ochre/Indian red mix beneath. Leave some of the underlying sandy orange colour showing through as you work down the picture. Leave to dry.

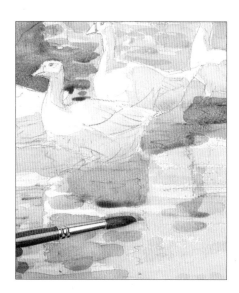

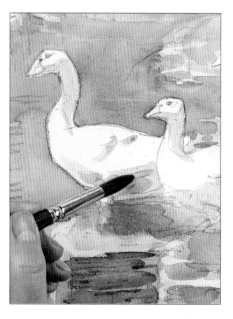

7 Mix a rich, brown-red from light red and a little ultramarine, and brush in the browns in the water.

Tip: Use the side of the brush, rather than the tip, to make horizontal marks for the patches of earth in the stream bed.

8 Using the same blue-grey mix as before, strengthen the shadows on the underbellies of the birds and in their reflections. Immediately the birds begin to look more rounded. You may need to repeat this process several times before you achieve the right density of tone.

9 Using the blue-grey mix, put in the shadows cast on the water by the bankside vegetation. Use the same colour for the long shadows cast on the water by the geese. Hold the brush almost horizontally so that your brushstrokes are the same shape as the rippled reflections.

Assessment time

The pale blue-grey shadows on the wings give a good sense of the form of the birds, but they do not yet stand out sufficiently against the background, which needs to be much darker. The water is so shallow that we can clearly see the bed of the stream, with its lovely, rich-coloured stones. We are beginning to build up the colour, but at present the water is too pale and there is no real feel of the sparkling sunlight.

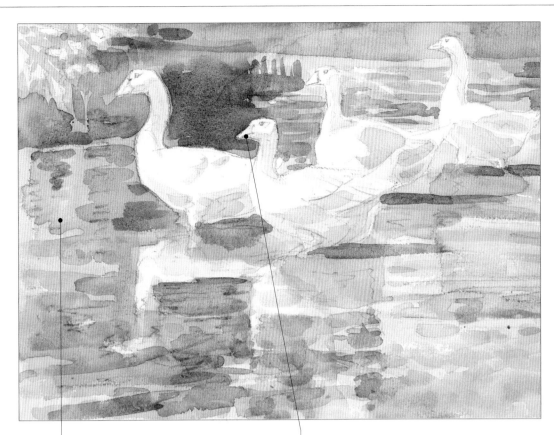

The background and water need to be made darker, in order for the brilliant white of the birds to really stand out.

Painting in small details such as the eyes and beaks will really bring the birds to life.

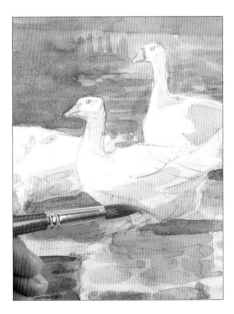

10 Using light red, touch in the orange of the geese's beaks and feet, leaving the tops of the beaks white where the sun hits them. (You may need to strengthen the colour later.) Stroke the same colour into the water, wherever you see darker browns.

11 Mix a bright, olivey green from yellow ochre, light red and a little cobalt. Brush it over the background shadow and into the water, into the reflection of the bankside vegetation. Note how the green is modified by the underlying colours.

12 Gently touch the green colour from Step 11 very lightly on to the underbellies of the geese, where the colour is reflected up from the water.

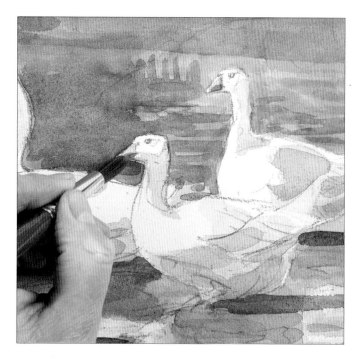

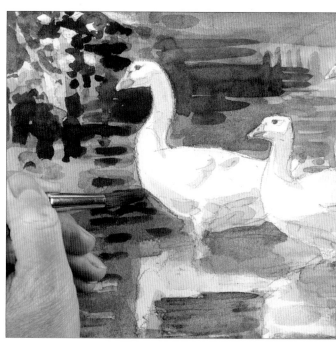

13 Mix a dark orange-red from light red and a tiny amount of ultramarine and, using only the very tip of the brush, carefully touch in the shadows on the underside of the beaks.

14 Mix a blue-black from ultramarine and Indian red and put in the eyes. Use the same colour to strengthen the shadows cast on the water in the background and along the side of the bank.

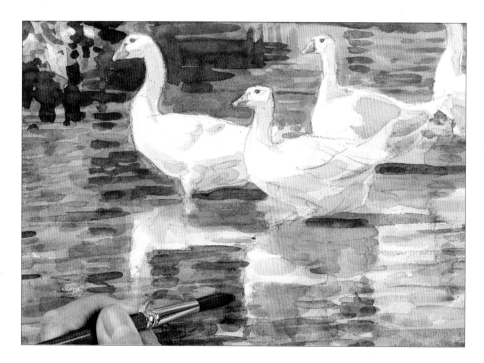

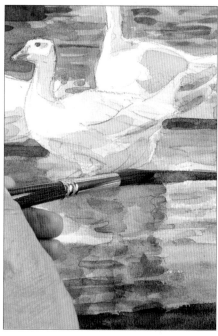

Tip: Pure black is rarely found in nature and a ready-made black can have a deadening effect in watercolour. It is better to mix your own black colour. Remember that blacks are usually either cold (containing more blue) or warm (containing more red/brown).

15 Use the same ultramarine and Indian red colour mix and continue to add dark ripples to the water in the foreground.

16 Mix a bright orange from cadmium yellow and light red, and strengthen the colour of the beaks. Strengthen the shadows cast by the geese's bodies with a mix of ultramarine and a tiny amount of alizarin crimson. Brush the same colour over the bottom right corner, to brighten the water in this area.

The finished painting

The geese have been simply but sympathetically painted, with the white of the paper standing for the very brightest parts, and the shadows on their wings and bellies created by applying pale layers of blue-grey to achieve the right density. The rich red-brown earth and pebbles on the stream bed impart a warm glow to the scene that enhances the feeling of warm sunlight. Short horizontal brushstrokes capture the rippling water, with layer upon layer of pale glazes creating a subtle interplay of tones and colours. Although the bankside vegetation is only hinted at, it provides a tranquil rural setting.

The dark background allows the lovely curving shapes of the geese's necks to stand out clearly.

Note how some of the original pencil marks remain visible, providing subtle linear detailing that would have been difficult to achieve in watercolour alone.

Note how the ripples distort the shape of the reflections.

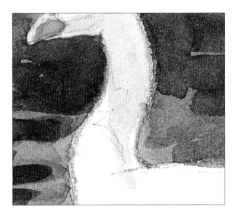

Puffin in watercolour

For this demonstration, the artist used just six colours – and two of those (cadmium yellow and scarlet) in only very small areas of the painting. Beginners often make the mistake of trying to find a ready-mixed paint for every hue that they need. If you restrict yourself to just a few colours it helps you to think about the colours you're using, and you will quickly learn just how many mixes you are able to achieve by using colours in different combinations and proportions.

The puffin's wing feathers are basically black – but when the wings are opened out, as here, light appears to stream through them. This kind of subject is an absolute joy for a watercolourist. You can leave patches of

the paper completely untouched, or covered by the very thinnest of glazes, for the very brightest patches, and gradually build up layer upon layer of colour in the mid- and dark-toned areas until you get the density of tone that you need. Remember that watercolour paint always looks a little paler when dry than it does when wet – so don't worry if the initial wash is a bit dark.

Vary your techniques to exploit the potential of the medium to the full. Working wet into wet allows you to create soft and diffuse blurs of colour that are perfect for the background sky, foreground vegetation and shadows on the bird's chest, while drybrush work in the softer feathers adds subtle but very effective textural detailing.

Materials
- *Good-quality watercolour paper*
- *6B pencil*
- *Watercolour paints: alizarin crimson, ultramarine, viridian, raw umber, cadmium yellow, scarlet*
- *Brushes: medium round, small round*

The subject
The cliff rising up behind the puffin gives the composition a strong diagonal line, which is counterbalanced by the angle of the wings. From this side-on viewpoint, all the detail of the wings and head can be clearly seen.

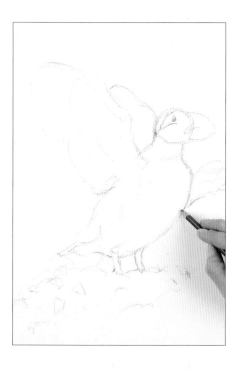

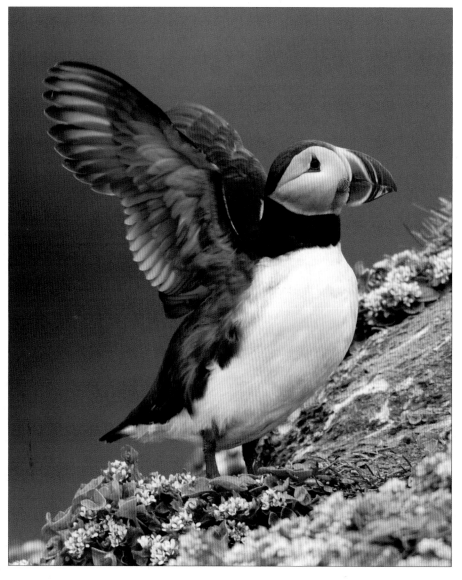

1 Using a 6B or other soft pencil, lightly sketch the bird and the line of the cliff on which it is standing. Try to reduce the bird's body, head and wings to simple geometric shapes – ovals and spheres. Define the areas of black and white on the body with a faint pencil line so that you've got a guide to where to apply the paint.

Tip: Ignore the detail at this stage – just concentrate on getting the overall shapes right.

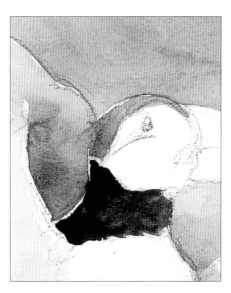

2 For the background, mix a cool dark purple-black from alizarin crimson, viridian and ultramarine, and a warm dark purple-black from alizarin crimson and viridian. Using a medium round brush, apply dilute washes of these colours around the bird, judging for yourself whether a warm or a cool tone is required. Use the negative shapes – the space around the bird – to help define the bird's shape.

3 Add a little raw umber to the purple-black mix from Step 2. Brush this on to the exposed rock just to the right of the puffin. Add a little ultramarine to the mix and, using a diluted wash, block in the underside of the right wing. Mix ultramarine with a tiny bit of alizarin crimson and block in the left wing, which is much darker in tone. This tonal variation will separate the wings visually from each other.

4 Darken the colour that you used for the left wing in the previous step and block in the neck and the top of the head. This is virtually the darkest tone on the bird, so once you've established it you will find it easier to judge the mid and light tones.

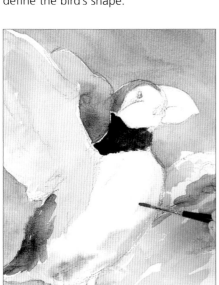

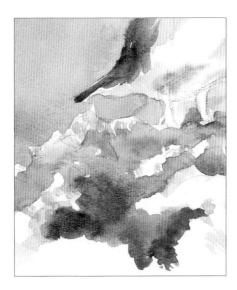

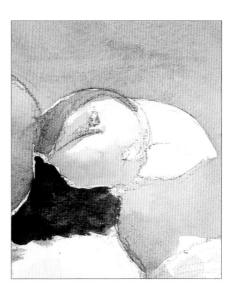

5 Use the same dark purple-black for the tail feathers. Wet the bird's chest with clean water. Using a fine round brush and a dilute version of the purple used for the bird's right wing, put in the warm colour on the underbelly. The paint will blur and spread. Using a small round brush and very dilute ultramarine, put in the darker tones within the white feathers.

6 Mix a warm green from cadmium yellow and ultramarine. Using an almost dry brush, so that you can create some textural marks, dab the colour on to the rocks, leaving some gaps white. Dot in some of the warm purple-black from Step 2 where necessary, keeping your marks loose and free. Again, let the colours mingle wet into wet.

7 Apply a dilute purple over the shadowed areas on the bird's head.

▶

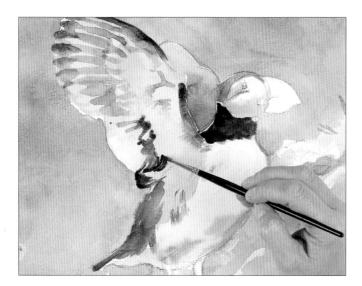

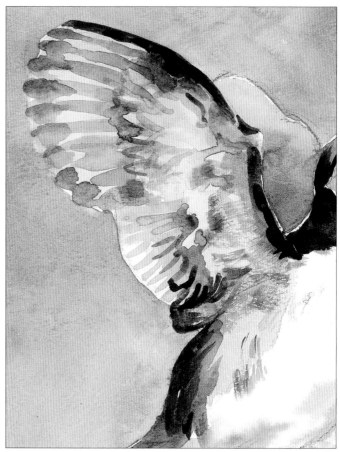

8 Add raw umber to the cool purple-black mix from Step 2. Using a small round brush, brush it around the edge of the near wing, as shown, so that the two wings are visually separated. Using the same colour, put in the long, dark flight feathers on the near wing, leaving gaps in between to create the effect of light shining through. Put in the smaller feathers at the base of the wing, using fine, curving brushstrokes.

Tip:The paper should still be damp from the initial wash of colour, so the paint will blur and 'feather' a little – perfect for creating the texture of feathers! If the paper has dried too much, carefully brush over the painted flight feathers with clean water to soften the edges of the paint marks.

9 Continue adding texture to the wings, using an almost dry brush and feathering your strokes outwards. Apply another layer of colour to the back and tail feathers, to deepen the colour.

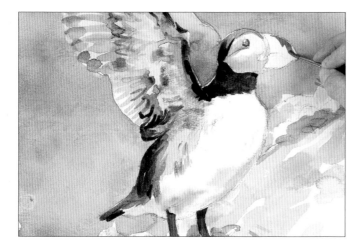

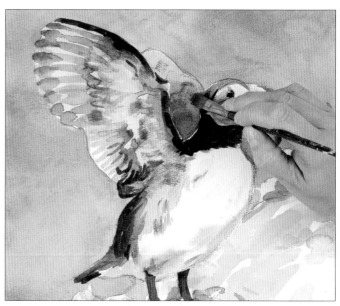

10 Mix a bright red from scarlet and a little alizarin crimson. Using a small brush carefully put in the red of the beak, eye, nostril and legs.

Tip: Add more alizarin to the mix to paint the back leg. It is further away and slightly in shadow.

11 Add more ultramarine to the cool purple-black mix from Step 2 and put in the dark detailing on the head and beak. Using the same mix and a dry, flat brush, drag the colour over the far wing to create more texture.

The finished painting

This is a simple yet effective watercolour study of one of nature's more comical-looking birds. The painting demonstrates the versatility and subtlety of watercolour, with delicate wet-into-wet applications being used to build up tone without leaving any harsh edges and carefully controlled brush marks being used to delineate the individual flight feathers. The colour palette is limited (even the sky in the background is made up of the differing proportions of the colours used on the bird), and the overall effect is harmonious.

The line of the cliff top rises up through the image in a sharp diagonal line, which adds interest to the composition. Although both the background and cliff are painted very sketchily, they provide enough information to give us a clue to the puffin's natural habitat.

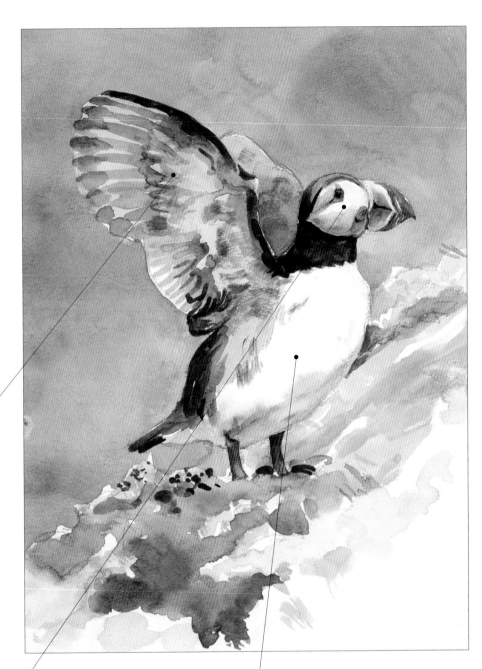

The large flight feathers are painted in bold brushstrokes on slightly damp paper, so they spread out and the edges appear diffuse. Note how the white paper implies light shining through the outspread wings.

Note how well the bird stands out against the soft wet-into-wet washes of the background tones.

Drybrush marks hint at the soft, downy texture of the chest feathers, while wet-into-wet soft blends create the shaded areas on the underside of the chest.

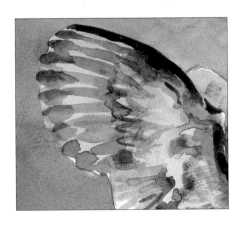

Swimming fish in water-soluble pencils

This colourful project combines elements of both drawing and painting. In the early stages, water-soluble pencils are used in a linear fashion as drawing tools; later, they are washed over with clean water, so that the pigment spreads on the support just like watercolour paint. You can also apply dry water-soluble pencil over wet washes to deepen the colour, either by using the pencils directly or by brushing water over the tip of the pencil so that the brush picks up a little pigment. The benefit of this technique is that you don't create hard edges.

As you'll be applying water to the paper, use watercolour paper, which is absorbent enough not to tear under the weight of the water. When you start applying water, work on one part of the image at a time – first the fish, then the water – so that the colours don't all blur together.

One of the most attractive aspects of this project is the sense of movement in the water. Observe how the ripples catch the light as this will help you to convey the movement. Use curved pencil strokes for the ripples and look at how the water breaks around the fish.

Materials
- *Watercolour paper*
- *Water-soluble pencils: orange, bright yellow, dark blue, olive green, yellow ochre, warm brown, reddish brown, red, blue-green*
- *Masking fluid and old dip pen*
- *Paintbrush*
- *Kitchen paper*

The subject
The colouring on the fish is spectacular – strong, saturated reds, yellows and oranges. Note how the shape of the fish is slightly distorted by the ripples in the water. The ripples themselves catch the light from above, which creates a glorious sense of movement and shimmering light.

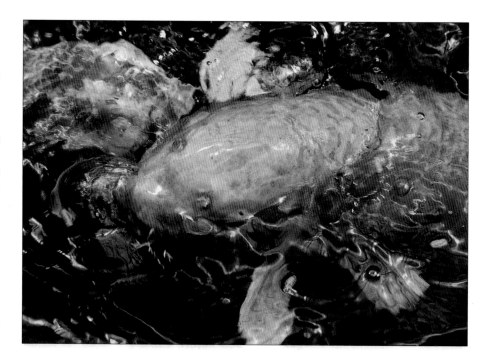

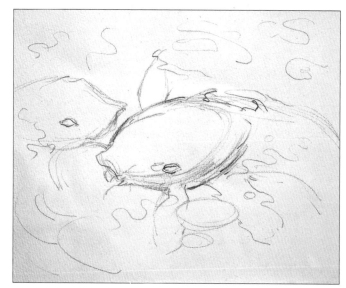

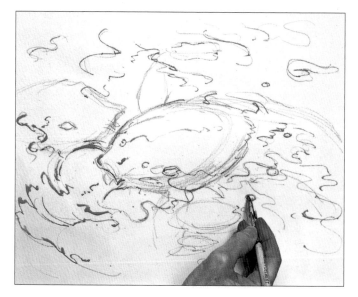

1 Using an orange water-soluble pencil, lightly sketch the outline of the fish, making a clear distinction between the top of the larger fish's head, which is just poking out of the water, and the rest of the body. Draw a few of the largest ripples in the water, too.

2 Using masking fluid and an old dip pen, mask out the white highlights on the water and the fish. Leave to dry.

Tip: You can speed up the drying process by using a hairdryer.

3 Lightly scribble bright yellow over all except the white parts of the fish. Apply orange to the reddest areas, pressing quite hard on the pencil.

4 Now start putting some colour into the water, using dark blue with a few touches of olive green for the very darkest parts.

5 Colour in the submerged fins of the large fish using a yellow ochre pencil and go over the reddest part of both with a warm brown. Continue adding colour to the water, using the same colours as before and making curved strokes that follow the shape of the ripples.

Assessment time
You've now put down virtually all the linear detail that you need. Once you start applying water, however, there's a risk that you might lose some of the detail: it's important, for example, to retain some of the ripples in the water – so decide in advance where you want the pigment to spread and, if the colours run into areas where you don't want them to go, be ready to mop them up with a piece of absorbent kitchen paper.

Although the shape of the fish is clear, it's hard to tell which parts are submerged and which are above the water.

Confident, flowing linear marks capture the ripples in the water – and at least some of these marks should be visible in the finished drawing.

6 Dip a paintbrush in water and gently brush over the large fish. Note how intense and vibrant the colour becomes.

7 Brush clean water over the painted water, following the lines of the ripples, leaving some highlighted ripples white.

Tip: You may find it best to lay the drawing flat at this stage, so that the water doesn't run down it.

Tip: If the water runs where you don't want it to go, simply blot it off with absorbent kitchen paper.

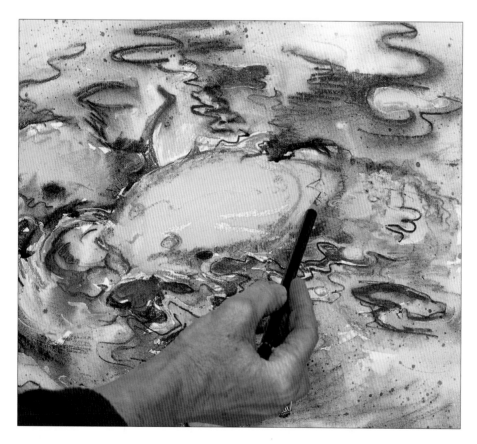

9 Dip a red pencil in water and darken the red of the fish where necessary. Reinforce the outlines of the fish with a blue pencil. Leave to dry.

8 Brush clean water over the small fish. Allow the support to dry slightly, but not completely, and go over the reddest parts of the fish with a reddish brown pencil. The colour will intensify. It will also blur and spread, so you won't get any hard edges. The blurred orangey-red will look as if it is under water – so it will become clearer which parts of the large fish are jutting up above the water's surface.

10 Rub off the masking fluid. Scribble blue-green into the darkest parts of the water, pressing quite hard with the pencil to create the necessary depth of colour.

The finished drawing

Capturing a sense of movement, this drawing demonstrates the potential and versatility of water-soluble pencils and combines linear detailing with lovely, fluid washes that intensify the colours and blend them together on the support.

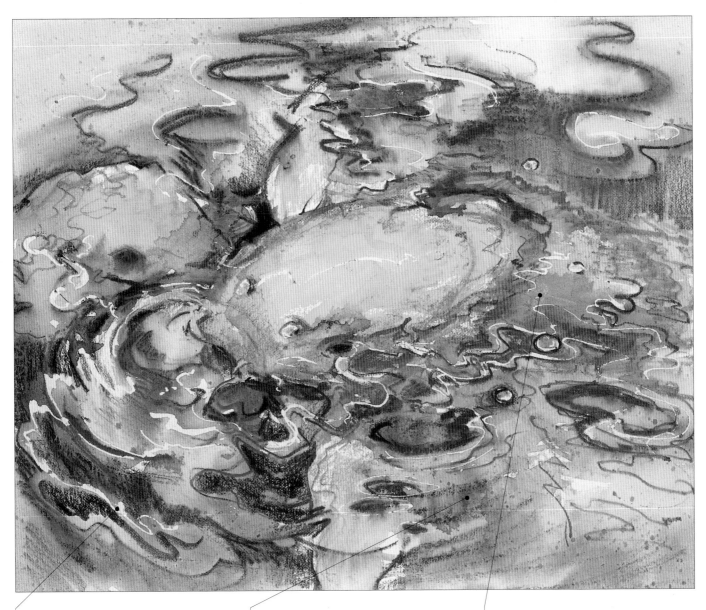

Masking fluid can be used to keep the highlights white.

Curved pencil strokes create a sense of movement in the water.

The transition from one colour to the next is almost imperceptible.

Dolphin in acrylics

With their high intelligence and inquisitive nature dolphins are, for many people, one of the most fascinating and appealing of all animal species. This demonstration gives you the chance not only to capture a good likeness of this beautiful creature, but to practise painting the effect of light on water.

If you're lucky enough to see live dolphins, do not rely entirely on photographs for your reference material. Sketching a leaping dolphin might seem rather daunting at first, but start by asking yourself a few simple questions. How high above the water surface does the dolphin leap? At what angle is the body in relation to the water? If you spend time studying them, you'll soon see some patterns recurring. Look, too, at the light. How intense is it? Is the sun high in the sky, hitting the top of the animal, or lower, illuminating the animal from the side? And what about the water? Where are the highlights and shadows, and how many different colours can you see within the water?

The dolphin's body is fairly uniform in colour, so the key to making this painting work is assessing the tonal values carefully in order to make the animal look three-dimensional. One of the joys of working in acrylics is that the paint is opaque – so if you get it slightly wrong you can simply paint over what you've already done.

You can have fun experimenting with different ways of capturing the splashes of water. Here, the artist spattered on white paint in the final stages – but you could spatter on masking fluid right at the start, to preserve the white of the paper.

Materials
- *Good-quality watercolour paper*
- *2B pencil*
- *Acrylic paints: cerulean blue, violet, titanium white, bright green, ultramarine, burnt sienna*
- *Brushes: medium round, small flat, small round*
- *Painting knife*

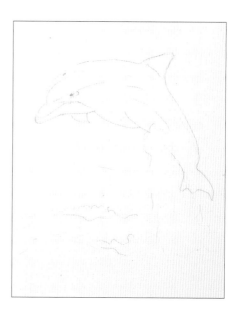

1 Using a 2B pencil, sketch the scene, putting in some of the ripples in the water as well as the dolphin. Check carefully to make sure the proportions of the dolphin and the curve of its back are correct. Here the dolphin's eye has been positioned 'on the third' – a classic compositional device.

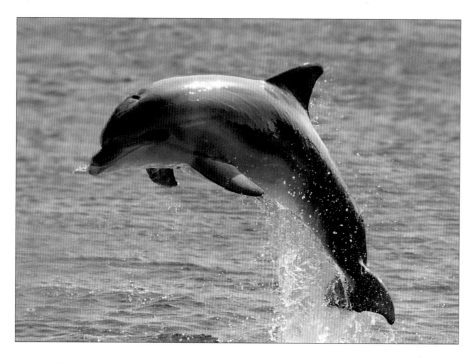

The subject
This scene has a wonderful feeling of light, with the sunlight sparkling on the sea. The dolphin is leaping right out of the water, its beautifully arced back creating a lovely dynamic shape. The splashes of water give a great sense of motion. Here, the artist decided to make a portrait-format painting in order to emphasize the height of the dolphin's leap.

2 Mix a bright blue from cerulean, violet and white. Using a medium round brush, dab it on the water area quite thickly, varying the proportions of the colours in the mix and using short horizontal strokes to create the effect of ripples in the sea. Add in some bright green, allowing it to blend into the blue mix. Leave gaps for the bright highlights on the water.

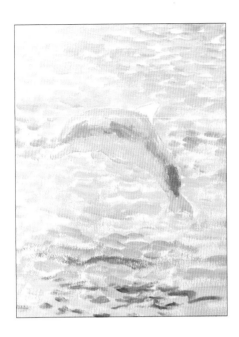

3 Continue with the blue-green mixes, working carefully around the outline of the dolphin, until all the sea area has been roughly put in. This is similar to the approach used by the Pointillist painters; when viewed from a distance, the colours will appear to combine together to create shimmering mixes.

4 Mix a light violet from violet and white. Using a small flat brush, put in the light tones on the top of the dolphin's back. Add ultramarine to the mix and put in the mid tones. Once you've established the mid tones, you'll find it easier to judge how light or dark the rest of the animal needs to be.

5 Continue developing the form on the dolphin, using almost pure violet for the darkest tones on the centre of the back and a mix of cerulean and white for the lightest tones.

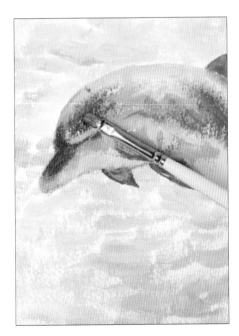

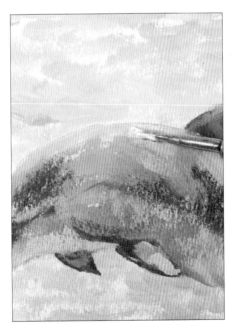

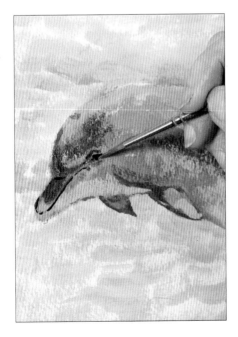

6 Add burnt sienna to the dark mix on the nose, fins and centre of the back. This adds warmth to the colour as well as darkening it. Keep the paint quite thick. Use an almost dry brush, with very little paint, and drag the brush lightly across the paper to create a slightly broken, mottled texture.

7 Keep assessing the light and dark tones as you work. Note how the sun catches the top of the dolphin's body: use a very pale mix of violet and white here and make sure that the edge of the body is sharply defined, so that it stands out from the water.

8 Using the tip of a small round brush, carefully paint the details of the nose and eye in pure violet.

▶

Assessment time

It is only by correctly placing the light and dark tones that you can make the animal look really rounded and three-dimensional – and one of the most common mistakes is to make both the darkest and the lightest tones too close to the mid tones. However, acrylic paint is opaque, so you can just paint over what you've already done if you need to make minor adjustments. Here, the dark tones are dark enough – but the top of the dolphin's body needs to be a bit lighter to create the impression of strong sunlight hitting the body.

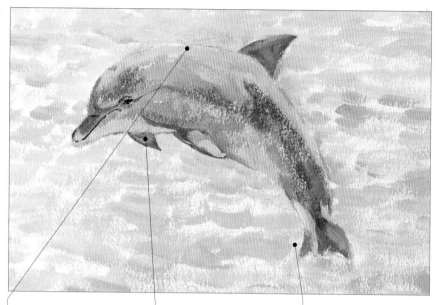

This area is too close in tone to the mid tones: it needs to be lighter.

The dark tones work well: they help convey the rounded form of the animal as it turns away from the light.

Adding splashes of water as the dolphin emerges from the sea will really help to create a sense of movement in the painting.

9 Again using the small round brush, redefine the outline of the dolphin by putting some dark blue-violet into the water immediately behind it, so that the light colours on the dolphin's back really stand out. Apply dilute white to the very brightest areas along the top of the dolphin's back, using clean water to blend the paint into the previous colours so that you do not get any harsh transitions from one tone to the next.

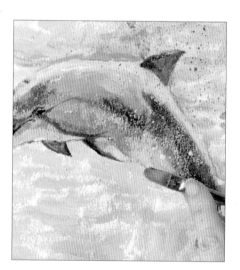

12 Spatter violet paint over the water behind the dolphin and thin white paint over the dolphin's body, where it emerges from the water.

> **Tip:** Tap gently, and do not overload the brush with paint – otherwise you may find that the droplets of spattered paint are too large.

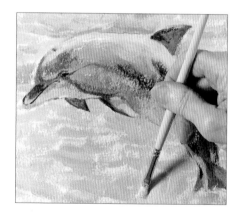

10 Mix violet with lots of white to make a very pale blue-white. Using the small flat brush again, brush this mix on in long, vertical strokes for the water streaming off the underside of the dolphin's body.

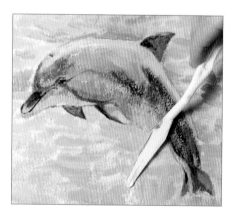

11 Repeat the previous step, but this time use a palette knife instead of a brush, and make the paint much thicker so that the streams of water are more pronounced.

The finished painting

This is a very lively and atmospheric painting that is full of movement. Note that if you divide the picture space into three, both horizontally and vertically, the dolphin's nose and tail fall more or less on the intersection of the thirds – a classic compositional device. The colour palette is limited – mostly blue-violet, blue and green, which gives a lovely, restful colour harmony – but the tones have been extremely well observed, giving good modelling on the dolphin. Short, horizontal strokes of the brush have been used to create the gently rippling sea, with spattering and longer brushstrokes adding the texture of the splashes of water.

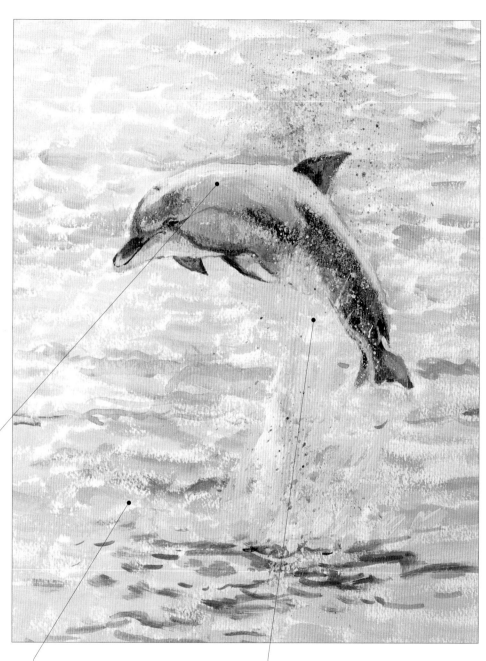

Drybrush work on the dolphin's body allows the texture of the paper to show through and creates a lovely mottled effect on the dolphin's skin.

Although the sea has been loosely and spontaneously painted, note how many different colours there are in the water, with gaps left for the bright highlights.

Spattering and long strokes of thicker paint are used to convey the splashes of water.

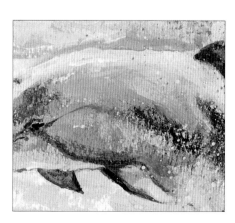

Tropical fish in acrylic inks

Your main challenge in this project is to recreate the wonderfully vibrant colours of the fish. Acrylic inks (used here) are one option: simply mix them on a palette, as you would with watercolour or acrylic paints, to create the colours you need. You could also try combining acrylic paints with a pearlescent or an iridescent medium. Pearlescent mediums create a shimmering effect, while iridescent mediums contain tiny flakes of mica that, when mixed with paint, appear to change colour depending on the direction of the light. These mediums are particularly effective with transparent colours.

Note that many of the markings on the fish are not solid, unbroken lines. If you paint them as solid lines, you run the risk of creating an image that is more like a cartoon character, or a design for stained glass. Instead, use the tip of your brush to dab on tiny dots and dashes of ink and create a much more lifelike effect.

The coral in the background of this image adds a lovely texture behind the fish. You can put in as much or as little of it as you wish, but remember that the fish is the most important part of the painting and should remain the focus: the coral is behind the fish, so paint it in less detail. Let the inks do a lot of the work for you. Drop the coral colours on to wet paper, so that they blur and spread, and try tilting your drawing board to create interesting runs of colour. When the background has dried, you can then decide if you want to add more linear detailing and texture to the coral – but do not allow it to dominate the painting.

Materials
- *Good-quality watercolour paper*
- *2B pencil*
- *Masking fluid*
- *Ruling drawing pen, dip pen or brush*
- *Acrylic inks: crimson, phthalocyanine blue, pearlescent blue, burnt sienna, bright green, yellow-gold, bright red, pearlescent violet, pearlescent crimson*
- *Brushes: rigger, large round*

The subject
A side-on viewpoint allows us to see the shape and markings of this tropical fish, while the deep blue of the sea sets off the fish's vibrant colours. Note that the fish is angled slightly upwards, which makes for a more dynamic composition. The coral provides a natural-looking setting without detracting from the main subject.

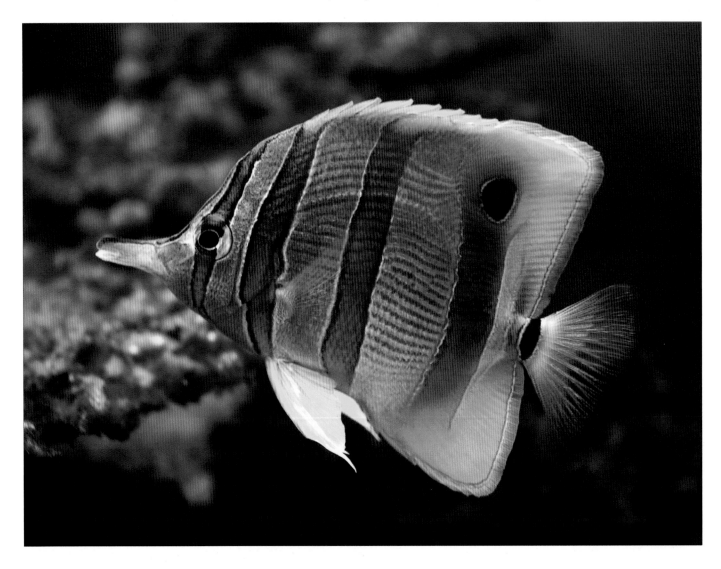

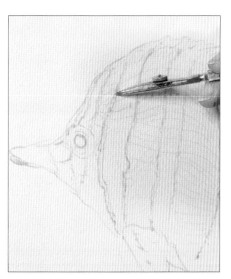

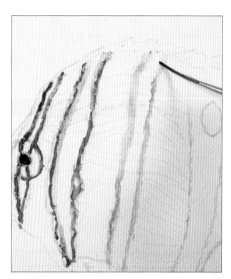

1 Using a 2B pencil, sketch the fish, putting in the main markings.

2 Using a ruling drawing pen, a dip pen or an old brush dipped in masking fluid, mask out the very light markings on the fish. Leave to dry.

3 Mix a deep purple-black from pearlescent crimson and phthalocyanine blue acrylic inks. Using a rigger brush, put in the very dark lines on the edges of the fish's striped markings. The colour is darkest near the fish's head: add more water to lighten the colour as you work down the body.

 Tip: It's a good idea to mark the tips of the fish's nose and tail lightly on the paper before you start, to ensure that you can fit everything in.

 Tip: The masking fluid must be completely dry before you go on to the next stage.

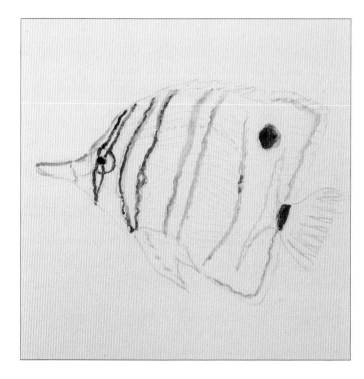

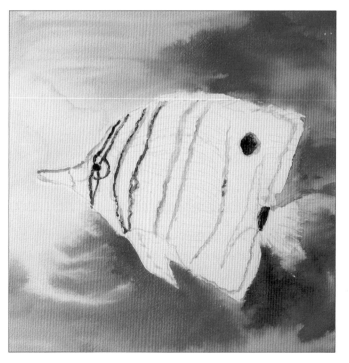

4 Add more phthalocyanine blue to the mix and put in the blue lines and circular markings near the tail. Don't worry about the mixes varying slightly in tone: if the fish's markings were all painted a uniform, solid colour, the image would look more like a cartoon than a painting.

5 Wet the background with clean water, taking care not to go over the fish. Using the dropper from the ink bottle, drop on pearlescent blue and phthalocyanine blue inks, then brush the colours together with a large round brush, lifting off ink in places to get some tonal variation in the water. Leave the coral reef on the left of the image untouched.

▶

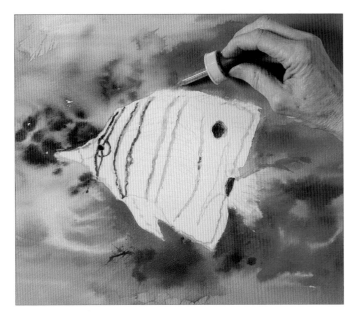

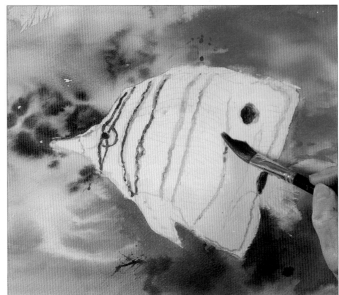

6 Dot burnt sienna ink on to the coral area, touching the pipette directly on to the paper to get little blobs of colour that spread outwards, wet into wet. Repeat with bright green ink, again allowing it to spread naturally.

7 Brush clean water over the areas of the fish that are going to be orange or yellow. Using a medium round brush, brush yellow-gold ink over these areas. The ink will spread over the damp paper of its own accord and, by working wet into wet, you will avoid getting any obvious brush marks.

Tip: While the ink is still wet, tilt your drawing board in different directions to get interesting runs of colour. The emphasis in this painting is entirely on the fish, so don't worry too much about painting every little detail on the coral – a general impression of the colours and textures is sufficient.

Tip: It doesn't matter if you go over the inks you laid down in Steps 3 and 4: once the ink has dried, it should not lift off.

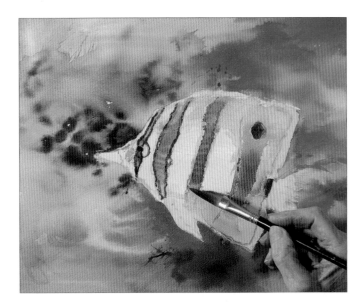

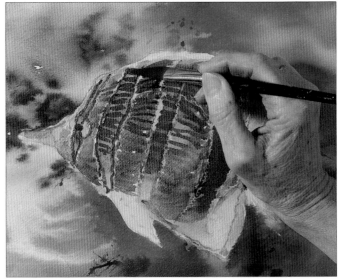

8 Mix a bright orange from yellow-gold and bright red inks. Brush in the orange parts, applying two or more layers for the really dark orange parts. In some areas, the orange is a deep, burnt orange – add more red to the mix for this. Brush on a second layer of colour in short, horizontal strokes so that you begin to develop some of the striped markings.

9 Deepen the orange/red markings by applying another layer of colour. Mix a deep violet from pearlescent violet and a little pearlescent crimson and paint the violet vertical stripes. Add more crimson to the mix and, holding the brush almost vertically and allowing only the tip to touch the paper, put in the horizontal markings that run across each stripe.

Assessment time

In the final stages, concentrate on boosting the depth of colour on the fish where necessary and on refining the markings on the fish's body, so that you create more texture. You also need to make sure that the fish stands out from the background; in places, the fish almost merges into both the coral and the surrounding sea. The area of sea just below the coral, to the left of the fish, is distractingly bright.

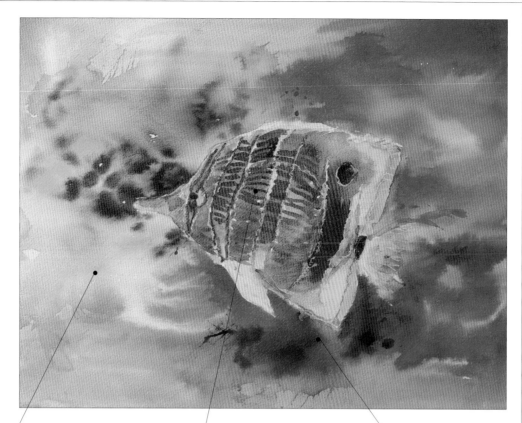

The coral is rather indistinct and formless and needs to come forwards in the image.

The markings can be reinforced a little more strongly.

Darkening the sea around the fish will allow it to stand out more clearly.

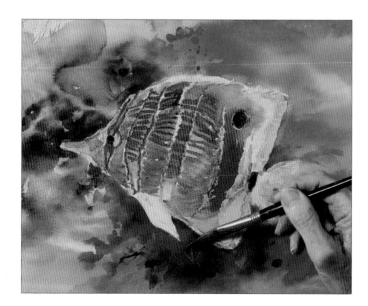

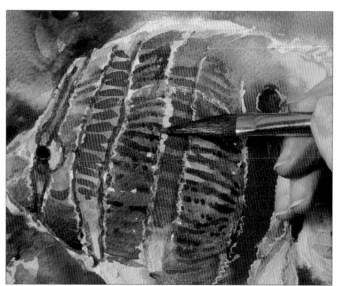

10 Wet the background with clean water, brushing carefully around the fish. Dot the deep violet colour from Step 9 into the coral, wet into wet, allowing it to spread to create more texture and colour. Carefully apply dark blues and purples underneath the fish, cutting right in around the edge to define its shape more clearly and allow it to stand out from the background.

11 Using the pearlescent crimson and phthalocyanine blue mix from Step 3 and the tip of the brush, go over the horizontal markings again, making tiny dots of colour. Textural details such as this are another way of ensuring that the fish stands out from the background.

▶

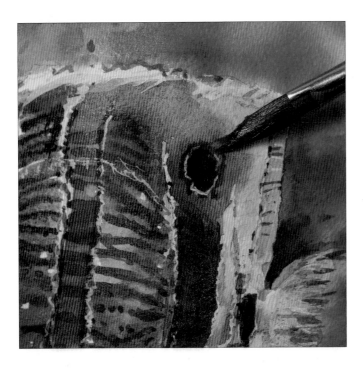

12 Use the same colour and 'dotting' technique to redefine the vertical bands that you painted in Step 3. Cut in around the 'frilly' edges at the top of the fish with dark blue, so that the shape of the yellow fronds is more clearly defined. Darken the tiny band of orange around the eye-like marking near the tail. Leave to dry.

13 Using your fingertips, carefully rub off all the masking fluid that you applied in Step 2 to reveal the very lightest markings on the fish.

14 Some of the white now looks too stark. Brush over it with very dilute pearlescent blue or violet, as necessary, leaving only the very brightest markings as white paper.

The finished painting

This lively painting exploits the wet-into-wet technique to the full, with wonderfully atmospheric blurs of colour in the sea and coral. The layers of colour on the fish have been built up gradually, with delicate wet-on-dry brushstrokes being used for many of the markings. The deep blue of the sea sets off the vibrant yellow and orange stripes beautifully.

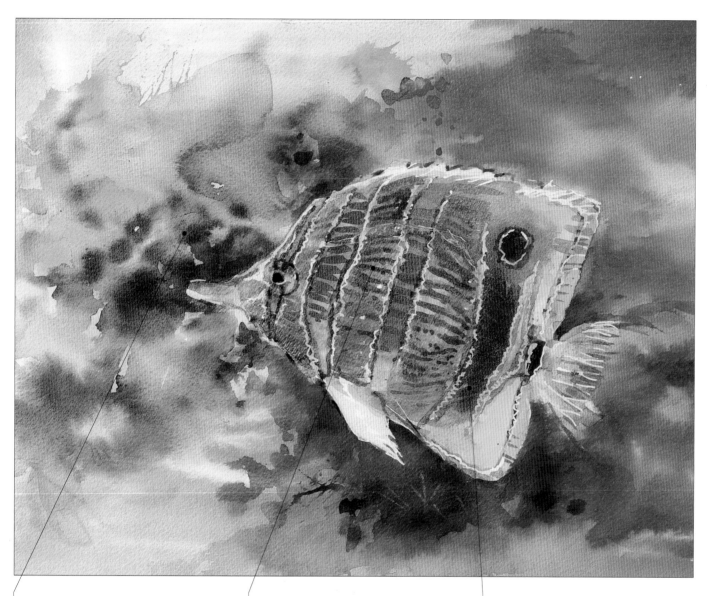

The colours have blurred and spread, wet into wet, creating interesting shapes and textures without detracting from the main subject.

The markings have been painted using tiny dots and carefully controlled horizontal brushstrokes, creating delicate but important textural detail on the fish.

The complementary colours – orange/ deep blue and yellow/violet – really sing out and help to give the subject a feeling of great energy.

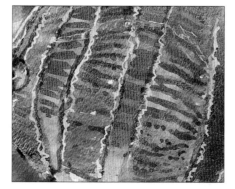

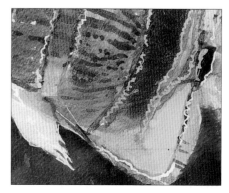

Tropical butterfly in oils

Both butterflies and moths belong to the scientific order Lepidoptera, which means 'scale-wing' in Latin, and most butterfly wings are covered with tiny, individually coloured scales arranged in partially overlapping rows, like tiles on a roof. Butterfly houses give you the chance to see all kinds of exotic, brilliantly coloured and patterned species. This peacock pansy butterfly (*Nymphalidae precis almana*) is indigenous to Nepal and neighbouring regions and is characterized by the eyespots on the wings, which act as a deterrent to potential predators.

The artist selected a smooth-surfaced board for this study in oils, for two good reasons: first, he wanted this to be a detailed painting and a smooth surface allows you to put in small details without the paint spreading and sinking into the support; second, he did not want the texture of the support to show through in the final painting.

To speed up the drying time so you can complete the painting in one session, add a drying agent such as drying linseed oil.

As each scale on the wing is differently coloured, you will find infinitely subtle gradations of tone. One way of conveying both the texture of the wings and the subtlety of the colour shifts is to stipple the paint on, using the tip of the brush, to create optical colour mixes in the same way that the Pointillist painters such as Georges Seurat (1859–91) did. However, although some inks and liquid watercolours can come close, it is difficult to match the intensity of iridescent colours with even the brightest of pigments.

Materials

- *Smooth-surfaced board*
- *HB pencil*
- *Oil paints: chrome yellow, cadmium orange, geranium lake, brilliant pink, titanium white, ultramarine blue, turquoise blue deep*
- *Turpentine (white spirit)*
- *Drying linseed oil*
- *Brushes: selection of fine rounds, filbert*

The subject

With its dramatic eyespots and brilliant colouring, this peacock pansy butterfly makes an appealing subject for a painting. However, the artist decided not to include all the flowers, as he felt they detracted from the butterfly. It is perfectly permissible to leave out certain elements of a scene in order to make your painting more dramatic.

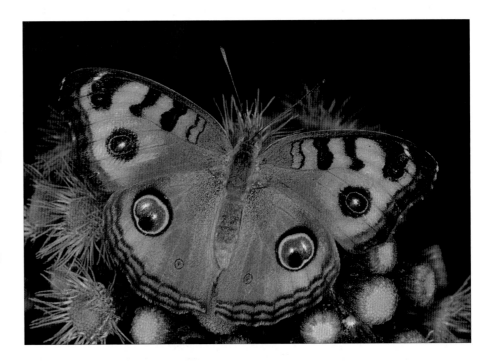

1 Lightly sketch the butterfly in HB pencil. It is entirely up to you how much detail you put into your underdrawing, but including the veins and the fringe-like pattern around the outer edge of the wings will make it easier for you to keep track of where you are in the painting.

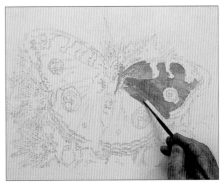

2 Using a fine round brush and alternating between chrome yellow and cadmium orange, start putting in the basic colour of the wings. Thin the paint with turpentine (white spirit) and mix it with drying linseed oil so that it is the consistency of single (light) cream.

Tip: Use a different brush for each colour, so that you do not have to keep stopping to clean brushes.

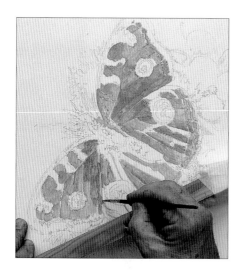

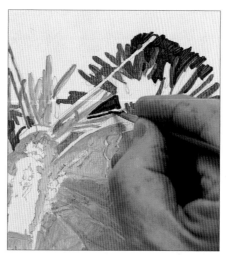

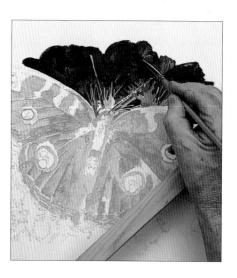

3 Continue until all the yellow is complete, looking closely at your subject to see the different tones. You may need to turn the support around and use a mahl stick to keep your hand clear of wet paint. If you do not have a mahl stick, you can improvize one by taping rags around one end of a thin piece of wood or dowelling, as the artist did here.

4 Mix a range of bright pinks from geranium lake, brilliant pink and titanium white and start painting the flowers on which the butterfly is resting. Mix a dark, purplish blue from ultramarine blue and geranium lake and start putting in the background, taking care not to get any colour on the butterfly. Again, use a mahl stick, if necessary, to keep your hand clear of any wet paint.

5 Continue painting the background, carefully cutting in around the flower tendrils.

> **Tip**: When you are clear of the butterfly and flowers, switch to a larger brush to enable yourself to cover the background more quickly.

6 Using the same colours that you used for the flowers and background, start putting in some of the dark detail on the butterfly, using short brushstrokes to convey the texture of the scales on the wings.

7 Paint the 'eyes', using cadmium orange and the purple/pink mixture from Step 4, and stipple the colour on with the tip of the brush to create an optical colour mix. Note that there are bluish-purple patches next to the two largest eyes: add more white and ultramarine blue to the mixture for these areas. Paint the 'fringe' around the outer edge of the wings in oranges and pinks, as appropriate.

▶

Assessment time

The main elements of the painting are in place. All that remains is to add more fine detailing to the butterfly and complete the surrounding flowers and background, working carefully and methodically. Although the artist had originally intended to include the flowers to the right of the butterfly, at this point he decided that they would detract too much from the painting of the insect.

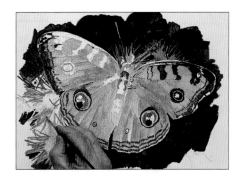

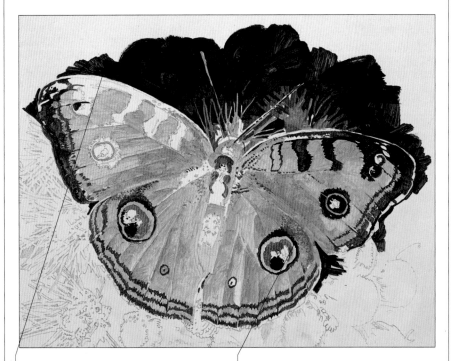

The dark background acts as a foil to the butterfly. Keeping its edges irregular adds to the informality of the study.

The detail is beginning to take shape; features like this are best put in during the final stages, when the underlying colours and shapes have been established.

8 Using a fine brush and the same pinks and purples as before, paint the flowers on the left-hand side, gradually working down the painting. Paint as much of one colour as you can while you have it on your brush. When you have finished the flowers, paint the dark background.

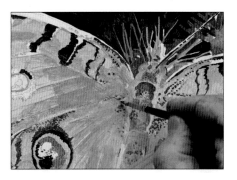

9 Paint the body of the butterfly, blending the colours on the support so that the brushstrokes are not visible.

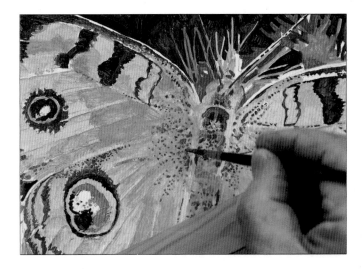

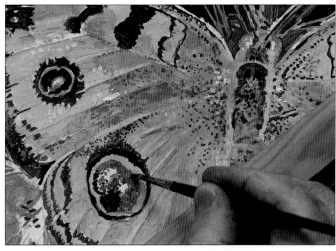

10 Continue painting the dots of colour on each side of the body. Although the dots are clustered more densely near the body, the same colours also run along some of the veins. Finish painting the 'eyes' on the left-hand side of the butterfly, using the same colours as before.

11 Mix a bright blue from turquoise deep blue and white and dot it into the whites of the 'eyes'. The patterning is now beginning to stand out strongly. Reinforce the orange areas around the two largest eyes with cadmium orange, deepening the colour with geranium lake where necessary.

The finished painting

Although this was never intended as a photorealistic painting, Pointillist-style dots of colour help to capture the iridescent quality of the wings – something that cannot be achieved easily in paint. Much of the painting consists of a single layer of paint, which is appropriate for the thin and delicate structure of the insect. Note the clever use of different lengths of brushstroke to create texture: longer, blended strokes are used for the furry body, while short strokes and tiny stipples convey the individual scales on the wings. The artist has also used some artistic license in reducing the number of flowers so that the butterfly is more clearly defined against the dramatic, dark background.

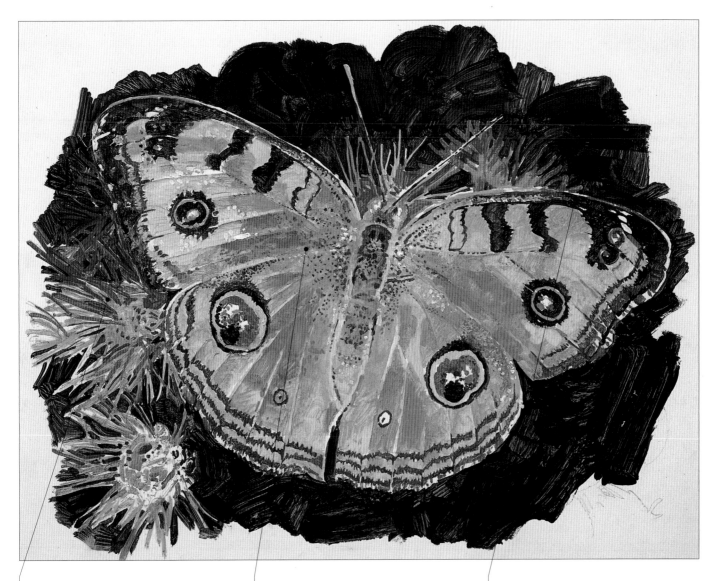

The flowers are loosely painted but echo some of the colours in the butterfly.

Different lengths of brushstroke create different textures.

The butterfly stands out clearly against the dark background.

Dragonfly in watercolour

Dragonflies can often be seen in summer on or near garden ponds or waterways and with their spectacular, jewel-like colours, they are a delight to watch and sketch. They can fly at incredible speed, so your only real chance of sketching them is when they are at rest. This gives you the perfect opportunity to study their anatomy closely, as most dragonflies at rest hold their wings out horizontally (unlike damselflies, which hold their wings together or just slightly open when at rest). You will see that they have four semi-transparent wings, which broaden near the base at the point where they attach to the body, and two large eyes, which take up most of the head.

If you're painting from a close-up photo, beware of putting in too much detail on the dragonfly, even though it is clearly visible in your reference. It is difficult to see this much detail with the naked eye, so if you include it in your painting it will look unrealistic.

You might choose to fill your picture space with the dragonfly, in which case you will probably be painting it several times larger than life size. If you choose to include more of the surroundings, think about the scale and make sure that the insect and the surroundings are in proportion to each other. Position the insect in the foreground of your painting, so that you can paint the detail. The further away the insect is, naturally, the less detail you will be able to discern, so if you have a detailed insect in the middle distance of your painting, you will destroy the sense of scale and distance. By placing the dragonfly in the foreground you can also, to some extent, free yourself from the problem of it being in scale with the background. In the demonstration shown here, if the dragonfly was on one of the lily pads, it would be very small if painted to the correct scale.

Look, too, for interesting lines and shapes in the surroundings that will bring another visual element to your painting. Here, the artist made a feature of the vertical stems in the background, which contrast with the rounded shapes of the lily pads and make for a more dynamic composition.

Materials
- *Heavy watercolour paper*
- *4B pencil*
- *Watercolour paints: yellow ochre, Indian red, cadmium yellow deep, cerulean, cobalt blue, ultramarine, lemon yellow, light red*
- *Brushes: large or medium round, rigger*

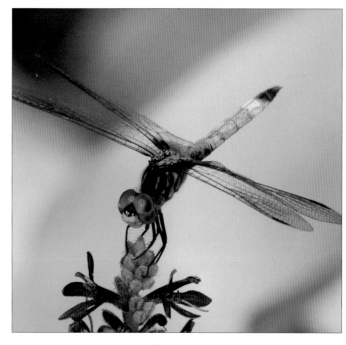

The subject
To create this painting, the artist worked from two photos – a close-up shot of a dragonfly (above) and a photo of waterlilies on a lake (left). Although the dragonfly is a fascinating subject in its own right, he wanted to place it in a recognizable setting rather than simply replicate the blurred, out-of-focus background of the reference photo. He elected to place the dragonfly in the foreground of the image, with the round shapes of the waterlily pads and the vertical lines of the grasses behind providing added interest.

Thumbnail sketch

Simple thumbnail sketches are always a good way of working out the composition of your painting and are essential when you're combining two or more references. Here, the artist opted for a version in which the dragonfly is in the foreground so that attention is concentrated on it, and the lily flower is off-centred some distance behind it.

3 Mix a pale green from cadmium yellow deep and cerulean. Loosely establish the light blue-greens of both the lily pads and water.

1 Using a 4B pencil, sketch the subject. Pay particular attention to where the reflections start: note how the water distorts the shape of the reflections so that the edges of the grass stems appear to ripple slightly.

2 Mix a yellowy orange from yellow ochre and a touch of Indian red. Using a large or medium round brush, loosely wash in the underlying yellow colour of the lily pads and the submerged foliage.

4 Mix the deep blue of the water from cobalt blue, ultramarine and a little yellow ochre. Loosely brush this colour on.

 Tip: Don't worry if you paint over the grass stems. These are very dark in colour, so any blue paint will be easy to cover at a later stage.

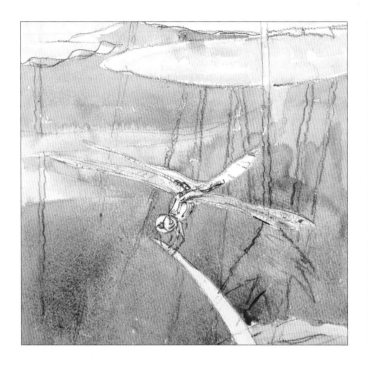

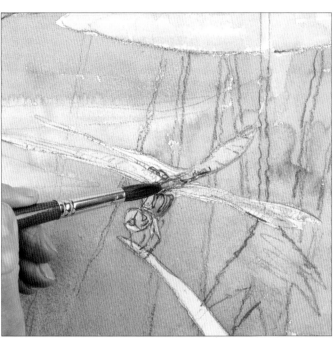

5 Make the colour stronger as you work down the paper. The closer it is to the viewer, the darker the water should look. The dragonfly's wings are semi-transparent, so you can see some of the water through them: drag the brush lightly across the wings, barely touching the surface, to create this effect. Leave to dry.

6 Mix a very light blue-green from cerulean and a tiny bit of lemon yellow and paint the dragonfly's head and body. Lightly brush cobalt blue over the dragonfly's thorax.

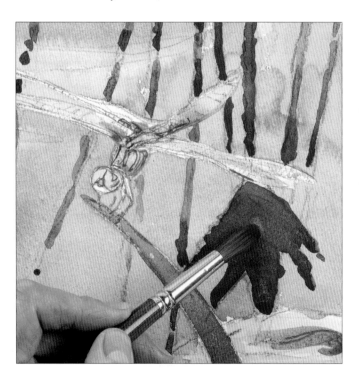

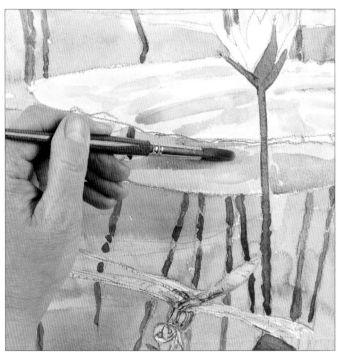

7 Mix a dark reddish brown from light red and ultramarine and put in the dark grass stems and their reflections.

8 Mix a bright green from cerulean and lemon yellow. Brush this colour mix over the lily pads, allowing some of the initial yellow colour applied in Step 2 to show through. Keep the lily pads fairly light in colour, in contrast to the rich, dark blues of the water.

Tip: Use a wiggly line for the stem reflections, as their shape is distorted by the water.

Assessment time

All the elements of the image are now in place, but the image is too pale overall. Concentrate on strengthening the tones – but remember that watercolour always looks slightly lighter when dry than when wet. Build up the layers gradually until you achieve the density of tone that you want. You also need to make the dragonfly stand out more from the background; the way to do this is to make the background much darker.

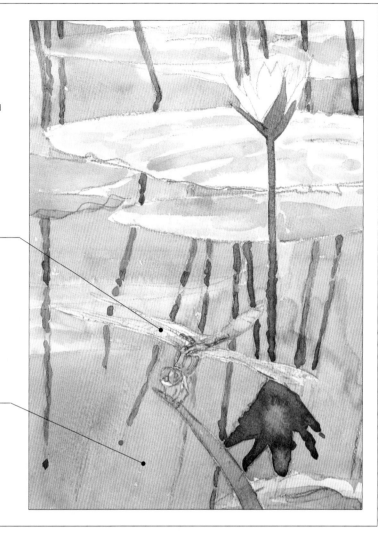

The dragonfly is merging into the background and needs to stand out more clearly.

The water is too pale, and needs to be a much more rich blue colour in the foreground area.

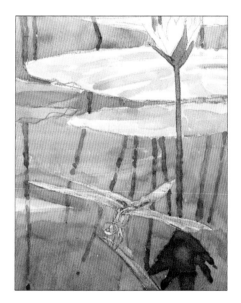

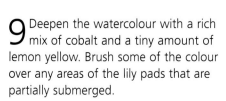

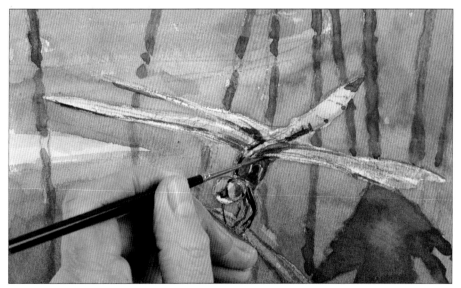

9 Deepen the watercolour with a rich mix of cobalt and a tiny amount of lemon yellow. Brush some of the colour over any areas of the lily pads that are partially submerged.

10 Mix a dark purple-black from ultramarine and Indian red. Using a rigger brush (or any thin brush that comes to a fine point), put in the detailing on the dragonfly – the dark colours on the underside of the thorax and along the edges of the delicate lace-like wings. Use an almost dry brush and very little paint so that you can control exactly where you place these very fine lines.

▶

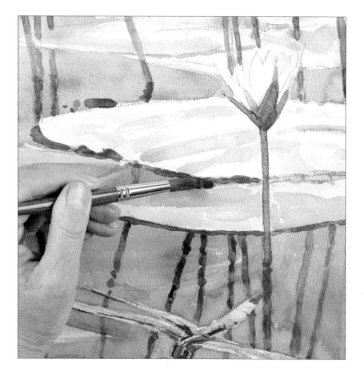

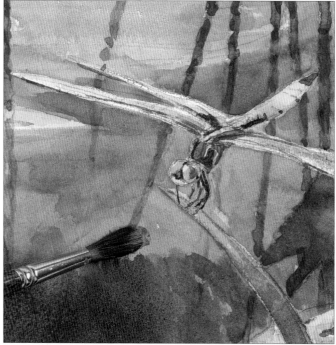

11 Darken the reflections of the grass stems a little, using the same light red and ultramarine mix as before. Mix a dark blue-green from ultramarine and yellow ochre and put in the slight shadows under the edges of the lily pads so that they look more three-dimensional.

12 Using the cobalt blue and lemon yellow mix from Step 9, darken the area immediately around the dragonfly so that the subject stands out from the background more. Brush the same colour over the bottom left corner of the image, where the water is more densely shaded.

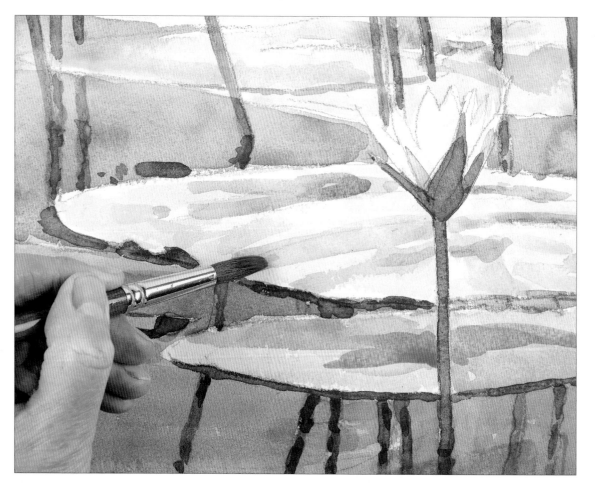

13 Mix a bright blue-green from lemon yellow, cerulean and a little ultramarine, and darken the foremost lily pad so that it comes forward in the painting a little more.

The finished painting

This painting has a lovely feeling of spontaneity that is perfectly in keeping with the subject; one feels that the dragonfly has alighted only momentarily and might take off again at any moment. The lily pads and stems have been painted fairly loosely, but their lines and shapes counterbalance the horizontal lines of the insect's wings. The restricted colour palette – predominantly soft blues and greens – is harmonious and restful to look at. The colours in the water have been built up gradually in thin layers, with each layer modifying the previous one; as a result, the water contains many subtle variations that are far more effective than a flat application of one tone or colour could ever be.

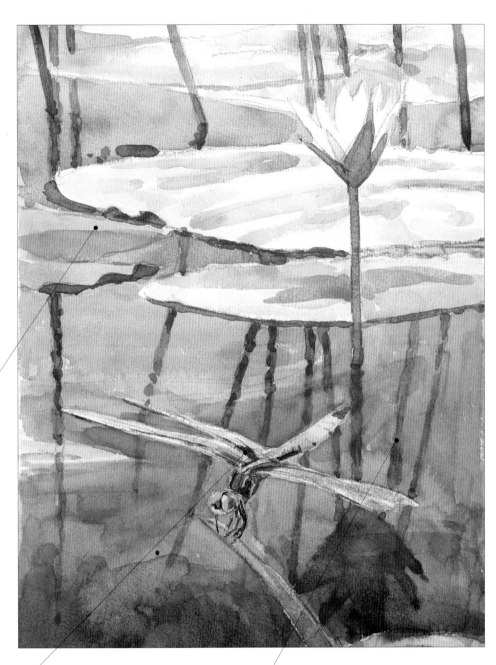

Note how a slight shadow under the lily pads immediately makes them look three-dimensional.

The dragonfly's wings are semi-transparent, so some colour can be seen through them; nonetheless, they stand out well against the darker blue of the water.

Note how the reflections are painted in slightly wobbly lines, to show how the water distorts them.

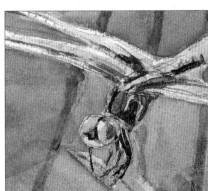

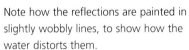

Beetle in acrylics

One of the difficulties that wildlife artists face is that specimens in the field may be set against an unsympathetic or distracting background. If that's the case, then why not use a bit of artistic licence and combine several references to create your own painting?

Your references may be in the form of sketches made in the field, or photographs that you have taken yourself or found in books or on the Internet. Whatever the source, remember to think about the relative scale of the different elements – particularly when you're painting things that are very different in size.

It's also important to make sure that the lighting is consistent. If the sunlight in your sketch or photograph of the habitat comes from the left, the shadows will fall on the right; and if the light illuminating your wildlife subject is from the right, then the shadows will fall on the left. If you follow your references exactly and put in both sets of shadows, they will cross over one another and your drawing or painting will look unrealistic. Decide which direction you want the light to come from in your painting and work out how dense the shadows need to be.

Finally, check that the species you're painting would actually be found in that habitat or on that particular plant. Check the seasonality, too: if you're painting a butterfly on a flower, for example, make sure that both would be found at the same time of year.

Materials
- *HB pencil*
- *HP pre-stretched watercolour paper*
- *Gum strip*
- *Masking fluid and old brush*
- *Acrylic paints: titanium white, yellow ochre, permanent green light, burnt sienna, raw umber, cadmium yellow, ultramarine, burnt umber, permanent rose, cadmium red, phthalocyanine green*
- *Brushes: fan-shaped hog brush, soft badger brush, selection of round brushes*
- *Craft (utility) knife (optional)*

The subject and the setting
For this painting of a rose chafer beetle (*Cetonia aurata*), the artist worked from photographs of a beetle taken in a natural history museum (below) and a thistle – one of the plants on which this particular beetle feeds – growing in the wild (above).

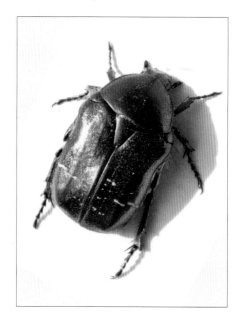

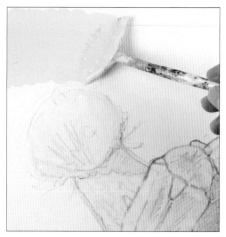

1 Using an HB pencil, sketch the beetle and plant, putting in some light shading for the darkest areas, then paint over the beetle and thistle with masking fluid and leave to dry. Wet the paper, using a brush dipped in clean water. Mix a pale green from titanium white, yellow ochre and permanent green light. Brush this colour over the whole painting, including the masked-out areas, working it well into the fibres of the paper.

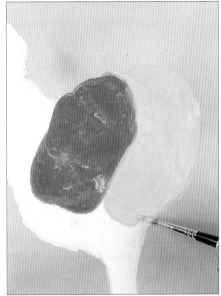

2 Dot pale yellow (white/yellow ochre mix) and dark brown (burnt sienna/raw umber) randomly over the green. Blend the colours together with a fan brush, then go over the marks lightly with a soft badger brush to get rid of any brush marks. Leave to dry.

3 Carefully peel off the masking fluid. Mix a bright but dark green from permanent green light and yellow ochre and block in the beetle. Add cadmium yellow and white to the mix to make a bright, light green and block in the green of the thistle heads.

4 Add ultramarine and a little burnt umber to the bright green mix and begin putting in the shaded areas on the thistle heads. Go over this again with the same mix to solidify and intensify the colour.

5 Mix a gold or bronze colour for the beetle from yellow ochre, burnt sienna and cadmium yellow. Block in the gold colour of the beetle quite roughly, keeping the paint thin so that some of the underlying green is still visible in places. Darken the mix by adding burnt umber and ultramarine, then paint in the edges of the elytra (the wing casings) and the darker parts of the wings.

6 Mix a rich, golden brown from burnt sienna and yellow ochre and paint the highlights on the elytra. Mix a dark, purple-pink from permanent rose, white, ultramarine and a little burnt umber and put in the mid-toned patches on the thistle heads.

7 Mix a bright pink from white and permanent rose and paint the petals of the flower head, leaving the brightest parts untouched. Add a little burnt sienna and put in the darker tones. Mix a dark purple-red from burnt umber, permanent rose, cadmium red and ultramarine and darken the shaded sides of the 'scales' on the thistle stems so that they begin to look more three-dimensional.

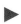

Assessment time
Although the different tones of gold and green on the beetle's shell help to make it look rounded, at this stage there is no real sense of the hard, shiny surface of the shell – some bright highlights are needed in order to convey this. The flower heads are taking shape well, but still look somewhat flat and one-dimensional.

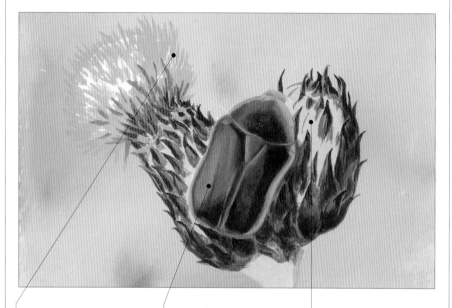

The flower head lacks form and textural detail.

The beetle is too uniform in colour – there are no highlights to indicate light reflecting off the hard carapace.

The underlying green colour of the thistle head is distractingly bright.

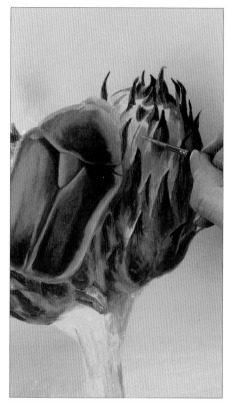

8 Mix a rich, golden brown from burnt sienna and yellow ochre and paint the highlights on the elytra. Mix a dark, purple-pink from permanent rose, white, ultramarine and a little burnt umber and put in the mid-toned patches on the thistle heads.

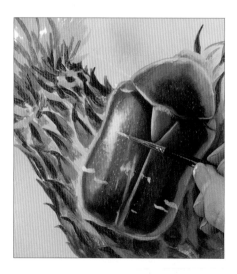

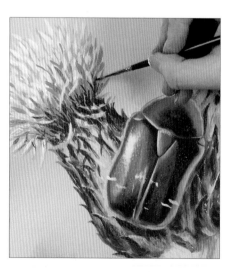

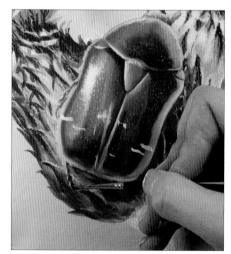

9 Add lots of white to the light green mix from Step 3 and put in the bright highlights on the beetle's shell. These highlights help to establish the curve of the beetle's body and make it look more rounded and three-dimensional.

10 Add lots of white to the bright pink mix from Step 7 and gently stroke it into the flower head to give it more form. Mix a cool purple from permanent rose, white, ultramarine and a tiny bit of burnt umber and put in the shadow colour in the flower head.

11 Mix a very thin dark green from burnt umber, ultramarine, phthalo green and permanent green light and glaze it over the shadow cast on the plant by the beetle. Use the same colour to put in the segments of the legs.

The finished painting

This is a deceptively simple-looking painting, with only two pictorial elements – the beetle and the plant. Nonetheless, the composition has been carefully thought out: the beetle and left-hand flower head are angled to point diagonally away from one another, thus introducing an element of visual tension to what, at first glance, is a very static scene.

The background is soft and muted, but painted in natural colours. The colours are complementary: the pinks and purples enhance and balance the greens. The different tones of green and gold within the beetle have been well observed, creating a good sense of form, while the bright, crisp highlights on the beetle's shell convey its hard, shiny surface.

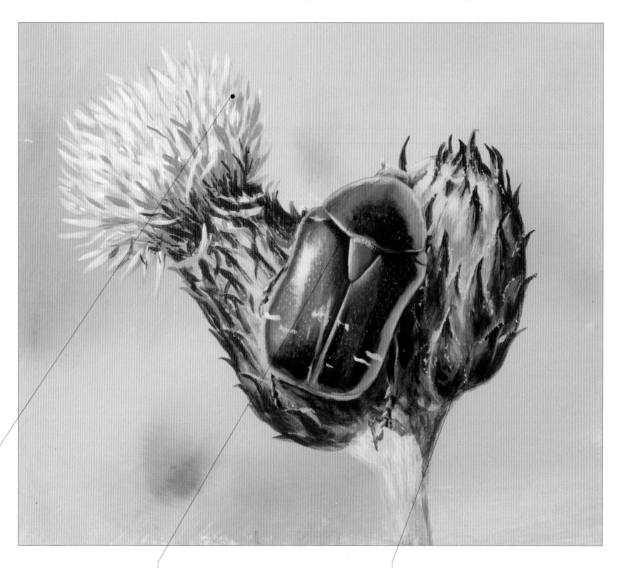

Note the use of different tones of pink on the petals. This helps to make them look rounded and three-dimensional.

The highlights on the beetle's shell are crisp and sharp, indicating that the surface is hard and shiny.

Note the use of cool purple for the shadow areas within the thistle head. This is important in creating a sense of form.

Bee in pastels

Both soft pastels and pastel pencils were used in this demonstration, with the soft pastels being used predominantly for the out-of-focus background elements and the pastel pencils for areas that require finer detail.

To create the soft background effect, the artist has simply blended the soft pastels with her fingers to create a very smooth surface with no obvious pastel marks. When blending, work on sections that are similar in colour first – all the pinks, and then all the greens. If you try to put down all the background colours and then blend the whole thing, you'll end up with a very muddy-looking result. And remember that you don't have to fill in every gap between the flowers; the paper is already a useful leafy-green colour, so use it to your advantage.

At first glance, both the bee and foreground flowers might seem like rather complicated subjects. The key, as always, is to try to see them as blocks of colour rather than as specific things. Start by putting down light layers, simply to establish the position on the paper, and then gradually build up to the correct density of colour, adding textural detail as you go.

There are so many tiny flowers in this particular scene that it's easy to lose track of where you are in the drawing. As the bee is the main subject, use it as a point of reference. Note, for example, where a particular flower aligns with the base of the wings or the edge of a yellow stripe and then take an imaginary line across from the bee to where the flower starts, so that you can be sure of positioning it accurately.

Materials

- *Mid-green pastel paper*
- *Pastel pencils: charcoal grey, yellow, white, fuchsia pink, peach, dark green, bright green, turquoise blue, purple, black, orange-yellow, pink-brown, lemon yellow, flesh colour*
- *Soft pastels: violet, pale pink, ultramarine blue, pale sky blue, brown, purple, white*
- *Cotton bud (cotton swab) or torchon*

The subject

There is an incredible amount of detail in this reference photo, from the tiny hairs on the bee's body to the individual flower petals. Don't lose sight of the fact that the bee is the main subject of the drawing: although they are important, the flowers should always be of secondary interest.

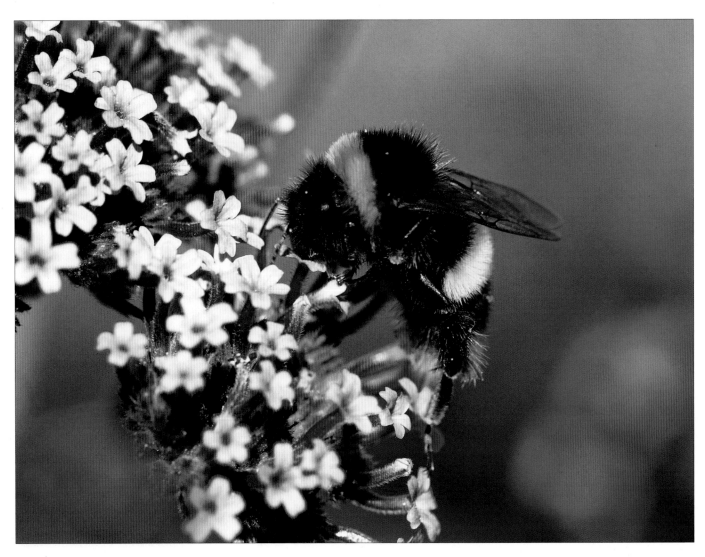

1 Using a charcoal grey pastel pencil, block in the dark markings of the bee's body. Do not press too heavily on the pencil: in this early stage, you are simply establishing the positions of the bands of colour, not attempting to create the right density of tone.

2 Block in the yellow markings, using a yellow pastel pencil. Establish the position of the transparent wings using the charcoal grey pencil.

> **Tip**: Turn the paper around to prevent smudging when you draw the wings.

3 Using a white pastel pencil, begin mapping out the main flowers. As with the bee, you're not attempting to get the right tone at this stage, you're trying simply to establish the positions and shapes; try to see the flowers as blocks of colour rather than as individual blooms. Make loose, scribbly marks that you can work over again later.

5 Using fuchsia pink and peach pastel pencils, scribble more colour over the out-of-focus flowers, then blend the marks with your fingers.

4 Using a violet soft pastel, scribble in the out-of-focus pink flowers in the background, then blend the marks with your fingertips. Add pale pink, ultramarine blue and pale blue soft pastel on top, as appropriate, and then blend the marks again with your fingers to get a smooth coverage.

> **Tip**: Note that the colours tend to be warmer (pinks and peach) in the centre of the flowers with slightly cooler colours (blues and violet) towards the edges of the flowers.

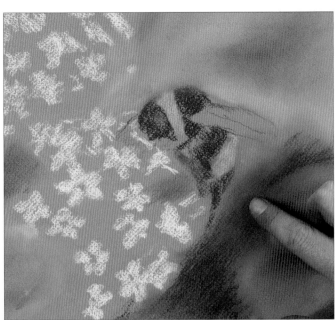

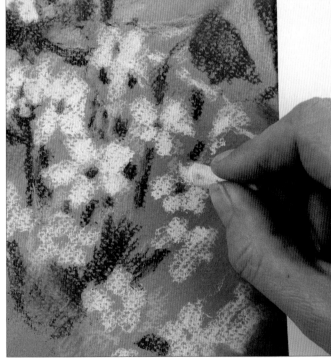

6 Loosely put in the shapes of the leaves behind the flowers, using dark green and bright green pastel pencils. Apply a little turquoise blue pastel pencil along the edge of the out-of-focus flowers to create a slight shadow and the impression of depth, then blend the marks with your fingers.

7 Continue working on the background, adding brown and purple soft pastel just below the bee, where the background is much darker. Take the blended background right up to the edge of the bee: you'll draw over it later to define the detail on the bee.

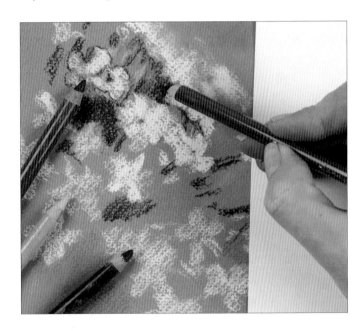

8 Using fuchsia pink, peach and purple pastel pencils, scribble in the pinks and purples of the flowers. Try to see the flowers as blocks of colour, rather than as individual blooms. Roughly block in the spaces between the flowers using a black pastel pencil; overlay purple on the brown for the very darkest patches.

 Tip: Lay a piece of clean paper over your drawing to prevent smudging what you've already done.

9 Using pink and peach pastel pencils, put in the flower stalks. Dot in bright yellow between the flowers, for the lighter bits of foliage. Now that you're building up colour on the flowers, you may find that you need to strengthen the whites that you put down initially. Use a white soft pastel for this, rather than a pastel pencil, as a pencil will not give you a bright enough white.

Assessment time

Apart from the bee's wings, all the main elements have been mapped in and the drawing is beginning to take shape. However, the bee, in particular, lacks form and detailing. You also need to take time to assess the tonal balance of the drawing as a whole at this point: now that the pinks and purples of the flowers have been put in, the out-of-focus background of the early stages seems quite cold in comparison.

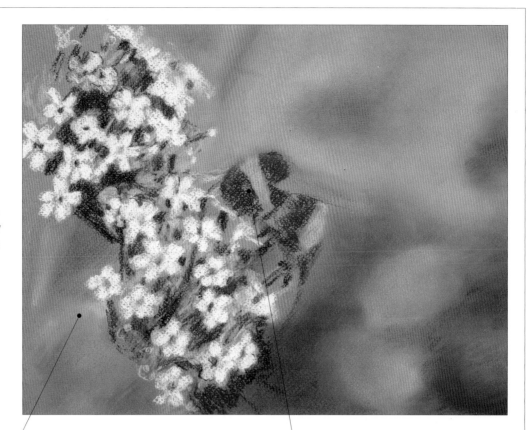

Set against the pinks of the flowers, this area of the background now seems too cool and blue.

Now that you've established the position and shape of the bee, you can concentrate on building up the depth of colour required and on developing the texture of the tiny hairs.

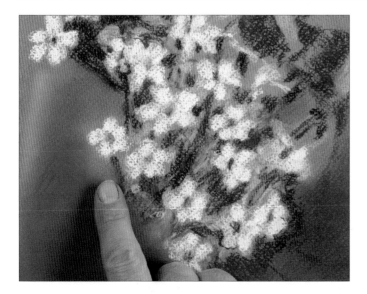

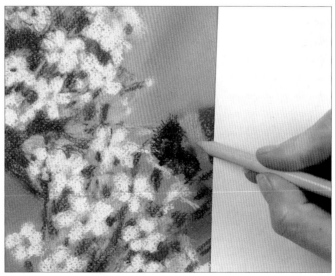

10 Darken the background, using the same colours as before, and gently blend the marks with your fingertips. Drawing is always a gradual process of assessment and refinement: if you had made the background very dark to begin with, you would not be able to apply lighter colours on top.

11 Using a black pastel pencil, go over the black parts of the bee again to instensify them, using a scribbling motion for the densest areas and fine lines for the tiny hairs. Some of the yellow areas of the bee are in shadow: use an orange-yellow pastel pencil for these, making short vertical scribbles to build up the texture and tone.

▶

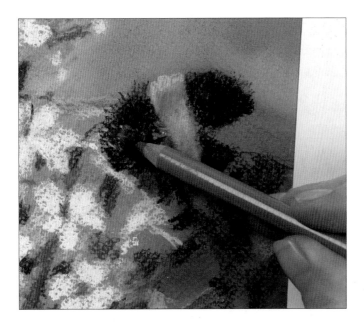

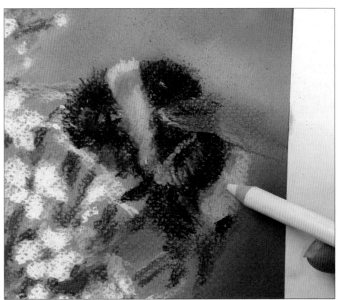

12 If you look carefully, you will see that there are tiny flecks of other colours in the bee's hairs – yellow, orange and a pink-brown in the black areas. Put them in using tiny pencil strokes. These subtle optical colour mixes add depth and enhance the overall effect.

> **Tip:** Roll the pencils around in your fingers as you work so that they do not blunt into a wedge shape.

13 Some pale colours can be seen through the transparent wings – lemon yellow, orange-yellow and peach. Put these in quite lightly, using pastel pencils. Note that the colours that can be seen through the wings will appear slightly more muted than those elsewhere in the background; the effect is rather like looking at something through a sheet of plastic. Use a lemon yellow pencil for the very brightest areas of yellow, scribbling quite hard to get the necessary depth of tone. Put some tiny flecks of black into the yellow for the spaces between the hairs.

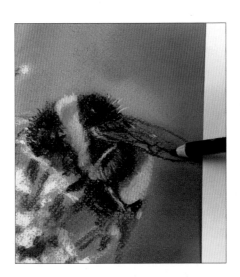

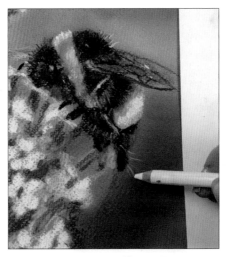

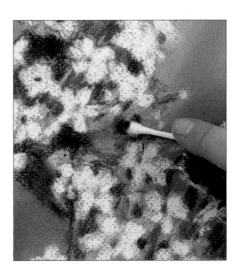

14 Draw in the veining on the wings using a black or very dark purple pastel pencil. These lines need to be very precise, so make sure that your pencil is sharpened to a fine point before you start.

15 There are some very bright, backlit hairs around the edges of the bee. Put these in with white and flesh-coloured pastel pencils.

> **Tip:** Wipe the white pencil tip on scrap paper to clean off any other colours that it may have picked up.

16 Add the flowers immediately below the bee, using the same colours as before. (It would be extremely difficult to put these flowers in at an earlier stage without running the risk of smudging them when you work on the bee.) Blend the dark background colours in the small spaces between the flowers using a cotton bud or torchon.

The finished drawing

In this skilful pastel drawing the emphasis is very firmly on the bee, with the foreground flowers being treated more loosely so that the bee really stands out. As in the reference photograph, the background is a series of impressionistic blurs of vivid colour, which gives the drawing a strong and contemporary feel. Any textural detail is reserved mainly for the bee itself, with tiny flicks of sharp-tipped pastel pencil being used to create the impression of individual hairs. Within the body of the bee, layer upon layer of pastel has been built up to create an intricate optical mix of different colours. The result is a delightful interpretation of an everyday garden subject.

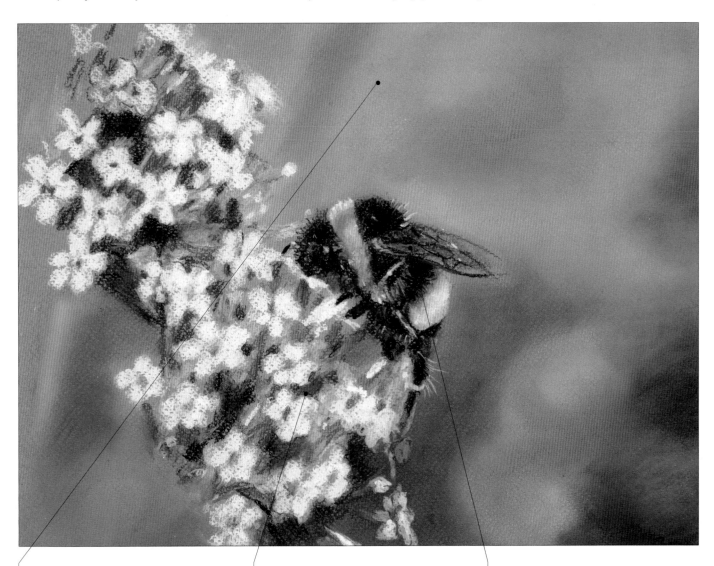

The background has been smoothly blended so that no trace of the original pastel strokes remains.

The flowers have been worked loosely and lightly so that they do not overpower the main subject.

Note the contrast in texture between the tightly packed hairs on the bee's body and the delicate tracery of the wings.

Butterfly in coloured pencil

This drawing was done using a close-up photograph as reference. When photographs are taken using a close-up or macro lens, the depth of field – the part of the image that is in sharp focus – is only a few centimetres. This means that the background is blurred, throwing attention on to the main subject. Here, the background foliage is reduced to blobs of colour; the artist chose to incorporate them into the composition as a semi-abstract graphic device, which gives the drawing a very contemporary feel.

Coloured pencils come in a huge range of colours but, even so, you may find that you do not always have the exact colour or tone that you need and that you have to create your own colour mixes. The most important thing to remember when working with coloured pencils is that the colours cannot be physically combined in the way that two paint colours can be mixed together on a palette. The only way to mix two or more coloured pencil colours together is to layer them and allow the mixing to happen optically, on the paper. You can apply a light colour over a dark one, or vice versa; the resulting mix will differ depending on which colour is applied first.

It can be very difficult to work out which colours you need to use, particularly for beginners, so if you're unsure, test out your colour combinations on a piece of scrap paper first. Once you've decided on your colours, it's a good idea to scribble the names and sample patches on to a piece of paper, so that if you take a long break between drawing sessions, you'll remember which colours you were using.

Work very lightly; in the early stages, the colour should be barely perceptible. To increase the depth of colour and tone, it's much better to build up several layers than to apply a single layer too heavily, which could risk damaging the paper.

The demonstration was done on smooth white illustration board. As in watercolour painting, the colour of the support is used for any whites in the subject (in this case, the white markings on the butterfly's wings) and the very brightest highlights. Work out first where the whites are going to be and leave space for them.

Materials
- *Tracing paper*
- *Smooth illustration board*
- *HB pencil*
- *Coloured pencils: cadmium yellow lemon, lemon, orange yellow, burnt ochre, burnt sienna, black soft, sap green, juniper green, apple green, light carmine, alizarin crimson, Payne's grey*
- *Kneaded eraser*

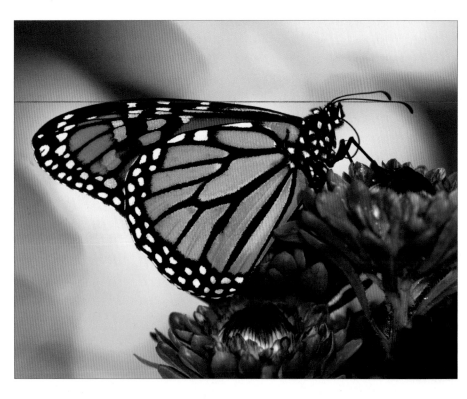

The subject
Because the depth of field – the area of the photo that is in sharp focus – is so shallow, the background is just an impressionistic blur of colour, allowing the butterfly to stand out clearly; even the antennae and proboscis are clearly visible, while the beautiful wing markings look almost like stained glass. The foreground flowers provide a setting for the butterfly without detracting from it.

1 Using an HB pencil, trace or draw the outline of the butterfly's wings and the flower tops on illustration board. At this stage, do not put in the legs or antennae. Using cadmium yellow lemon and lemon, apply two very light coats over the background of the green areas. Vary the pressure to create lighter and darker areas, but keep the strokes small and smooth.

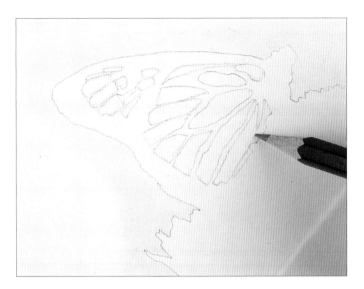

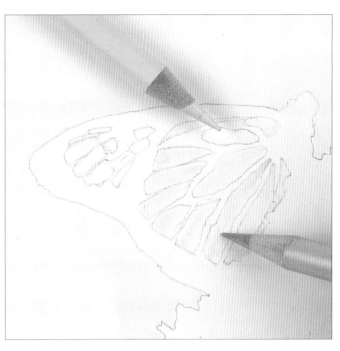

2 Still using the HB pencil, trace or draw in the orange wing markings. Correct any mistakes by dabbing off the pigment with a kneaded eraser. (Work gently; if you rub, you may damage the paper.)

Tip: Mould the kneaded eraser to a very fine point, so that you can lift out small areas. When the tip of the eraser becomes too dirty to use, simply pull that part off and discard it.

3 Using the side of the pencil, block in the orange areas in with a very light base coat colour of lemon yellow, then go over it again in orange yellow. Concentrate pressure where the colours are most intense and blend the pencil strokes softly outwards.

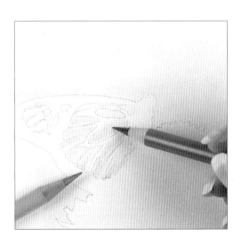

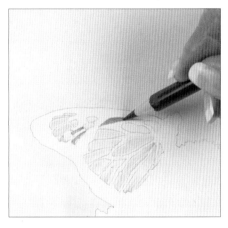

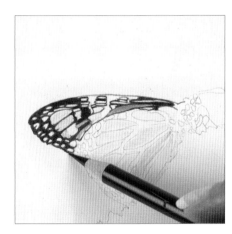

4 Use burnt ochre to pick out stronger, darker areas of colour, trying to capture the delicate gradations of tone. Create highlights within the markings by going over the base colour in more cadmium yellow lemon. Continue to build up the depth of colour in the markings, alternating between orange yellow and burnt ochre and using very light, tiny straight strokes. The yellow highlights then appear brighter.

5 For the markings at the top of the wing use the same process of building up the colour, but apply more burnt ochre. For the richer and darker markings, use a very light application of burnt sienna. Gradually build up the burnt ochre to darken and enrich these areas further if necessary.

Tip: Practise blending the three colours on scrap paper to achieve the right intensity and effect.

6 Draw in the white spots on the wings and body very lightly, using an HB pencil, then go around these markings in black soft coloured pencil, firmly, keeping the pencil well sharpened. Block in the black, noting that the edges of the black areas blend into the colours rather than being a sharp, crisp line.

▶

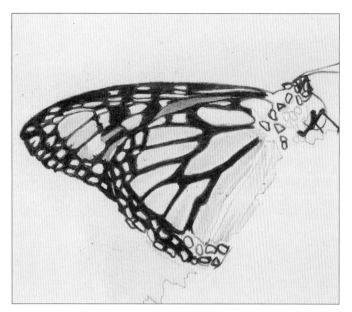

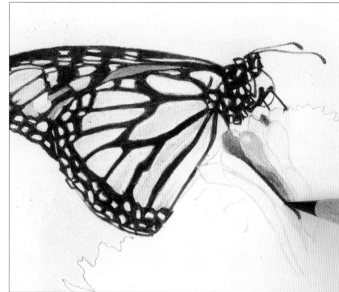

7 Finish the spots and go over the HB lines with black soft on the legs, body, antennae and proboscis.

8 Trace or draw in the flowers and foliage very lightly, using an HB pencil. Go over the HB foliage lines in sap green and apply soft touches of yellow to the tips of the leaves. Pinpoint areas of deeper colour in juniper green to help you map out the area. Apply a very light undercoat of yellow all over the foliage. Go over this in apple green, and then sap green. Fill in the darker areas in juniper green. For the very dark areas of shade, use black soft.

Tip: Now that you've mapped in the main colours of the butterfly, you can move on to the flowers. It's a good idea to alternate between the two, rather than attempting to complete all the insect first. In this way you maintain the tonal balance of the piece as you are continually assessing one part against the other.

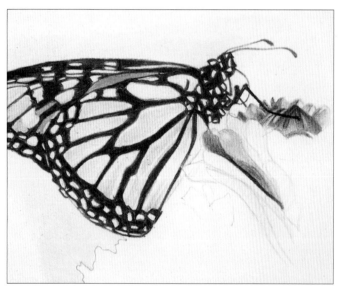

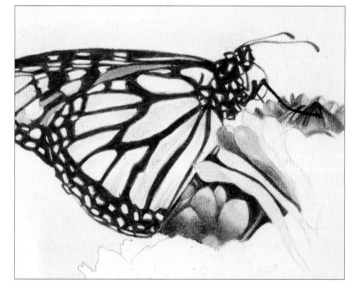

9 For the flower, apply a light layer of light carmine, then go over it in alizarin crimson. Using black soft, start at the tip and draw fine light lines down the petals, blending softly into the alizarin crimson as the colour darkens further down the flower head. Go back over with light carmine. Sketch the leaves behind the flower in sap green over the background yellow, then go over lightly with sap green and juniper green. Use black soft to put in the butterfly's foot on the flower.

10 Fill in the rest of the leaves using a very light layer of yellow and building up the greens as before, leaving the lighter colours showing where there are highlights. Work up the darks now, to enable you to get the balance of the other colours right. Use Payne's grey and then black soft in the deeply shaded areas. In areas with little definition, build up blocks of colour and finish by applying a layer of very light black soft.

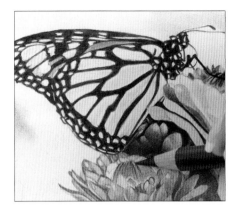

11 Lightly draw a rectangle around the picture area, using an HB pencil, so that you are absolutely clear where the edges of the picture lie. Block in the out-of-focus green background behind the butterfly in a very light layer of sap green, fading it out into the yellow where necessary. Begin adding juniper green for the bluer, darker areas, alternating and blending it with lemon.

12 Block in the leaves of the flowers with a light layer of cadmium yellow lemon, then apply the base colour of apple green followed by sap green, leaving the yellow undercolour showing for the very lightest areas. Use juniper green for the darker areas and the shadows.

13 Continue working on the leaves, using the same colours as in the previous two steps. Complete the pink flowers, using light carmine as the base colour with alizarin crimson on top for the veining on the petals. Leave the white of the illustration board showing through where necessary for the light, bright petal tips.

Assessment time

All the elements – butterfly, foreground flowers and background – are lightly in place; now you can concentrate on building up the correct density of colour and tone, using the same colours as before. It's very important to keep sight of the drawing as a whole and assess each part in relation to the rest: if you try to complete either the butterfly or the background in isolation from each other, the chances are that you will get the tonal balance wrong.

At this stage the artist has mapped out the main blocks of colour in the background, but the area is still far too pale. The foreground flowers look rather flat and insubstantial, and require more linear detail; the shadows, in particular, need to be made much darker.

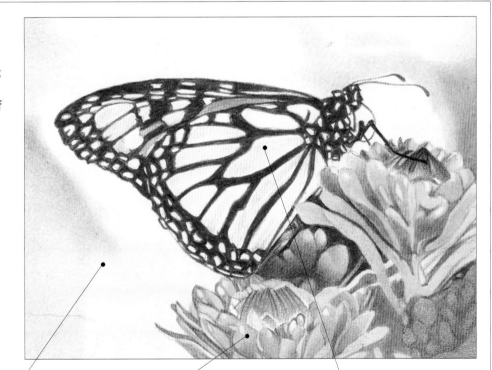

The background is pale and distractingly bright.

The flowers and leaves in the foreground look very flat; increasing the contrast between the light and dark areas will make them look more three-dimensional.

The wing markings need several more layers in order to build up the right depth of colour.

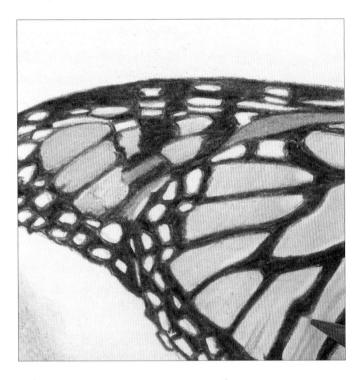

14 Darken the colour on the wings. On the far wing, which is darker than the near wing, apply a light layer of burnt ochre.

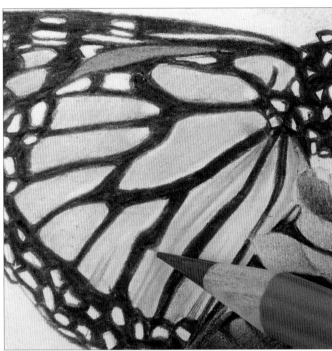

15 On the near wing, apply a fine layer of orange yellow over all the coloured markings, then use burnt ochre for the finer markings within the coloured segments.

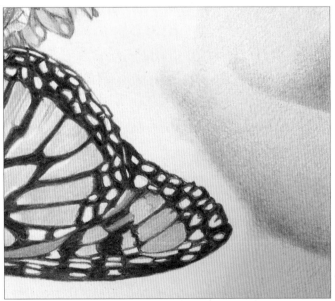

16 Darken the green background where necessary, using juniper green, which is a cooler, bluer green than the other greens.

Tip: You will probably find it easier to work on the top left corner if you turn the drawing upside down. Protect the rest of the drawing by laying a sheet of clean paper over it if necessary, so that your drawing hand does not smudge the layers of colour that you have already laid down.

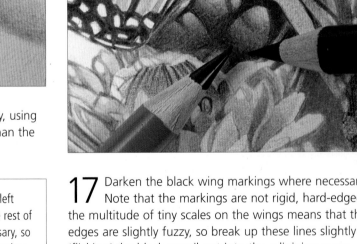

17 Darken the black wing markings where necessary. Note that the markings are not rigid, hard-edged lines: the multitude of tiny scales on the wings means that the edges are slightly fuzzy, so break up these lines slightly by 'flicking' the black pencil out into the adjoining areas. Alternating between juniper green and black soft, put in the dark shadow areas on the leaves.

The finished drawing

This drawing demonstrates the precision and subtlety that can be achieved using coloured pencil. It captures the butterfly in fine detail, with delicately applied layers of colour creating subtle tonal variations within the subject and tiny pencil strokes picking out the slightly fuzzy edges of the individual scales on the wings. The foreground is drawn in a stylised way to create a general impression of the leaves and flowers, although it still has depth, while the background is an impressionistic blur of similar-toned colours that allows the butterfly to stand out in all its glory.

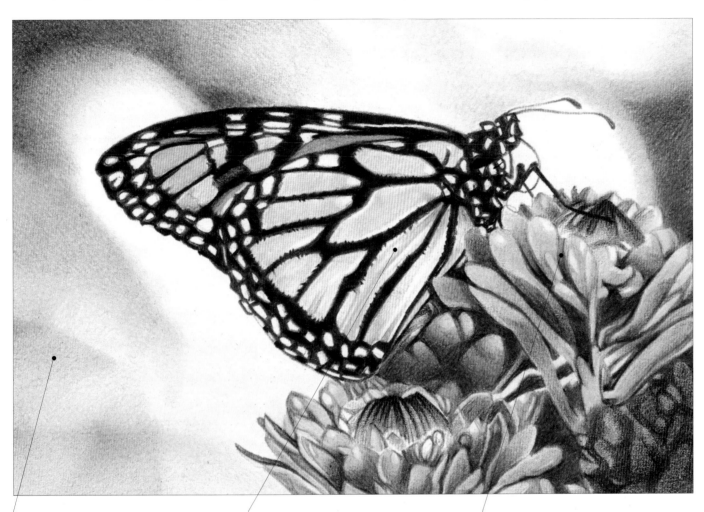

The background is made up of several layers of yellows and greens, lightly applied so that the colours mix optically on the paper.

Fine strokes made using the fine point of the pencil convey the subtlety of the wing markings.

The contrast between the light and dark areas makes the flowers and leaves look really three-dimensional.

Glossary

Additive A substance added to paint to alter characteristics such as the paint's drying time and viscosity.

Alla prima A term used to describe a work (traditionally an oil painting) that is completed in a single session. *Alla prima* means 'at the first' in Italian.

Blending Merging adjacent colours or tones so that they gradually merge into one another.

Body colour Opaque paint, such as gouache, which can obliterate underlying paint colour on the paper.

Charcoal Charcoal is made by charring willow, beech or vine twigs at very high temperatures in an airtight kiln. It is available in powder form and as sticks. It can also be mixed with a binder and pressed into sticks ('compressed' charcoal).

Colour

Complementary: Colours opposite one another on the colour wheel.

Primary: A colour that cannot be produced by mixing other colours, but can only be manufactured. Red, yellow and blue are the three primary colours.

Secondary: A colour made by mixing equal amounts of two primary colours.

Tertiary: A colour produced by mixing equal amounts of a primary colour and the secondary colour next to it on the colour wheel.

Colour mixing

Optical colour mixing: Applying one colour on top of another in such a way that both remain visible, although the appearance of each one is modified by the other. Also known as *broken colour*.

Physical colour mixing: Blending two or more colours together to create another colour.

Cool colours Colours that contain blue and lie in the green-violet half of the colour wheel.

Composition The way in which the elements of a drawing are arranged within the picture space.

Closed composition: One in which the eye is held deliberately within the picture area.

Open composition: One that implies that the subject or scene continues beyond the confines of the picture area.

Conté crayon A drawing medium made from pigment and graphite bound with gum. Conté crayons are available as sticks and as pencils.

Drybrush The technique of dragging an almost dry brush, loaded with very little paint, across the surface of the support to make textured marks.

Eye level Your eye level in relation to the subject that you are drawing can make a considerable difference to the composition and mood of the drawing. Viewing things from a high eye level (looking down on them) separates elements in a scene; when viewed from a low eye level (looking up at them), elements tend to overlap.

Fat over lean A fundamental principle of oil painting. In order to minimize the risk of cracking, oil paints containing a lot of oil ('fat' paints) should never be applied over those that contain less oil ('lean' paints) – although the total oil content of any paint mixture should never exceed 50 per cent.

Fixative A substance sprayed on to drawings made in soft media such as charcoal, chalk and soft pastels to prevent them from smudging.

Foreshortening The illusion that objects are compressed in length as they recede from your view.

Form *See* Modelling.

Format The shape of a drawing or painting. The most usual formats are landscape (a drawing that is wider than it is tall) and portrait (a drawing that is taller than it is wide), but panoramic (long and thin) and square formats are also common.

Glaze A transparent layer of paint that is applied over dry paint. Light passes through the transparent glaze and is reflected back by the support or any underpainting. Glazing is a form of optical colour mixing as each glaze colour is separate from the next, with the mixing taking place within the eye.

Gouache *see* Body colour.

Graphite Graphite is a naturally occurring form of crystallized carbon. To make a drawing tool, it is mixed with ground clay and a binder and then moulded or extruded into strips or sticks. The sticks are used as they are; the strips are encased in wood to make graphite pencils. The proportion of clay in the mix determines how hard or soft the graphite stick or pencil is; the more clay, the harder it is.

Ground The prepared surface on which an artist works. Also a coating such as acrylic gesso or primer, which is applied to a drawing or painting surface.

Hatching Drawing a series of parallel lines, at any angle, to indicate shadow areas. You can make the shading appear more dense by making the lines thicker or closer together.

Crosshatching: A series of lines that crisscross each other at angles.

Highlight The point on an object where light strikes a reflective surface. Highlights can be drawn by leaving areas of the paper white or by removing colour or tone with an eraser.

Hue A colour in its pure state, unmixed with any other.

Impasto Impasto techniques involve applying and building oil or acrylic paint into a thick layer. Impasto work retains the mark of any brush or implement used to apply it.

Line and wash The technique of combining pen-and-ink work with a thin layer, or wash, of transparent paint (usually watercolour) or ink.

Mask A material used to cover areas of a drawing, either to prevent marks from touching the paper underneath or to allow the artist to work right up to the mask to create a crisp edge. There are three materials used for masking – masking tape, masking fluid and masking (frisket) film.

Medium (1) The material in which an artist chooses to work – pencil, pen, pastel and so on. (The plural is 'media'.) (2) In painting, 'medium' is also a substance added to paint to alter the way in which it behaves – to make it thinner, for example. (The plural in this context is 'mediums'.)

Modelling Emphasizing the light and shadow areas of a subject through the use of tone or colour, in order to create a three-dimensional impression.

Negative shapes The spaces between objects in a drawing, often (but not always) the background to the subject.

Overlaying The technique of applying layers of watercolour paint over washes that have already dried in order to build up colour to the desired strength.

Palette
(1) The container or surface on which paint colours are mixed.
(2) The range of colours.

Perspective A system whereby artists can create the illusion of three-dimensional space on the two-dimensional surface of the paper.
Aerial perspective: The way the atmosphere, combined with distance, influences the appearance of things. Also known as *atmospheric perspective*.
Linear perspective: This system exploits the fact that objects appear to be smaller the further away they are from the viewer. The system is based on the fact that all parallel lines, when extended from a receding surface, meet at a point in space known as the vanishing point. When such lines are plotted accurately on the paper, the relative sizes of objects will appear correct in the drawing.
Single-point perspective: This occurs when objects are parallel to the picture plane. Lines parallel to the picture plane remain parallel, while parallel lines at 90° to the picture plane converge.
Two-point perspective: This must be

used when you can see two sides of an object. Each side is at a different angle to the viewer and therefore each side has its own vanishing point.

Picture plane An imaginary vertical plane that defines the front of the picture area and corresponds with the surface of the drawing.

Positive shapes The tangible features (figures, trees, buildings, still-life objects etc.) that are being drawn.

Primer A substance that acts as a barrier between the support and the paints. Priming provides a smooth, clean surface on which to work.

Recession The effect of making objects appear to recede into the distance, achieved by using aerial perspective and tone. Distant objects appear paler.

Resist A substance that prevents one medium from touching the paper beneath it. Wax (in the form of candle wax or wax crayons) is the resist most commonly used in watercolour.

Sgraffito The technique of scratching off pigment to reveal either an underlying colour or the white of the paper. The word comes from the Italian verb *graffiare*, which means 'to scratch'.

Shade A colour that has been darkened by the addition of black or a little of its complementary colour.

Sketch A rough drawing or a preliminary attempt at working out a composition.

Solvent *See* Thinner.

Spattering The technique of flicking paint on to the support.

Support The surface on which a drawing is made – often paper, but board and surfaces prepared with acrylic gesso are also widely used.

Thinner A liquid such as turpentine which is used to dilute oil paint. Also known as *solvent*.

Tint A colour that has been lightened. In pure watercolour a colour is lightened by adding water to the paint.

Tone The relative lightness or darkness of a colour.

Tooth The texture of a support. Some papers are very smooth and have little tooth, while others have a very pronounced texture.

Torchon A stump of tightly rolled paper with a pointed end, using for blending powdery mediums such as soft pastel, charcoal and graphite. Also known as *paper stump* or *tortillon*.

Underdrawing A preliminary sketch on the canvas or paper, over which a picture is painted. It allows the artist to set down the lines of the subject, and erase and change them if necessary, before committing irrevocably to paint.

Underpainting A painting made to work out the composition and tonal structure before applying colour.

Value *See* Tone.

Vanishing point In linear perspective, the vanishing point is the point on the horizon at which parallel lines appear to converge.

Viewpoint The angle or position from which the artist chooses to draw his or her subject.

Warm colours Colours in which yellow or red are dominant. They lie in the red-yellow half of the colour wheel and appear to advance.

Wash A thin layer of transparent paint.
Flat wash: An evenly laid wash that exhibits no variation in tone.
Gradated wash: A wash that gradually changes in intensity from dark to light, or vice versa.
Variegated wash: A wash that changes from one colour to another.

Wet into wet The technique of applying paint to a wet surface or on top of an earlier wash that is still damp.

Wet on dry The technique of applying paint to dry paper or on top of an earlier wash that has dried completely.

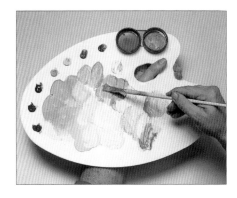

Suppliers

Manufacturers

Daler-Rowney UK Ltd
Peacock Lane
Bracknell
RG12 8SS
United Kingdom
Tel: (01344) 461 000
Website: www.daler-rowney.com

Derwent Cumberland Pencil Co.
Greta Bridge
Keswick
Cumbria CA12 5NG
United Kingdom
Tel: (017687) 73626
Website: www.pencils.co.uk

Sennelier
Max Sauer S.A.
Z.I. 2, rue Lamarck BP 204
22002 St-Brieuc Cedex
France
Tel: 02 96 68 20 00
Fax: 02 96 61 77 19
Website: www.sennelier.fr

Winsor & Newton
Whitefriars Avenue
Wealdstone
Harrow
Middlesex HA3 5RH
United Kingdom
Tel: (020) 8424 3200
Website: www.winsornewton.com

Stockists

United Kingdom

Art Express
1 Farleigh Place
London N16 7SX
Tel: (0870) 241 1840
Website: www.artexpress.co.uk

Atlantis Art Materials
Britannia House
68–80 Hanbury Street
London E1 5JL
Tel: (020) 7377 8855
Website: www.atlantisart.co.uk

Ken Bromley Art Supplies
Curzon House, Curzon Road
Bolton BL1 4RW
Tel: (01204) 381 900
Fax: (01204) 381 123
E-mail: sales@artsupplies.co.uk
Website: www.artsupplies.co.uk

Dominoes
66 High Street, Leicester
Tel: (0116) 253 3363
E-mail: info@dominoestoys.co.uk
Website: www.dominoestoys.co.uk

Hobbycraft
Hobbycraft specialize in arts and
crafts materials and own 20 stores
around the UK.
Freephone (0800) 027 2387
Website: www.hobbycraft.co.uk

Jackson's Art Supplies Ltd
1 Farleigh Place
London N16 7SX
Tel: (0870) 241 1849
Website: www.jacksonsart.co.uk

Paintworks
99–101 Kingsland Road
London E2 8AG
Tel: (020) 7729 7451
E-mail: shop@paintworks.biz
Website: www.paintworks.biz

Stuart R Stevenson
68 Clerkenwell Road
London EC1M 5QA
Tel: (020) 7253 1693
E-mail: info@stuartstevenson.co.uk
Website: www.stuartstevenson.co.uk

The Studio Art Shop
13 Crawford Arcade
King Street, Stirling FK8 1AX
Tel: (01786) 446454
E-mail: info@thestudioartshop.com
Website: www.thestudioartshop.com

Turnham Arts & Crafts
2 Bedford Park Corner
Turnham Green Terrace
London W4 1LS
Tel: (020) 8995 2872
Fax: (020) 8995 2873

United States

Many of the following companies
operate retail outlets across the US.
For details of stores in your area, phone
the contact number below or check
out the relevant website.

Art Store
Website: www.artstore.com
(15 stores nationwide)

The Art Supply Warehouse
6104 Maddry Oaks Court
Raleigh
NC 27616
Tel: (800) 995 6778 (toll free)
Fax: (919) 878 5075
Website: www.aswexpress.com

Dick Blick Art Materials
PO Box 1267
Galesburg
IL 61402-1267
Tel: (800) 828-4548
Website: www.dickblick.com
(More than 30 stores in 12 states)

Hobby Lobby
Website: www.hobbylobby.com
(More than 300 stores in 27 states)

Madison Art Shop
17 Engleberg Terrace
Lakewood
New Jersey 08701
Tel: (800) 284 4846 (toll free)
Fax: (800) 961 1570
Website: www.madisonartshop.com

Michaels Stores
8000 Bent Branch Drive
Irving
Texas 75063
Tel: (800) 642 4235
Website: www.michaels.com
(More than 750 stores in 48 states)

New York Central Art Supply
62 Third Avenue/11th Street
New York
NY 10003
Tel: (212) 473-7705
Orders: (800) 950-6111
Fax: (212) 475-2513
Website: www.nycentralart.com

Rex Art
3160 SW 22 Street
Miami
FL 33145
Tel: (305) 445-1413
Fax: (305) 445-1412
Website: www.rexart.com

Canada
Colours Artist Suppliers
10660-105 Street
Edmonton
Alberta
Canada T5H 2W9
Tel: (800) 661 9945
Website: www.artistsupplies.com

Curry's Art Store
2485 Tedlo Street
Mississauga
Ontario
Canada
Tel: (416) 967 6666
Toll Free: (800) 268 2969
Fax: (905) 272 0778
E-mail: info@currys.com
Website: www.currys.com

Island Blue Art Store
Tel: (800) 661 332
Website: www.islandblue.com

Kensington Art Supply
132 10th Street NW
Calgary
Alberta T2N 1V3
Tel: (403) 283 2288
Fax: (403) 206 7095
E-mail: info@kensingtonartsupply.com
Website: www.kensingtonartsupply.com

The Paint Spot
10516 Whyte Avenue
Edmonton
Alberta T6E 2A4
Tel: (780) 432 0240
Fax: (780) 439 5447
E-mail: info@paintspot.ca
Website: www.paintspot.ca

Australia
Art Materials
E-mail: enquiries@artmaterials.com.au
Website: www.artmaterials.com.au

Oxford Art Supplies Pty Ltd
221–225 Oxford Street
Darlinghurst
NSW 2010
Tel: (02) 9360 4066
Fax: (02) 9360 3461
E-mail: orders@oxfordart.com.au
Website: www.oxfordart.com.au

Oxford Art Supplies Pty Ltd
145 Victoria Avenue
Chatswood
NSW 2067
Tel: (02) 9417 8572
Fax: (02) 9417 7617
E-mail: mailorder@oxfordart.com.au
Website: www.oxfordart.com.au

Premier Art Supplies
43 Gilles Street
Adelaide
SA 5000
Tel: (618) 8212 5922
Fax: (618) 8231 0441
E-mail: sales@premierart.com.au
Website: www.premierart.com.au

New Zealand
Draw Art Supplies Ltd
PO Box 24022
5 Mahunga Drive
Mangere Bridge
Auckland
Tel: (09) 636 4989
Fax: (09) 636 5162
E-mail: enq@draw-art.co.nz
Website: www.draw-art.co.nz

Fine Art Supplies
Website: www.fasart.com

Art Supplies.co.nz
312 Ti Rakau Drive,
Botany, Auckland
Tel: (09) 273 9450
Website: www.artsupplies.co.nz

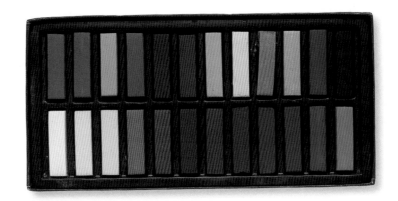

Index

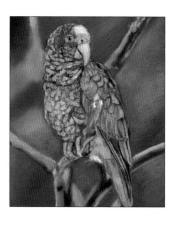

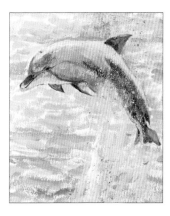

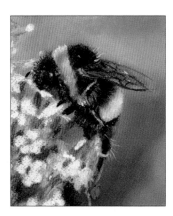

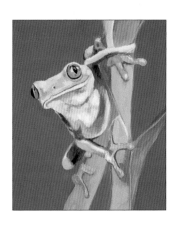

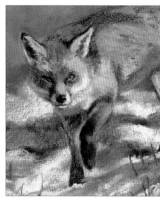

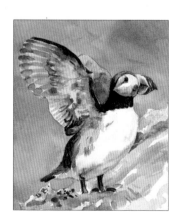

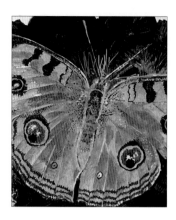

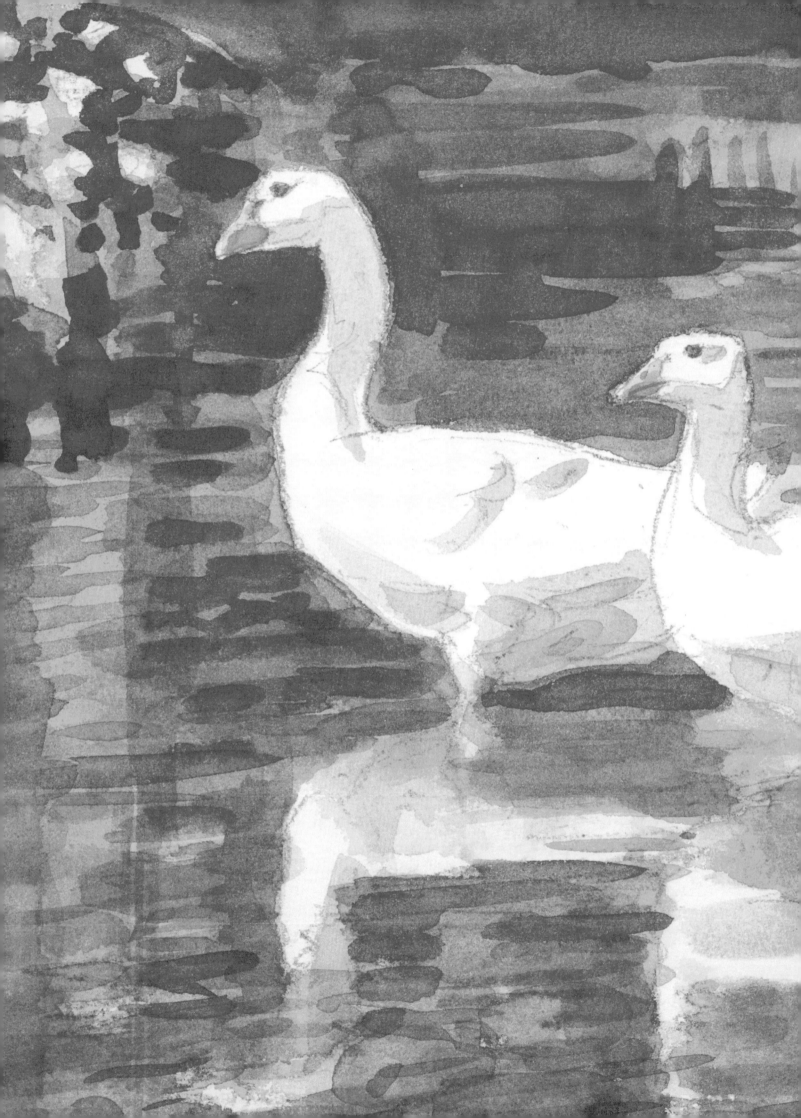